To Genevieve

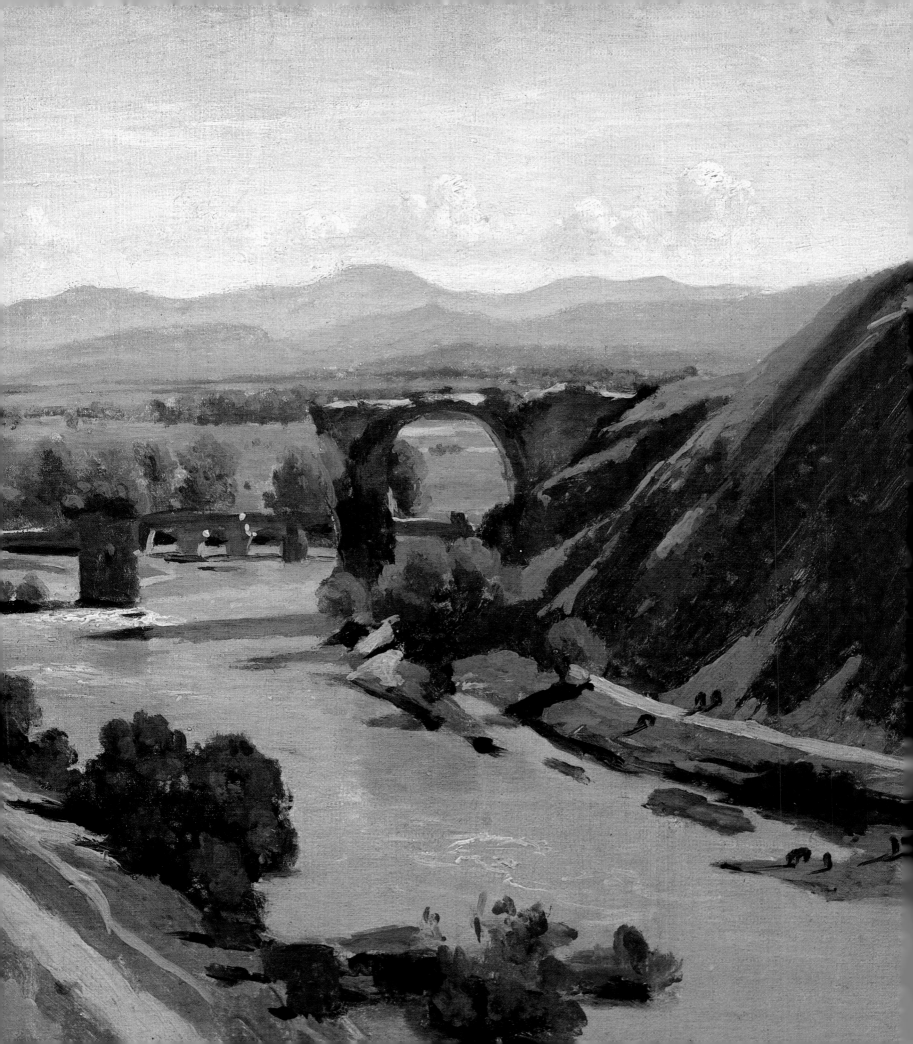

PREFACE

This book began as a dissertation at Columbia University, New York. My first debt is to the school and to my teachers there, especially Theodore Reff, Kirk Varnedoe, Richard Brilliant, Allen Staley, and the late Milton J. Lewine. The dissertation was supported by fellowships in the Department of European Paintings at The Metropolitan Museum of Art, New York, in 1979–80 and 1982–83. For this support and for their advice and encouragement I am grateful to Sir John Pope-Hennessy, Katharine Baetjer, and Charles S. Moffett.

Only about half of the book is about Corot. Much of the rest concerns the international school of open-air painting that he joined when he arrived in Italy. When I began my work more than ten years ago, interest in this subject was confined to a tiny community of enthusiasts. Or, to be more precise, the subject did not yet exist as such; a few scholars, collectors, and dealers were then in the process of piecing it together as a coherent object of study. This effort of historical imagination recovered a tradition of painting that had disappeared from memory more than a century earlier. That recovery is the essential foundation of this book, for I will argue that Corot's achievement in Italy cannot be understood apart from the tradition that preceded him there.

I was lucky to meet several participants in this collective project who generously shared with me their hard-won discoveries and perceptions. I owe my deepest gratitude to John Gere; Sir Lawrence Gowing; Jacques Fischer of the Galerie Fischer-Kiener, Paris; and Wheelock Whitney III, then of Hazlitt, Gooden & Fox, London, now of Wheelock Whitney & Company, New York. I also learned a good deal from Pierre C. Lamicq; the late Colin P. McMordie; Chantal Kiener of Fischer-Kiener; and Stephanie Maison and J.M.K. Baer of Hazlitt.

I am thankful for the kind and tireless assistance of the curatorial staffs of the Bibliothèque Nationale and the Musée du Louvre, Paris. Hélène Toussaint and Jacques Foucart at the Louvre were exceptionally helpful, and the Service d'Etude et de Documentation in the Département des Peintures, vigorously maintained by Foucart, was an indispensable resource. I wish also to acknowledge the aid and advice of Claude Aubry, Galerie Claude Aubry, Paris; Philippe Brame, Galerie Brame & Lorenceau, Paris; Jacqueline Cartwright, The Lefevre Gallery, London; Denis Coutagne and Bernard Terlay, Musée Granet, Aix-en-Provence; Pierre Dieterle; Gerhard Gerkens, Museum für Kunst und Kulturgeschichte, Lübeck; Christoph Heilmann, Bayerische Staatsgemäldesammlungen, Munich; Helmut R. Leppien, Kunsthalle, Hamburg; Régis Michel, Musée du Louvre; Pierre Miquel; Peter Nathan, Galerie Nathan, Zurich; William O'Reilly, Salander-O'Reilly Galleries, New York; Dominic Tambini, Wildenstein & Co., New York; and Eugene V. Thaw and Patricia Tang, E.V. Thaw & Co., New York.

In 1981, at the invitation of John Szarkowski, I organized at The Museum of Modern Art, New York, an exhibition titled *Before Photography: Painting and the Invention of Photography*. Supported by a grant from the National Endowment for the Arts, my work on that project contributed substantially to this book. Since 1981, while writing the book, I have worked at the Museum under John Szarkowski and have benefited greatly from his encouragement and wisdom.

This book has been edited and designed by Gillian Malpass, who also super-

left Detail from pl. 200 (Corot).

vii

vised its production. Her intelligence and enthusiasm have shaped every aspect of the book, and I thank her warmly. Invaluable contributions have been made also by Wheelock Whitney III, who read much of the manuscript, and by John Gere, who read all of it. Jeanne Bouniort, who translated the text for the French edition, saved me from a number of mistakes. By acknowledging these great favors I do not mean to spread blame for the errors that remain.

Throughout my work I have relied upon the grace, hard work, and good humor of Genevieve Christy, my wife.

In the Museum of Fine Arts, Boston, is a copy, by whom unknown, of Corot's view of the Tiber Island in Rome. It no longer hangs in the galleries but it did when I was ten years old, and I loved it. Because of it, when I first visited Rome I went directly to draw the motif. Now I know that my act of homage was a faint echo of Corot's homage to his predecessors, and I wish to record my gratitude to the forgotten but not incompetent copyist of Corot's magnificent painting.

P.G.

N.B. Throughout the text and notes, and in the plate captions, Corot's works are cited by catalogue number in Alfred Robaut and Etienne Moreau-Nélaton, *L'Oeuvre de Corot* (1905) and its three supplements (1948, 1956, and 1974), with the respective prefixes, "R.," "RS1.," "RS2.," and "RS3." (See page 229, note 1, and the Bibliography.) In the plate captions, dimensions are recorded in centimeters.

CONTENTS

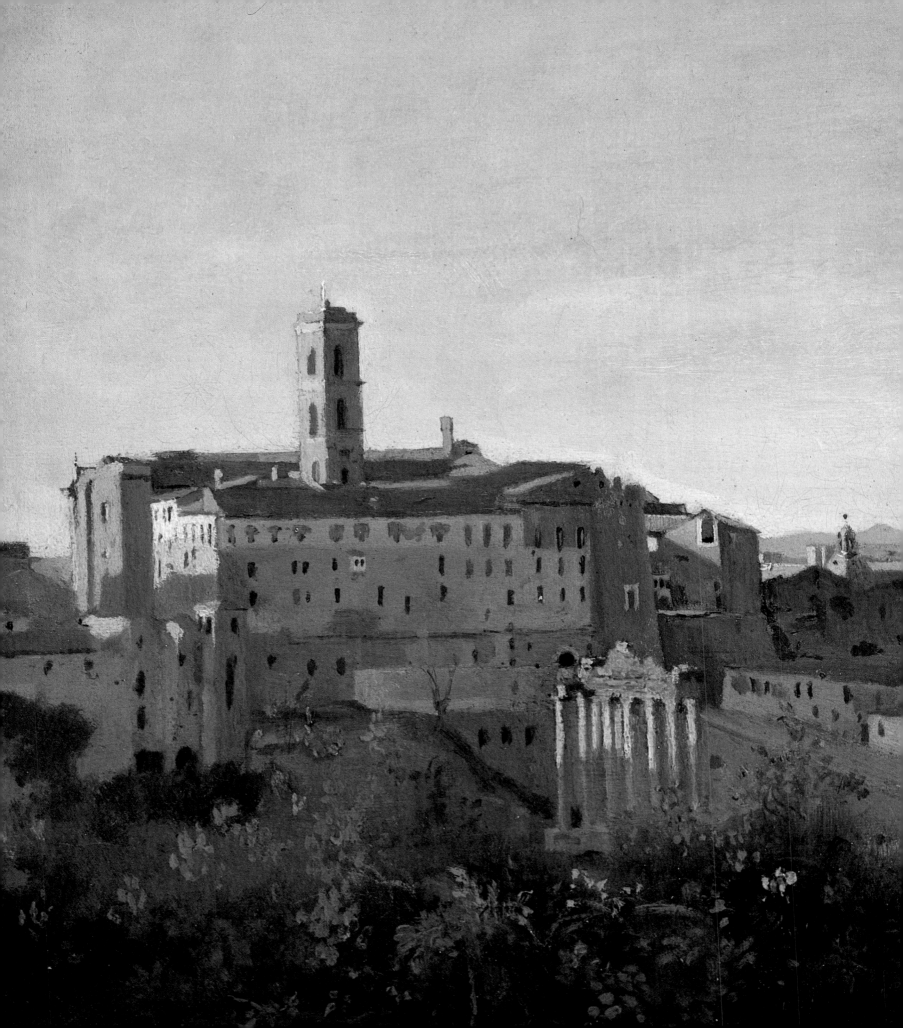

INTRODUCTION

JEAN-BAPTISTE-CAMILLE COROT was born in 1796, at the outset of the First Republic of France, and died in 1875, at the outset of the Third. His career, more than half a century long, spanned a period of great turmoil and transformation in French life and culture. Through it Corot worked ceaselessly, creating a prodigious and complex body of work, rich in innovation. Among landscape painters trained in the Neoclassical school, whose origins lay in the *Ancien Régime*, Corot alone provided nourishment for the very different aesthetic of the second half of the nineteenth century. For this achievement he has been hailed as a pioneer. Yet he never rejected the principles of his earliest training, nor did the development of his art follow a simple path. It has always been difficult to grasp Corot's work as a coherent whole.

Apart from his work Corot left few clues to his outlook. The cloying persona of benign secular saint, crafted by others with Corot's acquiescence late in his life, is a blank mask. His statements, or rather those of his statements that his disciples chose to record, only rarely escape cliché. At work in a milieu of controversy, Corot was unusually detached from worldly affairs and even from artistic disputes. From an early stage in his career, however, he displayed a high and searching ambition, and he persisted in it through more than two decades of indifference and even hostility to his work. For better and for worse, Corot was devoted to painting.

Corot's detachment in itself was an expression of the cultural environment to which he belonged. His parents' modest prosperity insulated him from financial necessity; although not rich until late in life, he never needed to earn a living. Corot's financial independence corresponded to a deepening ideal of artistic independence. Increasingly over the course of his career the artist came to be viewed as a free agent, unbeholden to state, academy, patron, or critic. Corot's detachment may be understood as an appeal to the disinterested judgment of history, as an earnest personal dialogue with tradition.

The imperative of artistic originality – the idea that achievement entails innovation – was centuries old. In the nineteenth century, especially in France, it acquired a new urgency, sharpened by ceaseless social ferment. This sense of urgency brought a heightened sense of uncertainty to the relationship between present and past. One refuge from risk was to embrace the past as an unsurpassable model; another was to reject the past utterly, thus claiming the authority of inevitable change. Because Corot adopted neither of these extreme positions, he is ill suited for either of the roles so dear to the durable mythology of nineteenth-century art, in which the conservative, academic villain is pitted against the radical, independent hero. For the genre of landscape that mythology took an especially dramatic form, in which the adventurous hero set out from the timid group to confront nature alone, as if for the first time, trusting only his eyes and rejecting the stale lessons of the studio. Conceived in this way, the evolution of landscape painting charts the progressive emancipation of the individual from repressive convention, culminating in an art of purified vision, innocent of pictorial habit or rule. Some of Corot's work can be made to fit this paradigm, but at the cost of incomprehension in the face of his work as a whole.

left Detail from pl. 180 (Corot).

Since the 1850s Corot has been celebrated without interruption, but only for certain aspects of his work. The aspects selected for praise have shifted over time so that, roughly speaking, the work most admired at the outset is now a disappointment and vice versa. Always, the sense of Corot's achievement has corresponded to the prevailing outline of progress in nineteenth-century art. At any point the election of part of Corot's work to the grand unfolding of artistic progress has transformed the remainder into a puzzling failure – of talent or, in the favored explanation, of nerve. In the most extreme formulation Corot was both a courageous pioneer, for his outdoor painting, and a craven retrograde, for the Salon pictures he painted in the studio. This formulation distorts even the aspect of Corot's work it seeks to praise, by removing any opportunity to understand the whole of his work as the fruit of an individual effort.

There is no longer a shred of originality in discrediting the inherited mythology of nineteenth-century art. The polarity of its terms, the emphasis on conflict, the simplistic concept of progress as an unbroken sequence of triumphs, and the tendency to project upon the individual the stark role of hero or villain, have exhausted their usefulness as critical tools. The paradigm is too crude to describe broad patterns of change in which many artists participated, each differently, none with a zealot's preconscience of the whole; and it does violence to the long and rich careers of such artists as Corot and his contemporaries Delacroix and Ingres, for whom the issue of tradition and innovation was not a matter of black and white. Nevertheless, the old mythology of conflict was not a capricious fiction. It arose to explain the new pace and character and discontinuities of nineteenth-century art, and if the old explanation is discarded new ones must take its place. No artist, no individual work, can be understood in isolation from the powerful momentum of change.

This book does not aim to construct a new paradigm of nineteenth-century painting, nor even a revised outline of Corot's career. It is rather an empirical inquiry into a brief, splendid episode at the very beginning of that career. Inevitably, however, the problem of tradition will arise and will broaden the inquiry far beyond the work of Corot.

* * *

In the fall of 1825, at the age of twenty-nine, Corot concluded his education in the studios of Paris and embarked for Italy. There he joined a lively international community of young artists from the North, who, like him, had undertaken the time-honored journey to Italy. Like the many other landscape painters among the group, Corot spent most of his time drawing and painting outdoors, in and near Rome. He stayed nearly three years; from the episode more than 200 drawings and 150 small landscape paintings have been recorded.[1] The best of these works possess a sweet perfection, free of striving and struggle. There is no heroic triumph over difficulty, no display of mastery over vast resources; only a seamless collaboration of mind, hand, and eye.

In addition to the many outdoor drawings and paintings that Corot made in Italy, he painted a pair of exhibition pictures, which he sent to Paris for his debut at the Salon of 1827. This division of artistic labor – between open-air study and finished studio composition – had a long prior history. Nor was it unusual that Corot devoted most of his time in Italy to outdoor work. For him as for his companions the trip to Italy was understood as an extension of the artist's education. Just as history painters at the French Academy were expected to copy famous works of painting and sculpture, landscapists took Rome and the

countryside as their model. For nearly half a century before Corot arrived in Italy outdoor painting had been a regular component of this program of study after nature.

In the course of the nineteenth century, however, as the practices and ambitions that Corot had taken for granted became obsolete, the status of his early outdoor paintings became problematic. By the time modern taste embraced Corot's Italian landscapes as great works of art, very little knowledge of their original function or historical context survived. A good deal of this book is devoted to recovering that context. The nature of the problem may be introduced by reviewing the history of appreciation and understanding of Corot's early Italian landscapes.

* * *

Corot's Italian work enjoyed a considerable reputation among his peers, virtually from the beginning. Already in March 1826, only four months after Corot had arrived in Rome, a more seasoned colleague proclaimed him "our master" on the basis of a single open-air study (R.66; pl. 179).[2] Upon returning to France, Corot followed the established practice of displaying his landscape studies in his studio, as souvenirs and as sources of inspiration and instruction, for his colleagues and students as well as for himself.[3] Corot's sketchbooks of the 1830s and later contain several long lists of studies, especially those from the first trip to Italy, that he had lent to other painters.[4]

The growing professional reputation of Corot's Italian work first reached the public in the early 1850s, when he began to achieve celebrity and critics started to write about him at length. In 1853 Théophile Silvestre wrote:

> The *studies* painted by Corot before his trip to Italy do not have much character . . . but Italy struck him very much by vigorous contrasts of light and shadow, by the stately effect of masses deployed against the sky. The long observation of a country so brightly lit must have made future work easy for him, even in landscapes of indistinct aspect. . . . By transposing one by one to the canvas the colored masses as he had observed them, he was able to establish accurately the ensemble of a landscape, absolutely as if it were a matter of assembling the various pieces of a mosaic. In this way he painted all his Italian views.[5]

This is the most perceptive – and extensive – description to appear in the nineteenth century. In the decades that followed, accounts of Corot's career regularly included a brief mention of the Italian work, often with praise but never with much discussion. On the occasion of Corot's death in 1875 Philippe Burty wrote of Corot's Italian landscapes:

> Some of these studies, very personal works and marked by the delicacy of the drawing and the keenness of the overall structure, are famous in the studios. Corot lent them willingly, and they have had a happy influence on the contemporary school.[6]

In an essay of 1882 Jules Claretie wrote:

> Corot keeps in his studio . . . a number of very compact and careful studies, which one day will show by what long and slow effort he eventually was able to endow his brush with such a freedom of touch and his tonality with such a fluent tenderness.[7]

The notion that the discipline of Corot's early studies lay behind the success of his later, freer manner was a leitmotif of nineteenth-century criticism. In an important essay of 1861 Paul Mantz wrote:

> He brought back from this journey [to Italy] a large number of studies that are simple and precise, especially in regard to the drawing, although sometimes a bit dry in execution . . . they represent stretches of terrain, trees, rocks, buildings; precious documents that the artist used much later, and that became in his hands an inexhaustible source of poetic inspiration.[8]

Mantz's appraisal of the Italian studies is in keeping with his sense of Corot's overall artistic development. In this essay he established the view that Corot had gradually freed his natural lyric talent from the repressive conventions of Neoclassical landscape painting. Under this conception, which placed Corot's mature Salon pictures at the head of advanced landscape painting, and which prevailed until after the turn of the century, the early Italian work could be seen only as a background and a contrast to later triumphs.[9] David Croal Thomson, writing in 1892, put it this way:

> In the two studies by Corot, "The Coliseum" [R.66; pl. 179] and "The Forum" [R.67; pl. 180] now in the Louvre, . . . the work is altogether different from that usually associated with Corot's name; it is hard in outline and "tight" in technique. It is in every way opposed to the style adopted by the master in later years. But it will be asked – and it is difficult to answer – would Corot not have been able to paint the pictures which have made him famous, if he had not thoroughly gone through the training manifested in these early works?[10]

The "hard outline" and "tight technique," also noted in Corot's Italian drawings, were associated with the style of his masters and the Neoclassical school to which they belonged. By the 1860s that school, especially its leader Pierre-Henri de Valenciennes (1750–1819), had fallen into disrepute. Most of the outdoor studies Valenciennes had painted in Italy in the 1780s had disappeared at his death into a single private collection, and comparable works by his contemporaries and students were progressively forgotten in the second half of the nineteenth century. These painters were known and ridiculed for their Salon paintings, regarded almost universally as pompous vehicles of dead academic values, unredeemed by the least trace of personal feeling or direct observation of nature. Charles Blanc led this general attack on the school of Valenciennes; in an essay on Corot's teacher Achille-Etna Michallon (1796–1822) he wrote, "to speak frankly . . . historical landscape is a false genre."[11] In 1853 Silvestre had written, "Michallon was one of those professors who preached respect for truth [to nature] even as they disfigured it in their pedantic works."[12] Michallon and others occasionally escaped the wide net of disapproval but never did Valenciennes, of whom Henri Focillon despaired in 1927: "there remains little in his art."[13]

This disdain for the Neoclassical school – a corollary of rising critical acclaim for the Romantic naturalism of the "School of 1830" – deeply influenced the way Corot's early Italian landscapes were understood. By the early twentieth century, when a new generation began to acclaim these works as among Corot's best, the context in which they had been created had vanished from historical memory. Specifically, the rich tradition of early outdoor painting in Italy had fallen into oblivion. Late nineteenth-century accounts of Neoclassical landscape occasionally mentioned open-air studies, but only as an exception to the general rule. Such passing references amounted to a rhetorical device, designed to emphasize by

contrast the barren artificiality of the Neoclassical school as a whole.[14] This strategy had two lasting effects. First, what in fact had been a widespread practice of painting from nature in Italy in the half-century before 1830 was represented as the isolated and exceptional activity of one painter or another. Second, what Corot and his masters had viewed as a unified process was recast as a sharp conflict between the progressive naturalism of the outdoor study and the conservative routine of the studio composition.

The view of Corot's career established by Paul Mantz in 1861 prevailed for a generation after the artist's death in 1875. During this period Corot's enormous oeuvre became increasingly well known. In his lifetime he had never presented his work in a retrospective exhibition, and only once had he shown an Italian study (R.66; pl. 179), at the Salon of 1849.[15] Public exhibition of the earlier works in quantity and with frequency began only in 1875, when a showing of 226 works was organized to commemorate Corot's death.[16] From that time onward works of all periods could be seen (at least in Paris) with growing frequency in group exhibitions, both official and commercial, and at sales of collections that included substantial representations of Corot's work.[17]

The remarkable catalogue raisonné of Corot's work, begun by Alfred Robaut during the artist's lifetime, appeared in 1905.[18] In addition to the illustrated catalogue itself, which included drawings as well as paintings and was followed by a scrupulous bibliography, Etienne Moreau-Nélaton's biography of Corot presented a far more extensive and reliable account than any that had come before. Robaut and Moreau-Nélaton did not depart from the overall interpretation of Corot's career that Mantz had established before the artist's death, but their work created a rich resource for the study of Corot, which in effect encouraged subsequent reinterpretations. Beyond this, Robaut and Moreau-Nélaton assembled a substantial collection which, upon donation to the Louvre between 1906 and 1927, made it possible to study at first hand a fine sample of Corot's Italian landscape studies in oil and the great majority of his surviving Italian drawings.

The first scholar to make use of – rather than simply borrow from – the catalogue of 1905 was Germain Bazin, whose *Corot* was published in 1942.[19] In the intervening period there had appeared a series of hagiographic monographs, uniform in their praise for the benign and beneficent personality of "Papa Corot," in their lack of attention to particular works, and in their indifference to matters of fact.[20] Without the benefit of new scholarship, however, a profound change was taking place in the way Corot's work was appreciated and understood.

The view that Corot's early Italian landscapes and late figure pieces represent his highest achievement, and that these private or personal works are far superior to his public Salon paintings – a view still widely if less virulently held today – began to take hold in the early decades of this century. By 1930, at least in advanced circles, it was accepted as fact. In 1907 Edgar Degas (who owned one of Corot's best Italian landscapes [R.98 *bis*; pl. 207]) questioned the Louvre's recent purchase of Corot's late *Belfry of Douai* (R.2004), telling Moreau-Nélaton, "Ah, for my part, I would have preferred the *Monte Cavo*."[21] In 1922 Walter Sickert admired an early Roman study by Corot as "one of the modern miracles of the world."[22] In 1925 Roger Fry, writing of Corot's Italian landscapes, stated that "apart from his figure pieces and one or two larger landscapes, it is by these frank and immediate responses that Corot takes his predominant place in modern landscape."[23] In 1930 Alfred H. Barr, Jr., in one of his first catalogues for the young Museum of Modern Art in New York, claimed: "These diminutive Italian landscapes demand superlatives. Surely they are among the most beautiful

small paintings in European art."[24] Not only the intensity of praise but also the tendency to single out the Italian landscapes from the rest of Corot's work marks a new stage.

By the 1920s Impressionism was regarded as a central episode in modern art. The notion that fidelity to unembellished visual experience was a central achievement of modern painting lies behind Roger Fry's praise for Corot's Italian landscapes as "frank and immediate responses." This phrase identifies the works with a progressive trend in nineteenth-century painting that culminated in the Impressionist "innocent eye," triumphing over the empty authority of academic art. Especially since the prior tradition of outdoor painting in Italy was by this time almost entirely forgotten, Corot's apparent devotion to pure vision seemed particularly advanced. In this view Corot in Italy was not only a precursor but virtually an Impressionist *avant la lettre*. Lionello Venturi wrote in 1941: "Thus in 1826, quite alone and without any programme, but in the most natural way, Corot jumped fifty years ahead of painting and passed from neo-classical to impressionistic taste."[25] Such a view entailed the perception of a sharp contrast between Corot's outdoor work, especially the Italian landscapes, and his Salon pictures, especially the later ones. The following passage, written by Clive Bell in 1927, is typical of the way in which this contrast was explained:

> When he was young [Corot] was adequately stimulated by what he saw, and the difficulty of rendering his passionate and personal vision evoked all his gift of expression. But as he grew older and more at ease with his proper experience, he had, or rather thought he had, to lace his genuine and genial reactions with something grander. . . .[26]

Bell's preference for early over late – a precise reversal of the view set forth by Mantz in 1861 – elsewhere appeared as a preference for nature study over exhibition picture. The common message was that Corot's work from nature represented his true talent and inclination, his Salon paintings, a submission to official or commercial taste. As early as 1896 André Michel had written:

> If one could arrange in the same gallery, on one side the official "composi-tions" that Corot painted in his first years of active production, based on the precepts of his masters and intended for submission, in the Salons, to the judgment of the public, – and on the other side the little studies that he executed alone, without any worry of exhibition or a jury, of rules to apply or critics to avoid, *sub Jove crudo*, in the real presence of nature – one would be struck by singular contradictions. As much as he would appear encumbered and constrained in the former, he is equally spontaneous, original, and charming in the latter.[27]

Soon this judgment crystallized in the often-repeated comparison of Corot's study of the ruined Augustan bridge at Narni (pl. 200) with the composition based on it, which Corot sent to Paris for the Salon of 1827 (pl. 203). Describing the transformation of study into composition, Julius Meier-Graefe wrote in 1930, "From fresh Impressionism came stale Romanticism."[28] In 1942 Germain Bazin explained:

> While the study is a marvel of spontaneity, already containing the germ of Impressionism, the ambitious canvas is a mediocre exercise of a Neoclassical student. Thus we see the first outline of that dual and contradictory activity that Corot would pursue to the end of his life, and that, by a profound

misunderstanding, would oblige this painter of direct emotion to think of himself as a history painter.[29]

The image of conflict between genuine personal expression and inherited academic rules has remained a staple of Corot criticism. It allows the modern critic to dismiss the greater part of Corot's effort as a capitulation to conventional taste, and thus to identify the remainder – Corot's work from nature – with the authentic tradition of modern art. As Lawrence Gowing put it in 1965:

> The simple and consistent standpoint in the face of nature, which Corot took up from the beginning, was the basic, original nourishment of modern painting. It supported all great painting of the nineteenth century and it began with him.[30]

At the same time that this critical pattern was taking form, another, very different interpretation was emerging. Where the former emphasized Corot's fidelity to visual experience, the latter called attention to the formal rigor and classical motifs of the Italian studies. In the essay quoted above, Alfred Barr compared Corot in Italy not with the Impressionists but with Giotto, Fra Angelico, Poussin, Cézanne, Derain, and Picasso.[31] Among these painters Poussin was the most frequently cited, his name evoking classical sobriety and nobility of purpose. This aspect of Corot's Italian work was especially appealing to French critics of the 1920s, who turned to the classical tradition as a refuge of stability – and nationalism – from recent artistic and political upheavals.[32] In an article published in the Purist journal *L'Esprit nouveau* and illustrated with Corot's Italian studies, Roger Bissière explained:

> Ingres and Corot, in particular, occupy an important place in contemporary concerns. Their work is ever new, and the most opposed camps claim affinity with them. I believe that one must seek the explanation in the fact that they possess in the highest degree the virtues of their race, and that they represent, more than all other painters, tradition and discipline.[33]

Thus in the 1920s and 1930s, as Corot's Italian landscapes achieved a canonical position in the history of modern painting, critics justified that position for what would seem to be opposite reasons. On one hand Corot was regarded as a precursor of the Impressionists, praised for his personal attachment to nature and for his independence from false academic values. On the other he was regarded as a champion of tradition and discipline, praised for his allegiance to classical order and for his aloofness from the abuses of modern individualism. In fact these were not mutually exclusive positions; many critics held both, seizing upon Corot as the essential link in the glorious unfolding of French landscape painting. Henri Focillon wrote in 1927:

> By his origins, by the masters who formed him, by the Italy of his youth, by his feeling for order, Corot belongs to the great tradition of classical landscape. By his exquisite feeling for tonal values, by the poetry of atmosphere, and by the airborne freshness of his palette, he anticipates Sisley. In him the forms of French genius that seem most opposed are reconciled.[34]

Focillon may have been implying that Corot's role as a link in French painting depended upon a long evolution in his own work. Other critics, however, saw the opposing tendencies already fully reconciled in Corot's early Italian studies. In an essay of 1928, on the Italian landscapes and figure studies, Elie Faure stated plainly: "It is thanks to Corot that one may discover between Poussin and

Monet . . . a single inclination in the effort of French painters."[35] This perception of equilibrium in Corot's Italian landscapes, between classicism and naturalism, between tradition and modernity, between order and freedom, has become a salient theme. It received its most elaborate expression in an essay by Max Raphael concerning a single early Roman landscape by Corot. The following sentence is typical of the essay:

> We have here a coexistence of individuality and union, of ostensible deliberateness and willful chance, which clearly expresses the search for the harmonious interplay of being and consciousness.[36]

Raphael's essay represents the extreme of the critical tradition I have been describing, not least because its abstract, metaphysical argument is divorced from any historical context. In the early twentieth century, recognition of Corot's extraordinary accomplishment in Italy did not inspire curiosity about the circumstances in which he had worked. As a result his Italian landscapes came to be treated as an isolated peak of artistic achievement, cut off from the particular tradition that had formed them and from Corot's other work, connected only to other monuments of art history, such as the landscapes of Claude and Poussin, Monet and Cézanne.

* * *

The fundamental aim of this book is to examine Corot's early Italian landscapes within their immediate artistic context. The recovery of that context began quite by accident in 1930, when the princesse de Croÿ bequeathed to the Louvre the collection of art formed by her ancestor the comte de l'Espine, finance minister under the Restoration. The collection included, among much else, several hundred drawings by Corot's teacher Michallon and many landscape studies in oil painted by Valenciennes in Italy in 1782–84. When some of the latter were shown in 1930 in an exhibition of selections from the collection, they came as a revelation.[37] Since the mid-nineteenth century Valenciennes had been ridiculed routinely as a hopeless reactionary, the pompous mouthpiece of every false doctrine that modern landscape painters had struggled to overcome. Although scholars knew his treatise of 1800, in which he had recommended sketching outdoors in oil, they discounted the theoretical advice, having no evidence that Valenciennes himself had applied it in practice. In 1925 Prosper Dorbec, after discussing the treatise, concluded, "In sum [Valenciennes] mistrusted all those particularities of aspect, the observation of which would lie at the very core of the program of the School of 1830."[38] Once rediscovered, Valenciennes's Italian studies constituted powerful evidence that the Neoclassical landscape school and its leader had been unfairly judged. René Huyghe was quick to apply the evidence to his understanding of Corot:

> Corot remains a poetic miracle, but no longer a historical miracle. Valenciennes, in his official role, is associated with the most insipid degeneration of classical landscape; in his intimate work he directly introduces the young Corot, the Corot of Italy. It is through his work in particular that one may follow the glacial evolution from "Poussin to Corot," which one could hardly understand while this essential link was missing. Have not many historians of the nineteenth century classified Corot in the Barbizon School? Once Corot is linked with classical landscape, *opposed* to the innovative school of Fontainebleau, everything becomes clear. . . . One may object that

it is more suitable to mark the break about 1820: before, academic landscape: Valenciennes, Michallon; after, realist landscape: Corot, Rousseau. But do not Michallon and, above all, Valenciennes prove themselves to be, *in private*, devoted realists? . . . Classical landscape ended with realism (this is the revelation of Valenciennes); modern landscape began with realism.[39]

Huyghe did not explain how classical landscape could have ended in realism. But his brief remarks contain two original and provocative perceptions: that our understanding of Corot's work is profoundly influenced by the frame of reference in which it is considered, and that the appropriate context for Corot's Italian landscapes is not what came after but what came before. This book might fairly be summarized as an application of these two perceptions.

The argument here will rely on a great deal of evidence that was unavailable in 1930. One important body of material is the corpus of outdoor oil studies painted in Italy by the Welsh artist Thomas Jones (1742–1803) at the same time that Valenciennes was at work there.[40] Also long-forgotten, Jones's studies reappeared in the sale room in 1954, eventually to be exhibited in significant numbers for the first time in 1970.[41] Since then a broadening accumulation of other evidence and attempts to make sense of it have provided a basis for the present inquiry.

In the Italian work of Valenciennes and Jones in the early 1780s outdoor painting emerged as an autonomous practice from the old academic tradition of study after nature. This phenomenon, which at once signaled a crisis in the landscape tradition and created a new opportunity, is the subject of Chapter I. The path from Valenciennes's and Jones's landscapes to Corot's is really two paths, which reconverge in Corot's early work. The first path is to be traced in France, through the school of Neoclassical landscape that Valenciennes founded and to which Corot attached himself as a student. That school and the broader artistic circumstances that shaped Corot's outlook and ambitions are the subject of Chapter II. The second path is to be traced in Italy, where between the 1780s and the 1820s a continuous stream of young artists arriving from the North created an international school of outdoor painting, centred at Rome. The evolution of that school, its reliance on the venerable pictorial and literary image of Italy, and the enrichment of its own conventions are the subject of Chapter III. The precedent is essential to Corot's achievement. Although his first trip to Italy occurred at the outset of his career and of modern landscape painting in France, it was not so much a beginning as an end – the culmination of nearly half a century of open-air painting in Italy, a rich tradition which Corot inherited at the peak of its maturity. Chapter IV, the last, considers Corot's Italian landscapes themselves. Thanks to a wealth of material it is possible to follow Corot's development in great detail and to analyze his methods. If earlier chapters strive to show how much Corot owed to his predecessors, Chapter IV explores our greater debt to him.

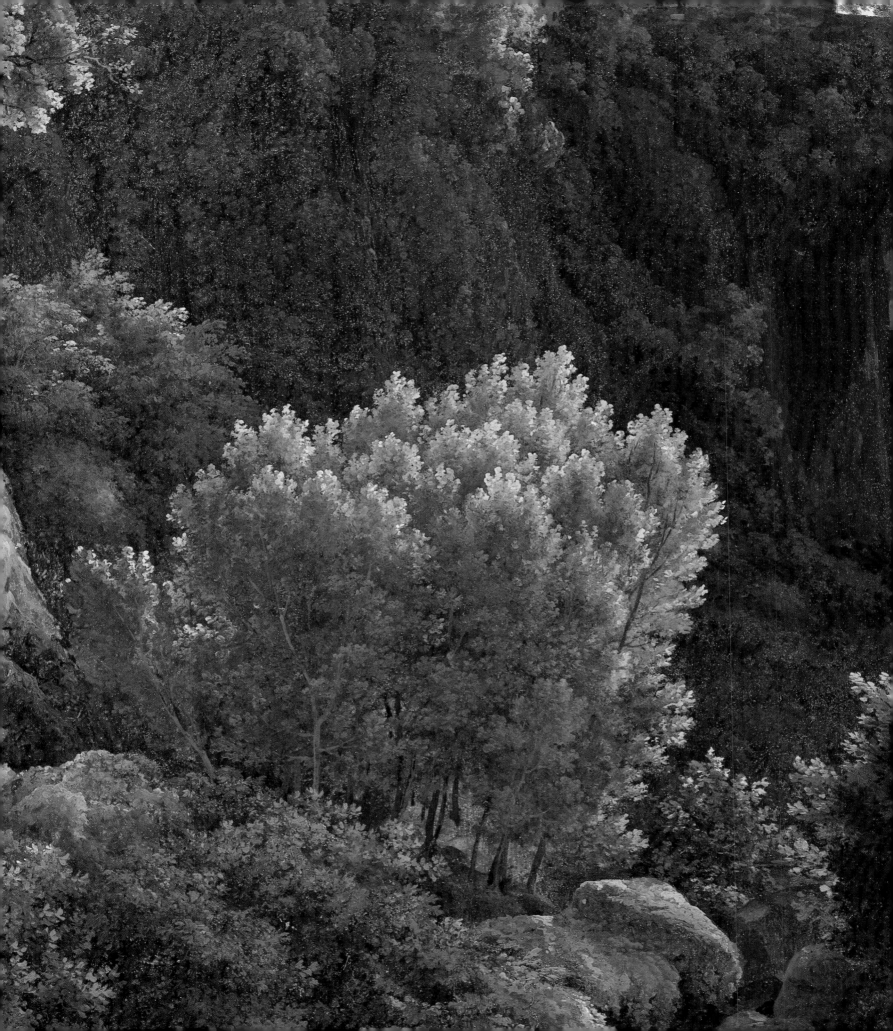

I PAINTING FROM NATURE

PAINTING, INCLUDING LANDSCAPE PAINTING, has always been an indoor art. Only once and only briefly – in the heyday of Impressionism – did open-air work become the norm. Before Impressionism outdoor painting, when practiced at all, was distinctly subordinate to studio work.

During the three years of his first trip to Italy Corot spent most of his time working outdoors, accumulating some 150 landscapes in oil colors and over 200 drawings. These were studies after nature, not to be confused with ambitious studio compositions, such as the two Corot sent to Paris for the Salon of 1827. The distinction, centuries old, arose from the naturalist foundation of Renaissance art. The principle that every pictorial invention must be rooted in observation had spawned the practice of visual note taking, from the slightest drawing of a hand or foot to the most detailed record of the full model. The generic term "sketch" groups such studies with the preliminary stages of composition, separating the various accumulations of preparatory work from the end product – in French, the "*tableau*"; in British usage, the "picture"; in American usage, the "finished picture" or "exhibition picture."[1] As E.H. Gombrich has explained, the sketch had been fundamental to artistic practice since the Renaissance:

> The hallmark of the medieval artist is the firm line that testifies to the mastery of his craft. That of the postmedieval artist is the sketch, or rather the many sketches which precede the finished work and, for all the skill of hand and eye that marks the master, a constant readiness to learn. . . .[2]

Post-Renaissance academies institutionalized the sketch and codified its functions. The words "*bozzetto*," "*modello*," "*ébauche*," and "*esquisse*" signify various stages of developing a pictorial idea.[3] "*Etude*" or "study" designates a record of nature, directly observed. In the studio, "nature" of course at first meant the human figure. But as landscape painting emerged as a discrete genre, the term "study" readily served for on-the-spot sketches of trees or rocks or, eventually, the open landscape. Corot called his Italian landscapes *études d'après nature* or simply *études*.

In academic theory the sketch was an ephemeral work, a by-product whose usefulness was exhausted when the exhibition picture was complete. Whether or not a particular sketch in the end contributed to a specific finished picture, it remained a private work, hidden from the public in the closed professional environment of the studio. Because sketches were informal and experimental they typically exhibit free or rapid execution. Since the sixteenth century painters had cultivated this quality of liveliness and spontaneity.[4] In the public discourse of the eighteenth and especially the nineteenth century the sketch became prized as an immediate trace of the painter's original idea or perception, unfettered by rule. Diderot's attitude is characteristic of the aesthetic:

> Sketches [*esquisses*] possess a warmth that finished pictures do not. They represent a state of ardor and pure verve on the artist's part, with no admixture of the affected elaboration introduced by thought: through the sketch the painter's very soul is poured forth on the canvas.[5]

Diderot's affection for the sketch should not be interpreted as a sign of open conflict between personal sensibility and academic authority – a conflict that did not erupt until much later. Recognizing and savoring the special qualities of the sketch meant recognizing and accepting its special place in the established system. As a distinct form, with its own conventions and terminology, the sketch had been created and nurtured within the academic hierarchy. Diderot's statement and others like it served to reconfirm that identity.

The terminology of the sketch was (and still is) somewhat fluid. But if the terms were to a degree interchangeable, a fundamental division existed in practice, a division that is crucial here. On the one hand was the study after nature, devoted to a particular model or motif. The function of the study was empirical: to train the eye and the hand and to accumulate raw material for later use. On the other hand was the compositional sketch, through which the artist invented and refined a pictorial idea. Here the artist worked not from observation but from imagination; the function was not empirical but synthetic.[6] The exposition that follows concerns only the first of these divergent classes of sketch – the study after nature, here called "study," "*étude*," or "sketch."

The present inquiry is further limited to the genre of landscape. Unlike the figure painter, who might work from initial study to finished canvas in a single room, the landscapist who wished to study nature was obliged to quit the studio – and to take his materials with him. This practical necessity had profound implications, for by taking the trouble to pack his things and set out for the countryside, the painter declared that direct observation of nature had become an artistic imperative. The birth and evolution of this imperative – just when and how the habit of regular outdoor campaigns developed and matured – is a vital thread in the history of landscape painting.

Most landscape studies (and most figure studies) have always been drawings, in monochrome or slightly more elaborate media, such as the *trois crayons*. Studies in a full range of color – watercolor, gouache, or oil – are less common because more laborious. Thus the decision to work not only from nature but also in color suggests that empirical observation had acquired a still deeper urgency. This chapter is devoted to a particular moment in the history of the open-air landscape – the moment in the late eighteenth century when oil paint came into regular use.

* * *

In practical terms, oil paint is the most complex and recalcitrant of the media at the painter's command. It is also, in pictorial terms, the most versatile and powerful and, since its advent, the medium of many of the most ambitious and noble works. Bringing this medium to bear on the study of nature meant bringing a new urgency to the artistic problem, and a new opportunity. Henceforth, while still restricted in theory, the nature study in practice was open to the traditions and ambitions of painting at large.

Outdoor painting in oil was attempted as early as the 1630s, but it did not become a collective enterprise with a continuous history – a tradition – until the end of the eighteenth century. For the intervening period the surviving evidence is fragmentary and woefully incomplete.[7] But it does offer lessons that are relevant to the tradition that later emerged.

The first of these lessons arises from an accumulation of evidence indicating a flurry of open-air painting in and near Rome, beginning in the second quarter of the seventeenth century. Outdoor drawing, most often in washes of

1. Bartholomeus Breenbergh. *Tivoli*, 1620s.
Pen and ink and brown wash, 32.8 × 43.2.
New York, The Metropolitan Museum of
Art. Rogers Fund, 1962.

2. Nicolas Poussin. *Five trees*, 1630s. Pen and
ink and brown wash, 24 × 18.1. Paris,
Louvre.

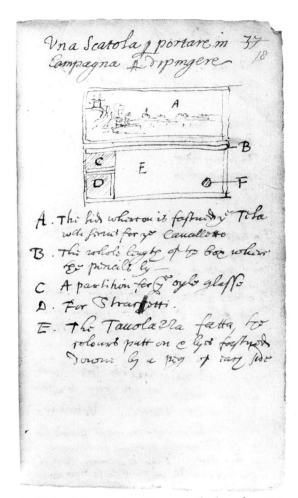

3. Richard Symonds. Diagram of a box for open-air painting, from a notebook used at Rome, 1650–52. London, British Library, Department of Manuscripts.

monochrome ink, was common among Nicolas Poussin,[8] Claude Lorrain,[9] and the Northern artists whom they followed into the Campagna[10] (pls. 1, 2). In this milieu of sketching from nature, several artists experimented with outdoor painting in oil. Among the participants were Claude, Gaspard Dughet,[11] Salvator Rosa,[12] and Diego Velázquez.[13] Most of the surviving evidence for this development is literary and is inadequate to support elaborate conclusions. Nevertheless, a diagram of a portable painting box, drawn about 1650 (pl. 3), lends concrete support to the written testimony. And a few painted studies survive that may be said, plausibly, to have been painted out of doors (e.g., pls. 4, 5[14]).

The caveat of plausibility applies throughout this book. It is known for a fact, from published criticism and theory as well as from private letters and journals, that studies by Valenciennes and Corot and others were painted in the open air. But for many related works the fact cannot be proven. Indeed, it is probable that, as outdoor painting gained currency, its effects sometimes were imitated in the studio. In the end what matters is not where a given work was painted but how it partakes of a new pictorial vocabulary that was forged in the open air.

4. Diego Velázquez. *Villa Medici gardens; grotto-loggia facade*, 1649–50. Oil on canvas, 48 × 42. Madrid, Museo del Prado.

5. Unidentified artist. *S. Trinità dei Monti and Palazzo Zuccaro*, *c.*1700. Oil on canvas, mounted on wood, 13.5 × 24.8. London, collection of Mr. and Mrs. John Gere.

Just how far Claude, Gaspard, and the others pursued their experiment in open-air painting is less important here than its subsequent mythology. It is unlikely that Corot ever saw outdoor studies in oil by these painters, but he must have known the legends, such as the following one reported in the mid-eighteenth century by P.-J. Mariette:

> Gaspard was not content to draw his studies after nature, as most landscape painters do. He also painted a good part of his pictures from nature. A little donkey, which he kept at home, and which was his only servant, carried all his painting equipment, his food, and a tent to shelter him from the sun and wind as he worked. He often was seen to spend whole days this way in the environs of Rome. Men worthy of trust told me this at Rome.[15]

In 1822, the year in which Corot began his formal education as a painter, Valenciennes's student J.B. Deperthes wrote that,

> On his promenades [near Rome], [Nicolas] Poussin let escape no occasion to seize, by means of slight sketches [*légères esquisses*], the picturesque effects of nature, and to draw trees of different sorts and rustic buildings whose beauty particularly struck him.[16]

The two passages are presented here not for what truth they may contain but as examples of a common rhetorical device. The rhetoric was designed to emphasize, quite rightly, that Gaspard and Claude and Poussin had achieved a new naturalism in landscape painting. It established a noble heritage for the practice of outdoor sketching, including outdoor painting, in the environs of Rome. Thus while in fact their open-air studies were works of substantial

6. François Desportes. *River valley*, 1700–10? Oil on paper, 20.8 × 49.4. Compiègne, Musée national du château.

originality, landscapists in Italy from Valenciennes to Corot considered themselves to be following spiritually, and quite literally, in the footsteps of the masters they most admired. That the link once had been broken, obliging the modern painters to recover a lost art, only strengthened their sense of identity with the past.

The second lesson to be learned from the period between 1630 and 1780 lies in the proliferation of commentary on outdoor painting in didactic texts of the eighteenth century. The most important passage occurs in the chapter "Du Paysage" of Roger de Piles's influential *Cours de peinture par principes* (1708):

> Painters ordinarily call by the name of study the parts that they draw or paint separately from Nature, parts destined to enter into the composition of their finished picture. . . .
>
> It is thus after nature and in the open countryside that some have drawn and finished the bits and pieces they have chosen, without adding colors. Others have painted with oil colors on strong paper of medium tint, and have found the method convenient, in that the absorption of the colors by the paper makes it easy to put color over color, even if different, one from the other. For this purpose they carry a flat box that comfortably contains their palette, their brushes, some oil, and some colors. This method, which in truth requires a certain amount of paraphernalia, is without doubt the best for extracting from nature a maximum of detail with a maximum of accuracy, above all if, after the work is dry and varnished, one wishes to return to the scene to retouch the main things and finish them after Nature.[17]

Although de Piles cited three other methods for studying nature in the field, the most extensive of his recipes is the one for oil painting. Later texts, culminating in Valenciennes's treatise of 1800, increasingly stressed oil colors as a distinct and preferable medium. But de Piles's book shows that this development was not a radical innovation. By 1800 the idea of the landscape study in oil and a rudimentary recipe had been common in academic literature for nearly a century.

This point is of some importance, for it demonstrates that the flowering of open-air painting in the late eighteenth century need not have seemed then – as it seems now – a profound innovation. Far from viewing their work as a break with the past or an assault on prevailing doctrine, Valenciennes and his contemporaries were employing a method long sanctioned by academic authority.

The most important evidence from the period before 1780 – the only substantial corpus of surviving works – is a group of several hundred oil studies on paper, made about 1700 by François Desportes (1661–1743), painter of hunting scenes for Louis XIV.[18] Many were painted in the studio, to record animals or objects of luxury destined to embellish Desportes's elaborate still lives. But Desportes painted out of doors also, carrying with him a portable painting box later described by his son.[19] Some of the outdoor studies are like those made indoors: a tree trunk or a flower isolated like a studio prop against the blank ground of the paper. Most relevant here are the true landscapes, about seventy views painted in the Ile-de-France.

Some of the landscapes strike us first by their delicate nuances of color and tone, their fresh and unified transcription of atmosphere and light, their empirical candor (e.g., pl. 6). Others are also remarkable for their bold framing, or their juxtapositions of near and far, the unusual modesty of their subjects, or their extreme simplicity (e.g., pls. 7, 8). Together they display an astonishing freedom from the conventions that guided landscape painting around 1700 and a vivid affinity with experiments that became prominent a century or more later.

Certainly the strain of robust realism that was part of Rubens's legacy played a role in Desportes's outdoor work, and it is easy to imagine that curiosity led him to transpose an established studio practice into the field. The treatise of de Piles, another *rubéniste*, reminds us that Desportes's outdoor program may not have been unique. Just as his studies were preserved together, another painter's studies may have been destroyed together. A small number of contemporaneous open-air oil studies are known and others yet may come to light.[20] Nevertheless, no immediate precedent for Desportes's extended outdoor effort and no comparable contemporaneous body of work is known. Finally, Desportes's achievement had no issue. He may have transmitted his enthusiasm for outdoor painting to Jean-Baptiste Oudry (1686–1755), the next leading painter of the royal hunt, but if so the thread ends there.[21]

As the evidence now stands, Desportes's outdoor work is a splendid anachronism. Yet the affinity between his work and the open-air aesthetic that began

7. François Desportes. *Wall and trees*, 1700–10? Oil on paper, 31 × 48. Compiègne, Musée national du château.

8. François Desportes. *Landscape*, 1700–10? Oil on paper, 29.5 × 50. Compiègne, Musée national du château.

to flourish a century later is telling. It suggests that the empirical challenge of outdoor painting poses special artistic problems, alien and unfamiliar to the routines of the studio. Although Desportes evidently discovered a personal enthusiasm for those problems, they as yet held no compelling value for others – for the tradition of painting. Later, when many artists together took up open-air painting, the challenge that Desportes had pursued in isolation became part of the shared tradition.

<p style="text-align:center">* * *</p>

The next significant body of surviving oil studies is the work of Thomas Jones (1742–1803),[22] who began to paint from nature in his native Wales in 1772. This work is part of a continuous development for which we have enough evidence to know that we lack a good deal more. In 1763–65 Jones had studied in London under Richard Wilson (1713–1782). Through Wilson (from whose hand no open-air paintings survive) Jones is linked to the teaching of Claude-Joseph Vernet (1714–1789), who had met Wilson in Rome in 1752 and had encouraged him to become a painter of landscapes.[23]

Vernet is a key figure in the story, and Rome once again the key locale. Joshua Reynolds, who knew Vernet in Rome in the early 1750s, reported as follows in a letter to a young marine painter, written some thirty years later:

> I would recommend you, above all things, to paint from Nature, instead of drawing; to carry your palette and pencils to the waterside. This was the practice of Vernet, whom I knew at Rome: he showed me his studies in colours, which struck me very much for the truth which those works only have which are produced while the impression is warm from Nature. . . .[24]

Charles-Nicolas Cochin (1715–1790), also advising young artists to *paint* from nature, likewise credited Vernet:

> It is by these efforts that M. *Vernet* made himself so familiar with nature. He always painted after her, despite the difficulty of carrying with himself the necessary materials, and of placing himself so as to be able to work quietly. He had the courage to overcome these obstacles, and when he did not have time to make a piece in color he wrote on his drawing indications of the hues of colors, and the greater or lesser amount of each color that he would have used to transcribe them.[25]

9. Joseph Vernet. *Temple of the Sibyl at Tivoli*, 1740s? Gray wash over pencil, 26.2 × 37.9. Paris, Ecole des Beaux-Arts.

Vernet himself, in a short didactic essay on landscape painting, probably written in the 1780s but not published until 1817, provided comparable advice:

> The shortest and surest means is to draw after nature. One must above all paint, because then one has drawing and color at the same time. . . . After having chosen well what one wishes to paint, one must copy as exactly as possible, as much in respect to form as to color, and not believe that improvement comes from adding or subtracting; one will be able to do that later in the studio, when one wishes to compose a picture, and make use of things one has made from nature.[26]

Vernet presumably delivered advice of this sort to Valenciennes when the two met in 1781–82.[27] It is with the Italian landscapes of Valenciennes and Jones, painted in the early 1780s, that the open-air study in oil emerges from the shadows of pre-history and takes on the shape of a tradition. The importance of this development cannot be overemphasized here. In so far as the available

10. Joseph Vernet. *Ponte Rotto, Rome*, c.1745. Oil on canvas, 40 × 77. Paris, Louvre.

evidence suggests, before 1780 outdoor painting had been attempted only sporadically. After 1780 it is possible to trace a continuous evolution, through which the open-air work entered the tradition of painting.

Some of Vernet's pen-and-ink studies have survived (pl. 9), but none in oil. In the absence of the latter it is difficult to assess the nature of Vernet's role in developments that followed. It is significant, however, that all reports of Vernet's outdoor painting are connected with his long stay in Rome, hardly interrupted from 1734 to 1753, rather than with his famous views of the ports of France or with any other works made in France, where he lived from 1753 to his death in 1789. Even the sole trace of actual oil studies by Vernet refers to his Italian period. The posthumous sale of his works in 1790 included a lot comprising "33 *Tableaux & Etudes*, painted after nature, at Rome as well as Naples, of different sizes, on canvas without frames."[28]

The *études* included in the lot were not necessarily works like those left by Desportes and Valenciennes. They well may have been small, finished, topographical views, which in the early nineteenth century were often described as studies after nature[29] (e.g., pl. 10). The same caveat applies to the reputation of Jakob Philipp Hackert (1737–1807), who arrived in Italy in 1768 and with considerable success adopted Vernet's role as the resident dean of landscape painting. He also is said to have insisted on the importance of painting from nature, but his surviving works, airless and obsessively detailed, have little in common with the open-air tradition as it subsequently evolved.[30]

There is insufficient evidence to discriminate among the potential influence of Vernet's (lost?) studies, the persuasiveness of his teaching, and the receptivity of the artists he taught. It is certain, however, that the fertility of the artistic environment of Italy played an essential role in the birth of outdoor painting. As it

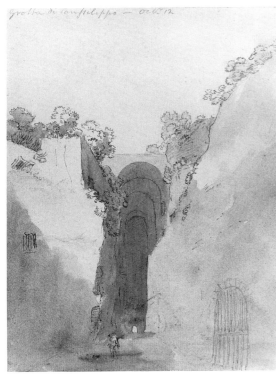

11. John Robert Cozens. *The Grotto at Posillipo*, 12 October 1782. Gray wash over pencil on paper, 24.2 × 17.8. Manchester, The Whitworth Art Gallery.

12. John Robert Cozens. *Near the Grotto at Posillipo*, 4 December 1782. Gray wash over pencil on paper, 23.8 × 17.8. Manchester, The Whitworth Art Gallery.

emerged in the last two decades of the eighteenth century, the practice belonged not to any national school but to the constantly replenished community of artists working in Italy, especially at Rome.

* * *

The present inquiry is based on the idea that painting from nature is a distinct artistic activity, with special functions, problems, and qualities. In fact, as the remarks of Cochin and Vernet suggest, that idea itself formed only in the mid-eighteenth century. Thus it is somewhat artificial to extract earlier instances of open-air painting from the course of tradition, grouping them under a rubric that did not yet exist. But even after the rubric was fully established, and even after outdoor painting had become a common practice, it remained part of a broader program of empirical study and, in turn, part of the still broader, evolving tradition of landscape painting.

By the mid-eighteenth century an elaborate cultural apparatus had attached itself to the landscape of Italy. It included the imagery of Poussin and Gaspard and Claude and a wealth of historical and literary associations readily provided by the guidebook if not by the visiting artist's own educated memory. The artist also knew (or could look up) the list of famous sites that deserved a visit. Together with the sites came the example and influence of the flourishing trade in topographical views. The trade in *vedute* had spawned a repertory of motifs, whose ritual repetition was part of their meaning.

For all landscape painters in Italy, especially for those who served patrons on the Grand Tour, the *veduta* tradition was a constant presence. A casual review of the work of the British watercolorists who came to Italy in droves in the second half of the eighteenth century will turn up dozens of repetitions of such motifs as "The Falls at Tivoli," "The Temple of Minerva Medica," and "The Grotto at Posillipo."[31] But the influence of the *vedutisti* was not absolute. For every finished painting or watercolor manufactured for the Grand Tour trade there are several modest notebook sketches of unfamiliar corners of the countryside. The latter, which like early oil studies were private rather than public works, are of particular interest here.

A case in point is the series of sketchbooks from one of the most famous of all Grand Tours: John Robert Cozens's work as a hired artist on the Italian tour of William Beckford in 1782–83.[32] Cozens (1752–1797), whose father, Alexander, had visited Italy in 1746, had himself been there before, in the employ of William Payne Knight in 1777–78. In short, Cozens was well prepared for his task. Many of the watercolors he worked up on his return predictably repeat familiar motifs required by the patron as souvenirs. The watercolors were based in part on rapid pencil-and-wash drawings, made on the spot in sketchbooks the artist carried with him. The sketchbooks contain also many drawings that have little to do with conventional view making. At Posillipo, for example, Cozens drew the famous grotto (pl. 11), but he drew also an uncelebrated clump of stone pines at the top of a cliff (pl. 12). For Cozens the experience of traveling and sketching was not limited by the repertory of tourism. Many of the sketches are justified not by the fame but the beauty of the subject, and by the challenge of discovering and recording such humble subjects: particular corners of the landscape that stood for the glory of nature.

Of course there was nothing new in this. A generation earlier, in the 1750s, Richard Wilson had produced a similar range of drawings, from familiar views (pl. 14) to unnamed fragments of nature (pl. 13).[33] Wilson in turn was repeating

the example of Claude, whose drawings present just such a continuum from instantly recognizable motifs of topography (pl. 16) to vivid details of nature (pl. 15).[34]

The precedent is fundamental to the Italian landscapes of Thomas Jones, student of Wilson and friend of Cozens. During his stay in Italy from 1776 to 1783, Jones made notebook sketches, finished drawings and watercolors, and oil studies. In their range and variety these works, like those of Wilson and Cozens, reflect the legacy of Claude. But the great majority of the oil studies gravitates toward one end of the continuum, the one most free of topographical convention and compositional formula, most fully devoted to empirical scrutiny of a chosen detail (pl. 17).

13. Richard Wilson. *Study of a large hollow tree with figures*, 1754. Pencil on paper, 28.2 × 21.1. New Haven, Yale Center for British Art, Paul Mellon Collection.

14. Richard Wilson. *View of St. Peter's*, c.1754. Black chalk, heightened with white, on paper, 30.3 × 52.7. England, private collection.

15. Claude Lorrain. *Wooded view*, c.1640. Brown wash on paper, 14.7 × 16.4. Haarlem, Teylers Museum.

16. Claude Lorrain. *View of St. Peter's*, 1646–47. Pen and ink and brown wash, 21.2 × 31.4. London, British Museum.

17. Thomas Jones. *Hilltop, Naples*, 1782. Oil on paper, 22.2 × 28.5. Birmingham, City Museum and Art Gallery.

Valenciennes's activity parallels the case of Jones.[35] Especially relevant to Valenciennes's work is the custom, cultivated in the French Academy at Rome, of sketching in the surrounding countryside. This had begun as a semi-formal practice under the directorate (1724–37) of Nicolas Vleughels (1668–1737).[36] With the approval of his superior, the Surintendant des Bâtiments du Roi, Vleughels regularly led his charges into the countryside to draw from nature.[37] There the young history painters were joined unofficially by landscapists, who generally did not hold pensions at the Academy. It is likely that these excursions helped to form the working habits of Vernet, who sought Vleughels's counsel when he came to Rome in 1734.[38]

18. Joseph-Marie Vien. Page from a sketchbook of views in and near Rome, 1744–50. Pencil on paper, 11.8 × 18. Washington, National Gallery of Art. Mark J. Millard Architectural Collection.

Outdoor sketching flourished under the directorate (1751–74) of Charles-Joseph Natoire (1700–1777),[39] who had been a *pensionnaire* under Vleughels in the 1720s. Like Vleughels, who had lamented the decline of French landscape painting since the demise of Poussin and Claude, Natoire encouraged the genre. In a letter of 1752 he expressed the hope that among his charges at the Academy, "there might be found someone who, not possessing all [the talent] necessary to achieve distinction in history painting, would take up the genre of landscape, which is so agreeable and so necessary since we lack it."[40]

Surviving landscape sketches by Vleughels and his students are scarce, but enough works remain from the 1740s onward to provide a sense of the excursions.[41] A page from an album of sketches drawn by Joseph-Marie Vien (1716–1809)[42] during his years as a *pensionnaire* (1744–50), typifies the habit of choosing humble subjects and unfamiliar aspects of famous ones (pl. 18). Thirty years later at Tivoli François-André Vincent (1746–1816)[43] and the two artists who appear in his drawing (pl. 19) chose an equally uncelebrated corner of the landscape in which to sketch some bushes, a stream, and a few old stones too humble to be called ruins. Another drawing by Vincent shows a fellow artist reclining on a Roman pedestal (pl. 20), thus documenting the modest spirit of freedom and release these history painters brought to their outdoor studies. In the

19. François-André Vincent. *Landscape near Tivoli with two artists sketching*, 1775. Black chalk on paper, 26.8 × 40.5. Paris, Institut Néerlandais, Fondation Custodia (Coll. F. Lugt).

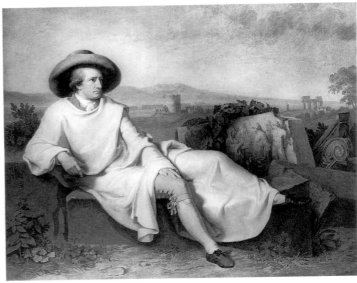

20. François-André Vincent. *Young man at the Villa Doria Pamphili*, 1771–75. Black chalk on paper, 24.7 × 37.2. Rouen, Musée des Beaux-Arts.

21. Johann Heinrich Wilhelm Tischbein. *Goethe in the Roman Campagna*, 1787. Oil on canvas, 164 × 206. Frankfurt, Städelsches Kunstinstitut.

famous portrait painted a decade later by Tischbein, Goethe (himself an avid sketcher of the Italian landscape[44]) adopts a similar pose (pl. 21). Here, as in Goethe's Italian journal, the classical ideal is not confined to books and museums but saturates the welcoming landscape, in which the sophisticate takes his ease.

The same informal spirit prevails in drawings of the 1750s and 1760s by Jean-Honoré Fragonard (1732–1806) and Hubert Robert (1733–1808),[45] such as the latter's glimpse of two artists with portfolios in hand, at work on the Palatine Hill (pl. 22). Characteristically Robert has focused on the intimate scene, banishing the great Colosseum to a faint presence in the background. In many French drawings of this period it is impossible to identify any site at all (pls. 23, 24[46]).

This vein of exploratory naturalism, far from challenging academic norms, was endorsed and encouraged by the artistic establishment. In 1759 Robert was appointed a *pensionnaire* at the Academy, an exceptional but not unique honor for a landscapist. Attached to the official letter informing Robert of the appointment was an extensive critique of his work by Charles-Nicolas Cochin, secretary and historiographer of the Academy. Cochin was a vigorous partisan of direct study after nature, and his advice to Robert is highly relevant here:

> It is to be desired that this young artist, born to achieve the greatest beauties, and already so far advanced on the road that leads to them, undertake throughout his stay at Rome not to content himself at all with going to draw views and then painting them at home; almost all those who have attached their talents to this unhappy manner of study have lost their way, even those with the happiest dispositions; it is not only the forms of nature that one must know in depth, it is the colors relative to the distance of objects, it is the effects produced upon them by direct and reflected light, effects that it is infinitely important to imitate justly and to engrave firmly in one's memory; one cannot reach this goal by divining it but only by painting everything after nature, especially during the time devoted to one's education, a time whose good employment influences the rest of one's life. . . . Above all, as he works after nature [the artist] must renounce every desire to pretend to correct or embellish her; she is always beautiful enough herself and is only too difficult to imitate. One must begin by knowing her well and both study and follow her with the most perfect obedience.[47]

22. Hubert Robert. *The Colosseum seen from the Palatine*, *c*.1760–65. Red chalk on paper, 33.5 × 44.7. Valence, Musée des Beaux-Arts.

23. Louis-Gabriel Blanchet. *Trees, Italy*, 1750s? Black chalk, heightened with white, on paper, 26.3 × 41. Formerly London, Witt Collection.

24. Jean-Jacques de Boissieu. *Buildings, Italy*, 1756–66. Pen and ink and brown wash on paper, 8.1 × 20.4. Rouen, Musée des Beaux-Arts.

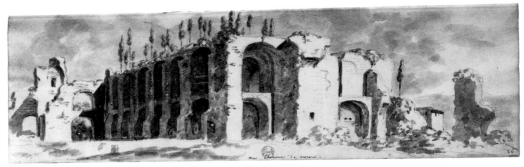

25. Pierre-Henri de Valenciennes. *Ruins on the grounds of the Villa Farnese, Rome*. Gray wash over pencil on paper, 11.6 × 35.8. "Rome" sketchbook, f. 26. Paris, Bibliothèque Nationale.

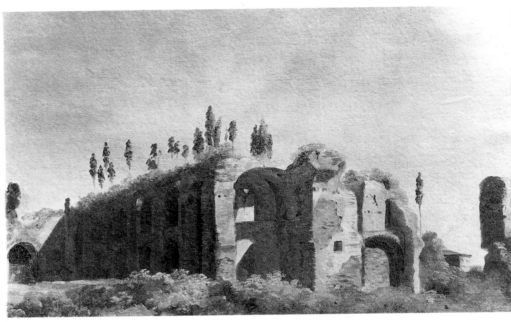

26. Pierre-Henri de Valenciennes. *Ruins on the grounds of the Villa Farnese, Rome*, 1782–84. Oil on paper, mounted on cardboard, 24.8 × 34.5. Paris, Louvre.

As far as we know, Robert did not paint in oil from nature. But he and a long list of less famous predecessors, contemporaries, and successors did apply the spirit of Cochin's advice. By the 1780s, when Valenciennes embarked on an extended campaign of outdoor painting in oil, his countrymen had accumulated fifty years of experience in nature sketching near Rome, reviving and extending a custom that had flourished under Claude more than a century earlier.[48] Valenciennes's predecessors had established outdoor work as a regular component of the young artist's training and had developed the convention of modest views of humble subjects, freely chosen by artists exploring the classic ground.

As if to test Cochin's (or Vernet's) preference for painting over drawing from nature, Valenciennes more than once essayed the same motif in both media (pls. 25, 26). The comparison is, and must have been, stunning: beside the vivid presence of the oil study the wash drawing is a schematic document. The leap cannot be explained solely by the advent of color. In the painting the materials of the world possess an articulate physicality, the light, a force and brilliance that are absent from the drawing. Cochin and Vernet were justified in their preference. By transposing the empirical spirit of drawing into the medium of oil paint, Valenciennes deepened and transformed the open-air enterprise. As his successors pursued the option in the decades that followed, they opened the door to a great new episode in European art.

*　　*　　*

Although it was written some fifteen years later, Valenciennes's treatise is an instructive companion to the outdoor studies he made in Italy in 1782–84.[49] To begin, it is notable that the book contains no echo of Vernet's and Cochin's insistent distinction between drawing and painting. Valenciennes evidently assumed that the artist would *paint* from nature and provided a lengthy description of method, clearly based on his own experience in the field. This assumption in itself is a sign that outdoor painting had acquired a new currency.

Like Vernet and Cochin, however, Valenciennes viewed open-air work as a student exercise, a discrete component within an organized program of instruction. His section on *Etudes d'après nature* begins as follows:

> Our student for several months has made drawings under our eyes; he has copied several paintings of the best masters, but he has not seen Nature. He needs to consult her, and in the pleasant season we go together to the countryside. It is there that we convey to him our observations on the manner of making studies that can serve him later to compose paintings.[50]

Constable, Corot, and others later extended their outdoor work well beyond their student years. As a consequence they progressively reconsidered the relationship between study and exhibition picture, transposing qualities of one to the other. By contrast, as was typical for the preceding period, Valenciennes seems to have made oil studies for only a few years, in Italy in 1782–84 and then in France for a short time longer.[51] Indeed, Valenciennes's oil studies apparently predate all of his surviving finished works.

The identification of outdoor painting with the artist's education had the effect of further isolating the practice, already defined as private, from the formal habits of public art. Within this protected realm, the young painter enjoyed a special freedom. If in the studio he learned by applying rigid rules, in the field he learned by experiment. Valenciennes's program for the *étude d'après nature* was conceived in opposition to the elaborate routines and thoughtful deliberations of studio work. For the open-air study was meant to capture a unique and ephemeral perception, which the painter was powerless (in Cochin's word) to divine. Immediately following the passage just quoted, Valenciennes launched into a spirited argument for speed of execution:

> [Studies] should be nothing more than *maquettes* made in haste, in order to seize Nature as she is.
>
> A painter of history, of portraits, of flowers or still lives, copies Nature in his studio, where she is constantly illuminated by the same light. . . .
>
> But when that object is illuminated by the sun, and when that light and its shadows change continuously by virtue of the movement of the earth, then it is no longer possible to spend a long time copying Nature without seeing the effect of light that one has chosen change so rapidly that one no longer recognizes the conditions under which one began. . . . It is absurd for an artist to spend a whole day copying a single view from nature. . . .
>
> One must first of all limit oneself to copying, as well as possible, the principal shades of Nature in the effect that one has chosen; begin the study with the sky, which will give the coloring of the background, next the coloring of the adjacent planes, and arrive progressively at the foreground, which in consequence will be in harmony with the sky that has served to create the local color. One well can sense that by following this procedure it is impossible to paint anything in detail, since all studies after nature should be made in a period of two hours at the most. . . .[52]

27. Pierre-Henri de Valenciennes. *Cloud study on the Quirinal Hill, Rome*, 1782–84. Oil on paper, mounted on cardboard, 25.6 × 38.1. Paris, Louvre.

In his own work in Italy Valenciennes had followed this method. None of his studies need have required more than the two hours he would later prescribe. Nevertheless, there is hardly a trace of bravura in Valenciennes's work.[53] Although they sometimes suggest hurry, his studies are painted with a deliberate hand, plainly guided by a concentrated effort of attention. This is true even of his studies of clouds (pl. 27), and would remain true of Italian landscape studies for decades to come. For if the painters occasionally indulged in a lively flourish of the brush, their main concern lay not in romantic flamboyance but in empirical description.

In his book Valenciennes went on to discuss studies of individual objects – trees, rocks, bushes, "which you can study separately because they are fixed."[54] But he felt that the most important and demanding studies were those aimed at capturing a passing condition of light and weather. His fascination with this problem had led him to make several pairs of studies, representing the same view under different conditions (e.g., pls. 28, 29). This practice, too, he later proposed to his students: "It is good to paint the same view at different times of day, to observe the differences that light produces on the forms. The changes are so palpable that one has trouble recognizing the same objects."[55]

Valenciennes's paired studies, like an experiment and its control, possess the

28. Pierre-Henri de Valenciennes. *Rooftop in shadow*, 1782–84. Oil on paper, mounted on cardboard, 18.2 × 33.7. Paris, Louvre.

29. Pierre-Henri de Valenciennes. *Rooftop in sunlight*, 1782–84. Oil on paper, mounted on cardboard, 18.2 × 36.5. Paris, Louvre.

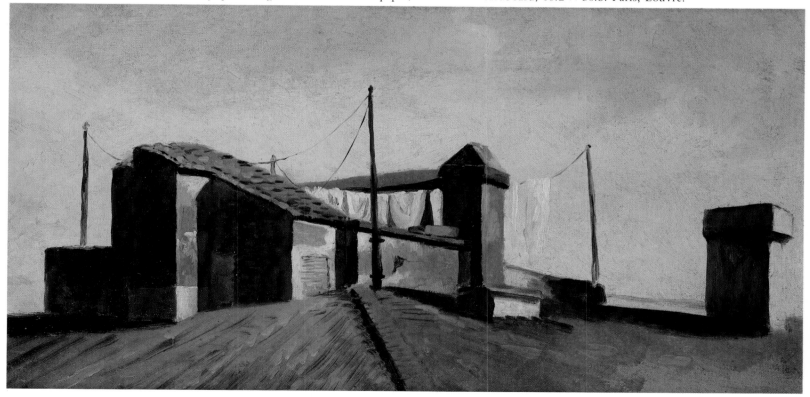

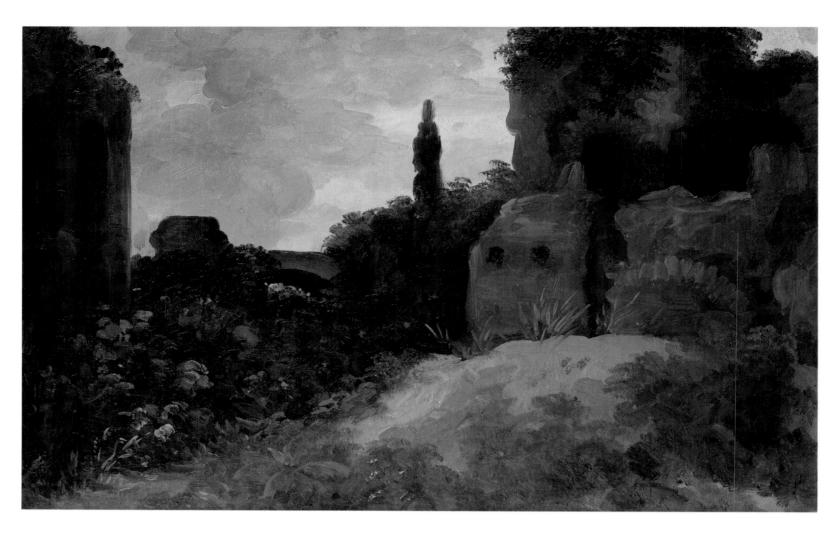

30. Pierre-Henri de Valenciennes. *Ruins on the grounds of the Villa Farnese*, 1782–84. Oil on paper, mounted on canvas, 26.3 × 40.4. Paris, Louvre.

rigor of scientific inquiry. That Valenciennes reached this empirical extreme suggests the degree to which his project of self-education had detached itself from prevailing artistic values. It is inadequate to note that he achieved a new sensitivity to events of weather and light, or that he cast a fresh eye on nature. By implying that Valenciennes enhanced the naturalism of landscape painting without revising its underlying conception, such an account fails to acknowledge the extent to which his whole outdoor program had withdrawn from the pictorial philosophy of the studio.

The empiricism of Valenciennes's pair of rooftop studies is all the more naked because the subject itself is so inconsequential, a mere prop for the experiment. Writing in 1808 to a former student who was confined by illness to her room, Valenciennes explained:

> [Your illness] does not keep you from painting from nature even in case of rain, since you must see something from your window, it doesn't matter what. It might be only a wall that you find to study; remember that I made studies of old chimneys at Rome. Once made, these studies became very interesting for their details of color.[56]

Valenciennes's pair of rooftop studies represents an extreme, but throughout his open-air work he favored very humble subjects. Time and again he set to work at a famous site, such as the Palatine Hill, and turned his back on the celebrated

31. Pierre-Henri de Valenciennes. *At the Villa Farnese, two poplars*, 1782–84. Oil on paper, mounted on cardboard, 25.3 × 37.8. Paris, Louvre.

monuments and familiar views. The result was a collection of odd corners of the landscape (pl. 30), unexpected vistas, and broad patches of sky over an anonymous hill or a cluster of vernacular buildings (pl. 27). The very humbleness of Valenciennes's subjects is a positive value, a mark of independence from the hierarchies of public art.

Valenciennes's way of approaching his subjects also was highly distinctive. Each study is a compact fragment, often abruptly framed. Within the frame the pictorial structure typically adheres to one of a few simple types. In many studies Valenciennes gave most of the image over to the sky, relegating matter to a narrow band at the base (pl. 27). In others he used the tall poplar trees, deploying them from top to bottom of the frame (pl. 31). In still others he discovered a serial unity of compact forms fitted together across a narrow horizontal format, from which most of the the sky is excluded. (pl. 32). Only occasionally, when he attempted a full reach of space from foreground to background, did he fall back on convention, on the *repoussoirs* and *coulisses* of traditional landscape composition.

At work outdoors in Italy at the same time, Thomas Jones adopted a remarkably similar strategy of vivid description, frankly humble subjects, and abruptly cropped views. Like Valenciennes on the Palatine Hill, Jones in Naples turned away from the scenic motif of the bay to paint fragments of buildings devoid of worldly consequence. The parallel extends even to two variant studies of a single motif, which Jones painted in 1782 (pls. 33, 34). There is, however, an important difference in the way that the two painters applied the common strategy. While Valenciennes was often hesitant and imprecise, Jones was confident and surehanded, achieving a palpable identity between subject and image that informs every stroke of the brush. The completeness of this achievement provides an occasion for considering the special formal problems of painting from nature.

By exchanging pencil for brush, the open-air artist undertakes to treat form and space, color and light simultaneously, as interdependent aspects of an indivisible problem. While the blank sheet provides the draftsman with a unifying ground, the painter discards this crutch with the first stroke of the brush. The patch of color thus created stands apart from the ground and belongs instead to a new pictorial fabric, as yet unachieved. If the image is to cohere, the fabric

32. Pierre-Henri de Valenciennes. *View of the Porta del Popolo, Rome*, 1782–84. Oil on paper, mounted on cardboard, 15.5 × 41.5. Paris, Louvre.

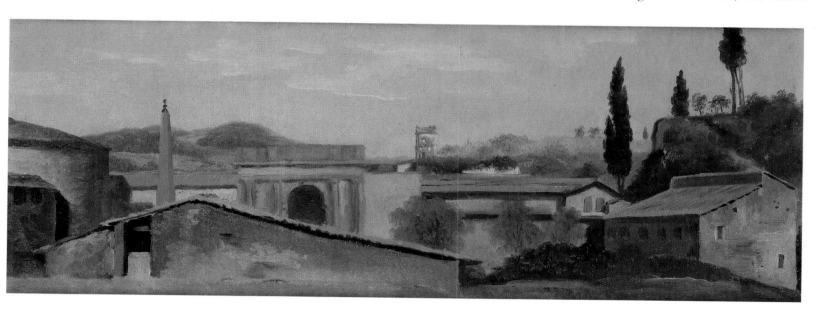

must be seamless, which means that the first and each subsequent patch must anticipate the image of which it will be part. The devices of studio composition are useless in meeting the challenge, for it is not conceived as an assembly of parts. The resulting difficulty is illustrated plainly in studies by Desportes where, when foreground and background were to meet abruptly on the surface of the picture, he abandoned the effort and left the image incomplete (e.g., pl. 8).

Jones's solution to the problem of outdoor painting, especially in his rooftop studies, is highly instructive. First, he recognized in the rough walls of ordinary Neapolitan buildings an immediate analogue for the material continuity of the painted image. Beyond the frontal plane of the wall, there are no difficult transitions of depth, only distant leaps, easily denoted by abrupt shifts in scale

33. Thomas Jones. *Buildings in Naples*, April 1782. Oil on paper, 14 × 21.5. Cardiff, National Museum of Wales.

34. Thomas Jones. *Rooftops, Naples*, April 1782. Oil on paper, 14.3 × 35. Oxford, Ashmolean Museum.

35. Thomas Jones. *Wall in Naples*,
1782? Oil on paper, mounted on
cardboard, 12.1 × 15.8. England,
private collection.

36. Thomas Jones. *The Grotto at
Posillipo*, August 1782. Oil on
paper, 20.3 × 27.3. London,
collection of Mr. and Mrs. John
Gere.

and light. Also crucial to Jones's success is the small size of his studies – some not much bigger than the hand that painted them – and the narrow scope of view. The small size made it easier to master the relationship between each touch and the whole image. The constricted view made it easier to discover a stable design within the scene.

Jones's method reached perfection in a tiny study of a wall in Naples (pl. 35). The material surface of paint corresponds unerringly to the surface of the wall it describes. The frontal address and the concise framing yield a powerfully symmetrical image, anchored by the central balcony, which collects (in the bits of laundry hung out to dry) the colors of the periphery (the green of the foliage, the blue of the sky, and the white of the wall in the upper left corner). Although the study is very small, the perfect planar coherence of the image gives it a grand scale, evoking the noble order and clarity of classical design. Yet the tables have been turned. Pictorial coherence no longer connotes a skilful synthesis of parts but sets forth the indivisible immediacy of vision.

This original quality of Jones's work did not depend solely on the planar severity and abrupt framing of his rooftop studies at Naples. At Posillipo he

37. Simon Denis. *View on the Quirinal Hill, Rome,* 1800. Oil on paper, mounted on canvas, 29.5 × 41. New York, private collection.

38. Jean-Antoine Constantin. *Houses and trees*, 1777–84. Oil on paper, mounted on wood, 21 × 30. Aix-en-Provence, Musée Granet.

accepted the canonical view of the grotto, but utterly transformed the image (pl. 36). The simplicity with which the flat colored shapes cohere, the felicity with which they persuade the eye introduced a new mode of description, as remote from the literal transcriptions of topography as from the labored effects of studio cuisine.

Often in Valenciennes's work, as in Jones's, classical lucidity of structure goes hand in hand with candor of perception. The narrow focus and pictorial concision of the two painters' work, the bright palette and unmannered execution soon became standard features of the Italian open-air study in oil as it evolved from an experiment into common use. Just as the individual styles of Valenciennes and Jones may be recognized within the rubric they together created, so the painters who succeeded them in the 1780s and 1790s each gave a personal inflection to what increasingly emerged as a shared vocabulary. Beside a suave study by Simon Denis (1755–1812) (pl. 37) the open-air style of Jean-Antoine Constantin (1756–1844), closer to the hand of Valenciennes, may seem untutored (pl. 38). Still more distinct is the brittle precision of studies by Jean-Joseph-Xavier Bidauld (1758–1846) (pl. 39) and Johann Martin von Rohden (1778–1868) (pl. 40). Linking them all is an original forthrightness of vision, an

39. Jean-Joseph-Xavier Bidauld. *Gorge at Civita Castellana*, 1787. Oil on paper, mounted on canvas, 50 × 37.5. Stockholm, Nationalmuseum.

unpretentious selection of motif, a harmony of architecture and nature, and a concise, simply structured format. The spatial breadth and atmospheric complexity of a study by Louis Gauffier (1762–1801) (pl. 41) is exceptional in Italian open-air painting of the 1790s, and would remain so for nearly a generation. The convention, as it became a convention, favored the compact detail, divorced from the ritual wholeness and complex assembly of studio art. This blunt format became a hallmark of unqualified empiricism.

Gauffier's view is eccentric in another respect as well, for it was painted near

Florence. Naples had most inspired the unbidden talent of Jones; Venice and Florence also occasionally appear on the map of early outdoor painting in Italy. As the tradition gathered momentum, however, its capital was Rome.

* * *

It is not known whether Jones and Valenciennes met, and thus impossible to say whether the two encouraged or learned from one another. In the long view the question is not pressing. What binds them together and separates them from Desportes is not that they were two instead of one but that their outdoor work marks the beginning of a continuous tradition.

The stylistic parallel between the open-air studies of Jones and Valenciennes is part of a larger parallel between the work of the two men. As a painter of pictures for exhibition, neither challenged established convention. More specifically, neither succeeded in bringing his outdoor work to bear on studio aesthetics, or left much evidence of a concerted effort to do so. More significant than the freshness of their work in the field is the extreme polarity – for both painters – between outdoor and indoor work.

Long before Jones and Valenciennes, outdoor sketching had outstripped the narrow function of collecting material for composition. Even so, the nature study had remained an integral part of an organic process directed toward ultimate synthesis in the studio. The fluid continuity of that process is as much evident in the work of Fragonard and Robert as in the work of Claude. For Valenciennes and Jones the process broke down. Emboldened by the powerful oil medium, outdoor sketching acquired a new autonomy, defined in opposition to the system of which it once had been part. The empirical and synthetic functions of landscape painting had become irreconcilable.

40. Johann Martin von Rohden. *Ruins in the landscape near Rome*, *c*.1796. Oil on paper, mounted on canvas, 56 × 73.5. Hamburg, Kunsthalle.

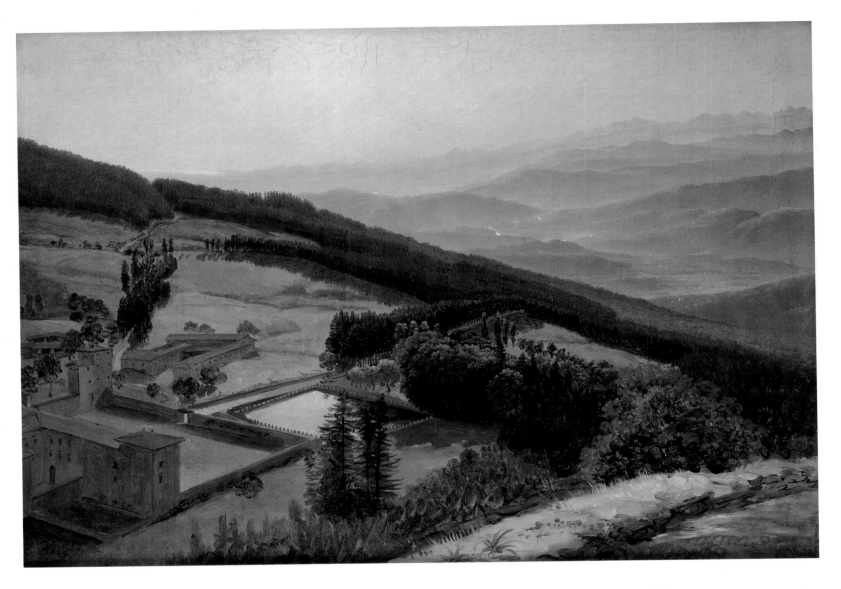

41. Louis Gauffier. *Convent at Vallombrosa and the Arno valley seen from Paradisino*, *c*.1796. Oil on canvas, 28 × 40. Montpellier, Musée Fabre.

Around 1800 throughout Europe the landscape tradition, some two centuries old, underwent a profound transformation. It is described less accurately as a gradual evolution than as a rupture, in which a new outlook and vocabulary replaced the old. This complex phenomenon assumed different forms in different local circumstances, and any attempt at generalization risks overriding the essential diversity. Nevertheless, an indispensable element in the multifold innovation was an original depth and intensity of empiricism. Neither John Constable nor Caspar David Friedrich regarded empirical description as an end in itself, and each relied heavily on local traditions; but for both, intense scrutiny of nature was the foundation of a new landscape art.

In the Italian studies of Valenciennes and Jones, and of others who succeeded them in ever greater numbers, the tension between the new empiricism and the old landscape traditions took on an unusual and highly polarized form. The pattern was repeated briefly some twenty years later in England by the young John Linnell (1792–1882), William Henry Hunt (1790–1864), and other painters working under the tutelage of John Varley (1778–1842). That episode lends support to the lesson drawn here from the experience of Desportes. By virtue of its material quiddity and descriptive richness, the oil medium in itself transforms

the empirical function of outdoor sketching. Analyzing the remarkable oil studies of Linnell and the others, and pointing to the brevity of their engagement with the practice, John Gage has stressed the difficulty of maintaining such an extreme empiricism in the face of a long-standing studio tradition.[57] Cut off so completely from convention, the young painters had no choice but to return to the studio, retreating from their precocious inventions.

As the new European tradition gathered momentum, the rift between empirical study and synthetic composition did not long remain in the state of polarity that is manifested in the work of Valenciennes and Jones. A rich account of landscape painting in the first half of the nineteenth century could be written as a history of efforts to repair the rift, to re-establish a fruitful exchange between the studio and the newly expanded resource of outdoor work. Such a history would discover a wealth of material in Britain, where the hierarchies of the continental academies had never coalesced, and where Joshua Reynolds's zeal to impose them had its weakest effect on the genre of landscape. Despite all that separated Constable and Turner, they shared a tenacious attempt to keep the lessons of the field alive in the studio and an impressive success in doing so. A generation later in France, Corot and his younger contemporaries undertook a parallel attempt, initiating a development that extended into the twentieth century.

In Italy around 1800 this dialogue took a peculiar form, eccentric to the mainstream traditions as they unfolded in the North. To a remarkable degree the landscape oil-study in Italy retained the fierce autonomy it had assumed under Valenciennes and Jones, contributing little to studio composition other than a few motifs and the flavor of the classical scene. The main reason may be that few landscapists pursued an extended career in the South. Most visited Italy for two or three years in their youth, then returned home, too soon to redirect the collective enterprise.

But if outdoor painting in Italy retained its distinct identity, it did not remain static. As landscape painters in ever-greater numbers arrived from the North, they enriched and extended the example of Jones and Valenciennes. Without breaking the limits of the *étude d'après nature*, without compromising its absolute principle of empirical candor, they progressively incorporated into their outdoor work the conventions of classical landscape painting and the motifs of the *vedutisti*. This process, which culminated in Corot's work, is the subject of Chapter III.

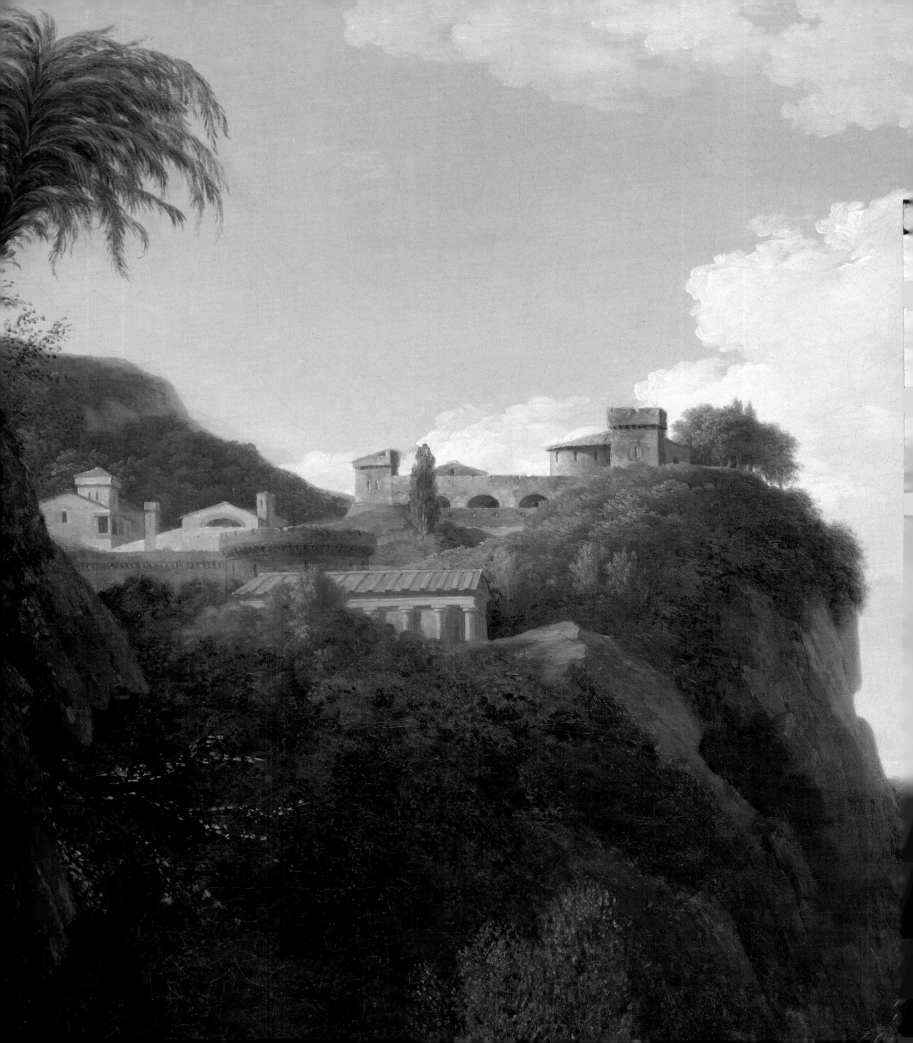

II COROT'S EDUCATION

FROM THE MID-NINETEENTH CENTURY well into the twentieth it was widely agreed that French landscape painting around 1800 had withered under the dominance of history painting. According to this view, modern naturalism emerged only in 1830, as part of a general rebellion in the arts, fostered by a new spirit of individualism and opposition to confining moral and aesthetic dogma. The young landscapists of 1830 learned little from their untalented, retrograde masters. Instead they took inspiration from seventeenth-century Dutch and contemporary English painters, especially Constable, who had come earlier to the new vision and had made such an impression at the Paris Salons of the 1820s. The Neoclassical precedent seemed so moribund, in other words, that a foreign catalyst was needed to explain the birth of the new French tradition.[1]

This formulation possessed an appealing symmetry. The Neoclassical generation was dismissed as reactionary; the generation of 1830 was admired as progressive. This stark outline has since been qualified by many exceptions, in which one or another aspect of Neoclassical landscape is enlisted as a harbinger of the coming naturalism. Inspired by a broad recognition that the old survey of French art from David to Delacroix was too rigid and too narrow, the recent trend has challenged the significance of 1830 as a point of decisive change. No coherent new outline has yet been drawn, but the old one has been blurred by the tendency to reach further and further back for the beginnings of modern French landscape, to connect the Neoclassical era with the future instead of the past.[2]

Both the traditional view and the piecemeal revision adopt a vantage point in the second half of the nineteenth century. Largely unconcerned with the Neoclassical period itself, both view it as a background to the more highly valued art that followed – to Barbizon naturalism of the 1830s and 1840s and, ultimately, to Impressionism. Hence the preoccupation with progress or lack of it, and the notion of progress as a single path leading from academic convention to a personal encounter with nature.

French landscape painting around 1800 was indeed a shallow, doctrinaire art, from which the new tradition that began to form after 1820 was a significant departure. But it is also true that Neoclassical landscape painting had marked a break with the aesthetic of the mid-eighteenth century and that its broad reforms left their stamp upon the succeeding generation. The Neoclassical legacy played an especially prominent role in the art of the young Corot, who entered the scene on the cusp of change, in the early 1820s. Although a pioneer of the modern tradition, Corot was also among those most deeply attached to the lessons of his masters.

Both of Corot's masters had been students of Valenciennes. In the decades after the Revolution of 1789, Valenciennes's school of *paysage historique* became the centerpiece of a new constellation of practice and theory, which reformulated landscape painting in terms adopted from the seventeenth century. As the leaders of the previous generation reached old age and left the scene – Joseph Vernet died in 1789, Fragonard in 1806, Hubert Robert in 1808 – the self-renewing tradition of the eighteenth century lost its momentum. Modern sensibility rejected the

left Detail from pl. 42 (Valenciennes).

41

recent past as frivolous and unsystematic, and construed fresh opportunity as a direct dialogue with the old masters.

Born in Toulouse in 1750, Valenciennes first traveled to Italy in 1769.[3] By 1771 he was in Paris, where he became a pupil of Gabriel-François Doyen. In 1777 he traveled again to Italy and stayed until 1784, except for a brief visit to Paris in 1781–82 (during which he met Vernet). Although he had exhibited in Toulouse as early as 1778, he did not exhibit at the Paris Salon until 1787, at the rather advanced age of thirty-seven. In that year he was elected first *agréé*, then *académicien* of the Royal Academy. He soon opened his atelier to students and in 1800 published his lengthy treatise on perspective and landscape painting.[4] From 1800 he was widely regarded as both the leading painter and the authoritative pedagogue of landscape. He was awarded the medal of the Légion d'Honneur in 1804 and became Professeur de Perspective at the Ecole des Beaux-Arts in 1812. He died in 1819, just as Corot was forming the ambition to become a painter of landscapes.

There are no identified exhibition pictures by Valenciennes earlier than those he submitted to the Salon of 1787. His drawings of the mid-1770s are the work of a provincial and not particularly original painter of rustic scenes. By the late 1780s he had brought himself up-to-date, absorbing the finesse and spatial breadth of Vernet's elegant style. His Salon debut, however, left little doubt that, far from simply following Vernet, Valenciennes had set for himself a new and different course.

All four works exhibited by Valenciennes in 1787 are set in antiquity (e.g., pl. 42).[5] The larger two illustrate lessons of civic virtue, drawn from Greek and Roman history and explained in the Salon catalogue.[6] As critics readily observed, the pictures emulate the grand, ordered vision of ideal landscape painting of the seventeenth century, especially the work of Nicolas Poussin.[7] In each of these respects – the reconstruction of ancient life, the themes of civic virtue, the pictorial vocabulary of French classicism – Valenciennes transposed to landscape the characteristic features of Neoclassical history painting.

The French school of *paysage historique* belonged to a broad, international movement. Certainly in Italy Valenciennes had become familiar with the revival of ideal landscape initiated there by Richard Wilson in the 1750s. More specifically, his ambitious program was shaped by the immediate artistic environment of Paris, to which Jacques-Louis David's bold innovations of the mid-1780s had delivered an invigorating shock. It is too simple to call Valenciennes the David of landscape, but it is accurate to describe his program as an attempt to renovate the genre of landscape according to the high-minded principles of the new history painting. If Valenciennes's work itself fell short of this goal – for moral and pictorial force his debut pales beside David's *Socrates* at the same Salon – his treatise of 1800 compensated with a missionary tone.

The hegemony of history painting weighed heavily on Valenciennes's pronouncements. Notwithstanding Diderot's enthusiasm for Vernet and other such departures from strict academic theory, the eighteenth century had left intact the hierarchy of genres, which placed history painting at the top and landscape near the bottom. After 1789 the same imperative of moral engagement that propelled the narrative art of David's school only deepened the conviction that the genre of landscape was inadequate to address man's highest ideals. On occasion this outlook led to outbursts of unusual hostility toward landscape painting. One critic wrote in 1796 that landscape was "a genre that ought not to exist!"[8] At a meeting in 1793 of the Société Républicaine des Arts, the belligerent history painter Jean-Baptiste Wicar argued that landscapists should

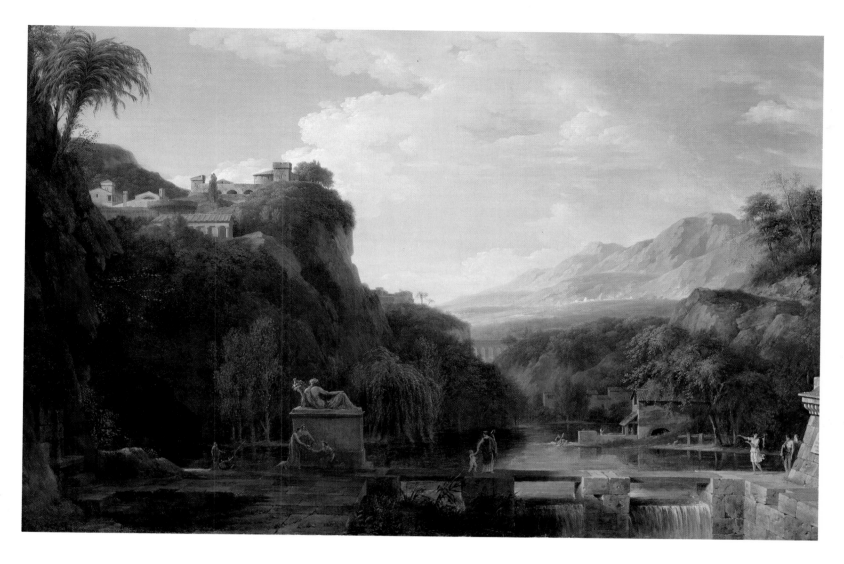

42. Pierre-Henri de Valenciennes. *Landscape of ancient Greece*, 1786. Oil on canvas, 100.3 × 152.4. Detroit, Detroit Institute of Arts. Founders Society Purchase, New Endowment Fund.

be sent to the factories where they might perform useful work. He claimed that "a landscape, a flower have no power over morals."[9]

Just as the Revolution failed to adapt all aspects of life to its severest principles, this extreme rhetoric was powerless to suppress the genre of landscape, long established and widely admired. Still, the anti-landscape hyberbole is a key symptom of the artistic climate to which Valenciennes addressed his treatise. His aim was not to challenge the hierarchy of genres but to invoke a long-standing hierarchy within the genre of landscape. In 1708 Roger de Piles had distinguished in landscape painting between *le style héroïque* and *le style champêtre*, implicitly ranking the former above the latter.[10] Building on this distinction and its elaboration in intervening texts, Valenciennes stressed the seriousness and elevation of what he called *paysage historique*, a cognate of de Piles's *style héroïque*. He drew an explicit parallel between the landscape hierarchy and the comprehensive hierarchy of genres, and thus claimed for *paysage historique* a status equivalent, or nearly equivalent, to *peinture d'histoire*. In his treatise he cited as exemplary practitioners of *paysage historique* only celebrated history painters:

Nicolas Poussin, Annibale Carracci, Titian, Domenichino, and a few others did what Homer, Virgil, Theocritus, and all the great poets would have done if they had painted with colors. These painters were imbued with the

43

reading of those sublime poets; they had meditated upon them; and, closing their eyes, they saw that ideal Nature, that Nature adorned with the riches of imagination, which only genius can conceive and represent. . . .

What a difference between a picture of a cow and a few rustic sheep in a field, and a picture of the burial of Phocion; between a landscape of the banks of the Meuse and one of the shepherds of Arcadia; between a scene of rainy weather by Ruisdael and the Deluge by Poussin! . . .

We shall not bother to speak generally of the *Beau idéal*; Winckelman [*sic*] and others have already defined it. . . . We shall try only to prove that there also exists a *Beau idéal* in historical landscape. . . .[11]

Valenciennes was a great critical success, credited with restoring to prominence the noble style of the seventeenth century. The following passages, written respectively in 1800 and 1806, are typical:

[Valenciennes] is one of those who have most contributed to the return of the grand style and good taste that ennoble this genre of painting.[12]

[Valenciennes] has created in a certain way a new genre: for the *historical style*, in landscape, seemed to have been abandoned since Poussin, doubtless out of despair at following in his footsteps.[13]

The critics also often praised Valenciennes as the founder of a new school of painters. C.P. Landon wrote in 1808:

One owes to this able master not only pictures that are majestic and truly poetic in style but also several young artists worthy of following in his footsteps. Since the return of M. Valenciennes to France the art of landscape has been ennobled, one could say regenerated.[14]

43. Pierre-Henri de Valenciennes. *The Eruption of Vesuvius and the death of Pliny*, 1813. Oil on canvas, 147 × 195. Toulouse, Musée des Augustins.

44. Pierre-Henri de Valenciennes. *The Idalian woods with Cephisa and Cupid*, 1797. Oil on wood, 42 × 76. Ottawa, National Gallery of Canada.

Perhaps the most important of these younger artists was Jean-Victor Bertin (1767–1842),[15] who entered Valenciennes's studio in 1788, after three years with Doyen, and began to exhibit in 1793. A third major figure was Jean-Joseph-Xavier Bidauld,[16] who first exhibited in 1791. Although not a student of Valenciennes and only eight years younger, Bidauld was in many respects his artistic inheritor. Together with Bertin he carried Valenciennes's artistic philosophy into the 1840s.[17]

The work of Valenciennes, Bertin, and Bidauld best represents the ambitions and achievements of the Neoclassical school, which reigned as the highest form of landscape painting in France from the last decade of the eighteenth century through the first two of the nineteenth.[18] In the same period French history painting bristled with ideological engagement and pictorial vitality, but such a claim cannot be made for landscape. Although the school of Valenciennes owed its initial self-definition and its sense of modernity to the school of David, the two soon diverged. For a generation after 1789, *paysage historique* followed a static norm, ever more detached from the world beyond the studio and the Salon.

A rare exception is Valenciennes's *Eruption of Vesuvius* (pl. 43), in which the violent earthquake and great billows of smoke and ash bring geological specificity and a new immediacy to the familiar eighteenth-century theme.[19] Painted in 1813, the year after Valenciennes became a professor at the Ecole des Beaux-Arts and exhibited at the Salon of 1814, nearly thirty years after his debut, this large picture may have been intended to re-establish Valenciennes's reputation and high ambition.[20] If so, it serves only to underscore the shallowness of his work over those thirty years, of which his *Cephisa and Cupid* is far more representative (pl. 44). Such a frivolous, erotic fantasy, painted in 1797 in the wake of the Terror, may be construed as a longing for the carefree pleasures of the *Ancien Régime*. That Valenciennes had fled Paris in the bloody years of 1792–95 lends credence to such an interpretation.[21] Nevertheless, the motif of withdrawal into a timeless, harmonious past had been announced in Valenciennes's earliest work, before the Revolution, and changed little thereafter. If for history painters antiquity was fraught with passion and conflict, dense with urgent analogy to contemporary affairs, for Valenciennes and his school the classical past was a dreamland of tranquility. Despite Valenciennes's rhetorical invocation of ancient

45. Jean-Victor Bertin. *View of a town in the Sabine mountains*, 1814. Oil on canvas, 65.7 × 89.7. Houston, The Museum of Fine Arts. Museum purchase with funds provided by the estate of Nina Cullinan in honor of Margaret Cullinan Wray and Mary Cullinan Cravens.

46. Pierre-Henri de Valenciennes. *Mercury and Argus*, 1793. Oil on wood, 24.4 × 32.4. Barnard Castle, County Durham, The Bowes Museum.

authors and high moral ideals, the nominal narrative theme of a work of *paysage historique* is rarely more than a pretext for the *beau idéal*. As often as not, Valenciennes, Bertin, and Bidauld dispensed with the pretext altogether.

The recipe for this brand of ahistorical historical landscape is suggested by Bertin's *View of a town in the Sabine mountains*, painted in 1814 (pl. 45). The inevitable horizontal rectangle combines a selection of standard ingredients: large, well-formed trees; a tranquil source of water; a stretch of fertile terrain, easily traversed by the obligatory figures; a gently curving road; a cluster of old but timeless buildings; often a solid rock or cliff; a reassuring vault of sky; and in the distance a mountain. These elements, composed in a self-contained whole, present a balanced pictorial harmony. There is nothing beyond the mountain, nothing outside the picture. It is an abstract image of nature, removed from history and its conflicts, conceived as a perfect home for man.[22]

Bertin called his picture a view, but it is devoid of topographical or natural specificity. If *paysage historique* was detached from history, it was equally remote from empirical observation. Although there is no evidence that Bertin himself drew or painted from nature, Valenciennes, Bidauld, and many other Neoclassical landscapists had done so extensively in Italy. Nevertheless, their oudoor work played no role in their studio routine, as though an impenetrable barrier existed between the two. Corot's contribution to the Salon of 1827 is especially telling in this regard. The two pictures he exhibited, although entirely conventional in conception, display an immediacy of natural observation that none of his masters had achieved in their finished work.

The conventions of *paysage historique* recalled and ultimately derived from Poussin's landscapes of the 1640s and early 1650s, such as the *Diogenes* and the *Orpheus and Eurydice* (pl. 47) in the Louvre. The reference was perfectly clear to Valenciennes's contemporaries, who credited him and his followers with reviving the classical style. Today, despite its planar schemes and its sobriety of color, the Neoclassical style seems to have succeeded only imperfectly in repudi-

47. Nicolas Poussin. *Landscape with Orpheus and Eurydice*, 1650s. Oil on canvas, 123 × 200. Paris, Louvre.

48. Jean-Victor Bertin. *Italian landscape*, *c*.1810. Oil on canvas, 60 × 96. Boulogne-Billancourt, Bibliothèque Paul Marmottan.

49. Nicolas-Didier Boguet. *View of Lake Albano*, 1795. Oil on canvas, 178 × 260. Grenoble, Musée de Peinture et de Sculpture.

ating eighteenth-century artifice and frivolity. The irony is that Valenciennes's emulation of Poussin's robust designs was most successful in his smaller, less ambitious works, such as the *Mercury and Argus* of 1795 (pl. 46). Otherwise, the Neoclassical landscape style too often exhibits a fragile, attenuated quality, over which the flavor of classicism is but a superficial gloss. In many of Bertin's works, such as the *Italian landscape* of about 1810 (pl. 48), Poussin's bold rhythms are rendered in miniature, frozen in a crystalline light borrowed from Northern painters such as Jan van der Heyden. In Bidauld's *Psyche and Pan* (pl. 50), as in Valenciennes's *Landscape of ancient Greece* (pl. 42), the intended homage to Poussin is unmistakable, but the flaccid pictorial structure and mincing details evoke the rarified delicacy of eighteenth-century art.

Poussin's authority, although the most frequently invoked, was not exclusive. Nicolas-Didier Boguet (1755–1834), at work in Italy, made a career of recapitulating the work of Claude Lorrain (pl. 49).[23] Gaspard Dughet was admired and imitated; Domenichino and the Carracci were cited as exemplary. But the range of pictorial reference was not broad. Bidauld's *Psyche and Pan* and his *View of Isola di Sora in the Kingdom of Naples* together define the approximate limits of the Neoclassical style – and of its thematic content as well.

The theme of Bidauld's *Psyche* (pl. 50) is drawn from Greek mythology, appropriately set in a Poussinesque composition peopled with figural quotations from antique sculpture.[24] The composition of Bidauld's *View of Isola di Sora* (pl. 51), an image of Virgil's pastoral Arcadia, derives from Claude, the greatest painter of Virgilian themes. Indeed, it is the reference to Claude, not the picture's title, that suggests Virgil.

The two works are representative of the heroic and pastoral modes of Neoclassical landscape painting, as defined by Lecarpentier in 1817 in a work largely based upon Valenciennes's treatise:

1. Heroic landscape, which must occupy the first rank, because it seems closest to the genre of history, and because it demands great erudition of those who wish to devote themselves to it with distinction;

50. Jean-Joseph-Xavier Bidauld.
Historical landscape with Psyche and Pan,
Salon of 1819. Oil on canvas, 97 × 130.
Paris, Louvre.

51. Jean-Joseph-Xavier Bidauld. *View of
Isola di Sora in the Kingdom of Naples*, Salon
of 1793. Oil on canvas, 113 × 145. Paris,
Louvre.

2. The pastoral genre, which recalls ancient customs with that ever noble simplicity of which *Theocritus* and *Virgil* left such seductive pictures in their divine writings.[25]

This classification was repeated with somnolent persistence throughout the period.[26] In the literature as in the art the distinction between heroic and pastoral masked a deeper affinity; at the heart of both categories lay a hush of emotional repose and inert harmony. Bidauld's choice of subject in the *Psyche* was characteristic of Neoclassical landscape, which drained Greek and Roman mythology of violence and conflict, even of action. The residue was a closed world of untroubled calm, virtually interchangeable with Virgil's Arcadia.

Although Valenciennes and his school called their work "historical landscape," it had little to do with history, or with the drama and moral tensions of literature. The criticism of the period reflected and confirmed this condition. A typical passage of praise for a painting by Valenciennes at the Salon of 1800 completely ignores the picture's subject:

> Grand style, felicitous forms, beautiful accents in the sky and in the design, beautiful choice of buildings, broad and well-appointed effect. Everything in this winning picture speaks of imagination and erudition, a pure and reasoned taste, a stately union of all that constitutes the historical genre.[27]

In a similar vein the young Quatremère de Quincy, in an essay of 1806, lamented the absence from Joseph Vernet's pictures of "those *historical* trees that constitute the ideal of landscape."[28] In landscape the terms *genre historique*, *style héroïque* and their variants had become little more than superficial stylistic labels.

For all their high ambitions and critical success, Valenciennes and his followers had reduced the classical landscape tradition to a tepid nostalgia for antiquity, devoid of grandeur as well as of drama. They diluted the pictorial vocabulary of Poussin and Claude into a pleasant and often attractive but also shallow and lethargic formula. They preached the study of nature and practiced it eagerly in Rome, but they found themselves unable to make use of their outdoor work once they had returned to Paris and the studio. Their adulation of a distant peak of aesthetic perfection – their preoccupation with the *beau idéal* – so overshadowed their enterprise that their work ossified into a static emblem of cultural authority.

* * *

Such a gap between pretension and achievement invited derision, and by the middle of the nineteenth century *paysage historique* had come to seem not merely shallow but atavistic, utterly opposed to the new tradition that then was unfolding. A corollary of this fall from grace was a rise in esteem for those contemporaries of Valenciennes who had dissented from the Neoclassical aesthetic. Landscapists who pursued Northern rather than Southern traditions, such as Jean-Louis Demarne (1752?–1829) and Georges Michel (1763–1843), naturally were more appealing to Barbizon taste. They were hailed as precursors to the modern tradition, just as Valenciennes and his students were recast as conservative villains. This retrospective projection of conflict between progressive and conservative camps has distorted the underlying consensus of French landscape painting around 1800. Valenciennes's rhetorical disdain for Ruisdael is evidence not of conflict but of a closed system of accepted styles, in which North and South were the key points of reference. Those who followed Dutch and Flemish models – the *Septentrionaux* – no less than their classicizing contemporaries –

52. Jean-Louis Demarne. *Hay pitchers' lunch*, Salon of 1814. Oil on canvas, 29 × 44. Cherbourg, Musée Thomas-Henry.

53. Jean-Louis Demarne. *Village fair*. Oil on wood, 36.5 × 50.5. Paris, Louvre.

the *Méridionaux* – viewed seventeenth-century precedent as exhaustive and authoritative.

Demarne, born in Brussels, studied in Paris in the 1760s under the history painter Gabriel Briard.[29] Failing to win the *prix de Rome* in 1772 and 1774, he turned to genre and landscape, basing his style on the work of seventeenth-century Northerners such as Berghem, Cuyp, Dujardin, and the van Ostades.

Demarne's subject was the bustle and commerce of village life, filled with comings and goings, work and play, and a crowded display of precisely rendered details. The artist traveled to Switzerland, the Franche-Comté, and Normandy, and sometimes titled his pictures with place names from these areas or from the environs of Paris. On rare occasions the unexpected clarity of observation and the specific accidents of topography make themselves felt in his work (pl. 52). But the manifest intent of the vast majority of Demarne's paintings is not to evoke a particular place but to invoke an association with old Dutch pictures (pl. 53).

This characteristic feature of Demarne's work was recognized at his Salon debut in 1783 by Grimm, who regretted the painter's habit "of imitating the Dutch masters more readily than nature."[30] Grimm's view of Demarne's voluminous production persisted, but it did not always carry a negative implication. Demarne had been accepted as an *agréé* of the Academy and was admired as a specialist in Netherlandish scenes, which were no less attractive for being repetitive. As Landon put it in 1812, "The brush of M. Demarne is inexhaustible; it always distinguishes itself by freshness of color and truth of composition, even in often-repeated subjects – fairs, highway scenes, animal markets, etc."[31] Indeed, the narrowness and repetitiveness of Demarne's art are the keys to its function. A passion for collecting old Dutch pictures had preceded and survived the Revolution of 1789; Demarne simply transposed it to contemporary art. Joséphine Bonaparte owned four pictures by Demarne and nearly every other notable collection of the period included at least one.[32]

Compared with the frankly artificial cottages and milkmaids of Boucher, Demarne's recovery of seventeenth-century Dutch conventions may seem like a return to nature. But the gap is equally great between Demarne and the succeeding generation, who enlisted the Northern tradition as a resource for innovation. Demarne and the many like him among the *Septentrionaux* were not precursors of

Barbizon naturalism. On the contrary, their slavish adherence to Northern models served a fashionable taste, which located the essential innovation in the distant past.

In certain respects the art of Georges Michel[33] presents a very different case. Instead of the bustle of village life, Michel loved the vast empty landscape, with large skies filled with gathering gray clouds. Instead of Demarne's communal optimism, Michel presented a melancholy view of nature. Instead of greeting each Salon with a dozen or more works, he stopped exhibiting altogether after 1814 (he had begun in 1791). Instead of enjoying steady commercial success, he spent the last two decades of his life in poverty and seclusion. In short, Michel's moody aesthetic offers an alternative both to the volubility of Demarne and the rectitude of Valenciennes, and his career suggests the pattern of rejection so often suffered by advanced French artists later in the century.

Shortly after Michel's death in 1843, Théophile Thoré, later followed by Alfred Sensier, sought to establish for the painter a reputation he had not enjoyed in his lifetime.[34] Citing his reclusive personality, the melancholy skies of many of his paintings, and the loose, sometimes vigorous handling of what appear to be his later works, Thoré and Sensier acclaimed Michel as a neglected precursor of the Barbizon school. They attributed his failed career to the repressive authority of the Neoclassical school. As Thoré, quoted by Sensier, put it:

> Why did the author of all those roughly built-up sketches thus dissipate his real talent and his vocation as a great artist? Why?
> While Michel was seated on the outskirts of Paris, Bidault [sic] was seated at the Institut.[35]

Thoré's and Sensier's argument has been very influential. It is now commonly accepted that Michel's departure from the Neoclassical norm should be interpreted as a symptom of progress toward modern naturalism.[36] In fact, while Michel was less slavish toward seventeenth-century precedent than Demarne, he is miscast as a pioneer. Despite the verve of his best pictures, his work as a whole fits snugly within the complacent aesthetic of the *Septentrionaux*.

Although Michel's art is superficially very different from Demarne's, it developed in the same milieu. Michel often worked as a copyist and restorer of Dutch landscapes for the dealer Lebrun, for the collector Fesch, and for Vivant Denon at the Louvre, where he lived for a time. Like Demarne he followed noted Northern masters and rarely challenged the conventions they had established a century and a half earlier. Also like Demarne he was a specialist, confining his work to a narrow range of subjects and pictorial models. He stayed close to the dune or plain landscapes of Jan van Goyen and Ruisdael, mimicking their narrow tonal harmonies, atmospheric unity, and simplified forms (pl. 54).

The notorious difficulty of dating Michel's pictures derives as much from the slender range of his art as from the scarcity of dated works. And while in certain works he developed a more flamboyant and expressive style (pl. 55), it is entirely plausible that he did so not in anticipation of the romantic aesthetic of 1830 but in response to it. In any case the stylistic evolution was not an outgrowth of empirical observation. Michel's inherited imagery remained unchanged; the windmills are not those of Montmartre but of seventeenth-century Holland. Even his numerous drawings, reported to have been made from nature, bear a heavy Dutch accent; and it is notable that neither Michel nor any other painter among the *Septentrionaux* left behind a body of oil studies from nature, as did Valenciennes and several members of his school.

In this sense Michel and Demarne are closer than initially they may seem,

54. Georges Michel. *Landscape with windmill, c.1800?*
Oil on canvas, 57 × 75.5. Paris, Louvre.

55. Georges Michel. *Landscape with windmill, c.1825?*
Oil on canvas, 58.4 × 80.6. Cambridge, Fitzwilliam
Museum.

not only to each other but to their classicizing contemporaries as well. Just as
Valenciennes and Bertin renewed and preserved the authority of Southern ideal
landscape, Demarne and Michel preserved the Northern alternative. Beneath
the differences between the two schools is the shared perception that the entire
formal and expressive range of landscape painting had been established once
and for all time in the seventeenth century. This view dominated the theory
and criticism of landscape painting in the decades before 1820. Typical is the
classification offered by Landon in 1812:

> The first class is that of historical or heroic landscape, as it was conceived by
> several masters of the French and Italian schools: Poussin, Domenichino, the
> Carracci, and others. . . .
>
> Landscapes of the second class, of a style less severe than those of the
> first, [belong to the category in which] Claude Lorrain, a French painter, so
> eminently distinguished himself. . . .
>
> The third class includes landscapes in the manner of Flemish or Dutch
> painters . . . [;]Ruisdael, Wynants, Berghem, Herman van Swanevelt, Karel
> Dujardin, and others brought to this genre a rare perfection.[37]

The key here is not so much Landon's admiring references to the old masters as
his smug confidence that their achievements provided a comprehensive outline
of contemporary practice. By 1812 to choose Poussin over Ruisdael (as had
Valenciennes) or Ruisdael over Poussin (as had Michel) was not so much to seek
a new path for modern landscape painting as to reconfirm the closed circle of
familiar options. The *Septentrionaux* and the *Méridionaux* occupied complemen-
tary positions in a rigid pattern, from which the impetus for change had been
withdrawn.

Although they had died only a few years earlier, neither Fragonard nor Hubert
Robert had any place in Landon's scheme. The generation of Valenciennes
succeeded with remarkable thoroughness in reforming the ambitions of modern
French landscape painting. But the reform collapsed into stasis, a circumstance
that is all the more striking when compared with innovations abroad – with the
personal mysticism of Caspar David Friedrich, the coherent naturalist program
of John Constable, and, perhaps most striking of all, since it involved a deep

53

56. Théodore Géricault. *Landscape with a Roman tomb (midday)*, 1818. Oil on canvas, 250 × 219. Paris, Musée du Petit Palais.

admiration for Poussin and Claude, the wide-ranging art of Joseph Mallord William Turner. It is precisely this climate of complacency that separates French landscape painting before 1820 from the new tradition that followed.

* * *

Between the late 1780s and the early 1820s no fewer than a quarter and often as many as a third of the works exhibited at each of the official Paris Salons were landscapes.[38] In 1791 restrictions on admission to the Salon were lifted, and the total number of works grew substantially, from 218 in 1789 to 1,433 in 1822. Yet the proportion of landscapes changed little.[39] The statistic reflects the durability of the genre in the face of rhetoric that denounced its moral vacuity. That same durability, based on long-standing habits of practice, patronage, theory, and teaching, also made possible a debilitating isolation. Over a period in which other branches of French painting flowered, often responding to life outside the studio, the genre of landscape contracted into an ever more parochial posture.

Inevitably there were exceptions. Perhaps the most telling is a suite of landscapes painted by Théodore Géricault in 1818, whose grandeur and brooding melancholy have no parallel in the work of Valenciennes and his school (pl. 56).[40] Other exceptions of a different sort will claim attention later in this chapter, in the context of Corot's student work. Still others arose after 1800 under state patronage. Napoleon's military campaigns and imperialist adventures produced commissions for propagandistic reportage, in which the landscape format provided a vehicle for local detail and specific incident (pl. 57).[41] After 1815 the Bourbon Restoration spawned another landscape speciality, a branch of the *style troubadour*.[42] When the subject placed the costume drama of royal history out of doors, particulars of topography often embellished the pageantry of the narrative (pl. 58). In the hands of such painters as Nicolas-Antoine Taunay (1755–1830) or Pierre-Athanase Chauvin (1774–1832), both specialties combined fantasy and artifice with precise observation and documentary detail. Against the stylistic lethargy of the period these qualities may seem to announce a new opportunity for landscape. Precisely because they served specialized functions, however, the new varieties of landscape were isolated from the mainstream of the genre, and they disappeared with the patronage that had created them.

The new tradition initiated in the 1820s and 1830s by Corot, Théodore Rousseau, and others was founded not on the accumulation of verifiable fact but on a new approach to the experience of nature. As they began to form that approach, Corot and the other young painters inevitably took as their starting point the mainstream legacy of the previous generation. The complacency of the *Méridionaux* and the *Septentrionaux* expressed the exhaustion in France of the grand landscape traditions. But the reform that had led to this impasse created an atmosphere of intimate dialogue with the masters of the seventeenth century, as if the clutter of the eighteenth had been swept away. Valenciennes's lofty rhetoric had rekindled the conviction that the landscape tradition was indeed grand, that it had been and could again be the vehicle of high achievement and deep moral sentiment. Even if Valenciennes and his followers had not fulfilled

57. Nicolas-Antoine Taunay. *French Army crossing the Saint-Bernard Pass*, 1808. Oil on canvas, 183 × 163. Versailles, Musée national du château.

58. Pierre-Athanase Chauvin. *Entry of Charles VIII into Acquapendente, 1494*, Salon of 1819. Oil on canvas, 190 × 280. Amboise, Musée de l'Hôtel de Ville.

this conviction, it helped shape the ambitions not only of Corot but also of Rousseau, whose work otherwise is so remote from that of Valenciennes.

For those who entered the Neoclassical studios, reverence for the grand tradition was linked to a structured program of instruction. The program incorporated drawing and painting from nature and thus offered an avenue of innovation. The alienation in Valenciennes's work between outdoor study and studio composition, in itself a symptom of breakdown in the tradition, gave a new distinctness and autonomy to working from nature.

From Valenciennes's school Corot inherited a sense of intimacy with the great achievements of the past, a high ambition, and an organized hierarchy of practice; and he retained them throughout his career. For this reason his work will be misunderstood if his Neoclassical masters are cast as two-dimensional villains or heroes, if they are reduced to a mere background against which Corot reacted, or credited with establishing the direction and momentum of his innovations. This proposition will be examined in greater detail in the following account of Corot's education.

* * *

Jean-Baptiste-Camille Corot was born in Paris on 16 July 1796 (28 messidor, an IV). He had two sisters, Annette-Octavie (1793–1874) and Victoire-Anne (1797–1821). His father, Louis-Jacques Corot (1771–1847), descended from a family of wigmakers originally from Burgundy. His mother, born Marie-Françoise Oberson (1769–1851), was the daughter of a prosperous Versailles wine merchant of Swiss origin. In 1793, when the couple married, Louis-Jacques was registered as a wigmaker at 115, rue de Grenelle.[43] Soon, however, he became a draper or cloth merchant and manager of a dress shop that sold Madame Corot's creations, at the corner of the rue du Bac and the quai Voltaire.[44]

Camille spent little time at home until he was eighteen. As an infant he was put out to nurse. From 1804 to 1807 he lived as a pupil in the house of a M. Letellier, in the rue de Vaugirard. In 1807 his parents sent him to school at Rouen, putting him in the care of a family named Sennegon. Camille left Rouen in 1812, apparently after failing at school. In 1813 his older sister married one of the Sennegon sons, and Corot remained forever close to the family. He completed his schooling with two years at a *pension* in Poissy.

Legend has it that Corot was a poor student and that in his maturity he never read a book. Even so, as a boy he must have become familiar with the Bible and the rudiments of classical literature. Early on his first trip to Italy, for example, he reported that he was reading Virgil[45] and playfully identified himself with Aeneas by referring to one of his girlfriends, left behind in Paris, as "Dido."[46] Corot was not erudite, but neither was he a simple child of nature. When he painted biblical and classical themes, as he did throughout his career, he was not treading on the alien ground of a moribund academic art but on familiar territory, which he shared with his audience.

In 1814, shortly before his eighteenth birthday, Corot returned to Paris and was apprenticed to a draper named Ratier. According to Robaut, it was not until a year later, on 1 May 1815, that Camille first dared to tell his father that he wanted to become a painter. The father refused and the son repeated the request each year on the same day – Louis-Jacques's saint's day – until it was granted in 1822.[47] This story may be a fiction devised by Corot for the attentive Robaut, but it is reasonable to suppose that Corot had formed the ambition to study

painting well before he actually began to do so, in 1822. In the meantime Corot left Ratier, finding a more congenial employer in the draper Delalin.

While working for Delalin Corot began to draw and even to paint. In a letter of 1821 he wrote to a friend that he continued to amuse himself by painting landscapes;[48] and Delalin is reported to have found his wares stained from time to time with oil paints from Corot's hands.[49] At some point during his long draper's apprenticeship Corot attended the open drawing classes at the Académie Suisse, where he doubtless met other young painters. Between 1818 and 1822 he also made three lithographs. Now lost, they are the only documented works from the period before Corot became a full-time student of painting.

The lithographs were titled *The Soldier dies and does not surrender*, *The Plague of Barcelona*, and *A Village fair*.[50] Each of these subjects was familiar in contemporary art. The first print, an image of Napoleonic defeat from the viewpoint of the common soldier, doubtless was intended to emulate the lithographs of Nicolas-Toussaint Charlet (1792–1845), who had popularized the subject. The second print, *The Plague of Barcelona*, also treated a theme of contemporary history.[51] Finally, the *Village fair*, which according to Corot included a great number of figures, was probably an essay in "the genre of Flemish kermesse," as Robaut suggested, presumably referring to Rubens's famous picture in the Louvre. The lithographs hardly define a distinct artistic personality, but they suggest an alert awareness of contemporary and older art, by no means limited to landscape.

On 8 September 1821, Corot's younger sister, who had married, died. Since she left no children her dowry was returned to her father. Soon thereafter Louis-Jacques offered his son a choice: Camille could have 100,000 *livres* to establish himself as a draper or the annual income from his sister's dowry to become a painter. With considerable delight Corot chose the latter option[52] and henceforth received between 1,500 and 2,000 *livres* a year (Robaut mentions both figures[53]) from his father. This was not an enormous sum, but it meant that if Corot were thrifty he would never again need to seek employment or patronage of any kind. He immediately took a studio on the quai Voltaire.[54]

By this time Camille was nearly twenty-six years old. Unwilling to break with his father, he had endured eight years in the draper's trade, yet had tenaciously conserved his desire to become a painter. Here is the first hint of Corot's character, one that was inwardly persistent and ambitious and outwardly avoided conflict and display. This aspect of his personality later would find expression in a recurrent theme of his major pictures. Over and over again he would paint a meditative figure alone in the landscape: Hagar (1835), St. Jerome (1837), Democritus (1841), St. Sebastian (1853), and a long series of anonymous monks, wanderers, and readers.[55] It is not necessary to believe that he identified himself explicitly with each or any of these figures to see that he admired their inner strength. For Corot they were not fashionably tortured souls of Romantic isolation, but models of self-reliance. In a sketchbook of the early 1820s he wrote, "The wise man is happy under persecution and even in oblivion."[56] A self-portrait painted by Corot for his parents shortly before he left for Italy in 1825 is a document of unblinking determination, innocent of flamboyance or pretense (pl. 59).

In so far as Corot's character already had been formed, his new financial position reinforced it. He had enough money for a modest painter's life but for little else. While in Italy he would twice renounce the idea of marriage as an obstruction to his career.[57] He resolved to devote himself to painting, and his income allowed him to do so. In the first half of his career Corot apparently

59. Corot. *Self-portrait*, 1825. (R.41.) Oil on paper, mounted on canvas, 32.5 × 24.5. Paris, Louvre.

never sought commissions and received only a few, none from the State. Unlike many landscape painters, he stayed aloof from the commercial trade in topographical and picturesque prints. He worked only for himself, for the disinterested judgment of history, and for the grand arena of the Salon, to which he sent pictures of the most ambitious sort.

Corot's formal artistic education began in May 1822, when at last his father granted his wish to become a painter. Corot immediately enrolled as a student of Achille-Etna Michallon, whom he already knew.[58] Although slightly younger than Corot, Michallon was extremely precocious and by 1816 had earned a considerable reputation.[59] The son of Claude Michallon (1751–1799), winner of the *prix de Rome* for sculpture in 1785, Michallon had grown up in the Louvre and then, after 1802, in the artists' lodgings at the Sorbonne, while the Louvre underwent renovation. A student of David, Valenciennes, Dunouÿ, and Bertin, he had first exhibited at the Salon in 1812 at the age of fifteen and received a second-prize gold medal. He had been favored with the patronage of Prince Youssupof, until the prince returned to Russia in 1814, and after that of the duchesse de Berry and of the comte de l'Espine, finance minister under the Bourbon Restoration. When Corot arrived at the studio of Michallon he entered a highly sophisticated environment.

Michallon died in late September 1822, apparently of tuberculosis. Brief as it was, Corot's period of study with Michallon was significant. By 1820 the genre of *paysage historique* had been in decline for a decade. Valenciennes had died in 1819 and Bertin, Bidauld, and others of their generation had settled into repetition and pastiche of their own earlier work. Michallon brought talent and energy to historical landscape painting and helped to initiate a revival of Valenciennes's high ideals. In the eyes of the young Corot historical landscape was not an outmoded formula but a vital art, the obvious path of ambition.

A crucial event in this context was the creation of a new *prix de Rome* for *paysage historique*, whose first winner, in 1817, was Michallon.[60] The Academy, dissolved in 1793 as an onerous institution of the *Ancien Régime*, had been fully reconstituted only after the Restoration of 1815. The new landscape prize was part of a program aimed at restoring, in the arts as well as in politics, the glorious classical age of Louis XIV.[61] This program was led by Quatremère de Quincy, the new *secrétaire perpétuel* of the Academy who soon became the oracle of academic dogma.[62] Under his guidance the new Academy reconfirmed the high principles Valenciennes had invoked in his treatise.

Michallon's talent was a catalyst for the new landscape prize. In 1816 he petitioned the government for support and won the endorsement of a number of leading painters.[63] In fact proposals for a landscape prize had been made intermittently since the 1790s.[64] Invariably these had insisted on the pre-eminence of *paysage historique* and excluded other forms of landscape. The intense concern to enforce the traditional hierarchy of academic values is reflected in the rules of the quadrennial competition. The most important condition was that "The subject prescribed for the competition will always be a subject of the noble and historical genre."[65] By establishing the prize, the Academy meant not to encourage landscape painting generally but to re-establish the authority of *paysage historique*, as Valenciennes had defined it. The critics understood this in no uncertain terms. The following passage from Miel's *Salon de 1817* is typical:

> The establishment of this prize is right and proper: it will contribute strongly to returning to honor the genre of historical landscape, in which most of the great masters – Titian, the Carracci, Domenichino, Rubens, Poussin –

distinguished themselves, and examples of which have been too rare in the French school since, to the great regret of lovers of painting, M. Valenciennes has retired.[66]

While Miel associated the prize with Valenciennes's legacy, J.B. Deperthes, a student of Valenciennes who had turned from painting to theory, explicitly linked it to the Restoration of the Bourbon monarchy:

> Granted participation in the noble institution of the *grands prix*, the young artist who devotes himself to a career of landscape painting will not attract the attention of such generous patronage without exerting himself to meet the expectations of the august protector, without achieving fully the hopes of the nation. . . . *Historical landscape* is henceforth called to contribute, along with the high forms of the arts, to the maintenance of the supremacy of the French School and to the realization of its brilliant future.[67]

This pronouncement, at once bombastic and servile, concluded Deperthes's *Histoire de l'art du paysage* (1822). With this work and his *Théorie du paysage* (1818),[68] written during the Academy's deliberations over the landscape prize,[69] Deperthes inherited Valenciennes's weighty mantle as the arbiter of landscape theory. In certain respects Deperthes modified Valenciennes's dogmatic position, but he retained the essential outline of the theory, including the division between *paysage historique* and *paysage champêtre* and the superiority of the former:

> one cannot deny that one of the two styles involves eminently, and more than the other, genius of invention, distinction in orderly composition, consummate tact in the choice of decorative effects, taste in combining them, nobility of the figures who populate the picture, and elevation of ideas – all of which combine to give life to a subject capable of moving the soul or exalting the imagination, and all of which link historical landscape to history painting, associating the former with the latter's incontestable pre-eminence over all the other genres comprising the domain of painting.[70]

Still more important than the critical reaction to the new landscape prize was its effect on practice. The final stage of the competition called for a finished work on a prescribed theme: "Democritus and the Abderitans" in 1817 (pl. 60), "The Rape of Proserpine" in 1821, "The Hunt of Meleager" in 1825.[71] A number of current or future young competitors for the prize also produced comparable works for exhibition at the Salon.[72] Thus from 1819 onward the the Salon witnessed a new influx of landscape compositions with classical themes, side by side with the works of the older generation. The new prize indeed had the intended effect of reviving *paysage historique*.

The renewed attention to classical themes was accompanied by a broader interest in the variety of models offered by the heroic tradition. Michallon's art in particular reflects an effort to revitalize historical landscape by recapturing its stylistic and expressive range. His *prix de Rome* entry of 1817 is an emulation of Poussin (pl. 60); an Italian peasant idyll of 1822 is closer to Claude (pl. 61). In other works – *Theseus pursuing the Centaurs* (1821; Paris, Louvre), *Philoctetes on Lemnos* (1822; Montpellier, Musée Fabre),[73] and especially *The Death of Roland* (pl. 62) – Michallon responded to other aspects of the Baroque tradition, including the turbulent example of Salvator Rosa. With the exception of Géricault's idiosyncratic contribution (pl. 56), nothing in the previous three decades of French landscape painting offered a precedent for the drama and grandeur attempted by Michallon in these pictures. Most were painted not in Paris but in

Rome, where Michallon lived from 1817 to 1821, and where he was exposed to a different scale of ambition, in the form of such painters as Turner and Josef Anton Koch (1768–1839).

With the expanded stylistic range came the principle of unity between subject and setting. The issue came to the fore in the critical response to Michallon's *Death of Roland*, painted in satisfaction of the commission that accompanied the *prix de Rome*, and exhibited at the Salon of 1819. The report of the Academy noted "a kind of severity suitable to the tragic situation of the subject."[74] Gault de Saint-Germain not only praised the affinity of subject and style but recognized the source of the latter:

> The vast landscape of M. Michallon fixes the attention of the viewer by a character of grandeur and energy of which there exists no example in the [French] school. The somber wastelands of Salvator, the turmoil of the earth under the brush of that famous Neapolitan, offer nothing more fierce nor more appropriate to the episode from the poem of Roland with which the painter has enriched his picture.[75]

After Michallon's death his successors in historical landscape painting did not pursue the romantic violence of *The Death of Roland*; certainly Corot was temperamentally unsuited to do so. Nevertheless, Michallon's high ambition, the grand style and moral seriousness of his work, had a profound impact on Corot. It fostered in him a deep attachment to the tradition of heroic landscape, which continued to find expression in his art, most pointedly in the large compositions of the 1830s and 1840s, such as *Hagar in the Wilderness* (1835; pl. 94) and *The Destruction of Sodom* (1843).[76]

Upon Michallon's death in the fall of 1822 Corot went to study under Jean-Victor Bertin, whose student he remained until he left for Italy in the fall of 1825. Much later, however, he discounted the choice. Shortly before his death in 1875 he claimed, "As for me, no one taught me anything. When one is left to oneself in the face of nature, one sorts things out as one can and, naturally, creates for oneself a personal style."[77] Relying upon this and other, similar statements, most writers on Corot have dismissed his academic education as irrelevant. At best they have given it short shrift, preferring to emphasize Michallon's advice to

60. Achille-Etna Michallon. *Democritus and the Abderitans*, 1817. Oil on canvas, 113 × 146. Paris, Ecole des Beaux-Arts.

61. Achille-Etna Michallon. *Composed landscape inspired by the view of Frascati*, 1822. Oil on canvas, 127 × 171. Paris, Louvre.

62. After Michallon. *The Death of Roland*, 1819. Lithograph. Paris, Bibliothèque Nationale.

study nature. In a remark invariably quoted in accounts of Corot's education, the painter recalled around 1850, "I made my first landscape after nature at Arceuil under the eyes of [Michallon], who gave me as his sole advice to render most scrupulously all that I saw before me."[78] Before considering Corot's early work from nature, however, it is essential to review his studio training, for the latter was far more important than Corot's biographers have wanted to believe.[79]

Studio instruction for landscape was based on the system for history painters.[80] Before beginning to work from the model (or from nature) the student copied from prints and then paintings. The prints were of two kinds: engravings after the old masters, and pedagogic albums (by 1820, almost all lithographic) which progressed from basic geometric forms through simple motifs to increasingly complex compositions.[81] The first kind of print introduced the achievements of the past; the second set forth the traditional, synthetic method of composition.

Corot copied both sorts of print. He also made at least two copies in oil, after paintings by Michallon[82] and Joseph Vernet.[83] Two other documents provide a useful if incomplete outline of his formal artistic education. One is a list of projects, written by Corot or one of his fellow students; the other is a small sketchbook comprising mainly pencil copies after prints and paintings. The list, numbered here for convenient reference, reads as follows:[84]

(1) Draw every evening
(2) little modern figures
(3) tracings of animals after Berghem, Paul Potter
(4) old Italian buildings [*fabriques d'Italie*]
(5) trees of different kinds
(6) a few compositions after my studies
(7) to give myself some subjects with historical figures
(8) make tracings in the *Annales*
(9) have a series of costumes of different centuries

(10) draw horses and dogs after van der Meulen
(11) If I could find well-drawn etchings of oaks, plants
(12) try to get figures of Le Prince to copy.[85]

In amassing these materials the student expected to improve his drawing skills and to develop a fund of details – animals, buildings, plants, figures – on which he could depend throughout his career. Corot acquired this conception of artistic practice from Michallon, whose comparable exercises in part survive,[86] and from Bertin. It was of course an entirely traditional procedure, the other side of Michallon's advice to study nature scrupulously, and it is the basis of all of Corot's Salon compositions.[87]

Two items on the list deserve special comment. Item (6), "a few compositions after my studies," shows that Corot quite conventionally thought of his nature studies as part of a comprehensive program leading to studio compositions. None of Corot's compositions from the period before 1825 survives, but one, recorded in a drawing by Robaut (pl. 63), indicates that Corot closely followed Bertin's example. Item (7), "to give myself some subjects with historical figures," shows that Corot understood that his compositions should illustrate historical, or rather literary, themes, for the *figures historiques* could be drawn from ancient history or myth, the Bible, and even modern literature.[88] One source of ancient themes for Corot and his contemporaries was the *Voyage du jeune Anacharsis en Grèce*, first published in 1788 by Jean-Jacques Barthélemy. An account of Greek life of the mid-fourth century BC, the book had become an indispensable manual for Neoclassical painters, so much so that in 1817 one critic could classify Michallon as a painter of historical landscapes simply by picturing him with "Anacharsis in hand."[89] Corot also used *Anacharsis*, recording in one of his student notebooks the page numbers of passages from which he might take appropriate subjects.[90]

A corollary to the frequent quotation of Michallon's "sole advice" to study nature is the myth that Corot had no interest in the paintings hanging in the Louvre.[91] In a note written a few years before the master's death, Robaut recalled questioning Corot on the matter:

I asked the master if he often went to the Louvre when he was young. He answered, *no*. Never did he feel either need or pleasure in going to see the galleries. He told me, nevertheless, that one time he went there in the company of a few comrades from the draper's trade, among them Mr. Clerambaut. [He said,] "I remember vaguely one thing, which is that my conduct was quite irreverent."[92]

The myth of Corot's indifference to the old masters, obviously encouraged by "Papa" himself, crystallized in Moreau-Nélaton's tongue-in-cheek admission that Corot had in fact visited the Louvre but that while there had copied only the copyists.[93] The joke evidently was based on a series of five drawings in an early sketchbook, each representing a young woman copying in the Louvre. The implication – that Corot had no interest in older art – has been reinforced on two of the three occasions when the sketchbook has been exhibited, major exhibitions of 1931 and 1962, where it was opened to one of these drawings[94] (pl. 64). In retrospect the choice seems highly tendentious, since most of the other drawings in the forty-page book, used between 1822 and 1825, are copies after works of art. Robaut himself recognized this fact and noted a number of copies in another early sketchbook, now lost;[95] but he did not pursue the matter further.

The sketchbook is extremely useful to a study of Corot's education, for it provides an extensive, if incomplete, record of his studio training. Not sur-

63. Alfred Robaut after Corot. Landscape composition, *c*.1822–23. Paris, Louvre, Département des Peintures, Service d'Etude et de Documentation.

64. Corot. *Copyist in the Louvre*, 1822–25. (R.3121, f. 16 recto.) Pencil on paper, 14.3 × 10.5. Paris, Louvre.

65. Corot. Copies after Flaxman, 1822–25. (R.3121, f. 32 recto.) Pencil on paper, 10.5 × 14.3. Paris, Louvre.

prisingly it shows that he was exposed to the conventional student fare of the 1820s, including antique sculpture, sixteenth- and seventeenth-century Italian and French painting, modern Neoclassical imagery, and lithographic instruction albums for landscape painters. That Corot had chosen to specialize in landscape is clear enough, but he also paid generous attention to other branches of painting, especially history painting.

Corot's interest in antique sculpture appears to have been little more than obligatory. He drew an Augustan portrait bust of Agrippa in the Louvre;[96] other sketchbooks contain related copies, including one of the *Borghese Gladiator*.[97] He was more comfortable with John Flaxman's illustrations to the *Iliad* and the *Odyssey*, which had been admired and imitated throughout Europe since they were first published in the 1790s. Corot crowded five pages of his sketchbook with copies after Flaxman.[98] Evidently he was more concerned with compiling material for later use than with understanding the compositions, since he copied only details, especially accessories of costume and armor (pl. 65). This strategy was at work in a number of other copies in the sketchbook and reflects the systematic method of analysis and composition taught in the studios, as well as in the lithographic instruction albums for students of landscape. Corot devoted three pages of the sketchbook to plant details (pl. 66) from albums of this sort, which led the student step by step from simple objects to modest compositions.[99]

66. Corot. Copy from an unidentified instruction album for landscapists, 1822–25. (R.3121, f. 13 recto.) Pencil on paper, 14.3 × 10.5. Paris, Louvre.

Further examples of Corot's analytical copying include a rapid sketch of the architectural background of *Brutus condemning his sons to death* (1812) by Guillaume Guillon-Lethière (1760–1832),[100] and a tiny detail from a landscape in the Louvre by Gaspard Dughet (pl. 232).[101] Most interesting is a series of six copies, five of them details, of prints after two landscapes by Jan Frans van Bloemen (1662–1749), called Orizzonte (pls. 67, 68, 69).[102] If Corot's choice of models expresses an attachment to the classical landscape tradition (there is also a copy after Claude[103]), his treatment of these models is significant, too. Often the selected details are more than fragmentary excerpts; they are in themselves complete little pictures, which transpose the ordered harmony of the model to a compact format. By simplifying the vocabulary of classical landscape, these self-sufficient quotations prepared Corot for working from nature near Rome. Many of his Italian landscapes evoke an intuitive link with the ideal imagery of the seventeenth century; the sketchbook drawings after Orizzonte

63

67. Corot. Copy after Orizzonte, 1822–25. (R.3121, f. 3 recto.) Pencil on paper, 10.5 × 14.3. Paris, Louvre.

68. Corot. Copy after Orizzonte, 1822–25. (R.3121, f. 4 recto.) Pencil on paper, 14.3 × 10.5. Paris, Louvre.

69. Engraving after Orizzonte from Croze-Magnan, *Le Musée français* (1803–9).

and Gaspard make that kinship explicit. Other copies in the sketchbook, after drawings or prints of Italian views, both real and imaginary (pl. 70), further prepared Corot for outdoor work in Italy.[104]

Landscapes account for only about a third of the copies in the sketchbook. Corot's choice of figural models also followed Neoclassical taste. There are copies after Polidoro da Caravaggio[105] and Valentin de Boulogne,[106] and others apparently after sixteenth- and seventeenth-century Italian or French works, although the specific models remain unidentified.[107] Among the contemporary works copied by Corot several document his adherence to the legacy of David. One represents the fifth labor of Hercules;[108] another, a depiction of a Roman oath, is ultimately derived from *The Oath of the Horatii* (pl. 71).[109] Still another page in the sketchbook bears Corot's own awkward attempt to compose a scene of antique warfare, similar in design to the picture that won the *prix de Rome* for history painting in 1824.[110]

In addition to these essays in bread-and-butter Neoclassicism, several other copies in the sketchbook follow a recent inflection of the tradition. One of the latter is a drawing after a *Good Samaritan* (pl. 72),[111] much like the one exhibited at the Salon of 1822 by Michel-Martin Drolling (1768–1851). In his commentary on the latter Landon reported:

> For the past few years this subject has been repeated several times at each Salon. It is a good subject for young artists, who think it better to take care with a few figures than to mangle a multitude, as we too often have occasion to note. "The Good Samaritan" lends itself to the study of the nude and of expression, the two principal aspects of painting.[112]

Closely related to this drawing is a copy after a *Death of Abel*;[113] two drawings of the penitent Magdalene complete the group.[114] Together the copies suggest that Corot was alert to a vein of contemporary imagery that combined the Neoclassical nude and Christian themes of suffering to produce a mood of pathos leaning toward sentimentality. Transposing it into landscape, Corot later mined this vein throughout his career. Absent from the sketchbook is any hint of interest in more advanced experiments in French painting around 1820, such as the work of Géricault or Delacroix.

The sketchbook of copies hardly constitutes a comprehensive guide to Corot's

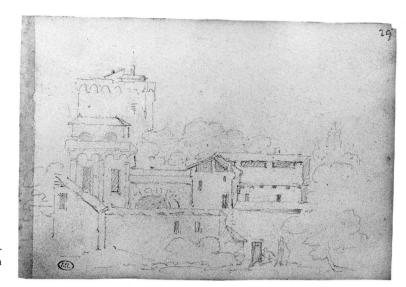

70. Corot. *Fabrique d'Italie*; copy after an unidenti-fied print, 1822–25. (R.3121, f. 29 recto.) Pencil on paper, 10.5 × 14.3. Paris, Louvre.

71. Corot. *Roman oath*; copy, 1822–25. (R.3121, f. 37 recto.) Pencil on paper, 10.5 × 14.3. Paris, Louvre.

72. Corot. *The Good Samaritan*; copy, 1822–25. (R.3121, f. 26 recto.) Pencil on paper, 10.5 × 14.3. Paris, Louvre.

studio education. But along with other scraps of surviving evidence, it goes well beyond dismantling the myth that Corot was an untutored naturalist. It points to a wholly conventional, if not in fact conservative, adherence to mainstream Neoclassicism and to its outline of the authoritative tradition. Also significant are the many traces of the old academic system of pictorial composition, based on the analysis and recombination of discrete elements, drawn both from older art and from nature. Michallon indeed advised Corot to study nature, but Corot did so in the context of an organized program of studio work aimed at learned synthesis.

*　　*　　*

73. Amélie Cogniet. *The Studio of Léon Cogniet*, 1831 (detail). Orléans, Musée des Beaux-Arts.

In his treatise and especially through his influential teaching career Valenciennes had institutionalized the oil study from nature. Thus open-air painting came to Corot as an integral part of his artistic education. Beginning with Valenciennes, the oil studies each landscape master had painted in his youth became a familiar presence in his studio, like the plaster casts of ancient sculpture in the studio of a history painter. Valenciennes used his Italian studies as a teaching tool, displaying them as models for his students.[115] Such a display appears in the background of a painting of 1831 describing the studio of the history painter Léon Cogniet (1794–1880), who had sketched outdoors in Italy around 1820 (pl. 73).

Upon the painter's death the studies came as a group before the public eye, if only briefly, at the posthumous sale of his works. Vernet's studies had appeared in this way in 1790, as did Valenciennes's in 1819 and Michallon's in 1822.[116] At least occasionally open-air studies were purchased at such sales by other artists and thus were recycled into the studio system.[117] Louis-François Bertin, father of Corot's companion in Italy, François-Edouard Bertin (1797–1837), reported to the painter Fabre on Michallon's posthumous sale:

> Did you know that the property of the unfortunate Michallon was sold for more than sixty thousand francs! Girodet payed four hundred francs for a little study for which we would not have offered twenty francs the day we visited the studio. *Long live the dead!*[118]

Although Bertin expressed surprise at the prices, he did not fail to bid three years later at the sale of Girodet's studio, which included a group of oil studies by Valenciennes, now in the Louvre.[119] Bertin reported to Fabre that he had bought, in addition to several drawings by Girodet, some *croquis* (i.e., probably pencil sketches rather than oil studies) by Valenciennes and Michallon.[120]

The growing importance of the oil study in formal landscape instruction is suggested by the documents of the French Academy at Rome, where winners of the new landscape prize were required to submit studies in oil for criticism. In October 1823 Jean-Charles-Joseph Rémond (1795–1875), who had won the prize in 1821, read the following criticism of his *Study after nature at Amalfi*: "One could say of this imitation [of nature] that is is more finished than a sketch [*esquisse*], less finished than an exhibition picture [*tableau*], but above all less true than a study [*étude*] painted after nature."[121] In other words, the oil study had become so much a part of academic practice that aesthetic criteria peculiar to its function had been established. Much of the discussion turned on the issue of whether the *étude* should be executed rapidly or finished with care. In his treatise Valenciennes had stated that studies after nature should be "*maquettes* made in haste, so as to seize Nature as she is."[122] This statement may have been calculated in opposition to

the highly finished manner of Hackert and Bidauld. Bidauld's studies are generally far more finished than those of Valenciennes, as the British painter Andrew Robertson noted when he visited Bidauld's studio in 1815:

> his studies from nature, in oil – finished on the spot, are delightful altho' not well chosen – the most minute parts copied exactly – these are really excellent. . . . he showed me one picture painted on the spot, about 2 and a half by 2 feet – a cascade in Italy in a deep glen – beautiful indeed, which he had sold for 200 louis – very minutely finished.[123]

Indeed, Bidauld was so concerned with finish in his studies that his student Jules-Romain Joyant (1803–1854) was haunted by the issue throughout his first trip to Italy, in 1829–30. In April 1830, after sending his studies to Bidauld and hearing a report of the master's response, Joyant wrote from Florence:

> I knew almost ahead of time the judgment that M. Bidauld would deliver on my studies. Not being finished like Flemish pictures, they could not please him. I regret that he is unwilling to help me with his advice until I submit to him less casual studies. Since the genre that I have adopted permits me to take only rapid sketches [*esquisses*], I despair that I will never be able to show him anything as finished as he desires.[124]

Bidauld's side of the dispute found vigorous support in Lecarpentier's treatise on landscape, published in 1817:

> The landscapist must put great order and care into his studies, and not accustom himself, from the outset of his pictorial career, to make nothing but slight sketches [*légers croquis*] or simple outlines [*aperçus*] of the objects of which he ought to conserve the most faithful memory. . . .
> If such studies made in haste and on the run, so to speak, soon fill up an artist's portfolio, they will later cause extreme inconvenience, leaving the artist only feeble recollections.[125]

In what amounts to a flat contradiction of Valenciennes's treatise Corot wrote in one of his Italian sketchbooks that "one must be rigorous in the face of nature and not content oneself with a sketch [*croquis*] made in haste."[126] Chapter IV will explore the implications of this view for Corot's work in Italy. Here the dispute over finish is raised only as evidence that the oil study enjoyed a growing role in artistic practice and critical discourse in the period of Corot's education.

Further evidence is to be found in the Salon and in the criticism.[127] Because the Salon was the major forum for painting, one may ask whether the regular appearance of *études* at the exhibition implies that they were intended as autonomous works of art. The question must be judged against the vast expansion of the Salon after 1791. Even a casual review of the catalogues shows that the great swell of works was due not only to an increase in the number of exhibiting artists but also to a far more liberal criterion of selection of works. Numerically the huge Salons of the 1810s and 1820s were dominated by minor works. Although critics sometimes complained that the lesser works were swamping the major paintings,[128] they continued to concentrate their attention on the latter. Thus it would be absurd to compare Delorieux's *Insects lithographed and colored after nature* (no. 311) with Géricault's *Scene of shipwreck* (no. 510), although both were shown at the Salon of 1819.

The appearance of *études d'après nature* at the Salon was part of the trend to include minor forms. Invariably the catalogue listed a single landscape painter's entries in descending order from *paysage historique* to *vue* to *étude*, registering a

hierarchy of importance. Beyond this the catalogue frequently spelled out the specific function of the study in descriptions of more ambitious works. Thus two of Bidauld's entries to the Salon of 1817 were recorded as follows:

> 73 – Landscape composed after studies made on Lago Maggiore. (Picture destined to decorate the Palais de Trianon.)
> 74 – Landscape whose composition recalls the valley of Ronciglione. It is composed after studies made in the environs of the town of that name, which is on the way to Florence [from Rome].

The Salon brought the study from the professional milieu of the studio into public view. It is clear, however, that this transposition only confirmed the traditional function of the study, as Valenciennes had outlined it in his treatise. Landon, the best guide to the conventional wisdom, regarded the study as an essential aspect of the landscape painter's *métier*. The following remarks, on a work by Bertin at the Salon of 1819, make clear the relationship between the *étude* and the painter's ultimate goal: the *tableau*.

> An examination of this picture seems to confirm a point we have made before. Landscape painters who wish to enrich or merely to conserve their talent need to keep enlarging without interruption the stock of studies that constitutes their principal resource. This landscape, which deserves nothing but praise for its composition, for the disposition of masses, and the elegance of the trees, leaves much to be desired in respect to the color scheme and the accuracy of the details.[129]

The mythology of Impressionism teaches that painting from nature was a radical step, consciously opposed to the threadbare methods of the academic studios. In the period of Corot's education precisely the opposite was the case. Drawing and painting from nature was not a challenge to traditional values but an integral part of the academic system of instruction and practice. Indeed, painting from nature first took hold not among the so-called independent naturalists such as Georges Michel, but in the conservative, Neoclassical studios.

Thus Corot's artistic inheritance was twofold. First, he learned that landscape painting was a vehicle of the highest ambitions for art, a genre that in both moral and aesthetic terms held a noble place in the grand tradition of painting. Second, he absorbed a structured program of work, in which direct study of nature was integrated with study of older art, each contributing through a process of synthesis to the realization of imaginative compositions.

<p style="text-align:center">* * *</p>

Robaut assigned some forty oil studies to Corot's student years of 1822–25.[130] There are also a few finished drawings and several small albums filled with pencil sketches.[131] Like Valenciennes and Michallon, Corot generally painted his studies on paper, although on occasion he used also canvas, cardboard, and wood. For the most part the works are small and horizontal in format, a little more or less than a foot high and somewhat less than two feet wide. Corot presumably carried a portable painting box similar to the one shown in use in one of his earliest studies (pl. 74). The open lid served as an easel.

Corot learned the techniques of outdoor painting from Michallon, whom he accompanied into the field.[132] He also copied Michallon's drawings[133] and at least one oil study.[134] There was nothing elaborate or fussy about the method; a

74. Corot. *Painter at work in the Forest of Fontainebleau,* 1822–25. (RS1.1.) Oil on paper, mounted on canvas, 29 × 41. Private collection.

minimum of underpaint prepared a scaffold for fresh color, mixed on the palette. As Corot himself wrote in an early sketchbook, he sought to "ébaucher le plus près du ton possible,"[135] that is, to establish the determining tonal scheme at the outset. Increasingly his goal would be to achieve a direct color match for each area, laying down a viscous mark whose form he could rework but whose hue he hoped not to change. It was a compact, deliberate method, which Germain Bazin has compared to Chardin's.[136] All of Corot's studies reflect a concentrated effort to describe rather than to show his skill; it is a frank, workmanlike art. Lawrence Gowing has written: "The brush deposits its message without the slightest display of deftness or bravura. Rather, with its adhesive burden, it stumbles a little, minutely hesitant or precipitate."[137] Whatever the differences among their styles of outdoor painting, Valenciennes, Bidauld, and Michallon all had shown little interest in the sketchy stroke for its own sake; in this as in other respects Corot followed his masters.

A few of Corot's early studies – tree trunks, a gate, simple vistas – derive from the old academic tradition of isolating components of the landscape (e.g., pl. 75). A few other studies, made in Paris, repeat familiar city views that Corot knew from paintings and countless prints (pl. 76). In several studies of each type a taste

69

75. Corot. *Tree trunk in the Forest of Fontainebleau,* October 1822. (R.5.) Oil on paper, 24 × 32. New York, Salander-O'Reilly Galleries.

for planar symmetry suggests Corot's classical bent. And often these student exercises contain hints of his talent for discovering subtle correspondences of design within the most ordinary motif (e.g., pl. 77). Nevertheless, the early French studies are tentative and immature in comparison with the Italian landscapes, some of them made only a year later. Also striking is the contrast between the diversity of Corot's work in France before 1825 and the seamless coherence of his outdoor campaign in Italy. Such a rapid advance reflects the strength of Corot's talent, but it also owed a great deal to his departure from an environment where open-air painting was still an embryonic experiment for one that enjoyed a full-blown tradition.

Between the 1780s and the 1820s French artists had contributed prodigiously to the Italian tradition, yet at home their pursuit of outdoor painting had been fitful at best. Upon returning to France from Italy, for example, Valenciennes (pl. 78) and Bidauld had continued painting from nature, but far less intensely; Valenciennes appears to have given it up altogether after about a year.[138] In

76. Corot. *The old Pont Saint-Michel, Paris*, 1823–24. (R.15.) Oil on paper, mounted on canvas, 25 × 30. Paris, private collection.

77. Corot. *Carrières Saint-Denis*, 1823–24. (R.39.) Oil, 18 × 29. Unlocated.

78. Pierre-Henri de Valenciennes. *Tidal estuary, Brittany*, after 1784. Oil on paper, mounted on canvas, 30.5 × 48.5. Karlsruhe, Staatliche Kunsthalle.

the Neoclassical studios it was understood that open-air painting would be practiced mainly in Italy, which offered the only proper model for students. Deperthes expressed this understanding in his history: "All those landscape painters whose works carry an impression of grandeur or elevation nurtured their talents under the beautiful sky of Italy."[139]

Admiration for Italy entailed indifference or even disdain toward the landscape of France. As Quatremère de Quincy put it in 1791, the student of landscape painting would not be able to find "in the locales of our country, in its shapes and forms, the grand models that he needs."[140] There are signs that the authority of Italy was weakening, but they are rare before 1830. In 1821 an anonymous pamphleteer ridiculed the recently established prize for *paysage historique*. Claiming that nothing new could be found in Italy, the author proposed that young painters be encouraged instead to study the native landscape.[141] In 1822 the critic Delécluze made a similar suggestion.[142] After 1830 this view began to triumph as young landscape painters stopped going to Italy. Except for Charles-François Daubigny (1817–1878), Corot was the last important French landscape painter to travel to Rome as a student.

Beginning with Valenciennes in the 1790s, the French Neoclassical studios taught the theory and technique of painting from nature, but for at least a generation this training remained focused on Italy rather than France. Nor could France boast a rich tradition of view making such as existed in Italy; the great outpouring of *voyages pittoresques* began only in the 1820s. In the absence of

an established consensus of where to go and what to paint, the abstract invocation to study nature was of little practical use to young painters in France.

Their first, exploratory steps are difficult to trace because so few works have survived. We know a few *études* by Paul Huet (1803–1869) from the early 1820s[143] (pl. 80), a somewhat larger body of outdoor studies by Richard Parkes Bonington (1802–1828) (pl. 79),[144] and isolated works by other painters (pl. 81). But these works do not represent an established resource upon which Corot could rely. Rather, they represent the initial stages of a new development, in which Corot himself was a leading participant.

The Salon catalogues provide some rudimentary evidence about this early period, since they often name the sites of outdoor studies that were exhibited.

79. Richard Parkes Bonington. *In the Forest of Fontainebleau,* *c.*1824. Oil on cardboard, 32.5 × 24. New Haven, Yale Center for British Art. Paul Mellon Collection.

Before 1820 Italian subjects dominated, but as French subjects began to proliferate, the popularity of certain areas emerged: the Auvergne, the Channel Coast, and, nearer Paris, Sèvres, Saint-Cloud, and the Forest of Fontainebleau.[145]

Of these locales, only Sèvres and Saint-Cloud enjoyed an established pictorial tradition. As early as the 1760s Louis-Gabriel Moreau (1739–1805), called Moreau the Elder, had begun to produce, in addition to conventional rococo fantasies, panoramic views of sites in the environs of Paris (pl. 82).[146] Although indebted to Joseph Vernet, Moreau's work in this vein is less self-consciously elegant, more fully devoted to the modest pleasures of the view. By the early decades of the nineteenth century this type of picture appeared frequently at the Salon. Among the leading practitioners were artists attached to the Sèvres porcelain factory, such as Jean-Baptiste-Gabriel Langlacé (1786–1864) and Jean-François Robert (1778–1832), who often painted the hills overlooking the Seine southwest of Paris (pl. 83). Dunouÿ and other leading Neoclassicists also contributed to this minor tradition, which lies behind several of Corot's earliest outdoor paintings (pl. 84). Although Corot replaced the crystalline details and

80. Paul Huet. *The Côte de Grace, near Honfleur*, c.1823. Oil on wood, 19 × 35.5. Bremen, private collection.

81. Léopold Le Prince. *Meadow at Thorigny (Sarthe)*, early 1820s. Oil on cardboard, 22.5 × 40. Paris, private collection.

82. Louis-Gabriel Moreau, the elder. *View of the château de Vincennes from Montreuil*, c.1770. Oil on canvas, 47 × 86. Paris, Louvre.

pale tints of convention with the matter-of-fact technique of the oil study, it is not difficult to recognize the familiar scenic format.

For Corot, Huet, and Rousseau, the views of the little masters of Sèvres and Saint-Cloud offered one of the few native models of landscape realism. These bright, unselfconscious pictures, obviously based on a love of the place and a certain minimum of careful observation, testify at least to a popular taste for local views. Nevertheless, the works invariably conform to a modest convention: a broad panorama from a height, painted in delicate tones on a small format. Although this convention offered a refreshing exception to the elaborate cuisine of the studios, it was too limited to have served as the basis of modern landscape painting in France.

The absence of established pictorial models for specific places is exemplified by the case of the Forest of Fontainebleau, where Corot as a student often worked. Even before Fontainebleau had been developed as a royal residence in the sixteenth century the forest had been known as a splendid hunting ground.[147] The nineteenth-century artists who went there did so for the same reason that the hunters always had: it was a large domain of rugged, untamed nature, close to Paris. By 1840 the forest was filled with painters and the tourists who followed them; there were guidebooks, paths and signposts, and suites of prints.[148] In 1820, however, this process of cultural appropriation had barely begun. Etienne Pivert de Senancour's *Oberman* (1804), a novel of melancholy withdrawal from civilization inspired by Jean-Jacques Rousseau and set in the forest, is an important early work of French Romantic literature, but it had no significant parallel in visual art for at least two decades. A detailed study of prints representing

the forest has shown that only a handful were published before the late 1820s.[149] In short, Corot's studies of the early 1820s represent one of the first extended artistic campaigns in the forest.

Since Corot lacked an established model, it is not surprising that his early Fontainebleau studies fail to form a coherent pattern; it is as if each work were a new beginning. Most of the studies are restricted in scope and scale, suggesting a tentative search for order among the sprawling chaos of rocks and trees (pl. 85). A few years later, in Italy, Corot progressed far beyond this early essay,

83. Jean-Baptiste Langlacé. *The Plain of Saint-Denis*, *c*.1825. Oil. Sceaux, Musée de l'Ile-de-France.

84. Corot. *View near Sèvres*, 1822–25. (R.23.) Oil, 23 × 31. Unlocated.

85. Corot. *In the Forest of Fontainebleau*, 1822–25. (R.31.) Oil on canvas, 21.2 × 29.2. Bristol, City of Bristol Museum and Art Gallery.

achieving in study after study a powerfully ordered pictorial structure and a striking unity of atmosphere and light.

If at Fontainebleau Corot was treading on uncharted territory, most of the outdoor work of his student years in France naturally relied on the few models readily available to him. A review of Corot's early work thus underscores the shallow resources of naturalism in France before 1825. Consider, for example, his *Entrance to the Park of Saint-Cloud*, which repeats a motif of his teacher Bertin (pls. 86, 87). Not only the subject but also the neat, simplified style derives directly from Bertin, who produced a number of comparable works. In fact Bertin's total oeuvre may be described as a continuum, from large Poussinesque canvases with antique themes to small, unpretentious views reminiscent of the Dutch little masters of the seventeenth century. Bertin's modest landscapes belong to a whole class of contemporary village and country scenes (pl. 88), whose precise details, uncomplicated compositions, and crisp atmosphere recall the pictures of Karel Dujardin and Jan van der Heyden. Just as Bertin's ambitious Neoclassical works provided a model for Corot's first essays in composition

86. Corot. *Entrance to the Park of Saint-Cloud*, 1822–23. (R.14.) Oil on canvas, 21.5 × 38. Paris, private collection.

87. Jean-Victor Bertin. *Entrance to the Park of Saint-Cloud*, c.1810. Oil on canvas, 32 × 22.5. Boulogne-Billancourt, Bibliothèque Paul Marmottan.

(pl. 63), these unpretentious scenes provided a point of departure for Corot's early work from nature.

Another case in point is Corot's study of the village of Chaville near his family's country house in Ville d'Avray, one of the most accomplished of the artist's earliest works (pl. 89). Doubtless working from nature, Corot replaced the polished details and smooth transitions of the popular style with the frank brushwork of the oil-study technique. Nevertheless, the whole conception of the motif – a modest image of healthy trees and plain houses – is derived from an established formula. An example is a lithograph of 1823 by Bertin, from a series published (like Bertin's earlier studies of trees) as models for students (pl. 90).

88. Louis-Auguste Gérard. *Landscape with a bridge*, c.1820. Oil on canvas, 24.5 × 34. Cambridge, Fitzwilliam Museum.

89. Corot. *Le Petit Chaville*, 1823–25. (R.16.) Oil, 24 × 33. Oxford, Ashmolean Museum.

90. Jean-Victor Bertin. Untitled lithograph, 1823. Paris, Bibliothèque Nationale.

91. Constant Bourgeois. Lithograph from *Receuil d'études de paysage*, c.1822. Paris, Bibliothèque Nationale.

92. Corot. *Mill*, 1822–25. (From sketchbook R.3006.) Pencil on paper, 9 × 14. Courtesy Galerie Schmit, Paris.

93. Corot. *Mill*, 1822–25. (R.218.) Oil, 24 × 33. Unlocated.

Around 1820 there appeared dozens of similar albums of lithographic studies, intended for consultation in the studio and as guides to sketching from nature. Invariably the "studies" were not in fact studies after nature but highly artificial renditions of Dutch landscape motifs: mills and thatched cottages, country roads, farm courtyards, and the like. Corot copied details of plants and trees from these albums, and he based many of his early nature studies on them as well. Typical of the genre is Constant Bourgeois's lithograph of a country mill, a subject familiar in eighteenth-century French art, but here presented in a plain, unembellished style that recalls Dutch art of the seventeenth century (pl. 91). In a pencil sketch (pl. 92), then in a oil study (pl. 93), Corot repeated the formula. Characteristically the oil study presents a much narrower fragment of the scene, excluding problems of spatial complexity, but this hardly masks the origin of the motif.

The prevailing theory of landscape identified the Southern tradition with lofty ideals and the Northern tradition with humble reality. Thus it is not surprising that Northern motifs, however enfeebled, circulated in the Neoclassical studios as models for sketching from nature. Nor is it unusual that Corot, on his early campaigns in the field, sought out subjects similar to those he already knew from the instruction albums. Corot's early work from nature in France – both before and after his first trip to Italy – may be described as a struggle to step beyond the degraded imagery that passed for naturalism in the studios of his youth, toward a richer art based on empirical study of the native landscape. Of course Corot was not alone in making this effort, which by 1831 had acquired enough momentum to be designated a school. In the early 1820s, however, the momentum was just beginning to gather and had not yet yielded fresh models that could command Corot's attention and direct his work.

It is possible that Corot learned something from examples of the far more advanced English naturalism, of which a number (including Constable's *Haywain*) were exhibited in Paris in the early 1820s.[150] But Corot's response to Constable is not clear until after his return from Italy;[151] nothing in his work before 1825 requires the explanation of a foreign influence. On the contrary, the surviving studies derive from readily available French sources: the sweet panoramas of the Sèvres painters; the small, unpretentious views of Bertin and others; and the homogenized rustic imagery of the lithographic instruction albums. To each of these models Corot brought a powerful native talent and the lessons of the Neoclassical oil study: a forthright fidelity to concrete visual experience, a fresh palette, and a simple technique of painting. What was missing in France was a resource of accumulated experience in confronting the native landscape itself.

*　　*　　*

Corot first exhibited at the Salon in 1827. Until then, certainly for the three years before he left for Italy in 1825, he considered himself and was considered by others to be a student. While his earliest outdoor essays in France suggest a new vigor of empirical naturalism, it is important to remember that these were student exercises. The character of Corot's early professional outlook is better represented by his Salon pictures and other full-scale works. Through the 1830s and into the 1840s these works extended and enriched the outlook of the previous generation but did not overthrow it. In scale and conception Corot's *Hagar in the Wilderness*, exhibited at the Salon of 1835, embodies the grand ambitions of his masters (pl. 94). That it also illustrates perfectly the academic function of the

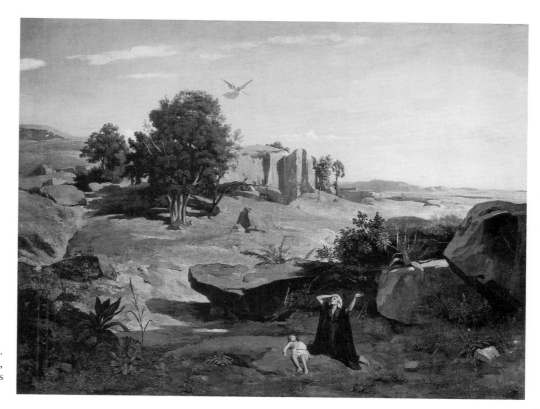

94. Corot. *Hagar in the Wilderness*, Salon of 1835. (R.362.) Oil on canvas, 180.3 × 270.5. New York, The Metropolitan Museum of Art. Purchase, Rogers Fund, 1938.

95. Corot. *Fontainebleau: Oak trees at Bas-Bréau*, 1830–34. (R.278.) Oil on paper, mounted on wood, 39.7 × 49.5. New York, The Metropolitan Museum of Art. Wolfe Fund, 1979, Catharine Lorillard Wolfe Collection.

study after nature further confirms Corot's attachment to the lessons he had been taught (pl. 95).

If Corot was more talented than his masters, if he brought new vitality and range to the Neoclassical legacy, if he looked to the North as well as to the South, he nevertheless embraced the idiom of the *Méridionaux* and the *Septentrionaux* as the vessel of the grand tradition. Eventually, through a complex process that is beyond the scope of this study, he transformed his inheritance into a new tradition. But Corot will be robbed of that achievement if he is cast as a maverick who rejected at the outset the moribund pedantry of his masters. Above all, such an image of the young Corot will misconstrue the zeal with which he seized the opportunity that awaited him in Italy, an opportunity that had been created by the Neoclassical aesthetic.

Corot's allegiance to the ideals of Valenciennes's school is expressed most clearly by his decision to complete his education in Italy: "That classic ground, where every site recalls an event and every monument awakes a memory, inspires the painter of history and of landscape in a way entirely different from other countries."[152] Corot did not compete for the new *prix de Rome* for landscape, but he had no need to, since his parents would pay for the journey. His prodigious talent had been shaped by the studios of Paris; in Rome he sought an environment that would nurture his art in a way that Paris could not. That is precisely what he found.

III "MAGICK LAND"

> We then continued Our route through Marino, where there happened to be a fair, and skirting the Lake of *Albano*, passed through *Castello Gondolfo*, *L'arici* and arrived at *Gensano* in the Evening— This walk considered with respect to its classick locality, the Awful marks of the most tremendous Convulsions of nature in the remotest Ages, the antient and modern Specimens of Art, and the various extensive & delightful prospects it commands is, to the Scholar, naturalist, Antiquarian and Artist, without doubt, the most pleasing and interesting in the Whole World—And here I can not help observing with what new and uncommon Sensations I was filled on my first traversing this beautiful and picturesque Country—Every scene seemed anticipated in some dream—It appeared Magick Land—In fact I had copied so many studies of that great Man, & my Old Master, Richard Wilson, which he had made here as in Other parts of Italy, that I insensibly became familiarized with Italian Scenes, and enamoured of Italian forms.
>
> *Thomas Jones, "Memoirs," 13 December 1776*[1]

IT IS DIFFICULT NOW to imagine a condition of culture in which the Stour valley was not yet Constable Country, in which Corot and Monet had not yet left their stamp on the Ile-de-France, or van Gogh and Cézanne, on Provence. These are only the most celebrated of many examples. Today we inevitably approach the landscape – almost any landscape – through a rich and tenacious cultural image. Before 1800 in the Western world this was so only for the Netherlands and Italy. Northern artists who traveled to Italy thus entered a special environment when they crossed the Alps.

The story begins with the Latin poets, especially Virgil and Horace, whose works already contain the fluid associations of history and myth, real landscapes and abstract ideals, that permeate the image of Italy. The present inquiry, however, is concerned with modern writers and artists, whose outlook was different, partly because they had Virgil and Horace on their minds. The modern image of Italy was created by foreigners, for whom the country was not a birthright but a goal. At any given spot, especially in Rome, the traveler welcomed a flood of historical and literary associations. The former inevitably concerned Rome's fall from greatness, a theme already present in a twelfth-century poem by Hildebert of Lavardin: "Rome, without compare, though all but shattered; Your very ruins tell of greatness once enjoyed."[2] Six centuries later Edward Gibbon recorded the intensity with which the actual place recalled the events of history:

> After a sleepless night, I trod with a lofty step the ruins of the Forum; each memorable spot where Romulus *stood*, or Tully spoke, or Cesar fell, was at once present to my eye; and several days of intoxication were lost or enjoyed before I could descend to a cool and minute investigation.[3]

This experience was not limited to the Forum and Rome for, as Joseph Addison wrote in 1705, "There is scarce any part of the Nation that is not Famous in

History, nor so much as a Mountain or River that has not been the Scene of some extraordinary Action."[4] Addison continued:

> before I entered on my Voyage I took care to refresh my Memory among the *Classic* Authors, and to make such Collections out of them as I might afterwards have occasion for. I must confess that it was not one of the least Entertainments that I met with in Travelling, to examine these several Descriptions, as it were, upon the Spot, and to compare the Natural Face of the country with the Landskips that the Poets have given us of it.[5]

In 1786 Goethe made just such a comparison at Lake Garda, where he had paused on his way south toward Rome, and where later Michallon and Corot would stop to paint.[6] In a letter Goethe quoted a line from the *Georgics* in which Virgil described the wind-blown lake. He added, "This is the first line of Latin verse the subject of which I have seen with my own eyes. . . . So much has changed but the wind still churns up the Lake which a line of Virgil's has ennobled to this day."[7] Some thirty years later, to mark *his* first encounter with the classic ground, J.M.W. Turner drew a rapid sketch, probably from the window of the coach carrying him to Rome, and labeled it, "The first bit of Claude."[8]

Goethe had not remembered Virgil's line spontaneously; he had looked it up in his guidebook, a German version of a French work that Valenciennes recommended in his treatise of 1800.[9] The guidebooks and the more discursive "journals" and "letters" (such as Goethe's own *Italian Journey*) are highly relevant here, because they helped shape the modern experience of Italy.[10] Reaching back to the sixth century, the guidebook tradition always focused on Rome, the center of religious power and of ancient culture. In the seventeenth and eighteenth centuries, serving an increasing number of travelers, the guidebooks matured as a literary form. They expanded geographically, giving ever-greater attention to subjects along the route to Rome and to other centers of art and power, such as Naples. The scope of reference also expanded to include medieval and modern culture and history. By the eighteenth century the guidebooks presented Rome and Italy as a historical continuum; for Goethe and his contemporaries the antique, the Renaissance, and the modern all were part of a continuous fabric.[11] Nevertheless, ancient history and culture still held a place of special importance.

The structure of the guidebooks may be described as a grid. Horizontally, they established an itinerary, a sequence of cities and sights, usually along the road to and from Rome. Vertically, they recorded the role of each place in history and art.

The itinerary exchanged the seamless geography of Italy for a blank map dotted with points of interest. There was a list of cities and towns and within each a list of famous monuments and views. These were ordered without respect to the chronology of history or to a hierarchy of cultural value, but rather serially, according to the route. Followed repeatedly over a period of centuries, the itinerary acquired a canonical status, creating a picture of Italy as a sequence of great places.

For each town, monument, or view, the guidebooks provided a totem of historical significance, beginning with the mythical exploits of Aeneas, proceeding through citations of ancient history and poetry, and concluding with quotations from modern visitors, such as Montaigne or the Président de Brosses.[12] This pedigree of layer upon layer of historical, artistic, and literary associations established the authority of each spot on the itinerary.

With the maturity of the tradition of the travel narrative, especially around 1800, came an increasingly personal and discursive style. Writers such as Goethe, Chateaubriand,[13] and Stendhal[14] indulged frequently in personal and philosophical reflections and amusing anecdotes. Nevertheless, the outline and motifs of the guidebook persisted, shaping both the pattern and the meaning of these otherwise idiosyncratic accounts.

This is true also for a new class of works appearing in the early nineteenth century, in which literary ambition finally overshadowed factual content.[15] In psychological novels, such as Madame de Staël's *Corinne* (1807),[16] or epic poems, such as Lord Byron's *Childe Harold's Pilgrimage* (1812–18),[17] the motifs and even the morals often were drawn directly from the tradition of the travel narrative. Thus Byron, describing Mount Soracte in his poem, contrived to refer to Horace's description of the same mountain in a line from the *Odes*.[18] Such a reference, mimicking the dutiful scholarship of the guidebooks and perhaps even borrowed from one,[19] sheds light on Corot's outlook in 1826 and 1827, when he drew and painted a whole series of views of the same mountain, near Civita Castellana on the route north of Rome (pls. 228–31). Even if Corot neither knew Byron's poem nor remembered Horace's line, he was inspired and directed in his work by the cultural aura that had accrued to Soracte through the centuries of ritual repetition.

This literary tradition was only part of Corot's cultural preparation for Italy. Concomitant with the guidebook tradition, with its dense accumulation of historical and literary references, there had grown up a tradition of view making. The history of the Italian *veduta* begins in the sixteenth century and first crystallized into convention in the work of Gaspar van Wittel (1652/53–1736), called Vanvitelli.[20] Here again the present inquiry is concerned less with the origins of the tradition than with the mature form in which Corot and his contemporaries received it.[21]

The *veduta* is an exact visual counterpart of the guidebook. Parallel to the itinerary is the repertory of *vedute*, a standard series of views, each representing a famous place. For each site the artists – painters, draftsmen, printmakers – gradually established the best vantage point, from which the important monuments could be seen most clearly. Often they chose a viewpoint that juxtaposed ancient ruins and modern buildings, invoking the living past of Italy in a visual equivalent of the historical pedigree provided by the guidebooks.

Through repetition, the favored viewpoint – and the corresponding pictorial design – achieved an iconic status. Indeed, repetition was an essential aspect of the *veduta* form. The major views of the repertory crowded out alternatives, so that each place and its history became identified with a single image or a limited few. Thus like the guidebooks, the *vedute* discouraged exploration, focusing the visitor's attention on a predetermined sequence of isolated highlights.[22] Giovanni Paolo Pannini's imaginary gallery, *Ancient Rome* (pl. 96), is much grander than today's picture-postcard displays, but in function it differs not at all.

Aspects of the *veduta* repertory may be found in casual pencil sketches and in monumental *tableaux*, painted for the gentlemen of the Grand Tour, but the mainstream of the tradition was handed down through prints. The prints in turn ranged from large, elaborate productions to tiny engravings made as illustrations to the guidebooks. By the mid-eighteenth century the guidebook itinerary and the *veduta* repertory – already parallel in structure – had begun to merge into a single form, notably in the work of Guiseppe Vasi (1710–1782), Piranesi's teacher. Vasi's *Itinerario istruttivo* (1763), a guide to Rome, was written to accompany his series of 250 *vedute*, the *Magnificenze di Roma Antica e Moderna*

(1747–61).[23] Soon text and image began to appear under the same cover in ever-cheaper, more popular books.[24] This format, like other aspects of the tradition, had originated at Rome, but eventually it was applied to Italy at large.

The way in which the itinerary-cum-repertory prepared and organized the visual artist's experience of Italy is suggested in a notebook devised by Turner on the eve of his first trip to Italy in 1819.[25] He labeled it "Foreign Hint" and divided each of six pages into a dozen equal rectangles, filling them with rapid pen-and-ink copies from a series of topographical prints (pl. 97). Read from left to right and top to bottom, these little sketches spelled out the coming journey. The page illustrated here followed the route south toward Rome: Perugia, Assisi, Spoleto, the valley of Terni, the Cascade of Terni, the lake of Piediluco, the Augustan bridge at Narni, the medieval bridge at Civita Castellana, and "Rome" – a view of St. Peter's from the north. Following the same route just a few years later, Corot repeated many of the same views.[26]

The early history of the *veduta* concerns the emergence of topographical accuracy from the convention of imaginary views. The growing taste for reliable descriptions – for the *veduta esatta* as opposed to the *capriccio* or *veduta ideata* – was due partly to the influence of Northern artists such as Paul Bril and Vanvitelli.[27] The latter's views are the epitome of careful documentation: bright, airless panoramas filled with precise detail (pl. 98).

After Vanvitelli the *veduta* required a certain minimum of reliable detail, but there remained considerable room for personal inflection or aesthetic embellishment. Just as the travel narrative blossomed into a rich literary genre, the *veduta* tradition spawned a wide range of artistic interpretation. The most celebrated example of this phenomenon – Piranesi's melancholy *Vedute di Roma* – is an exception to the general trend, in which artists embedded topographical details in the harmonious imagery of heroic or pastoral landscape painting.

Many of the standard *vedute* incorporated simplified versions of the grand schemes of ideal landscape painting. An example is the famous view of St. Peter's and the Castel Sant'Angelo, seen across the Tiber (pl. 99). The first versions occurred in the sixteenth century, even before the dome of St. Peter's had been completed.[28] As the view matured it acquired the typical embellishments of classical landscape composition (pl. 100). Thus by the time Corot painted his own version in the 1820s, the view had become both an icon of historical topography *and* a venerable formula of classical design.

Outside Rome topography and art, real and ideal, were all the more thoroughly intermixed. The classical landscapes of Gaspard and Claude, to a lesser extent of Poussin, had been drawn from the painters' experience of the countryside near Rome. In certain cases their ideal landscapes are refined views of topographical motifs (pl. 101). But even the purely imaginary pictures of Gaspard and Claude evoke the light and character of the Roman countryside, and they established the way in which the place itself was viewed.

The artistic image of Italy that Corot and his contemporaries inherited should be understood as a continuum. At one pole is the repertory of *vedute*: highly standardized views of particular places, often molded by the rhythms and compositional habits of classical landscape. At the other pole is classical landscape itself: the artificial imagery of Claude and Gaspard, which evokes the real landscape near Rome. The richness of this continuum often led artists and other visitors to identify the landscape before their eyes with the ideal inventions of art. Goethe savored the correspondence between the sight of Lake Garda and Virgil's poetic description, but he stopped short of characterizing the poet as a realist. At Horace's Villa the painter Allan Ramsay did just that:

there are many rural images in Horace's work which seem to ordinary readers to have been drawn from the general face of Nature but which upon

98. Vanvitelli. *Tivoli*, c.1700. Oil on canvas, 35.7 × 46.4. Baltimore, Walters Art Gallery.

99. Vanvitelli. *St. Peter's and the Castel Sant'Angelo*, 1682. Tempera on vellum, 23 × 43. Rome, Museo dei Conservatori.

100. Jonathan Skelton. *St. Peter's and the Castel Sant'Angelo*, 1758. Watercolor, 36.8 × 53. London, Victoria and Albert Museum.

closer examination will be found to be only studies, as the landskip painters call them, taken from his own estate.[29]

Such a claim might seem easier to make for poetry than for painting, but foreign visitors in Italy saw what the painters had taught them to expect to see. In 1758 Jonathan Skelton wrote from Tivoli:

> This antient city of Tivole I plainly see has been the only school where our two most celebrated Landscape Painters Claude and Gasper studied. They have both taken their Manners of Painting from hence. I see at the same time that one side of this place, from the very spacious even top of a high Mountain one may behold many of those most pleasing Compositions of Claude Lorrain in the Campagnia of Rome . . . [on] the other side you would be surprized with the most noble Romantic wildness of Gasper Poussin.[30]

The same attitude permeates Chateaubriand's rich descriptions of the landscape near Rome:

A singularly harmonious tint marries earth, sky, and water: thanks to an imperceptible graduation of color, each surface merges at its edges with others, so that one is unable to determine the point at which one nuance ends and the next begins. Doubtless you have admired in the landscapes of Claude Lorrain that light that seems ideal and more beautiful than nature? Well, it is the light of Rome![31]

The visual counterpart of this topos is readily illustrated in the works of Richard Wilson and Philipp Hackert. Wilson emulated the poetic art of Claude but often introduced recognizable landmarks into his pictures, blurring the distinction between high art and topography (pl. 102).[32] Hackert, fundamentally a topographer, presented his views with the artificial trappings of ideal landscape painting (pl. 103).[33]

The continuity between the *veduta* tradition, with its rich historical associations, and the imagery of classical landscape, with its evocations of Latin poetry, gave a special status to the Roman countryside not shared by any other stretch of land in the world. For Corot and his contemporaries, the tiniest corner of the countryside itself possessed dignity and importance, even where it boasted no specific link with ancient history or poetry. Often the attitude was articulated in aesthetic terms, as in Valenciennes's treatise:

101. Gaspard Dughet. *Tivoli*, late 1650s. Oil on canvas, 76 × 126. Oxford, Ashmolean Museum.

102. Richard Wilson. *Rome: St. Peter's and the Vatican from the Janiculum*, 1753–54. Oil on canvas, 100.3 × 139. London, Tate Gallery.

103. Jacob Philipp Hackert. *The Park at Ariccia*, 1804. Oil on canvas, 64 × 96. Montpellier, Musée Fabre.

The warmth of the climate of Rome endows all the vegetation with a character of vigor that one does not find in Northern countries; the earth has a warmer color, the rocks stand out forcefully, the greens there are darker and more varied, the skies, bluer, and the clouds, more colorful: thus landscapes made by Italian painters or by foreigners in Italy have pre-eminence over all others.[34]

This admiration for the landscape of Italy encompassed the humble, vernacular buildings of Rome and the hill towns. In a typical passage Valenciennes

described these structures as *fabriques charmantes* "which always group themselves with nobility."[35] A generation later, at the same time that Corot was working in Rome, Stendhal echoed the sentiment: "At Rome often a simple *shack* is monumental."[36]

Thus the aura of history and poetry, attached by a long tradition to famous monuments and sites, had expanded to embrace every aspect of Rome and her environs. This blanket endorsement of aesthetic superiority lay behind the casual sketches of the artists who wandered over the Campagna in the eighteenth century. Although led by guidebooks and familiar with the *vedute*, they explored the landscape freely, knowing that every step fell on classic ground.

The practice of outdoor painting, born in this milieu, at first gravitated toward one end of the continuum from casual sketch to conventional composition. Literally turning their backs on the topographical conventions of the *vedutisti*, Valenciennes and Jones sought out humble corners of the landscape and anonymous *fabriques charmantes*. Later, in the early decades of the nineteenth century, a growing roster of painters gradually extended the scope of the landscape study, welcoming the influence of the view painters beside that of Gaspard and Claude.

By the time Corot arrived in 1825, the oil-study repertory included the entire spectrum of the artistic image of Italy. Corot inherited the accumulated range of motifs, from the close detail of vegetation possessing "a character of vigor that one does not find in Northern countries" to the *vedute* of Narni and Civita Castellana that Turner had recorded in his notebook as icons of classical history and culture. This development – the process by which outdoor painting in Italy reached maturity – is the subject of the remainder of this chapter.

<p style="text-align:center">* * *</p>

At least since the mid-eighteenth century, when Wilson met Vernet, the population of foreign landscape painters working at Rome had been a constantly replenished pool of talent.[37] Some, such as Nicolas-Didier Boguet and Johann Christian Reinhart,[38] came to Rome as young men and never left. Others more typically came as students and stayed only a few years. Many, from Hackert in the 1760s to the Dane C.W. Eckersberg (1783–1853) and the Belgian Gilles Closson (1798–1842) in the 1810s, first visited Paris, where veterans of earlier Italian campaigns prepared them to take up the customs of the foreigners' quarter at Rome.[39] There they joined poets, historians, architects, musicians, and sophisticated travelers of all kinds, whose letters and accounts enrich our sense of the landscape work.[40]

In this active milieu, the oil study developed as one of several interrelated landscape forms, ranging from casual pencil sketches to prints, to finished watercolors and small oils manufactured for the tourist trade, to large ambitious canvases. Even as the oil study emerged as a distinct form, it remained part of and drew nourishment from this broad spectrum of practice.

A glimpse of the process by which outdoor painting became a staple of artistic practice at Rome is offered by the case of François-Marius Granet (1775–1849), more than one hundred of whose Italian oil studies are preserved in the museum that bears his name in Aix-en-Provence.[41] Before entering David's studio in 1793, Granet had studied at the drawing school of Aix under Jean-Antoine Constantin.[42] Constantin had become director of the school in 1786 after returning from a long stay in Rome. There, perhaps after meeting Valenciennes, he had begun to paint from nature (pls. 38, 104).

104. Jean-Antoine Constantin. *Inside the Colosseum*, 1777–84. Oil on canvas, mounted on wood, 34.8 × 49. Aix-en-Provence, Musée Granet.

When Constantin returned to Aix he brought his studies with him. Thus his student Granet, like other Northern artists over the next few decades, absorbed the sensibility of painting from nature at Rome before he ever went there. Of course Granet's education also introduced him to the view-making tradition. When at last in 1802 he traveled to Italy, accompanied by his friend the comte de Forbin, he was well prepared:

> We were stopped at the Porta del Popolo by a sentry who asked to examine our passport. As we waited our eyes roamed over that handsome square, which I recognized from a painting by Pannini I had seen at Aix during my childhood.[43]

After an introductory tour of the city, led by the history painter Guillon-Lethière, Granet immediately set about painting from nature. Not surprisingly he chose the Colosseum as his first subject. Dissatisfied with his initial attempt, he appealed to the Belgian landscapist Simon Denis for advice.[44] Following it, he proceeded to make a study of the Temple of Minerva Medica, which he soon sold for twenty-five *piastres*. "That gave me courage, as well as the means, to do other studies. And this is how I lived during the first years of my stay at Rome."[45]

105. Anne-Louis Girodet-Trioson. *Italian landscape*, c.1790. Oil on paper, mounted on canvas, 23 × 29. Dijon, Musée Magnin.

106. Léon Cogniet. *Lake Nemi*, 1817–24. Oil on paper, mounted on canvas, 30.2 × 24.6. Orléans, Musée des Beaux-Arts.

107. Léopold Robert. *Vesuvius*, 1821 or 1825. Oil on canvas, 18.6 × 28.3. Private collection.

The anecdote may well be a rhetorical fiction. Nevertheless, Granet's story reflects the multiple contacts between student and teacher, friend and foreign acquaintance through which the oil study prospered in Italy. Completing the circle some twenty years later in 1823, the young Belgian painter François Vervloet (1795–1872), following *Granet*'s advice, traveled to Subiaco, east of Rome, to draw and to paint.[46] There he met among others the French painters Louis-Etienne Watelet and Joseph-Nicolas-Robert Fleury (1797–1890).

Granet was a student of David and his main interests and ambitions had little to do with landscape, but he was not the only history or genre painter to participate in the increasingly popular vogue for outdoor sketching in Italy. He had been preceded in the 1790s by Louis Gauffier (pl. 41) and Anne-Louis Girodet-Trioson (1767–1824), both winners of the *prix de Rome*, and by François-Xavier Fabre (1766–1837).[47] Girodet's fascination with the landscape of Italy, which he ranked above her artistic treasures, is a persistent theme of his letters from Rome.[48] In September 1790 he wrote of his plans for a sketching trip to Tivoli and the Castelli Romani; and the following May he complained that he could not afford a popular type of field easel.[49] It is possible that Girodet's surviving Italian landscapes are imaginary compositions rather than open-air studies, but they are similar in spirit to the outdoor work of Granet and others (pl. 105).[50] After 1800 outdoor painting continued to figure in the Italian travels of ambitious young history painters from France. Among them were Léopold Robert (pl. 107), a student of David, and Léon Cogniet (pl. 106), winner of the *prix de Rome* in 1817.[51]

Among history painters, Jean-Auguste-Dominique Ingres (1780–1867) made perhaps the most telling contribution to the tradition of the Italian oil study. Neither before nor after his long first stay in Rome (1806–20) did Ingres express the slightest interest in landscape painting. Yet within a few months of his arrival at Rome he painted three small views, each in tondo format. He also began a long series of splendid pencil drawings of the city and the surrounding countryside.[52]

In January 1807 Ingres sent two of the paintings as a gift to his fiancée's father. This gift and the tondo format – a sign of self-conscious aesthetic refinement –

108. Jean-Auguste-Dominique Ingres. *Casina di Raffaello, Rome*, 1806–7. Oil on wood, diameter 16.4. Paris, Musée des Arts Décoratifs.

suggest that the Roman landscape study had acquired a new status. Even for Valenciennes the form had never been purely private; it was part of his *métier* and thus belonged to the professional milieu. For Ingres, however, the landscape study had become a self-sufficient form, which served as a souvenir of the painter's initiation into the sophisticated Roman art world.[53] The very subject of one of the three studies – the Casina di Raffaello seen from the French Academy (pl. 108) – supports this interpretation, for the picture's line of sight establishes a direct connection between Ingres and the old master he most admired. A pencil sketch for this painting[54] further suggests that for Ingres the landscape study was not a vehicle of spontaneity but a fully developed pictorial form, which he set out to master. In this respect Ingres anticipated by some twenty years Corot's open-air method, in which preliminary drawings played an essential role.

The participation of Girodet and Fabre, Ingres and Cogniet shows that the practice of outdoor painting from nature in Italy was not a narrow speciality of the landscapists. For some painters it was an amusing diversion, for others, a serious pursuit. For all it was an integral part of the informal exchange that flourished within the artistic community at Rome.

This role of the landscape study is suggested in a number of portraits of artists by their peers. In the background of his portrait of Granet (*c*.1807; Aix-en-Provence, Musée Granet) Ingres introduced a view of the Quirinal Hill, which

94

109. Léon Cogniet. *The artist in his room at the Villa Medici, Rome, upon receiving the first letter from his family*, 1817. Oil on canvas, 43.3 × 36. Cleveland Museum of Art, Mr. and Mrs. William H. Marlatt Fund.

110. Franz Ludwig Catel. *Schinkel in Naples*, 1824. Oil on sheet iron, 31 × 22. Berlin, Staatliche Museen Preussischer Kulturbesitz, Nationalgalerie.

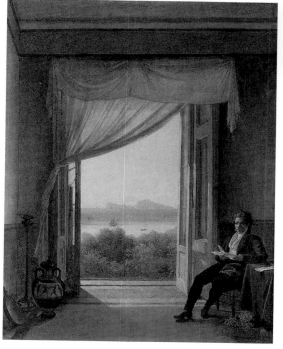

Lawrence Gowing has described as "virtually a quotation of the style and habit of open-air study."[55] The reference is if anything more explicit in Cogniet's self-portrait in his room at the Villa Medici (pl. 109) and Franz Ludwig Catel's similar portrait of his friend Schinkel at Naples (pl. 110).[56] Both pictures record the easygoing life of the foreign artist in Italy. In each the subject reads a letter from home in his spare traveler's billet, and in each the focus is the view through the window. The image can be found in many other early nineteenth-century interiors, but here it has a special meaning, since the view framed by the window is a direct allusion to the repertory of outdoor painting in Italy. For by 1824, when Catel painted his portrait of Schinkel, a repertory had indeed been established. Initially at least, the successors of Valenciennes and Jones had continued to avoid the familiar motifs of the *vedutisti*. But in the forty years before Corot's arrival in 1825, as scores of artists transformed an experiment into a tradition, they inevitably established conventions and motifs of their own.

111. Corot. *View from the artist's window, Rome,* December 1825. (R.43.) Oil on wood, 14 × 22. Paris, private collection.

112. Adolf von Heydeck. *View over the rooftops of Rome,* 1815. Oil on paper, 34 × 47. Wuppertal, Von der Heydt-Museum.

One such convention is exemplified by Corot's study of the Roman skyline with the dome of St. Peter's in the distance, painted within a month of his arrival at Rome (pl. 111). Taken alone it is a document of personal pleasure and contemplation, a charmingly spontaneous transcription of the view from the painter's own window. A survey of the precedents for this pictorial type shows, however, that Corot was working within an established idiom. Two years earlier Corot's friend Guillaume Bodinier (1795–1872) had painted a similar view of Roman rooftops, not from his window but from a spot on the Pincio near the Villa Medici.[57] This in turn is virtually the same view documented by Adolf von Heydeck (1787–1856) in an unfinished study of 1815 (pl. 112). A variant of the

113a–c (a, above; b and c on following pages). Johann Georg von Dillis. *Panorama of Rome from the Villa Malta*, 1817–18. Three parts, each oil on paper, mounted on canvas. a) 30.7 × 43.5; b) 29.2 × 43.4; c) 29.8 × 43.7. Munich, Bayerische Staatsgemälde-sammlungen, Shack-Galerie.

image appears in the middle part of a three-part panorama painted in 1817–18 by Johann Georg von Dillis (1759–1841) for Crown Prince Ludwig of Bavaria (pl. 113a–c).[58]

Nor was the popularity of the rooftop vista confined to the visual arts. An explanatory caption is provided in the *Lettres sur l'Italie* (1819) of A.-L. Castellan, a traveling companion of Gauffier and Fabre in the late 1790s:

> From my window I see several palaces, marble cupolas, and the top of Trajan's Column. . . . I feel reborn, all my faculties are excited, my imagination is inflamed . . . I am alone in the midst of Rome; but I question all the objects, and all of them answer me, all of them say: You are in the land of inspiration and marvels, in the sanctuary of an august and worthy religion, in the temple of the arts, ancient and modern.[59]

Castellan's *Lettres* is a glorified guidebook, but the theme appears also in more ambitious works of literature. Surveying Rome from the Capitol, Oswald, the hero of Madame de Staël's *Corinne*, imputes a moral value to the vista:

97

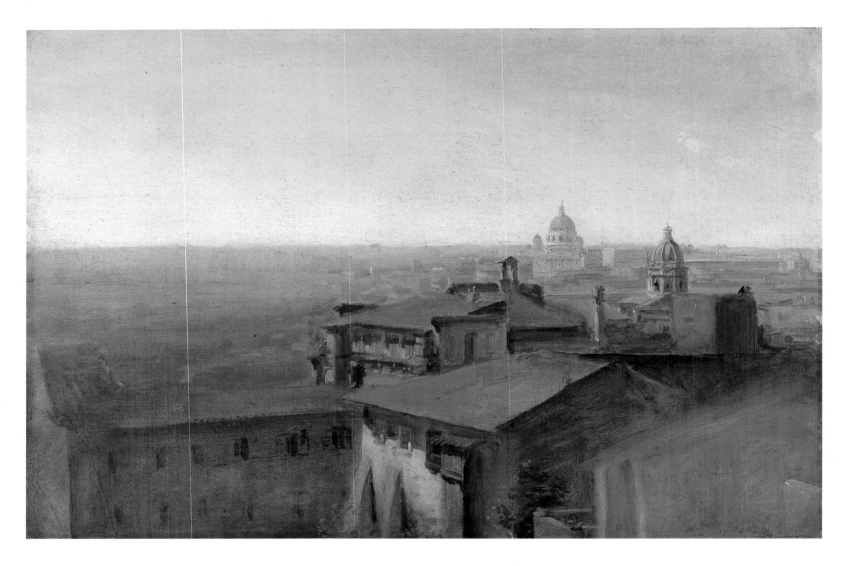

113b. Dillis. *Panorama of Rome from the Villa Malta* (center part).

The reading of history, the reflections it inspires, have much less effect on our soul than these stones in disorder, than these ruins amidst modern houses. The eyes are all-powerful over the soul.[60]

And the link between this literary motif and the conventions of painting is explicit in a letter of Chateaubriand, written from Rome in 1803: "From the height of the Trinità dei Monti, the distant church towers and buildings seem like the blurred sketches [*ébauches effacées*] of a painter. . . ."[61]

* * *

The rooftop panorama was one element in a typology of open-air painting that by 1825 was both extensive and highly codified. One end of its range was secured by the narrow detail of nature, which had been a convention of landscape sketching at least since the seventeenth century, and which the manuals of painting explicitly recommended. A section of Valenciennes's treatise, entitled "Studies of Trees, Rocks, Plants, etc.,"[62] could be illustrated aptly and amply by dozens of works similar to a tree trunk painted by Heinrich Reinhold (1788–1825) (pl. 114).[63] As the outdoor painters pursued this analytical approach, catalogu-

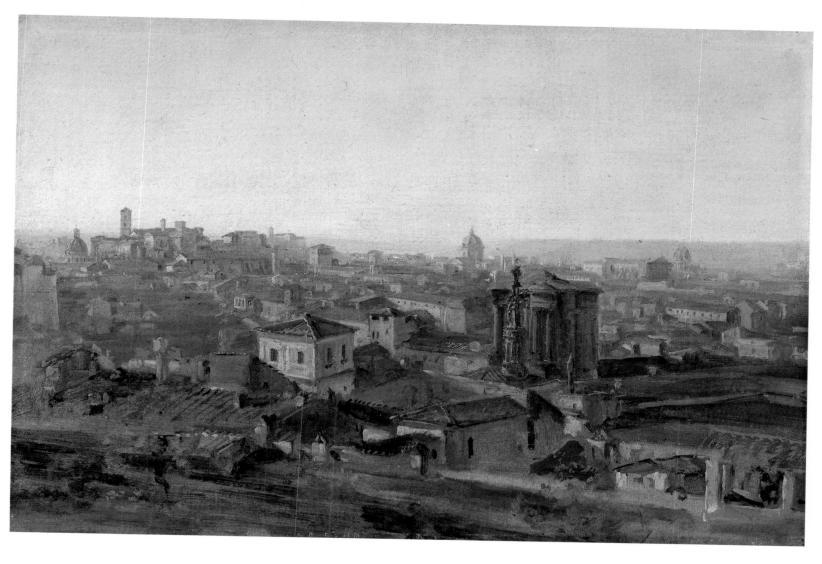

113c. Dillis. *Panorama of Rome from the Villa Malta* (right-hand part).

ing nature's component parts one by one, they settled upon an increasingly standardized vocabulary. Both aspects of the standard – the repetition of favored subjects and the format of the closely cropped detail – are represented in studies of rushing streams by Simon Denis (pl. 115), Michallon (pl. 116), Bidauld (pl. 117), and Corot (pl. 118).

Among the items on nature's list was the sky, but it was not a favorite. The whole community of foreign artists at Rome seems to have compiled fewer pure sky studies in a decade than John Constable alone sometimes made in a week. Despite Valenciennes's preoccupation with the volatility of the sky, his successors were little concerned with the drama of weather for its own sake. The exception is Granet, who stayed in Rome much longer than others and whose large corpus of outdoor work is correspondingly more varied. A sky study by Corot – a rarity in his Italian work – is also in a sense a paradox, for instead of capturing a fleeting state of weather, it celebrates the unchanging golden beauty of the Roman sky (pl. 119).

The landscapists who worked outdoors in Italy were fair-weather painters. They set out into the countryside from their Roman studios in the spring and returned in the autumn. In May 1827 Corot's friend Prosper Barbot (1798–1878) wrote in his journal:

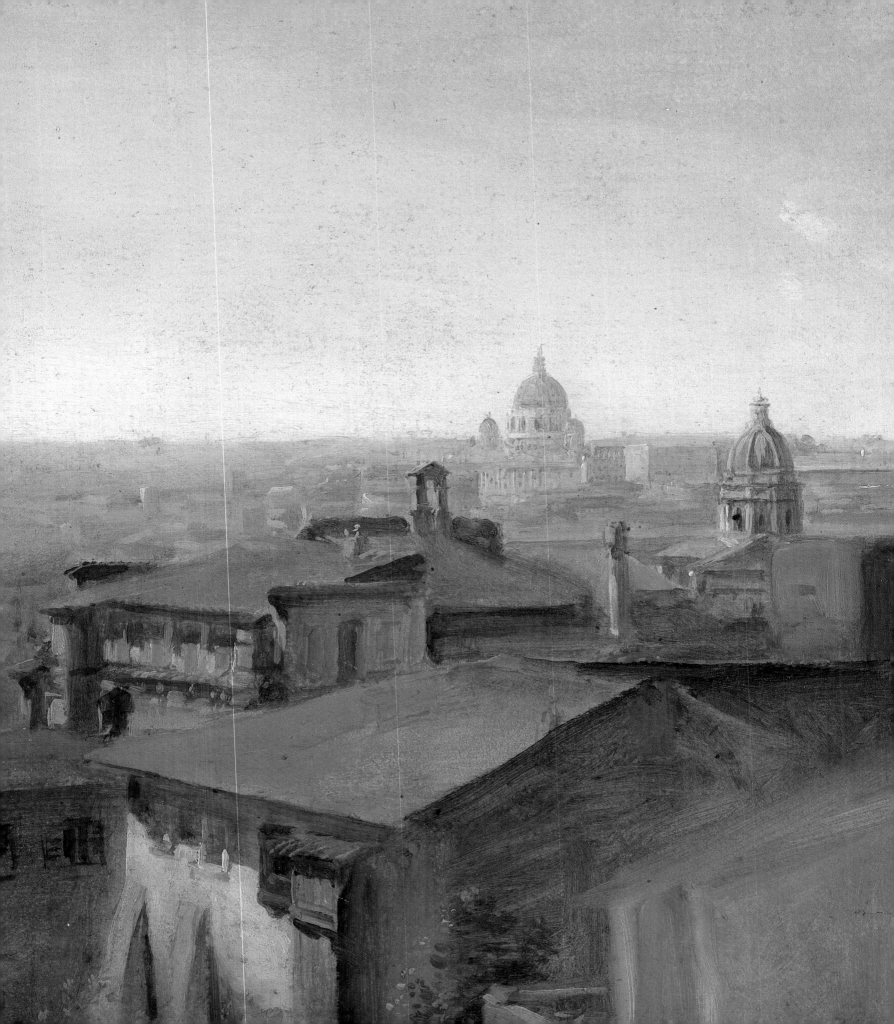

For a few weeks now the beautiful season has begun to show itself, with that dazzling charm that belongs to the climate of Rome. It invites us to take up again our open-air studies and we would already have answered that call were it not for the obligation to finish, for the next [Salon], the pictures that have provided our winter occupation.[64]

In mid-June Barbot and several others, on an extended sketching campaign in the mountains east of Rome, left Subiaco for Civitella, where they found two other landscapists, "demoralized, as we were, by the unrelenting bad weather." One of the two was André Giroux, winner of the *prix de Rome* for historical landscape in 1825. On 19 September 1818 Michallon wrote from Tivoli to his patrons in Paris, "Now that the rainy season has arrived, I will return to Rome to begin work on the picture that I must paint for the King."[65]

The landscapists painted outdoors in the summer and they painted at midday, although it must be admitted that midday is very long in the Roman summer. An exception to this habit was made for the sunset as it draped curtains of warm color over the vast flat expanse of the Campagna (pl. 149), but such exceptions were scarce. The reasons were in part practical. Bad weather posed an obvious

114. Heinrich Reinhold. *Tree study*, 1822–23. Oil on paper, mounted on cardboard, 25.6 × 23. Hamburg, Kunsthalle.

left Detail from pl. 113b (Dillis).

101

115. Simon Denis. *At Tivoli*, *c*.1800. Oil on paper,
21 × 28. London, collection of Mr. and Mrs. John
Gere.

116. Achille-Etna Michallon. *Waves at the foot of a
rock cliff*, 1817–21. Oil on paper, mounted on canvas,
25 × 38.5. Paris, Louvre.

117. Jean-Joseph-Xavier Bidauld. *Cascade, Italy, c.*1790. Oil on paper, mounted on canvas, 38 × 50. Carpentras, Musée Duplessis.

118. Corot. *The Velino above the Cascade of Terni,* 1826. (R.128.) Oil on paper, mounted on canvas, 22.5 × 38. Paris, private collection.

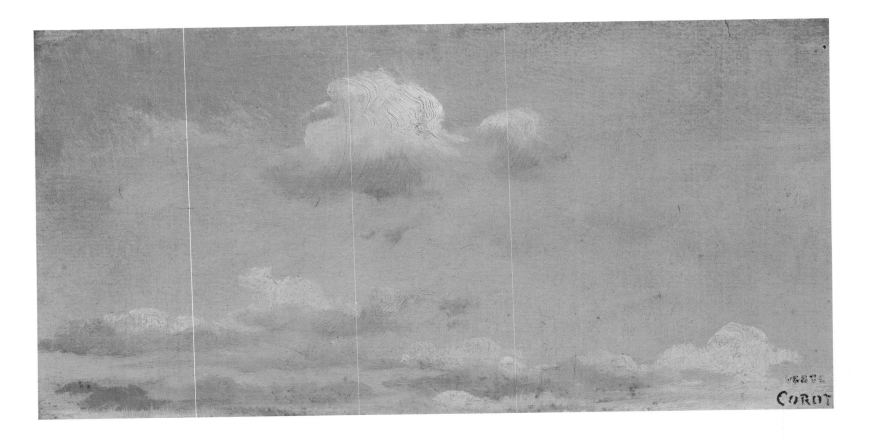

119. Corot. *Sky study*, 1826–28. Oil on paper, mounted on cardboard, 14.5 × 29.5. Paris, collection of Claude Aubry.

inconvenience; changing weather also was inconvenient, since it forced the painter to work more rapidly. But the dominant role granted to the steady bright sun was also an aesthetic choice. In the Italian landscapes of Corot and his peers the clouds sometimes gather and billow or even threaten rain, but rarely do they adopt the principal role. Instead of evoking an ephemeral state they most often reconfirm the timeless solidity of the motif below, whose noble forms are marked by sharp planes and decisive shadows.

* * *

The same compact format that the painters applied to rocks and trees served also for studies of ruins (pls. 120, 121). The very antiquity of the ruins, along with the foliage that adorned them, blurred the distinction between natural and man-made architecture. The bold geometry of stone, whether it had been put there by God or by the Romans, and the soft clusters or gentle swells of green formed an image of grandeur and harmony. Under the bright Italian sun and the steady gaze of the outdoor painters, the heroic and the pastoral, history and nature, merged into a reassuring icon. Elsewhere in European painting, rocks and ruins figured prominently in the imagery of the Romantic sublime, but for open-air painters in Italy these subjects were utterly free of *Sturm und Drang*.

As they explored the landscape outside Rome and Naples, the artists became collectively more and more efficient at identifying specific sites that satisfied their aesthetic expectations. At Sorrento, for example, they favored a narrow ravine which, like the Grotto at Posillipo, presented an imposing natural architecture. Only a few steps cut in the rock were required to put it to use as a ready-made

104

120. Carl Blechen. *Augustan bridge at Narni*, 1828–29. Oil on paper, 21.1 × 30.2. Berlin, Staatliche Museen, Nationalgalerie.

121. André Giroux. *Ruins on the Palatine Hill*, 1825–29. Oil on paper, mounted on canvas, 22 × 31.2. London, collection of Mr. and Mrs. John Gere.

122. François-Edouard Bertin. *Ravine at Sorrento*, 1821–29. Oil on paper, mounted on cardboard, 40.9 × 29.5. New York, The Metropolitan Museum of Art. Purchase, Karen S. Cohen Gift, 1986.

123. Heinrich Reinhold. *Ravine at Sorrento*, 1823. Oil on paper, mounted on canvas, 24.5 × 20. Hamburg, Kunsthalle.

124. Unidentified artist (Michallon?). *Ravine at Sorrento*, early 1820s? Oil on paper, mounted on canvas, 36 × 27.8. Paris, private collection.

ruin, every bit as grand as Hadrian's Villa or Caracalla's Baths. Not only the site but also the best spot from which to take it in were soon canonized by the outdoor painters. Thus the ravine at Sorrento was transformed from a natural wonder into an artistic motif, and as such it was approached by Corot's good friend Edouard Bertin (pl. 122), by Heinrich Reinhold (pl. 123), and by a third, unidentified artist, perhaps Michallon (pl. 124).

These three studies at Sorrento, painted within a few years of each other in the early 1820s,[66] introduce a significant new stage in the development of outdoor painting in Italy. The techniques, the basic pictorial vocabulary, and the essential themes of the landscape study in oil had been established in the 1780s. In the decades that followed, the imagery of outdoor painting had coalesced into a conventional typology, further aspects of which await exploration later in this chapter. By the mid-1820s that typology had begun to spawn a repertory of specific motifs, such as the ravine at Sorrento. Artistic experiment, in short, was drawing ever closer to the organized rituals of tourism. Eventually the wave of cultural appropriation would deaden the spirit of open-air discovery, but for the moment – the moment of Corot's first trip to Italy – the collective enterprise fueled the enthusiasm and sharpened the attention of the individual.

The mechanisms of this process are typified by the history of outdoor painting in the gardens of the Villa Borghese. In the early 1780s Valenciennes had painted there often, discovering for himself one secret spot after another. He was not alone, of course, but he shared with his fellows a thirst for exploration, expressed by the singularity of his choices within the vast park. This strategy of independence became more and more difficult to follow. A letter written by

125. Gilles Closson. *Orangery of the Villa Borghese,* 1825–29. Oil on paper, 21 × 33.5. Liège, Cabinet des Estampes.

Frederike Brun in 1795, eleven years after Valenciennes left Rome, records the popularity of the Villa Borghese among the landscape painters:

> The Villa is overflowing with lovely elysian charm. . . . Rounded hillocks undulate up and down, pines carry green umbrellas delicately woven together against the blue sky. Artists work in the open air, and take from the inexhaustible richness of the most pleasant contours and shady spots the foregrounds and backgrounds and often the whole decor of their paintings.[67]

A passage from Castellan's *Lettres* is a good deal more specific about the artistic exchanges that took place in this communal open-air studio. The author, a student of Valenciennes and doubtless familiar with his master's Roman studies, recounts an afternoon of sketching in the Villa Borghese:

> I was drawing an antique tomb half-hidden by the long hanging branches of a weeping willow, when along comes a man whom I recognized as a painter by the large portfolio he carried under his arms. He advances, retreats, first goes one way then the other, sits down a moment, gets up, goes a bit further, all the time keeping an eye on the subject I was drawing; finally he comes to set up his things near me. Because we were separated by a clump of juniper, he could not see me; he sets to work, singing the song: *Sul margine d'un rio.* The openness, the agreeable manners of this artist, his gaiety, make me wish to find in him a Frenchman, a friend. Swept along by this

126. J.-A.-D. Ingres. *Orangery of the Villa Borghese*, 1806–7. Oil on wood, diameter 17. Montauban, Musée Ingres.

presupposition, I mingle my voice with his and, once the couplet is finished, we greet each other with a smile and the conversation begins. I show him my drawings, he opens his portfolio to me, and from the fine, spiritual touch of his drawings, I recognize [Johann Christian] Reinhart, a very distinguished German artist, a few of whose works I had seen at Naples.[68]

Scores of unrecorded meetings of this sort must lie behind the popularity of certain landscape motifs. Perhaps Castellan's or Reinhart's portfolio contained a study, for example, of the nearby orangery of the Villa Borghese with its antique appendage, a segment of a Roman acqueduct. This structure crops up frequently in open-air studies of the early nineteenth century: a block and then a long narrow band of white, punctuated by the black apertures of the arcade, nestled in a sea of lush foliage. Not only the subject but this very image – an icon of man-made Paradise – soon earned a place in the new landscape repertory. It appears in paintings by Closson (pl. 125), by Ingres (pl. 126), and by Corot's friend Léon Fleury (1804–1858) (pl. 127), and in drawings by J.M. von Rohden and Eckersberg.[69]

Repeated again and again, the motif was like a detail taken from one of the crowded panoramas of the *vedutisti*. In fact a very similar motif of open-air painting was created in just this way. On the right in Vanvitelli's view of Tivoli (pl. 98) is the town's unmistakable monument: the round Temple of the Sibyl, perched on the brink of the deep gorge. The open-air painters of the early nineteenth century rejected Vanvitelli's comprehensive view and exchanged the horizontal for a vertical format, painting the temple at the very top, above the descending cliff (pls. 128–31). In this way they managed to preserve the salient topographical feature within the narrow scope of the nature study.

The same process of reconciliation between the old tradition of topographical views and the younger tradition of outdoor painting was at work among the celebrated monuments of Rome. Valenciennes had painted the Colosseum once but otherwise his Roman sketches barely acknowledge the roster of notable sights that so fully occupied the attention of the tourist. Gradually after 1800 the guidebook favorites were welcomed into the world of open-air painting, although still for the most part on the same restricted terms that applied to Tivoli's round temple. Studies of the 1820s by Rémond (pl. 134)[70] and Fries (pl. 132) take as subjects ruins that were familiar to armchair travelers who had

127. François-Antoine-Léon Fleury. *Orangery of the Villa Borghese*, 1827–30. Oil on paper, 15.2 × 26. London, collection of Mr. and Mrs. John Gere.

128. Unidentified artist (Bidauld?). *Tivoli*, *c*.1800. Oil on paper, 29.4 × 19.2. London, collection of Mr. and Mrs. John Gere.

131 (*facing page*). Louise-Joséphine Sarazin de Belmont. *Tivoli*, 1826. Oil on paper, mounted on canvas, 58.1 × 41. San Francisco, The Fine Arts Museums. Museum purchase, Art Trust Fund and The Fine Arts Museums Foundation.

129 (*below left*). François-Marius Granet. *Tivoli*, 1802–19. Oil on paper, mounted on canvas, 28.6 × 21.7. Aix-en-Provence, Musée Granet.

130 (*below right*). Friedrich Nerly. *Tivoli*, 1834. Oil on paper, mounted on cardboard, 54.4 × 39.8. Hamburg, Kunsthalle.

132. Ernst Fries. *View from the Colosseum toward the Palatine*, 1823–27. Oil on paper, mounted on cardboard, 25.4 × 37.8. New York, private collection.

133. Carl Blechen. *The Roman Forum*, 1828–29. Oil on cardboard, 36 × 51. Vienna, Oester-reichische Galerie.

never visited Rome. Characteristically, however, both painters rejected the panoramic scope of topographical reportage. Fries's vantage point has rendered the Colosseum (and the Palatine Hill) all but unrecognizable. Rémond's view includes only one of the three grand vaults of Constantine's Basilica, which the *vedutisti* always dutifully presented together. In 1828 or 1829, when Carl Blechen adopted the canonical view of the Forum (pl. 133), he helped to dismantle the last barrier between conventional view making and open-air work. Corot's Roman views also belong to this late development.

On the conceptual map of the tourist, Rome was divided into Ancient and Modern, a distinction that corresponded, imprecisely, to the distinction between Roman and Christian. The open-air painters, devoted Neoclassicists, began with the Ancient and Roman and even when they embraced the topographical tradition never fully absorbed the Modern and Christian range of its spectrum. Certainly the relative newness and the ornate rhetoric of counter-Reformation architecture was inimical to the painters' theme of timeless grandeur. Nevertheless, a compromise was offered by the monuments of medieval Christianity,

134. Jean-Charles-Joseph Rémond. *View from the Palatine*, 1821–25. Oil on paper, mounted on canvas, 32.4 × 27. New York, private collection.

135. François-Marius Granet. *Church of the Ognis-
santi, Rome*, 1802–19. Oil on paper, mounted on
canvas, 21.2 × 28.5. Aix-en-Provence, Musée
Granet.

which were old enough to be considered timeless, and whose unadorned, cubic
forms appealed to a sensibility schooled in Neoclassical geometry. This com-
promise found its richest expression in the outdoor work of Granet, whose
many studies of block-like Roman buildings look backward to the checkerboard
chiaroscuro of Breenbergh (pl. 1) and forward to the tonal mosaics of Corot.
Often Granet's subjects are anonymous vernacular buildings – the *fabriques
charmantes* so much admired by Valenciennes – but there are also churches drawn
from the tourists' itinerary (pl. 135).

In Corot's work this trend blossomed into full maturity. Granet's scores of
studies only rarely, as if grudgingly, treat the motifs of the *vedutisti*, and then
almost always in cropped details or from unusual viewpoints. Corot, by contrast,
embraced the view-making tradition with enthusiasm, both adopting the
canonical vantage point and widening his frame to match the standard view.
An excellent example is his study of the Tiber Island (pl. 188), an amalgam of
classical and medieval architecture, which boasted a pictorial lineage some three
centuries old.

136. Corot. *Lake Albano and Castel Gandolfo*, 1826–28. (R.160.) Oil on paper, mounted on canvas, 22.9 × 39.4. New York, The Metropolitan Museum of Art. Purchase, Wolfe Fund, 1922.

137. Jonathan Skelton. *Lake Albano and Castel Gandolfo*, 1758. Watercolor and pen and ink on paper, 37 × 53.1. Manchester, Whitworth Art Gallery.

138. Claude Lorrain. *Pastoral landscape with Lake Albano and Castel Gandolfo*, 1639. Oil on copper, 30.5 × 37.5. Cambridge, Fitzwilliam Museum.

The fluid reciprocity between the topographical and ideal-landscape traditions makes it difficult, and somewhat artificial, to assign each a distinct role in the development of outdoor painting in Italy. Corot's study of Castel Gandolfo and Lake Albano (pl. 136) illustrates the difficulty. The fame of the town and of Bernini's church, the beauty of the lake and its surroundings, had earned the subject a place in the view-making repertory that was as secure and almost as old as the one enjoyed by the Tiber Island.[71] At the same time the motif had an equally rich history in the tradition of classical landscape. Corot did away with the pastoral accoutrements that embellish works by Claude (pl. 138) and Jonathan Skelton (pl. 137), but his view belongs no less to the classical tradition. The message of nobility and harmony is conveyed by the gentle sweep of the lake enclosed by banks of green full of promise, by the town that sits proudly on the crest of the hill, and by the poise and completeness of the whole. Corot's concise

vocabulary only clarifies his message. Nature – earth, air, and water – exists in timeless accord with civilized man.

It is also the amplitude of Corot's *Lake Albano*, the reach of scale between the town and its setting, that evokes the classical ideal. Such an effect had become available as the collective tradition broadened and enriched the narrow format of the open-air study. This development, an outgrowth of accumulated experience, an expression of growing confidence in handling complexities of depth and scale, marks the maturity of the tradition. Typically of the period before 1800, Bidauld's study at Civita Castellana (pl. 39) adopts the same constricted vertical format that other painters favored at Tivoli. A generation later, when Jacques-Raymond Brascassat (1804–1867)[72] approached a similar subject at Marino, he deployed a more generous horizontal format (pl. 139). If here Brascassat's pictorial prose dilutes the intensity of Bidauld's poetic concision, the passage from fragment to view nevertheless suggests an essential enrichment of outdoor painting. Initially defined in opposition to the completeness of landscape composition, the oil study had begun to emulate and absorb its conventions. Between the empirical intensity of the nature detail and the comprehensive sweep of ambitious studio convention, an intermediate link was provided by modest finished pictures of the seventeenth century, which described both real (pl. 140) and imaginary (pl. 141) sites.[73]

From Bidauld to Brascassat the thematic content of Italian outdoor painting remained unchanged. From the vernacular of the *fabrique d'Italie* to the equally ubiquitous Roman ruin, the architectural motif evoked man's civilizing presence in the rugged but fruitful landscape. As the painters fanned out into the Campagna beyond the walls of Rome, they had little trouble locating such motifs. Writing of the scene north of Rome, Stendhal observed:

> The sight of the landscape is magnificent; it is not at all a flat plain; the vegetation here is vigorous. Most points of view are dominated by the

139. Jacques-Raymond Brascassat. *Marino*, 1826. Oil on canvas, 43 × 59. Orléans, Musée des Beaux-Arts.

140. Frederik de Moucheron. *Roman landscape*, 1650s. Oil on canvas, 35 × 48. Strasbourg, Musée des Beaux-Arts.

141. Karel Dujardin. *Italian landscape*, 1650s? Oil on wood, 20.6 × 27. Cambridge, Fitzwilliam Museum.

remains of some aqueduct or by the ruins of some tomb, which mark the countryside of Rome with a character of grandeur that nothing else approaches.[74]

If Brascassat's *Marino* leans toward the blandness of picturesque topography, the general tendency was in the opposite direction, toward the grandeur of classical composition. In Corot's *Lake Albano* or in studies by Granet (pl. 142)

142. François-Marius Granet. *Landscape near Tivoli*, 1802–19. Oil on paper, mounted on canvas, 21.6 × 28.8. Aix-en-Provence, Musée Granet.

and Joseph August Knip (pl. 143),[75] the architectural element does not merely denote man's presence. It is the focal point for a fugue of nature, a scheme of balance and enclosure, from which excess and accident have been banished. Not only does the image derive from Poussin and Claude, it so fully invests empirical experience with their serene reason and harmony, that nature herself seems a perfect expression of human order and proportion. When, further beyond Rome, the buildings and ruins receded in scale and sometimes disappeared altogether, their thematic role then fell to the overlapping contours of the hills and mountains (pls. 144, 145). If the close-up motifs at Tivoli and Civita Castellana are like details taken from the backgrounds of older pictures, these studies of the Alban hills or the Sabine mountains are like miniature distillations of the whole.

* * *

By the 1820s outdoor painting in Italy had acquired the self-sustaining momentum of a mature tradition. Having absorbed the resources of topography

118

143. Joseph August Knip. *Landscape near Rome*, 1810–12. Oil on paper, mounted on cardboard, 33.2 × 48.6. Hamburg, Kunsthalle.

144. Théodore Caruelle d'Aligny. *Italian landscape*, 1822–27. Oil on paper, mounted on canvas, 41.2 × 68.2. Boston, Museum of Fine Arts. Seth K. Sweetser Fund.

145. André Giroux. *Landscape near Olevano*, 1825–30. Oil on paper, mounted on canvas, 19.5 × 28.5. Private collection.

and ideal landscape, it went on to extend them, adding new entries to the catalogue of motifs and further enriching the interpretive range of Italianate landscape. An example is the number of studies devoted to the more barren and inhospitable stretches of the Roman Campagna. The *vedutisti* had been very selective there, focusing narrowly on ruins of acqueducts and other isolated monuments. Claude had described the emptiness of the place in his drawings, but his followers had favored the lusher, more welcoming image that is typical of his paintings. In the early nineteenth century the empirical principle of outdoor painting, coupled with a collective zeal for every inch of classic ground, fostered a fresh look at the Campagna.

The result was a broad, panoramic image, in which vastness took on the role of grandeur (pls. 146–49). Dwarfed in space, the monuments evoke the remoteness of the Empire. Here the drama of hills and mountains was absent, except in the distance, and for it the painters often substituted the drama of light. In the extreme case the warm tones of sunset create an elegiac effect, a romantic nostalgia for Roman glory (pl. 149). The melancholy mood, like the harshness of the subject, added a new dimension to outdoor painting in Italy, an exception to its characteristic rectitude and cheerfulness.

The creation of these and other new motifs marks a maturity that was as much social as artistic. View making of course has always been a social art, just as tourism is a social activity. In both, the ritual of repetition reinforces the shared

146. J.M.W. Turner. *The Roman Campagna, with the Tiber, from Castel Giubelio*, 1819. Pencil and watercolor on paper, 25.8 × 40.4. London, Tate Gallery.

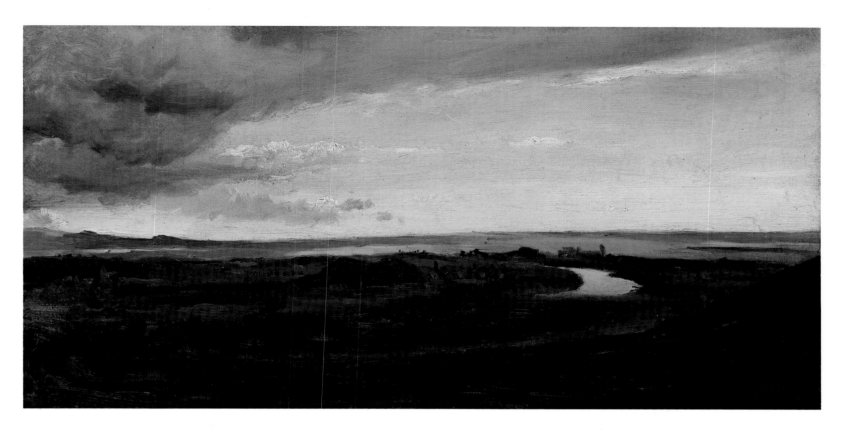

147. Corot. *The Roman Campagna, with the Tiber,* 1826–28. (R.103.) Oil on paper, mounted on canvas, 23.3 × 44.7. Private collection.

values of community and class. The very presence in Italy of so many foreign painters expressed those values, reconfirming the long-standing cultural authority of Rome. If the open-air painters at Rome had no audience beyond themselves and a small circle of connoisseurs, the closed social environment was all the more confident of its rituals. What had begun nearly a century earlier as informal sketching excursions had by the 1820s taken on the qualities of an organized industry. To join the community of landscape painters in Italy was

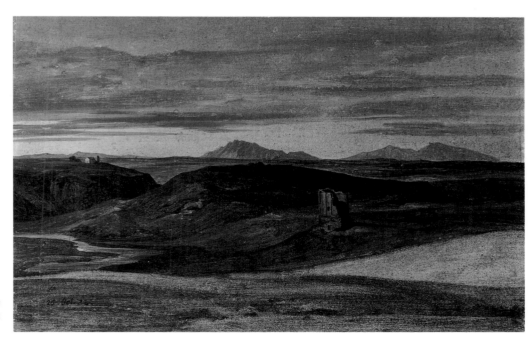

148. Heinrich Reinhold. *The Roman Campagna, with Mount Soracte,* 1819–24. Oil on paper, mounted on canvas, 16.8 × 25.8. Hamburg, Kunsthalle.

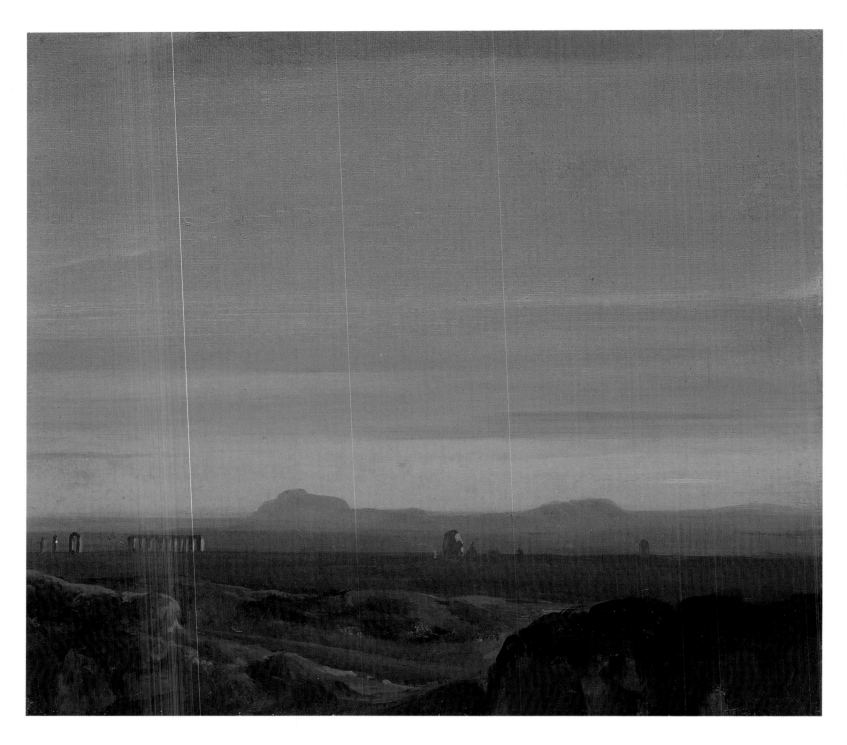

149. Carl Rottmann. *Ruined aqueduct in the Roman Campagna*, 1826–27. Oil on paper, mounted on canvas, 20.2 × 22.5. Private collection.

to become a member of an ever-more homogenized group, whose collective habits were so well established that no one questioned them.

Prominent among those habits were the routes the painters followed in the landscape outside Rome, as they traveled from one celebrated motif to another. There were three principal itineraries (see the map, pl. 158). The first was defined by the route from the north, which virtually all foreign artists traversed on their way to Rome, and which they frequently retraced on excursions from the city. Civita Castellana, a medieval town with little historical significance, surely owed its popularity among painters as much to its position on this route as to

its picturesque beauty. The second itinerary, closest to Rome on the route south toward Naples, encompassed the Castelli Romani: Frascati, Marino, Albano, Ariccia, Genzano. These towns had enjoyed a continuous popularity as country retreats for nearly two thousand years and, as Thomas Jones recorded in the passage that opened this chapter, they offered splendid views. Third, to the east, the painters stopped at Tivoli, the most famous site of all, on their way along the River Anio to Subiaco, where Nero and then St. Benedict had escaped Rome, and which henceforth had been an honored site of the Church.

These three itineraries – each of them liberally represented in the repertory of the *vedutisti*[76] – initially were discrete from each other. They prescribed separate excursions, from each of which the artists returned to Rome before embarking on another. Eventually, however, the volume of traffic overflowed the favored routes to colonize less accessible, less familiar sites. The most notable example of this expansion was the discovery of Olevano and nearby Civitella, fortress towns that lay among the rugged mountains east of Rome, between Subiaco (once the endpoint of an established itinerary) and the inland route to Naples. Olevano could boast little significance in Roman or Christian history, and before 1800 it had played no role whatsoever in visual art. Yet in the first quarter of the nineteenth century it became one of the most popular sites for open-air drawing and painting.[77] In 1803 Joseph Anton Koch was one of the first artists to visit and sketch the town and the surrounding landscape. Within two decades Olevano was famous for its major monument. This was not its ruined medieval fortress (there were no Roman ruins) but the Casa Baldi, a modern house built in the 1780s, which had become a hotel, tavern, and meeting place for traveling painters – a Caffè Greco *fuori le mura*.

Koch wrote that the landscape around Olevano had a "primitive character [*Urcharakter*], such as one might imagine while reading the Bible or Homer."[78] In the summer of 1827 the German poet Waiblinger wrote in a letter, "I have been all over the Sabine mountains; I have been to Tivoli; I have visited Horace's Villa, . . . the inaccessible ravines of Monte Gennaro, Subiaco, on the heights, and Cervara . . . and at Olevano I found what I have always dreamed of seeing."[79] The discovery of Olevano, in other words, was not a departure from the communal aesthetic of foreigners in Italy. On the contrary, it represents the power of that aesthetic to colonize new territory, to absorb unfamiliar sites within the established typology of classical landscape. With astonishing rapidity the artists at Olevano settled upon particular viewpoints and motifs. A good example is the view from Olevano toward nearby Civitella, with an uninhabited rocky peak on the left. A painting by Reinhold (pl. 150), a drawing by C.F. von Rumohr (pl. 151), and a variant by Corot's traveling companion Johann Karl Baehr (pl. 152) testify to its popularity.

The cultural appropriation of Olevano and its surroundings was as complete as it was swift. On the hillside a half-hour's stroll from Olevano stood (and still stands) a grove of oak trees in a stretch of terrain so popular that it merited a name, La Serpentara. Speaking for Corot, Reinhold, and many others who painted La Serpentara (pls. 153–55), Ludwig Richter observed that it "seemed to have been created for painters."[80] For painters – not tourists or topographers or historians; once guided by all of these, the painters now constituted an autonomous force, whose collective habits had gathered such momentum and achieved such uniformity that they readily transformed any new site into a motif, stamping it with the communal aesthetic. Properly speaking La Serpentara was not a site at all, only an especially picturesque locale. Its appeal had everything to do with art and nothing with history. Yet in the short span of twenty years its

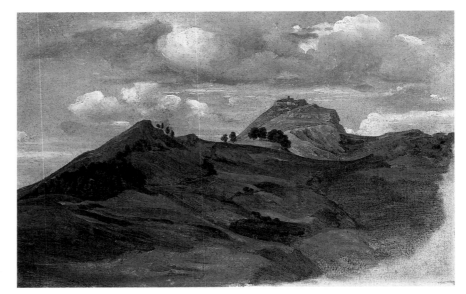

150. Heinrich Reinhold. *Civitella*, 1821–25. Oil on paper, mounted on cardboard, 16.5 × 25.7. Hamburg, Kunsthalle.

151. Carl Friedrich von Rumohr. *Civitella and the Serpentara*, *c*.1819. Pen and ink and watercolor on paper, 22 × 33.3. Bremen, Kunsthalle.

152. Johann Karl Baehr. *Civitella*, 1828. Pencil and wash on paper, 22 × 34.3. Bremen, Kunsthalle.

facing page Detail from pl. 153 (Corot).

pictorial image had become as authoritative and indelible as the most venerable *veduta* at Rome.

* * *

Around 1800 there emerged in Italy, especially in Rome, the first thoroughgoing school of outdoor landscape painting. Empirical observation in general and outdoor painting in particular came to play such a central role in the modern landscape tradition that the early episode in Italy must be understood within that tradition, as part of a new beginning. It was also a conclusion, the last great flowering of the classical landscape tradition. To grasp the achievement is to hold these opposing frames of interpretation in balance. If the empirical challenge of outdoor work breathed new vitality into a tiring ideal, the classical tradition also nurtured the first growth of open-air painting.

Between Valenciennes in the early 1780s and Corot in the late 1820s the theoretical basis of outdoor painting remained unchanged. The nature study was not an end in itself but a discrete component within an organized hierarchy. That hierarchy charted a process of synthesis, designed to culminate in an imaginative

153. Corot. *Olevano–La Serpentara*, 1827. (R.162.) Oil, 33 × 47. Basel, Rudolf Staechlin Family Foundation.

154. Heinrich Reinhold. *La Serpentara*, 1821–24. Oil on paper, mounted on canvas, 17.8 × 21.8. Hamburg, Kunsthalle.

composition, created in the studio and intended for exhibition. Within the theoretical framework, however, a great deal had changed. In effect, the synthetic process had reversed direction, so that the traditions of landscape composition became a resource for outdoor work.

In the early open-air studies of Valenciennes and Jones the empirical function of the nature study detached itself with striking clarity from the established habits of picture making. So complete was this uncoupling that two centuries later, after all that has intervened in painting, not to mention photography, the candor and immediacy of their studies is still striking. The polarity between their outdoor work and their studio compositions marked a crisis in the landscape tradition, a breakdown in the old synthetic process. By isolating the empirical function, by giving it a concrete identity, that crisis also created a new opportunity.

Nearly a century earlier Desportes had created a similar opportunity. Unlike Desportes, whose open-air achievement was an isolated experiment, Valen-

155. Friedrich Nerly. *La Serpentara*, *c*.1830. Water-color and pencil on paper, 20.2 × 31. Bremen, Kunsthalle.

156. After Hortense Haudebourt-Lescot. *The Draftsman*, 1824. Lithograph. Paris, Bibliothèque Nationale.

ciennes and Jones were followed by a few and then many others. That this occurred – that outdoor painting became a communal practice and matured into a tradition – must now be recognized as a salient expression of changing values. Yet the pursuit of this innovation depended upon the framework within which it had been created. The autonomy and enrichment of outdoor painting, in practice, derived from its specific function and subordinate place in theory.

If established theory provided the basis for the innovation, established tradition provided the essential nourishment. As foreign landscapists in Italy devoted more and more of their collective talent to outdoor work, they turned increasingly to the resource of convention. The richness of that resource cannot be described adequately by reference to the pictorial legacy of Poussin and Gaspard and Claude. What made the past so useful to the outdoor painters – what made the abstract vocabulary so available to their empirical experiments – was its deep attachment to specific places. The outdoor painters in Italy possessed an artistic ideal, which guided their ambitions; they possessed also a practical, detailed map, which guided their footsteps. I refer here not only to the *veduta* tradition, with its repertory of motifs, but to the whole apparatus of tourism, with its historical and literary signposts, its carriage routes, hotels, and meeting places.

Finally, the outdoor painters possessed a community. Artistically, the community provided an atmosphere of mutual encouragement and competition, and the security of a shared aesthetic. Practically, it provided an abundance of word-of-mouth advice on where to go and how to get there and what to paint. It was not a narrow community of a few advanced artists but a broad community of sophisticated tourists, which included painters. The breadth of the community is significant, for its numbers reinforced the authority of cultural values, which supplied both a *raison d'être* and wide support for the innovations of outdoor painting.

In many essential respects the growth of early open-air painting in Italy is at odds with the familiar pattern of innovation in modern art. There was no radical

128

manifesto that galvanized the new in opposition to the old; here the innovation arose from a deep allegiance to established values and academic theory. Instead of gradually shedding inherited convention, the new tradition began at a height of spontaneity and gradually matured by absorbing the lessons of the past. Instead of expressing the visionary outlook of a few independent artists, it served a broad, communal aesthetic.

Inevitably, the conventions of Italian open-air painting eventually ossified into a stifling routine. This process began in the 1830s and accelerated rapidly. Corot arrived in Italy in 1825, when the tradition was mature and lively but not yet old, when its customs and conventions were still a guide and support and not yet a burden. The vivid detail of nature, the view from the window, had not yet lost their freshness. The lessons of Gaspard and Claude and the motifs of the *vedutisti* had enriched the open-air study, bringing it authority and autonomy, but had not yet transformed it into routine.

This balance between spontaneity and convention may be summarized by comparing a portrait of Corot, drawn by his friend Ernst Fries at Civita Castellana in 1826 (frontispiece), with a lithograph of the 1820s by Hortense Haudebourt-Lescot (pl. 156).[81] In the drawing by Fries Corot sits on his collapsible tripod stool, gazing at the landscape: a model of youthful independence and determination. It is a fitting image of the author of vibrant Italian studies, in which the landscape is seen with a boldness and candor rare in earlier art. In a similar format the lithograph shows us a foppish hack, throwing off yet another view of Tivoli's cascades, with Italian peasants for muses. It reminds us that Corot's high achievement owed a great deal to the collective aesthetic of the Italian milieu. Arriving in Italy Corot joined an active community, adopting a rich tradition at its peak of maturity.

IV COROT IN ITALY

THE HISTORY OF EARLY OUTDOOR PAINTING in Italy could be told well enough without the mention of a single name. It was not the achievement of a few leaders and many followers but a broad development whose communal aesthetic absorbed peculiarities of artistic temperament and national origin. Although Corot's work contains many innovations, his distinction lies not so much in any new quality that he brought to outdoor painting as in the completeness with which he embraced the tradition. Arriving near the end of its vital period of growth and invention, Corot gave it its fullest and most lasting expression. In individual landscapes and in his whole pattern of work, Corot brought to splendid fruition the opportunity that others had prepared. How much this accomplishment owes to Corot's personal talent and how much to the collective tradition is an unresolvable question.

A great deal is known about Corot's work in Italy between December 1825 and the fall of 1828. For this period Robaut recorded more than 150 paintings, many of which are located today. In addition, some 200 drawings survive.[1] From the dates and place names Corot often inscribed on his drawings and from other evidence it is possible to follow his itinerary nearly month by month. The itinerary in turn provides the means to trace the development of Corot's art, even though only a small minority of the paintings are dated. The exposition that follows is not intended as a comprehensive catalogue, in which each work receives its due. But it introduces considerable detail, for the aim is to explore the process that lies behind the achievement: to watch Corot at work.

With his friend Johann Karl Baehr (1801–1869), a Latvian-born painter whom he met in the studio of Jean-Victor Bertin, Corot left Paris in September or October 1825. The two passed through Lausanne, Bologna, and Florence, and probably arrived at Rome in November, certainly by 2 December. The only three works that survive from the southward journey are a drawing dated October 1825 (R.2470) and an oil study (pl. 157), both views of Lausanne, and an oil study made at Lake Geneva (RS2.3), also dated October 1825. In Rome Corot found lodgings in the foreigners' quarter, near the piazza di Spagna. He rented a room and a studio on the fourth floor of the Palazzo dei Pupazzi, in the via del Capo di Case.[2] Although it had been raining continuously when Corot first arrived,[3] he soon set to work. There are ten oils and two drawings dated December 1825.

Corot stayed in Rome until early May 1826, when he left with Baehr on his first campaign into the countryside, at Civita Castellana, some thirty miles north of the city (see map, pl. 158). He returned briefly to Rome sometime in June. Two other recorded trips to Rome, later in the year, suggest that Corot returned to the city from time to time, perhaps to collect materials or money. It is probable that a number of short visits of this sort went unrecorded, but in any case Corot spent the better part of the sunny season, from May to October 1826, in the countryside north of Rome. In May and June he worked in and around Civita Castellana; in July, August, and September he stayed mostly at Papigno, near Terni, some thirty miles further north.

The entire Italian trip originally was planned to last no more than a year.[4]

157. Corot. *Lausanne*, October 1825. (R.42.) Oil on canvas, 21 × 32. London, private collection.

left Detail from pl. 251 (Corot).

131

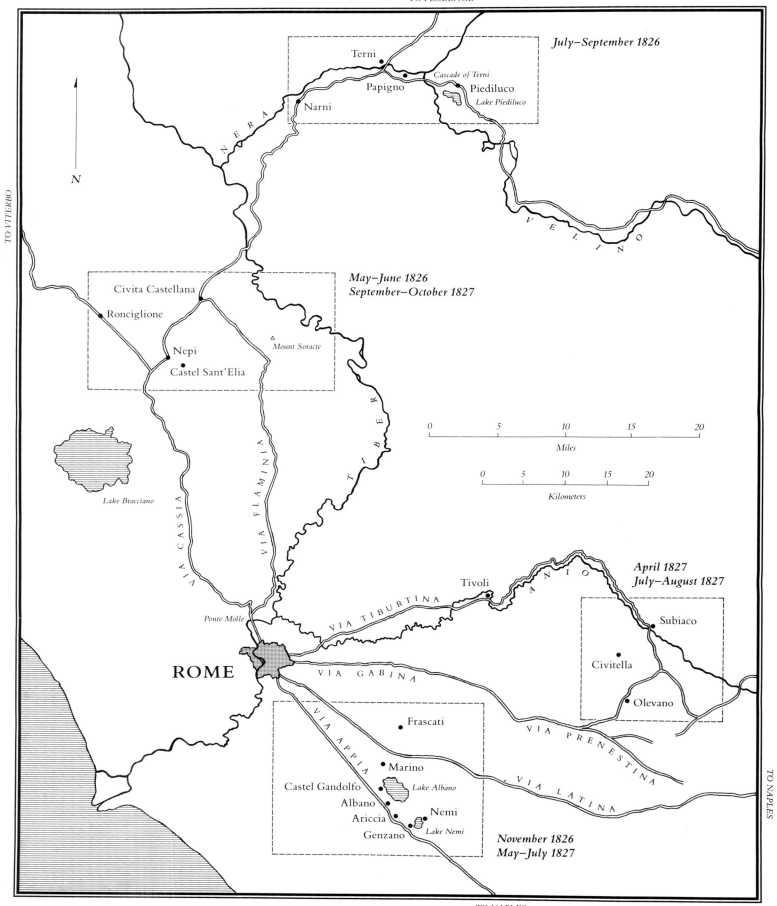

July–September 1826

Terni

Cascade of Terni

Papigno

Piediluco

Lake Piediluco

Narni

N E R A

V E L I N O

May–June 1826
September–October 1827

Civita Castellana

Ronciglione

△
Mount Soracte

Nepi

Castel Sant'Elia

V I A F L A M I N I A

T I B E R

Lake Bracciano

V I A C A S S I A

0 5 10 15 20
Miles

0 5 10 15 20
Kilometers

April 1827
July–August 1827

Tivoli

A N I O

V I A T I B U R T I N A

Subiaco

Civitella

Olevano

Ponte Molle

ROME

V I A G A B I N A

V I A P R E N E S T I N A

V I A L A T I N A

Frascati

V I A A P P I A

Marino

Castel Gandolfo

Lake Albano

Albano

Nemi

Ariccia

Genzano

Lake Nemi

November 1826
May–July 1827

TO VITERBO

TO NAPLES

Periodically, however, Corot asked for and received extensions (and money) from his family.[5] In the end he was away from home for some three years.

Corot spent October 1826 partly in the country, partly in Rome, but no works are datable to that month. It is possible that he had already begun to work on the two studio compositions that would occupy him over the winter. In November he made his first trip south to the Castelli Romani, a famous group of towns a little more than ten miles from Rome. The drawings Corot made in November at Frascati, Nemi, and Ariccia, could have been made on brief excursions from the city, but later Corot would stay in these towns, each within walking distance of the others, for a month or more at a time.

From December 1826 through March 1827 Corot was in Rome. A single drawing (R.2496) records his only visit to Tivoli, in December, but he spent most of these four months in the studio, composing and executing the two pictures he would send to Paris for the Salon of 1827 (pls. 203, 205). In April he traveled for the first time to Olevano, southeast of Tivoli. There is no trace of his activity in June, when he might have returned to Rome, but he spent all of May and part of July in the Castelli Romani. In late July and August he returned to the easternmost point of his travels, at Subiaco and nearby Olevano. Then in September and October 1827 he was back again in the north, at Civita Castellana, which he had first visited in May 1826. Once again he spent November, December, and January in Rome, preparing further studio compositions.[6]

In February and March 1828 Corot visited Naples, on a journey that lasted no more than about seven weeks.[7] In October 1828, most probably, he returned to Paris, stopping briefly at Venice on the way.[8] Otherwise there is little evidence for Corot's whereabouts in 1828. One drawing (R.2580) places him in Rome on 20 May; another, sketched at Olevano and simply dated 1828 (R.2618), must have been made during the summer. That is all.

The wealth of detail for 1826 and 1827 more than compensates for the slim record of 1828. The reason is that Corot matured very rapidly as an outdoor painter. The key period of development was the first ten months of the three-year trip, from December 1825 to September 1826. For this period and the year that followed, the record is very rich.

* * *

Between December 1825 and October 1827 it is possible to trace Corot's movements almost month by month. In this span of nearly two years he worked in Rome and in only four other areas, three of which he visited twice. The seven campaigns outside of Rome may be summarized as follows:[9]

1826	May–June	Civita Castellana
	July–September	Papigno–Terni–Narni
	November	Castelli Romani
1827	April	Olevano–Subiaco
	May–early July	Castelli Romani
	late July–August	Olevano–Subiaco
	September–October	Civita Castellana

Corot's highly restricted itinerary was characteristic of the artistic milieu he joined in Rome. Rarely, if ever, did he travel or work alone. In addition to his particular friends there was a virtual army of foreign artists, many of them landscape painters. At Rome they often met at the Caffè Greco, near the piazza di Spagna, which Corot used as a mailing address.[10] A group portrait by Franz

158. Rome and environs. Adapted from William Gell, "Rome & its Environs, from a Trigonometrical Survey" (London: Saunders & Otley, 1834). Dotted-line rectangles indicate Corot's principal sketching campaigns outside of Rome in 1826 and 1827.

159. Franz Ludwig Catel. *Crown Prince Ludwig in the Spanish tavern, Rome*, 1824. Oil on canvas, 63 × 73. Munich, Bayerische Staatsgemäldesammlungen.

Ludwig Catel documents as it celebrates the convivial spirit of the community (pl. 159). And Carl Blechen's account of his arrival at Rome, in December 1829, records the alacrity with which the community welcomed new members. Blechen began the day at Siena:

> In the morning we pushed on through Ronciglione toward Rome, where we arrived in the evening. We disembarked at an inn and in the morning went to the Caffè Greco, where all German artists go to drink coffee. There I encountered many acquaintances from Berlin. One of them suggested to me a house in the via Felice where I might take a furnished room, which I soon did. We lived quite well there, and it so happened that in the same house lived two older German painters, both of whom had married Italians – [Josef Anton] Koch and [Johann Christian] Reinhart.[11]

That the social dimension of the artist's life in Italy was no less active in the countryside is suggested in a picture by Joseph-Nicolas-Robert Fleury (pl. 160). A journal of 1827 by Corot's friend Prosper Barbot further documents the cohesiveness of the milieu among the country inns and hostels, which seem to have survived primarily on the patronage of traveling painters. The following passage is typical:

> On July third, since [Jules] Coignet was indisposed and the date of his departure had been fixed for the sixteenth of the month, I set out alone [from Rome] for Ariccia, where I found, at the hotel of Signor Martorelli, a numerous company of landscapists of all countries: four compatriots, plus Italians, Germans, English, Russians. Twice daily twelve or fifteen of us assembled at the table presided over and served by our host.[12]

For eight or nine months in the sunny season the painters traveled from one famous site in the countryside to another. At each place they stayed for several days or several weeks, returning occasionally to their base of operations at Rome. For three or four months in the winter each painter retired to his studio in Rome, to compose exhibition pictures based on his studies. Crossing and recrossing each other's routes, the painters wore these routes into smooth paths. Although Corot's response to familiar motifs sometimes was highly original, never in three years did he seek out a new subject. Not once did he visit a site that other artists had not been exploring for a generation. Nor did he actually travel very much. Except for the brief and relatively unproductive visits to Naples and Venice in 1828, Corot never strayed more than sixty miles from Rome.

Following a half-day's travel in the *vettura* or the mail coach, Corot would settle in one village, usually at an inn filled with other artists, for a month or two at a time. Each morning he would set out on foot to draw and paint, often in the company of his friends. He hired local peasant boys – his "slaves" – to carry his paraphernalia.[13] On these excursions he rarely walked more than about five miles. In the evening he returned to the inn to take his place at the common table with the other artists whom he had met and whom he would meet again, at Civita Castellana, Ariccia, Olevano, or other stops on the well-established circuit. Far from exploring the landscape at large, Corot and his colleagues followed a prescribed route, whose points of interest had achieved a status that none questioned.

Within this environment Corot worked ceaselessly. His letters from Italy to his friend Abel Osmond tell little of his communal life and still less about his work. The central theme of the letters is women – those Corot had left behind in Paris and those he encountered in Italy. An occasional passage, however, records his delight in the Italian landscape and climate and his devotion to his work. In March 1826 he wrote:

160. Joseph-Nicolas-Robert Fleury. *French artists in Italy* (Subiaco), 1823. Oil on canvas, 74.6 × 99.1. New York, private collection.

You could not imagine the weather we have at Rome. Here it is now a month that I am awakened each morning by a blaze of sunlight that strikes the wall of my room. In short, the weather is always beautiful. On the other hand, I find this brilliant sunlight dispiriting. I feel the complete impotence of my palette. Console your poor friend, who is thoroughly tormented to see his efforts in painting so miserable, so sad, beside the dazzling scene before his eyes. There are days, truly, when I would throw the whole lot to the devil.[14]

Corot was enthralled by the city and the light, but he was not attracted to the sophisticated cultural life of Rome, which Stendhal, Delécluze, and others recorded in their journals. Corot's friend Baehr, more of a dandy than a painter, frequented the soirées and balls, but Corot did not.[15] He met Jean-Victor Schnetz and Léopold Robert at the Caffè Greco, but he seems not to have entered their ambitious circle. He had friends who were *pensionnaires* at the Academy, but unlike them he followed no strict program of study. He went to the museum in Naples, but is said never to have visited the Sistine Chapel in Rome.[16] It is difficult to believe that he entirely ignored the great art collections in Rome, but he seems to have paid them only casual attention. Nor did he seek to take advantage of the demand for small topographical views of Rome and the Campagna. For Corot and most of the other landscape painters the essential museum was the landscape itself, and society was the lively, sometimes boisterous, gathering for dinner at the country inn.

In addition to Barbot and the painters mentioned in his journal,[17] Corot's friends included Julien Boilly (1796–1874),[18] François-Antoine-Léon Fleury,[19] Guillaume Bodinier,[20] François-Edouard Bertin,[21] and Théodore Caruelle d'Aligny (1798–1871).[22] Bertin and Aligny often are mentioned in connection with Corot's work in Italy. The habit of associating the three names, however, does not arise from their work in Italy in the 1820s but from their Salon pictures of the 1830s, when critics grouped them together as leaders of a revival of Neoclassical landscape.[23] Both Bertin, who had made an earlier trip to Italy, and Aligny, who had arrived before Corot, initially were more experienced. Bertin, raised in a household often visited by Girodet and Chateaubriand, doubtless contributed to Corot's cultural education.[24] But in the matter of painting from nature Corot eclipsed Bertin, Aligny, and the rest of his peers within a few months. Already in March 1826 Aligny acclaimed him "our master."[25]

Naturally Corot's closest friends were French, but his acquaintance was international. Among his working companions, for example, was the German Ernst Fries (1801–1833),[26] who drew a splendid portrait of Corot at Civita Castellana (frontispiece). In any case the social habits and stylistic vocabulary of open-air painting elided national barriers. As a painter of the Italian landscape Corot was as close to Heinrich Reinhold and Carl Blechen as to any of his French friends. What mattered for Corot was not what distinguished his companions one from another but what they shared. Corot learned from them a daily routine, a favored itinerary, and a catalogue of motifs – a highly codified program of work, which gave shape to his talent.

For some painters the conventions of outdoor painting in Italy were confining, even demoralizing. In 1829 young Jules-Romain Joyant, student of Bidauld, wrote that Rome was not the place to find

Interesting motifs or above all new ones. The little that one finds here has been rehashed in a hundred different ways, has been so thoroughly done

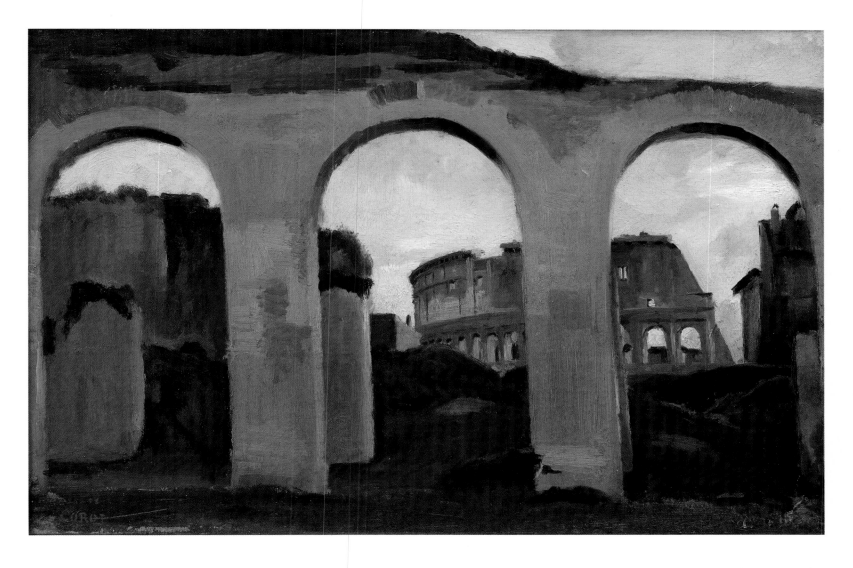

161. Corot. *The Colosseum seen through the arches of the Basilica of Constantine*, December 1825. (R.44.) Oil on paper, 23 × 34. Paris, Louvre.

and redone that there is no corner that does not recall heaps of prints and paintings.[27]

Joyant was in the minority, however. Far more typical was the attitude of Valenciennes's student Castellan:

> You will understand my enthusiasm, young artists, who tremble at the mere name of Rome; it is above all to you that I speak. Already familiar with all the monuments, the endlessly varied sights, the paintings, the statues that the works of your predecessors have treated from a thousand different points of view, you will feel, as I did upon arriving here, as if you were returning to your own country. . . . You wish to draw? A stone will provide a seat for you as it has for all your masters who arranged to meet, as it were, without consulting each other. A feeling for beauty attracts you and places you, like them, at the same spot. . . .[28]

This, too, was Corot's immediate response to Rome, as may be judged from one of the first studies he painted there, dated December 1825 (pl. 161). Corot's earlier work in France hardly anticipates such a picture. It is not a topographical view: the two famous monuments, presented here as fragments, have all but lost their conventional identity. It is not a landscape: there is neither a way to enter

162. Ernst Fries. *The Basilica of Constantine*, 1826. Black and white chalk on paper, 28.2 × 37.5. Munich, Staatliche Graphische Sammlung.

163. Corot. *The Basilica of Constantine*, 1826–28. (R.80.) Oil on canvas, 22 × 34. Private collection.

164. Achille-Etna Michallon. *The Basilica of Constantine*, 1820. Pencil on translucent paper, 27.3 × 42. Paris, Louvre.

165. Théodore Caruelle d'Aligny. *The Basilica of Constantine*, 1822–27. Pencil on translucent paper, 26.6 × 41.5. Rome, Museo di Roma.

the picture, nor space to stand within it. Corot has discovered in the place an austere and powerful design, at once simple and complete. It is not only the bold symmetry of the three arches that creates this effect. It is also the neatness with which two of the arches frame and bisect the Colosseum and, finally, the perfect identity between these two arches and the two open arches of the Colosseum. This identity completes the design, whose authority commands even the smallest element. It also creates for the eye a leap from near to far, thus restoring deep space to the rigid planar structure, saving it from abstraction. Typically of his best work in Italy, Corot has made it seem that classical rigor and immediacy of vision are not qualities opposed, but one and the same thing.

How is it that Corot, talented but immature as a painter, achieved such a work within a month of arriving at Rome? Castellan's remarks go a long way toward answering this question, for the subject was a familiar one. As a drawing by Fries and another study by Corot suggest, the three arches of Constantine's Basilica often were viewed from the other side, with the artist's back to the Colosseum (pls. 162, 163).[29] Corot's study of December 1825 (pl. 161) employed a less common viewpoint on the opposite side of the arcade, looking through it toward

138

166. Christoffer Wilhelm Eckersberg. *View of Rome through the arches of the Colosseum*, 1815–16. Oil on canvas, 32 × 49.5. Copenhagen, Statens Museum for Kunst.

the Colosseum. But here, too, there was a precedent, very close at hand. A drawing by Michallon, dated 1820 (pl. 164), and one by Aligny (pl. 165) shed considerable light on Corot's achievement. Because of small differences between the two drawings, because both were made on translucent paper, it is probable that neither was made on the spot, that both are tracings after a third work, presumably a print. I cannot name the print, perhaps Corot could not either, but the likelihood that he knew the image borders upon certainty.

Corot's advance upon the unimposing topographical precedent may have owed something to other precedents, such as a view from the Colosseum painted by Eckersberg in 1815–16 (pl. 166). Indeed, a comparison of the two paintings illustrates the thoroughness with which artists had made the place their own. The one precisely inverts the other's axis of sight; in Eckersberg's picture the arches of the Colosseum occupy the foreground, while the arches of Constantine's Basilica are visible in the distance at the left. Eckersberg, before Corot, discovered the power of pulling the arches taut against the picture plane. But otherwise his work is a conventional panoramic view, dense with topographical information, which Eckersberg dutifully cited when he exhibited the painting later at Copenhagen.[30] Corot's study serves no topographical function; it is not a feast for the eye but an indivisible whole, which captures the seamless unity of sight.

Corot did not discover Constantine's Basilica on a casual stroll through the

Forum. He knew it in advance as a pictorial motif, which he set out deliberately to master. In mastering it he transformed it; his picture of the three arches is a work of stunning originality. But up to the point when he sat down to paint, on the stone mentioned by Castellan, he had followed a thoroughly unoriginal path.

The relationship of Corot's painting to its precedents is like the relationship of David's *Oath of the Horatii* to earlier scenes of Roman virtue. The subject, the conception of its meaning, the pictorial vocabulary – all had been prepared. What remained was to give these elements an authoritative expression that afterwards would seem inevitable and unsurpassable. This paradigm of collective exploration and individual discovery, formulated to describe the development of figural art, is at odds with the conventional image of nineteenth-century landscape painting. For the latter, progress is typically described as the rejection of tradition and convention in favor of a personal response to nature. Yet in Corot's Italian landscapes just the opposite is the case. The accumulated efforts of the distant and recent past clarified Corot's purpose, providing a momentum that propelled his work beyond the confines that tradition itself had formed.

Corot's deep attachment to tradition went hand-in-hand with a keen enthusiasm for observation. Opposed to the architectonic stability of his study at Constantine's Basilica is the airy subtlety of another early study, one of many

167. Corot. *View of the Roman Campagna*, February 1826. (R.97) Oil on paper, mounted on canvas, 26 × 46. Cambridge, Fitzwilliam Museum.

168. Corot. *In La Serpentara, near Olevano*, 1826–28. (R.166.) Oil on paper, mounted on canvas, 30 × 44. Private collection.

169. Ernst Fries. *Italian landscape*, 1823–27. Oil on paper, 25.4 × 34.5. Heidelberg, Kurpfälzische Museum.

broad panoramas Corot made during his first few months at Rome, as if to get the lie of the land. This one, painted in February 1826, surveys the view southeast from the Vatican hill, toward Frascati and the Alban mountains (pl. 167).[31] In the foreground an abrupt shift from dark to lighter brown delineates a gentle slope in the terrain, and in the sky a nearly parallel diagonal links two layers of cloud, which extend from side to side of the picture. But Corot's passion for geometry takes second place to the ephemeral delicacies of atmosphere and light, as they play across the heavens and the landscape below. The design in the sky is a momentary event.

The study points to the path not taken. Considered all together, the Italian landscapes present a striking range of chromatic schemes, a mark of Corot's taste for experiment and his sensitivity to subtle distinctions of light and atmosphere. Nevertheless, weather itself is rarely the keynote, and Corot's choice of weather was narrow. Light is often dramatic, but its principal role is to reveal the timeless splendor of the motif. It shines with steady clarity upon a landscape whose meanings were almost two thousand years old.

Corot's open-air experiment was guided by a Neoclassical sense for the durability of things. Typical is a study of the rugged terrain near Olevano

141

(pl. 168). The abrupt cropping of the treetops and the large area given over to the foreground place the viewer in close proximity to the vivid scene. But the framing is not casual or arbitrary, for it selects a thoughtful, stable composition. Two trees anchor the center and the pattern of angular shadows below enforces at once the brilliance of the light and the material solidity of the earth. The terrain possesses all the liveliness of nature's accidents and all the integrity of a masonry wall.

As always Corot's sense of the motif owed a good deal to his predecessors and peers. A study by Fries also confronts the viewer with blazing light and a high horizon (pl. 169). But Fries's study lacks the completeness of Corot's work, its air of stateliness and discipline. This quality is present even in Corot's study of rushing water (pl. 118), where the river surges more vigorously than in works by other artists (pls. 115–17). The impression arises not from painterly abandon but from Corot's reserve and deliberation. The foaming white chaos, translated into the tangible substance of paint, draws a planar hierarchy of elegant diagonals. And the swelling arcs of green water are knit together in powerful concert, like the muscles of a hero's torso. Here in a fragment of untrammeled nature, no less than amid the noble monuments of Rome, Corot fused the empirical candor of outdoor painting with the pictorial rigor of the classical tradition. The indivisible collaboration of these qualities is the hallmark of Corot's achievement in Italy.

* * *

Thanks to a wealth of surviving evidence, it is possible to explore the process behind that achievement, to look into Corot's working method and the development of his art. To do so it will be useful to divide the work into several categories:

(1) *Figure studies* These are peripheral in Corot's achievement and will be considered separately and briefly.

(2) *Landscapes and views in Rome and the immediate environs* There are several dated paintings from the first four months of Corot's stay in Italy, before he first left Rome for the countryside, but there are no dated Roman paintings after March 1826. Thus, except for the initial stage, Corot's work in and just outside of Rome must be considered as a whole, without chronological distinctions.

(3) *Landscapes in the countryside* Very few of the paintings made beyond the immediate environs of Rome are dated but there are many dated drawings, which provide a chronological framework for the paintings. In this category, therefore, it is possible to study Corot's development over an extended period of two years.

The medium of drawing played a central role in that development and deserves careful attention.

Following a discussion of the role of drawing, the analysis will focus on three important sketching campaigns: at Civita Castellana in May–June 1826; at and near Papigno in July–September 1826; and a second campaign at Civita Castellana in September–October 1827, discussed in connection with the first.

(4) *Landscapes in Naples and Venice* These were short, relatively unimportant campaigns, both made in 1828.

Figure Studies

Robaut recorded some twenty figure studies painted by Corot on his first trip to Italy.[32] With few exceptions they were made indoors, many presumably during

left Detail from pl. 168 (Corot).

143

the winter months when Corot retired from the countryside to Rome. None of the figure studies is dated, however, and there is no basis for assigning approximate dates to them. In some the brushwork is hesitant and labored, in others, fluid and confident, but there is no clear pattern of stylistic development, such as exists for the landscapes.

Studies of local peasant types were part of every young landscape painter's program of work in Italy. Around 1730 Nicolas Vleughels had painted a suite of pictures of Italian peasant women, carefully recording the distinctive costumes that were part of their appeal to foreign artists.[33] As a *pensionnaire* in Rome Michallon painted an extensive series of such studies, going to great lengths to secure authentic subjects (pl. 170). In a letter asking permission for Michallon to paint peasants from the environs of Rome incarcerated in the Termini prison, an official of the French Academy wrote:

one finds assembled [in the prison] the various costumes of peasant women which, by virtue of their variety or singularity, are of very great interest to

170. Achille-Etna Michallon. *Peasant woman of the environs of Rome*, 1817–21. Oil on paper, mounted on canvas, 36.5 × 24. Paris, Louvre.

171. Corot. *Figure study*, 1826–28. (R.111.) Oil, 39 × 26. Unlocated.

172. Corot. *Figure study*, 1826–28. (R.109.) Oil on paper, mounted on canvas, 27.5 × 22.5. Paris, Louvre.

173. Léopold Robert. *The Unhappy mother*, 1825. Oil on canvas, 56.5 × 45.5. Autun, Musée Rollin.

a landscape painter and, indeed, constitute a necessary part of the studies he has come to Italy to make.[34]

Like the landscape studies, the figures served two basic functions. First, they were exercises in working directly from nature (i.e., the model); second, they were documents of costume and pose, which could be used for studio compositions with pastoral themes. The figures in Corot's Salon picture *View at Narni* (pl. 203) are similar in type and pose to the figures in his studies, although none corresponds exactly. In keeping with their function, Corot's figure studies present themselves as simple documents or studio exercises. With few exceptions each shows a single figure, complete, unpretentiously posed in the blank space of the studio (pls. 171, 172, 174).

Italian peasants, conceived as a benign, timeless presence, have a long history in art, beginning with the pastorals of Titian, then Claude, and the genre scenes of the Bamboccianti.[35] Around 1820, in the work of Corot's acquaintances Léopold Robert, Jean-Victor Schnetz, Victor Orsel, and others, they became an important subject for French painting.[36] Robert and Schnetz, students of David, applied to this subject not only the Neoclassical style but also Neoclassical ideals. They attributed to the peasant the purity and nobility of spirit that David had found in the heroes of Republican Rome. About the subject of his *Return from the feast of the Madonna dell'Arco* (1827; Paris, Louvre), a huge work on the scale of the most ambitious history paintings, Robert wrote, "It represented ancient bacchanals to me, and it seemed that it recalled them entirely."[37]

The work of Robert and his colleagues is symptomatic of an important artistic transformation. In the Italian peasant they found a subject that allowed them, without rejecting inherited ideals, to replace the remote themes of history painting with subjects and scenes they observed directly. Throughout his voluminous correspondence Robert wrote admiringly of Raphael and Poussin and David, without seeming to acknowledge the great gap, in subject alone, between their art and his.[38] There is a useful parallel here with Corot's landscape work. The Italian landscape and its historical pedigree allowed Corot to develop and explore an attachment to the immediate and concrete in visual experience without rejecting the formal studio art of Poussin and Claude.

In many paintings of Italian peasants of the 1820s there is a quality of nostalgia and sentimentality, arising from the artists' view of their subjects as contemporary primitives, uncorrupted by modern civilization (pl. 173). After observing Schnetz at work on a study of the famous Maria Grazia, Delécluze rhapsodized about the peasants:

> they are creatures fallen from heaven, like the snow of their mountains. They are unsullied by our civilization and while they live amidst it they cannot take part in it, or understand it. Here is what I want, because this spectacle fortifies my soul.[39]

Corot's conception of his peasant subjects derived in part from this vein of romantic primitivism. Among the figure subjects recorded by Robaut it is notable that men in their prime are few, heavily outnumbered by young women, boys, old men, and monks – types that most readily invite sentimental attachment. This choice of subjects owed a great deal to the milieu, but Corot replaced the conventional sentimentality with a mood of seriousness and contemplation. This mood would become a rich theme of Corot's mature work, above all in the late figures, which in their serene introspection recall their Italian predecessors. Unlike Michallon's figures, who have the blank expressions of bored or distracted models, Corot's peasants are absorbed with their inner thoughts, deep, mysterious, and often melancholy. We read this mood not only in their faces but also in their bodies, closed and compact, often with hands clasped. In one of Corot's most beautiful paintings a monk, cloaked and seated, becomes a massive pyramid, stable and self-contained (pl. 174). He reads his Bible with attention and reflection, his hand patiently poised to turn the page. This quality of equilibrium, of stillness and alert repose, of remoteness from the mundane and ephemeral, also is present in Corot's landscapes.

LANDSCAPES IN ROME AND THE IMMEDIATE ENVIRONS

Virtually every view Corot painted in and just outside of Rome was famous. Most of his studies repeat precisely, in vantage point and composition, long-established motifs of the *vedutisti*. Often this imagery evoked also the classical landscape tradition, as in two studies painted in December 1825 (R.48) and January 1826 (pl. 175). As a student in Paris Corot had copied prints of imaginary *fabriques d'Italie* (pl. 70); now at Rome he painted a real one, with a distinguished pedigree. The subject is a house just north of the Ponte Molle, called La Crescenza after its owners, the Roman Crescenzi family.[40] By the nineteenth century painters had come to call it "*la fabrique du Poussin*."[41] The sobriquet recalled Poussin's famous solitary walks in the surrounding landscape and recognized in La Crescenza an exemplar of the imaginary buildings he had introduced into the backgrounds of his pictures, such as *Summer* from the series of four seasons in the

146

174. Corot. *Italian monk reading*, 1826–28. (R.105.) Oil on canvas, 40 × 27.3. Buffalo, Albright Knox Art Gallery. George B. and Jenny R. Mathews Fund, 1964.

175. Corot. *View near the Tiber*, January 1826. (R.49–RS3.7) Oil on canvas, 18.7 × 33.3. Private collection.

Louvre. Claude in fact had painted La Crescenza, in a canvas similar in spirit to many of his nature studies (pl. 176). In 1820 Michallon also had drawn the motif, from the same direction as Claude, but from a closer viewpoint (pl. 177).[42]

In December Corot sought out La Crescenza and painted it from a distance (R.48). A month later he returned and moved closer, on the same axis of sight that Claude and Michallon had used (pl. 175). In the second work he achieved his definitive version of the image, in which the building sits with immutable

178. Corot. *View in the Farnese Gardens*, March 1826. (R.65.) Oil on paper, mounted on canvas, 25.1 × 40.6. Washington, The Phillips Collection.

176 (*far left*). Claude Lorrain. *View of La Crescenza*, *c*.1648. Oil on canvas, 38.7 × 58.1. New York, The Metropolitan Museum of Art. Purchase, The Annenberg Fund, Inc. Gift, 1978.

177 (*left*). Achille-Etna Michallon. *Building called "la fabrique du Poussin,"* 1820. Pencil on translucent paper, 21.5 × 26.3. Paris, Louvre.

nobility on the gentle hill. Its towers rise from the block-like structure in answer to the trees that rise from the terrain, making a sweet counterpoint of vertical accents within the horizontal frame.

Such a simple image of harmony between nature and man had been a staple of Italian outdoor painting since Valenciennes. But Corot's choice of subject – a famous one – marks a difference between him and the master of his masters. Valenciennes had avoided the celebrated monuments, as if to set his empirical enterprise apart from the habits of commercial topography. Corot favored such motifs, as if to invest his outdoor work with historical significance.

After about three months in Rome, at the beginning of March 1826, Corot set himself a task that further reveals his departure from Valenciennes's example. He set out to make a trio of finished studies (*études terminées*), a term that for Valenciennes had been a self-contradiction.[43] Valenciennes had criticized the practice of returning to the same site at the same time on successive days, arguing that the light and weather changed too much from day to day. Yet this is precisely what Corot did. For almost three weeks in March he painted every day on the Palatine Hill, working on one study in the morning (pl. 178), the second at midday (pl. 179), the third in the late afternoon (pl. 180).[44] He followed the sun. In the morning he faced east-southeast, toward the church of S. Sebastiano in Palatino. Then he moved slightly to the west, facing east-northeast, toward the Colosseum. In the afternoon he moved further west and sat down looking north, over the Forum.

Corot's concern to distinguish among particular conditions of light recalls

179. Corot. *View of the Colosseum from the Farnese Gardens*, March 1826. (R.66.) Oil on paper, mounted on canvas, 30.5 × 48. Paris, Louvre.

Valenciennes's pairs of studies of the same subject at different times of day (pls. 28, 29). In this sense the three Palatine views were an exercise in empiricism. But Corot's conception of the studies also had another source and another purpose. The scheme belongs to an old tradition of classifying nature's ceaseless change: the times of day, for example, or the seasons. The most famous series of pictures painted on this principle was Poussin's *Four Seasons*, in the Louvre, but there were many others, among which the pendant format was the most common, especially in the work of Claude.[45]

As Hélène Toussaint has observed, Corot applied the same organizing scheme to the pendant compositions he painted in the winter of 1826–27 and sent to Paris for the Salon of 1827.[46] Following a common practice, Corot superimposed three parallel conditions of nature in each of the two works. The *View at Narni* (pl. 203) represents morning, summer, and sunny weather; the peasants, at rest, are in tune with the calm splendor of the scene. The *Roman Campagna* (pl. 205) represents evening, fall, and a storm; in keeping with the landscape mood the peasants are vigorously active, rushing to get home before the worst of the storm arrives.[47] At the Salon of 1798 Valenciennes had exhibited comparable pendants: *Two views of Italy, one a scene of calm, the other of storm* (no. 399). At the Salon of 1827, where Corot's pendants appeared, his master Bertin showed *View in Tuscany, impression of morning . . .* and *View in the Sabine, impression of midday . . .* (nos. 1423, 1424).

The pendant format was of course aimed at imposing conceptual clarity upon the flux of nature. That Corot employed such a formula for his three Palatine

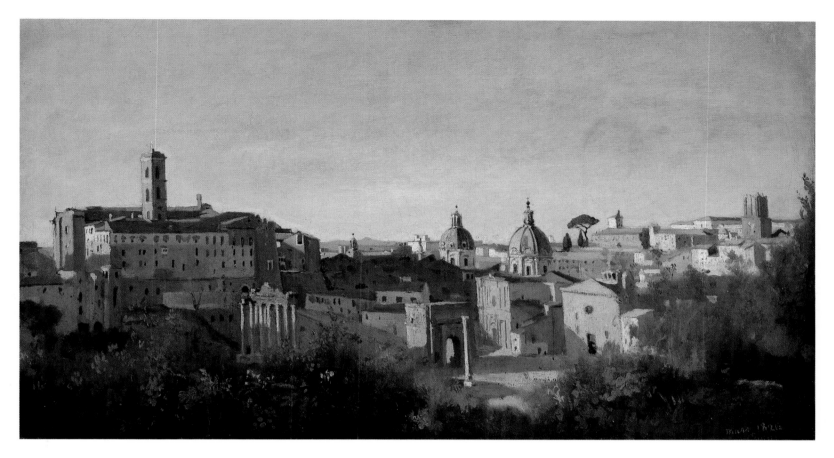

180. Corot. *View of the Forum from the Farnese Gardens*, March 1826. (R.67.) Oil on paper, mounted on canvas, 28.8 × 50.4. Paris, Louvre.

views of March 1826 is a symptom of his effort to bring order and stability to his studies after nature. But if Corot applied the spirit of the *tableau* to his sense of the *étude*, the reverse also is true. Painted in the studio after a long campaign in the countryside, Corot's two Salon pictures of 1826–27 are far less artificial and formulaic – far less remote from the studies – than is often supposed. Just as Corot applied the lessons of composition to his work from nature, so he achieved a degree of naturalism in his Salon pictures that was unprecedented in French Neoclassical landscape painting.

One small detail of the *Roman Campagna* gives the flavor of this achievement. It is the boy running for cover in the middle distance on the right. In the preparatory studio sketch for the picture (pl. 206), this position (and role) had been occupied by a horse and rider caught in an artificial leaping pose used so often in earlier landscapes to animate the scene. (There is one in the landscape by Gaspard Dughet of which Corot had copied a detail in an early student sketchbook[48] and another in Bertin's *Italian landscape* of about 1810 [pl. 48].) Transforming the horse and rider into a boy, Corot completed the process of bringing his picture down to earth, of translating inherited convention into the idiom of the contemporary Italian scene.

By devoting many sessions of work to the three Palatine studies, Corot showed his dissatisfaction with Valenciennes's rapid method. In one of his Italian sketchbooks he wrote:

> One must be severe in the face of nature and not content oneself with a hasty sketch [*un croquis fait à la hâte*]. How many times in reviewing my drawings have I regretted not having had the courage to stay at it half an hour more! . . . One must not allow indecision in a single thing.[49]

151

181. Johan Christian Dahl. *Villa Malta, Rome*, 1821. Oil on canvas, 34.5 × 38.5. Oslo, Nasjonalgalleriet.

If Corot did not intend explicitly to contradict Valenciennes's dictum that studies must be "made in haste" (*faites à la hâte*[50]), he instinctively did so in his work. The carefully observed details of the Palatine studies reflect a determined effort to replace Valenciennes's haste with a more deliberate approach. In fact one of the three "studies" – the *Colosseum* (pl. 179) – itself had been prepared by earlier studies: a painting of December 1825 and a drawing that doubtless immediately preceded the final work.[51]

The patient style of Corot's three Palatine views may owe something to the small finished pictures of Eckersberg and others (pl. 181). Michallon had painted a number of comparable works, which may well have been executed in the studio. An example is a view of the Colosseum (pl. 182), incomplete but in the painted areas highly finished. Notice especially the foliage of the tree in the foreground, which is described with extreme regularity, leaf by leaf. Whether made outdoors or in the studio, Michallon's view or others like it may have suggested to Corot an alternative to Valenciennes's often imprecise method, whose very different results are evident in a variant of the same motif (pl. 183).

Corot's *Colosseum* won him the admiration of Caruelle d'Aligny and other young painters in Rome; it was after watching Corot at work on the picture that Aligny announced to the assembled landscapists at the Caffè Greco that Corot was "our master." Perhaps partly for this reason, Corot cherished the picture and showed it at the Salon of 1849.[52] Along with the two companion views, he intended to bequeath it to the Louvre.[53] Nevertheless, he soon abandoned the procedure of multiple sittings and with it the somewhat labored style.

In May 1826, about a month after completing the three Palatine views, Corot left Rome for the first time, for Civita Castellana, some thirty miles north. There he embarked on a series of stylistic experiments, which led him far beyond his first plateau of competence, and which will receive close attention here. In the meantime it will be useful to examine Corot's mature Italian style as he applied it in several undated studies painted later at Rome. Any of them could have been made as late as the summer of 1828.

182. Achille-Etna Michallon. *The Colosseum*, 1817–21. Oil on canvas, 26.5 × 39. Private collection.

152

The Palatine views expressed Corot's determination to bring a new formality and completeness to outdoor painting. Reviewing the range of stylistic precedent, from the fluidity of Valenciennes to the precision of Bidauld, Corot leaned toward the latter. A daguerreotype made some fifteen years later from the same vantage point that Corot had adopted for the *Forum* proves how faithfully he recorded the dense accumulation of buildings.[54] He enlivened the rather deliberate manner with a delicate sensitivity to the light of the evening sun. But as yet he was unable to master the space as a complex whole. Spatially, both the *Forum* and the *Colosseum* are composed of two, imperfectly joined parts: a uniform middle distance, treated as a single plane of depth; and a dark, artificial foreground, probably painted or repainted later in the studio.

The way Corot resolved this limitation is suggested by his earlier study at Constantine's Basilica (pl. 161). That study, essentially a monochrome design, lacks the coloristic sophistication of the *Forum*. But it possesses a commanding unity, which favors clarity of structure over accuracy and multiplicity of detail. Corot's essential achievement was to marry this structural principle to his mastery of color and light. The key to that marriage was drawing.

Superficially, Corot's style was no different from the anonymous convention of outdoor painting in Italy. He used the same simple palette of fresh colors, deployed frankly on the paper or canvas. But Corot introduced a new rigor to the style, by the simple means of separating the problem of form from the problem of color.

In his mature Italian work Corot typically began a study by drawing the entire composition first in pencil, with little or no modeling. In some cases he made this preparatory drawing on a separate sheet and transferred it to the support of his painting. In other cases he drew directly on that support. Once confident that he had resolved the composition he began to fill in the outlines with paint, much as a child works on the designs of a coloring book. This is a crude description of a method that Corot applied with great subtlety, but he himself described the division of labor in much the same way:

183. Pierre-Henri de Valenciennes. *The Colosseum*, 1782–84. Oil on paper, mounted on cardboard, 25.5 × 38.1. Paris, Louvre.

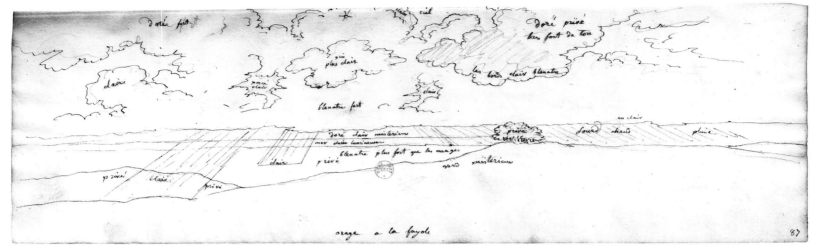

184. Pierre-Henri de Valenciennes. *Storm at La Fayolla*. Pen and ink over pencil on paper, 11.6 × 35.8. "Rome" sketchbook, f. 87. Paris, Bibliothèque Nationale.

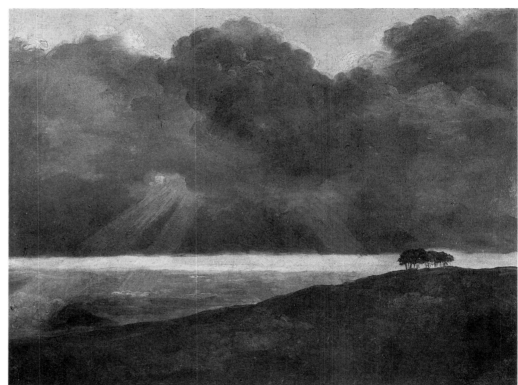

185. Pierre-Henri de Valenciennes. *Storm*. Oil on paper, mounted on cardboard, 17.8 × 23.2. Paris, Louvre.

facing page Detail from pl. 179 (Corot).

I have learned from experience that it is very useful to begin by drawing one's picture very purely on a blank canvas . . . next, to paint the picture part by part, each as finished as possible from the start, so as to have little left to do once the whole canvas is covered.[55]

Later, in a similar vein, he wrote, "First pursue form; afterward, values or relationships of tone, color, and execution."[56]

Corot's method was not without precedent. Valenciennes, like many other painters, sometimes made drawings labeled with color notes, often when changing weather made impractical even the most rapid painted sketch (pl. 184). In at least a few cases he later translated such a drawing into oil colors (pl. 185). Nor was there anything exceptional about beginning a study in oil with a rough sketch in pencil. Nevertheless, Corot's application of this old practice was

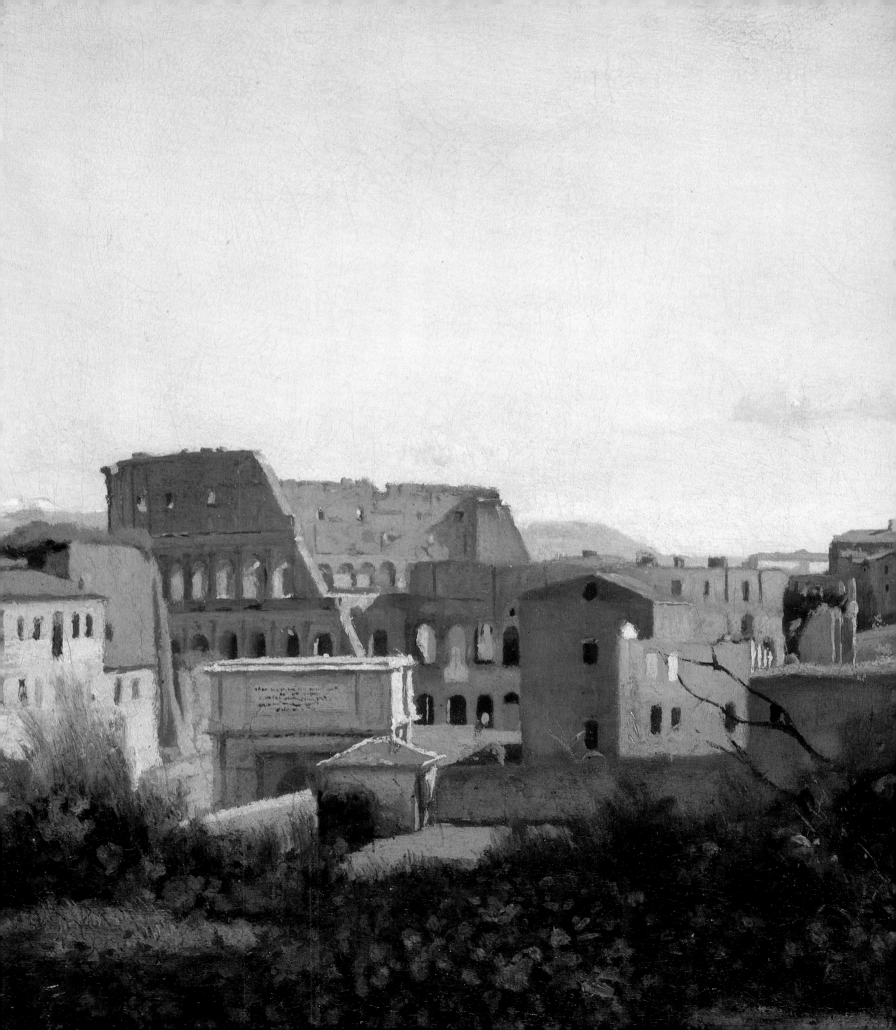

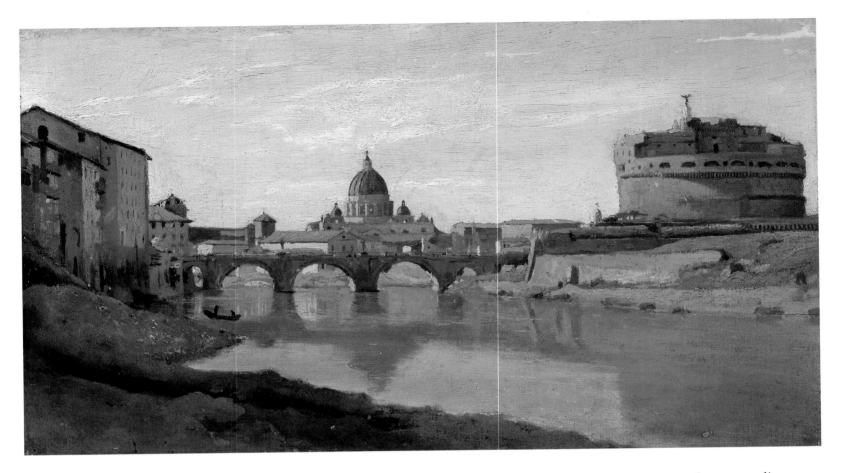

186. Corot. *View of St. Peter's and the Castel Sant'Angelo*, 1826–28. (R.70.) Oil on paper, mounted on canvas, 20 × 37. San Francisco, The Fine Arts Museums. Museum purchase, Archer M. Huntington Fund.

fundamentally new. For him the initial drawing was not merely an expedient, or a crutch, or a starting point; it became an integral and active element in his work.

The preparatory drawing was useful in two ways. First, it allowed Corot to establish a fully resolved composition in which each constituent element had a precisely determined function in the overall design. Here is the reason why these

187. Corot. *View of St. Peter's and the Castel Sant'Angelo*, 1826–28. Pencil on paper, 13.4 × 21.8. Rotterdam, Museum Boymans-van Beuningen.

156

188. Corot. *Island of San Bartolommeo*, 1826–28. (R.75.) Oil on paper, mounted on canvas, 27 × 43. Private collection.

small works have a monumental scale: it is the logical hierarchy of forms, from the smallest to the largest, that gives Corot's studies the authority of big pictures.

Second, the pencil drawing relieved Corot of the need to draw with the brush. As he filled in the outlines with paint, the drawing disappeared. The result was a taut mosaic of interlocking blocks of color, each treated as a single touch, or patch of touches, of the brush. Here the small size of the studies also played an essential role: only at that size could the system of one-touch units so successfully mediate between the hand and the picture's whole surface.

Exemplary of Corot's mature style are two of his most famous views, one across the Tiber toward St. Peter's Basilica and the Castel Sant'Angelo (pl. 186), the other of the Island of San Bartolommeo (pl. 188). In the view toward St. Peter's all elements of the scene have been translated into geometric units, linked by an underlying grid of horizontals and verticals. The bold curve of the Castel Sant'Angelo is accommodated within a massive rectangular form, its base extended by the rigid horizontal of the bridge. This architectonic scheme is animated by a series of overlapping symmetries. The silhouette of St. Peter's – symmetrical in its own arrangement of major and subsidiary domes – lies to the left of the center of the picture, to the right of the center of the bridge, but almost exactly in the center of the space between the fortress and the houses on the left bank of the Tiber. Another symmetry is deployed across the horizontal axis of the picture by the reflection of the two monuments in the water. Corot subtly reinforced

this symmetry, linking the reflections by the diagonal of the foreground bank, matched by a thin cloud in the sky.

A drawing of the same motif (pl. 187), stripped of modeling, is a smaller twin to the linear scaffold that lies beneath the opaque paint of the study. The sureness of the drawing, the absence of revisions, the close correspondence to the oil study even in small details suggest that it is not a preparation but a reprise. In that case the drawing reveals all the more clearly the systematic character of Corot's method, for if indeed it is a copy its function was to help Corot analyze and refine his own style.

The view of the Tiber Island is a variation on the theme (pl. 188). A stable, embracing symmetry organizes a hierarchy of forms, from the large and few at the periphery toward the small and many at the center. The bridge on the left answers the one on the right, itself bisected by shadow and by the decisive verticals of the houses seen through its arch. Those vertical accents are a model of harmonic progression, which Corot elaborated into symphonic richness at the center. There the compact arrangement of shapes is full of subtle correspondences, free of mechanical repetition. The constructive units of geometry seem to display an infinite variety, but in fact they all occupy a narrow range of size and shape. The same is true of the color scheme. Except for the blue of the sky and water, the palette is restricted to a limited sequence of ochres and browns and a single hue of green.

It is precisely this limited vocabulary that has allowed Corot to be so articulate. In its geometric hierarchy as in its color harmony, the picture is a mosaic of step-like intervals, each unerringly measured in respect to its neighbors and to the whole. The narrowness of the choices simplified the precise calculation of each, a precision that is essential. It is not the descriptive fidelity of the individual parts but their perfect concert in the whole that makes the image ring true. To isolate any small section of the island checkerboard is to see how poor it is in literal information.

The picture is radical in the way it describes light and space. The light is not a quality separate from the things it makes visible; the two are presented as one experience. Conventional modeling has disappeared. Also gone are the clues of linear perspective; barely a single diagonal slants into depth. The eye judges the advance and recession of the buildings, as it judges the unity of light, from the interplay of discrete parts within the tightly knit whole. Here, perhaps more clearly than in any other study, light and space are created solely by color. It is above all in this sense that Corot's Italian style belongs to the family of modern painting.

Corot's insistence on the integrity of the painted surface sets him apart from and perhaps ahead of his contemporaries. But his color mosaic is not like the diaphanous field of high Impressionism. Objects proudly retain their tangible identity, and the ordering presence of geometry is always felt. Nevertheless, Corot's alertness to the two-dimensional puzzle of painting ever was at work, leading him often to elegant solutions and, sometimes, to brilliant surprises.

One such surprise occurs in another small masterpiece of Corot's first maturity. It is a view over the brightly lit rooftops of Rome toward St. Peter's, framed in the foreground by the massive dark forms of two trees and the fountain in front of the Villa Medici (pl. 189). It was a popular motif, represented slightly earlier by Catel (pl. 191).[57] Corot's composition is a model of classical symmetry and sobriety. A preparatory drawing (pl. 190) shows how he refined and enriched the inherited image, discovering echoes of St. Peter's dome in the opening be-

189. Corot. *Fountain of the French Academy, Rome,*
1826–28. (R.79.) Oil on canvas, 18 × 29. Dublin,
The Hugh Lane Municipal Gallery of Modern Art.

190. Corot. *Fountain of the French Academy, Rome,*
1826–28. (R.2560.) Pencil on paper, 13.7 × 25.1.
Paris, Louvre.

tween the trees and in the forms of the fountain. In the process of working out
the design he made one further discovery, astonishing and radical.

From Corot's viewpoint on the Pincio, the great basilica is seen obliquely, so
that one of its smaller flanking domes is subsumed within the mass of the large

160

central dome, destroying the building's symmetry. Corot found that he could restore the beloved symmetry by substituting the spout of the fountain for the missing dome. This visual pun is not like the approximate rhyming shapes found in many older pictures. It is a precise identity, which exists only in the picture and not in the world it depicts, where the dome and spout are miles apart and vastly different in size. It is a stunning by-product of Corot's disciplined attention to the organized field of painting. And it celebrates the determining position of Corot's single viewing eye. Had he moved but a few inches, the strangely exciting identity between large and small, near and far, would have evaporated.

Yet there is no doubt that Corot's peculiarly modern discovery is an outgrowth and expression of his classical habits. Here is the same dense alloy of new and old that first presented itself in the study of three arches painted in December 1825 (pl. 161). There, too, Corot discovered a surprising identity – between two arches of the Colosseum and the two open arches of Constantine's Basilica in the foreground. In both pictures the identity leaps across a deep space that is available only to the eye. And in both pictures this spark of pure vision is integral to a rigorously classical design.

This highly original aspect of Corot's Roman work occasions a reminder that all of the studies under discussion repeat established motifs of the *veduta* tradition. The view across the Tiber toward St. Peter's has been traced to the mid-sixteenth century,[58] and others were nearly as old. In an instrumental sense even Corot's first pencil sketch was not an invention but a refinement. Just as the act of painting was regulated and clarified by the initial drawing, so the drawing itself was guided by tradition.

The confidence that Corot derived from the rich fund of Roman imagery is an

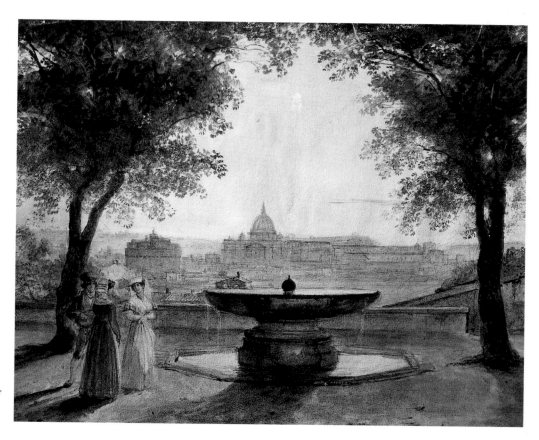

191. Franz Ludwig Catel. *View of Rome from the Pincio*, after 1811. Pencil and watercolor on paper, 22.5 × 30.4. Bremen, Kunsthalle.

192. Nicolas Poussin. *View of the Tiber*, c.1635–40. Pen and ink and brown wash on paper, 20 × 14. Montpellier, Musée Fabre.

193. After Léon Benouville. *Poussin on the bank of the Tiber, discovering the composition of his "Finding of Moses"*, 1857. Lithograph. Paris, Bibliothèque Nationale.

194. Corot. *La Promenade du Poussin*, 1826–28. (R.2481.) Pen and ink over pencil on paper, 28.5 × 45. Paris, Louvre.

essential ingredient in his work. It would be impossible to demonstrate just how his trust in the venerable design and august meaning of his views contributed to the poise of every mark he made on the paper. But what is known of Corot's outwardly restrained, even docile character, and of his inward determination, matches this image of his work. It was the deeply felt presence of past greatness, of Poussin and Claude, that spawned Corot's most original innovations.

Poussin of course had not been a view painter, but Corot had every reason to identify with Poussin as he sketched in the environs of Rome. Doubtless he felt this affinity most strongly on the banks of the Tiber just north of Rome, the neighborhood of the *fabrique du Poussin* that Corot painted in December 1825 and January 1826 (pl. 175). It was there that Poussin often had taken his famous solitary walks, to escape the city and study the landscape (pl. 192). Well before Corot's arrival in Rome, a particular stretch of the riverbank had been consecrated as the site of Poussin's meditative walks, as Delécluze reported in his journal on 8 February 1824:

> Then I left the city by the Porta del Popolo and took the route called *la promenade du Poussin*. It is a road that follows the banks of the Tiber up to the Ponte Molle.... This solitary spot pleased me; the memory of Poussin associated with the place was agreeable; it recalled to me my childhood, my earliest studies, my friend Lullin, and I was at Rome more than ever. I crossed the Ponte Molle and the battle of Maxentius came back to me in spirit.[59]

Later in the century this admiring identification of the actual landscape with the glories of Roman history and the greatness of Poussin would reach a peak of sycophantic delirium.[60] It is hard now to swallow *Poussin on the bank of the Tiber, discovering the composition of his "Finding of Moses"* (pl. 193), a painting of 1857 by Corot's disciple Léon Benouville (1821–1859). The picture shows Poussin himself seated on the bank of the Tiber next to the Ponte Molle, built on the site of the Pons Milvius, where Constantine consummated his defeat of Maxentius in AD 312. The object of Poussin's attention is three Italian peasant women, washing

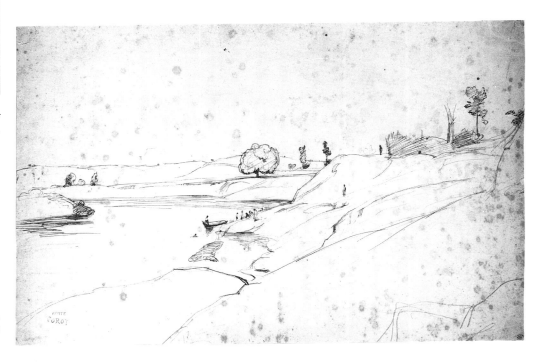

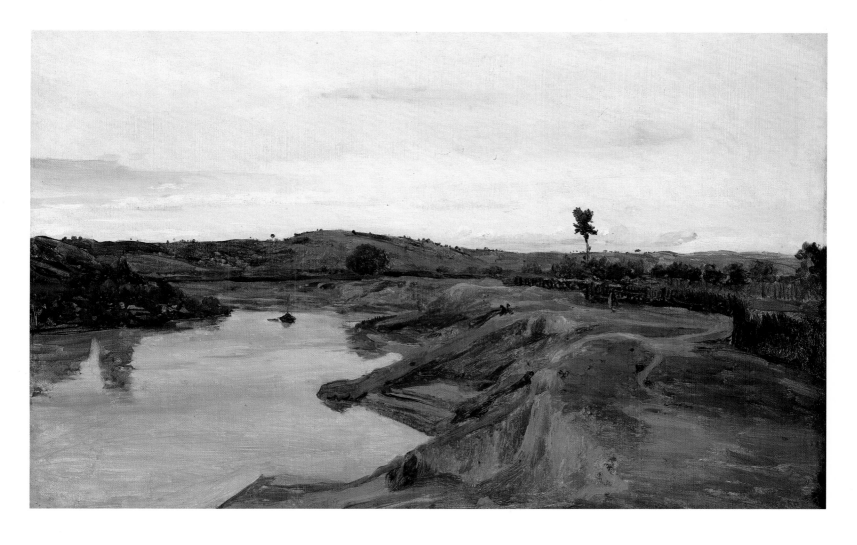

195. Corot. *La Promenade du Poussin*, 1826–28. (R.53.) Oil on paper, mounted on canvas, 33 × 51. Paris, Louvre.

clothes and bathing an infant in the river. As the picture's title makes clear, the implication is that Poussin, instead of inventing his *Finding of Moses* in the studio, merely transcribed a scene he witnessed on the banks of the Tiber.

Benouville's absurdly literal conceit collapses into self-parody. But his distinctly modern motive – to bring Poussin's lofty idealism down to earth – is relevant to Corot's work. For in effect Corot's view of the *promenade du Poussin* is an ideal Poussinesque composition discovered in nature (pl. 195). Corot intuitively applied the program that Cézanne later explicitly described as remaking Poussin from nature, and it is in this sense that Corot in Italy is best compared with Cézanne: for both painters the empirical grasp of nature was inseparable from the organizing impulse of art.

The drawing Corot made for his painted study of the *promenade du Poussin* shows this impulse at work (pl. 194). Already in the drawing Corot found a closed, balanced composition fixed in the center by the circular mass of a tree. In the painting he further rationalized the design. He moved further away and higher, to even the horizon, and gave equal areas below to riverbank and river. He divided earth from water with a powerful zig-zag descending from the horizon. And he moved the boat so that it drops below the horizon in an elegant symmetrical echo of the single tree that rises above the horizon on the other side of the picture.

Earlier Granet had painted a study nearby, which anticipates Corot's approach

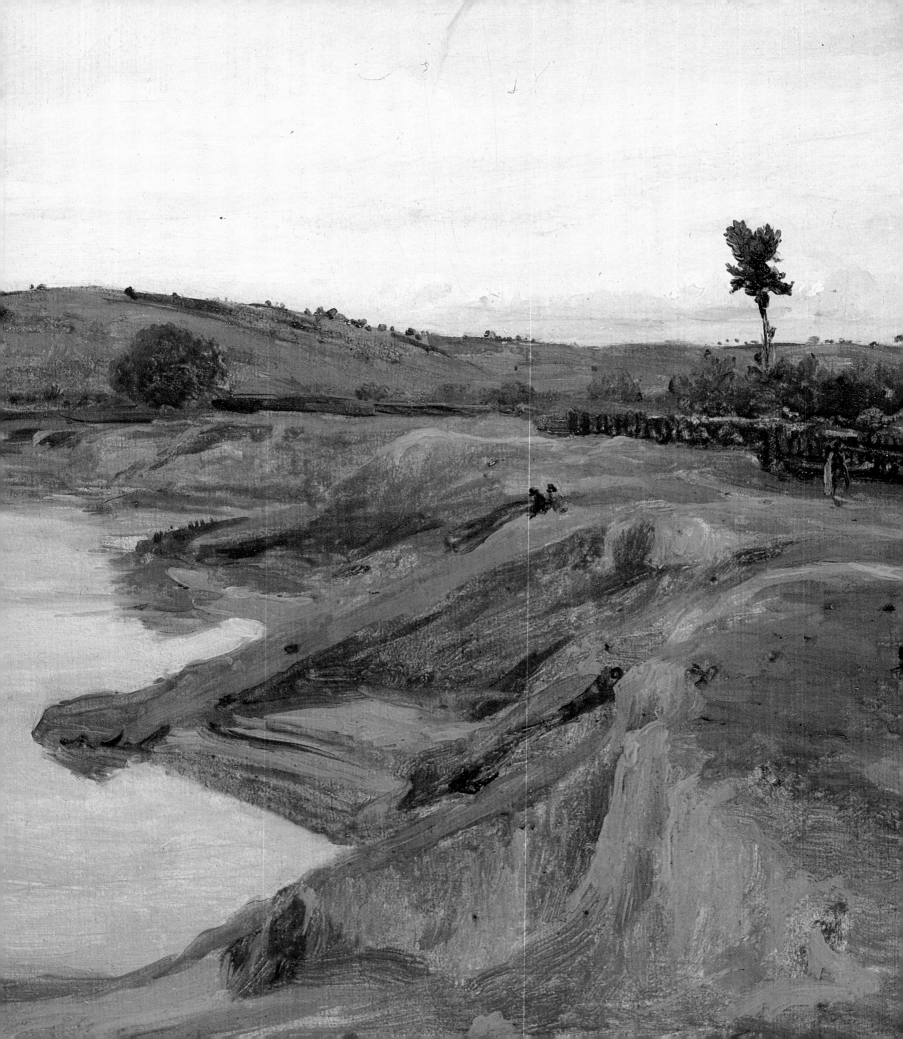

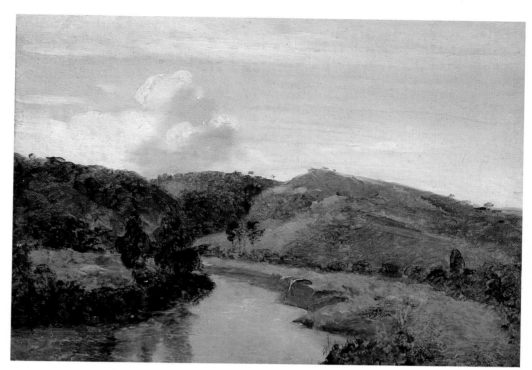

196. François-Marius Granet. *The Tiber near the Porta del Popolo*, 1802–19. Oil on paper, mounted on canvas, 22 × 30.4. Aix-en-Provence, Musée Granet.

(pl. 196). But Corot, exploiting the initial drawing, achieved in his study a deeper seriousness, a new wholeness and grandeur. Here and in his entire Italian program he effectively exchanged the poles of Valenciennes's theoretical model. For Valenciennes the primary function of the *étude d'après nature* was to provide the painter with an intuitive grasp of nature, which later he could apply to his compositions. Corot transformed this process, accepting its structure but reversing its direction, by applying his intuitive grasp of classical landscape composition to the *étude d'après nature*. In doing so he brought the deliberation and authority of formal studio art to his work from nature, without compromising its spirit of fresh visual discovery. This transformation arose in part from Corot's systematic training, in which study after nature was integrated with the study of older art. It also depended upon the example and support of many other outdoor painters who preceded and worked beside Corot in Italy. Nevertheless, Corot most completely realized the collective trend. The process by which he did so can be observed most fully in his work outside of Rome.

LANDSCAPES IN THE COUNTRYSIDE

In Rome Corot's reliance on established tradition may be judged by the frequency with which he borrowed from the repertory of *vedute*. In the countryside the repertory was less comprehensive. But there, too, Corot sought out a number of well-known motifs, such as the lakeside town of Castel Gandolfo (pl. 136) and the ancient Ponte Nomentano (pl. 197). In a watercolor of 1819–22 (pl. 198) Johann Christoph Erhard provided the famous bridge with an elaborate picturesque setting: a tree and peasants in the foreground and, in the distance, buildings, more peasants, a billow of smoke, and a mountain. In an oil study of 1826–27 by Carl Rottmann the high, distant vantage point yields a generous panorama of the surrounding terrain, in which the Roman bridge is presented as

left Detail from pl. 195 (Corot).

165

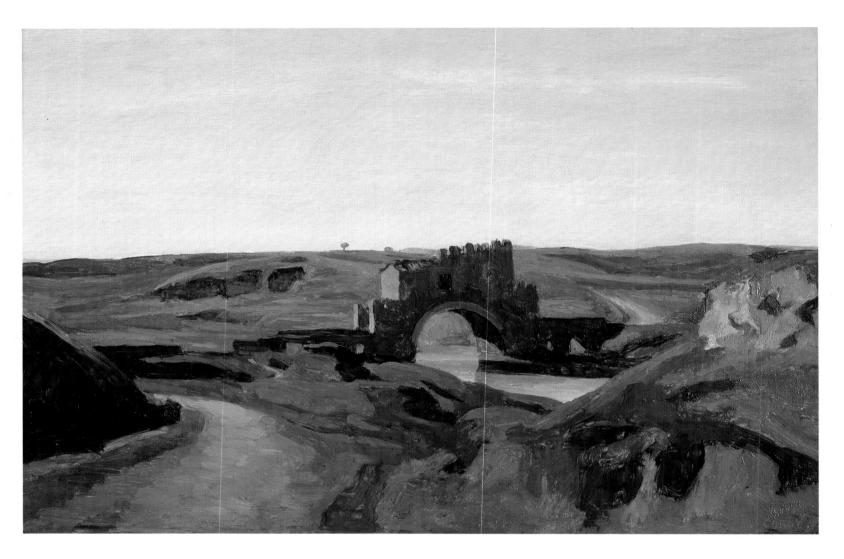

197. Corot. *Ponte Nomentano*, 1826–28. (R.72.) Oil, 28.5 × 42.5. Rotterdam, Museum Boymans-van Beuningen.

a highlight for the viewer's roving eye (pl. 199). Corot understood the motif very differently, focusing forthrightly on the monument and excluding superficial incident. His slightly oblique approach to the bridge allowed him to pick out a bright accent, placed exactly in the center of the picture, and to emphasize the bold, semi-circular curve of the arch. This curve is echoed by the bright crescents of the road, near on the left and far on the right, which frame the bridge in space much as the opposing banks in the foreground frame it across the breadth of the picture. The composition is unified but not static; the space is closed and focused but unfolds evenly from near to far.

The color and execution of this study also deserve comment. It is a robust work, dominated by rich, fluid browns, ebulliently laid down with a heavy brush. Corot's confidence in his powerful design and his delight in his skill are complete. Beside this study the view of the Tiber Island is quiet and restrained. Yet this is a delicate work, too. Subtle modulations of color fill the landscape with light and air. Tiny trees in the distance are perfectly calculated in scale, to make the space deep, while the crenellations of the bridge play a game of near-and-far with the horizon.

Corot borrowed another motif from the *vedutisti* for his study of the ruined Augustan bridge at Narni, painted in the fall of 1826 (pl. 200). It served as the basis for one of the two pictures he painted that winter and sent to Paris for

166

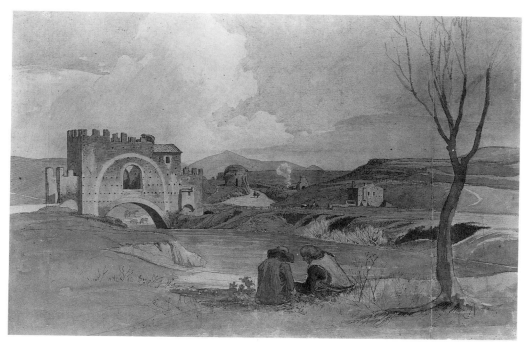

198. Johann Christoph Erhard. *Ponte Nomentano*, 1819–22. Pen and ink and watercolor on paper, 23.5 × 36.6. Hamburg, Kunsthalle.

199. Carl Rottmann. *Ponte Nomentano*, 1826–27. Oil on paper, 35 × 51.7. Dusseldorf, Kunstmuseum.

the Salon of 1827 (pl. 203). Corot worked toward the composition through preparatory drawings, two of which have survived, one a detail of the left-hand side of the picture,[61] the other a sketch for the whole (pl. 204).[62]

The transformation of study into exhibition picture is the occasion of a familiar litany in the modern literature on Corot: the painter added a conventional *repoussoir* in the lower right corner; he widened and flattened the left bank to provide a stage for the inevitable pastoral staffage; above this he added a screen of trees, a dense clump and apart from it two umbrella pines standing out against the horizon; and he tamed his brushwork, substituting a more uniform manner for the fluid strokes of the sketch. In short, it is said, he abandoned the spontaneous

200. Corot. *The Augustan bridge at Narni*, September 1826. (R.130.) Oil on paper, mounted on canvas, 34 × 48. Paris, Louvre.

vision of the initial study for an artificial formula, borrowed from Claude and designed to conform to the standards of public art.

The argument implies that Corot, like the modern viewer, preferred the *étude* to the *tableau* and prepared the latter only to satisfy a canon of taste he did not share. This implication contradicts everything that is known about Corot's training and outlook, not to mention the broad community in which he worked. It stresses the difference between the two works at the expense of equally important similarities. But the exhibition picture is not a wholly artificial concoction. It is an organic elaboration of the study, in which many qualities of the latter were retained. This was possible because the study itself was already a fully resolved classical composition, with balanced wings, a monument in the middleground, and a central vista leading into the distance. Even such minor details as the shadow of the bridge and the accents of light are already in harmony with the whole. So deeply did Corot admire Claude and Poussin, so fully did he understand their work, that from the outset he viewed nature in their terms. Far from seeking release from rigid Neoclassical principles, Corot had absorbed them so completely that they informed every aspect of his work.

The sureness of Corot's classical intuition will become all the more clear if his Narni study is compared with drawings of the same motif made in 1821 by his

201. Achille-Etna Michallon. *The Augustan bridge at Narni*, June 1821. Pencil on paper, 34 × 45. Paris, Louvre.

202. Ernst Fries. *The Augustan bridge at Narni*, May 1826. Pencil on paper, 44.9 × 58.5. Heidelberg, Kurpfälzische Museum.

teacher Michallon (pl. 201) and in 1826 by his friend Fries (pl. 202). All three works were made from approximately the same vantage point, established earlier by the professional view makers. Michallon and Fries have given exaggerated importance to accidental details of the terrain, especially in the foreground, which

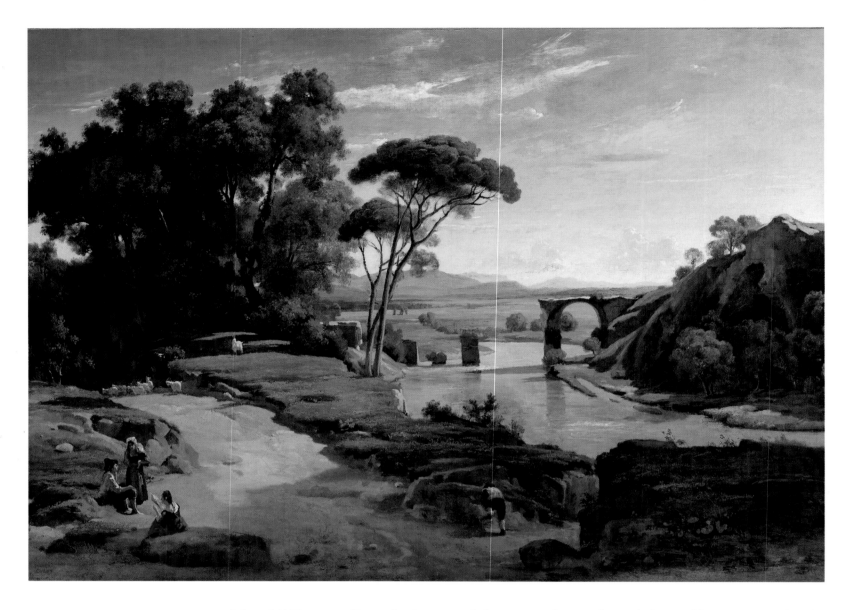

203. Corot. *View at Narni*, 1826–27. Salon of 1827. (R.199.) Oil on canvas, 68 × 94.5. Ottawa, National Gallery of Canada.

204. Corot. Preparatory sketch for *View at Narni*, 1826–27. Pencil on paper, 30.4 × 46.6. Ottawa, National Gallery of Canada.

complicate the image and draw attention to the artist's specific vantage point. In comparison, the foreground of Corot's study lies at a great distance from the viewer; it is fully incorporated into the balanced scheme and measured space of the whole. The drawings of Michallon and Fries are lively excerpts from a travelogue; Corot's study is sober and reserved, abstracted from experience. Yet the light and color and space are palpable and real; the fluid brushwork responds sensitively to the changing surfaces of foliage and water and stone. There is nothing artificial about Corot's classical image.

Corot painted the Narni study in September 1826, nine or ten months after arriving in Rome. In less than a year he had realized his goal of closing the gap between the empirical freshness of outdoor painting and the organizing principles of classical landscape composition. The following pages seek to analyze the process of that achievement in great detail.

One of Corot's most striking Italian landscapes, undated but probably painted in the spring of 1826, provides a good starting point. It is a view of the Campagna southeast of Rome, a work once owned by Degas and now in the National Gallery, London (pl. 207). One reason for proposing the early date is that the study

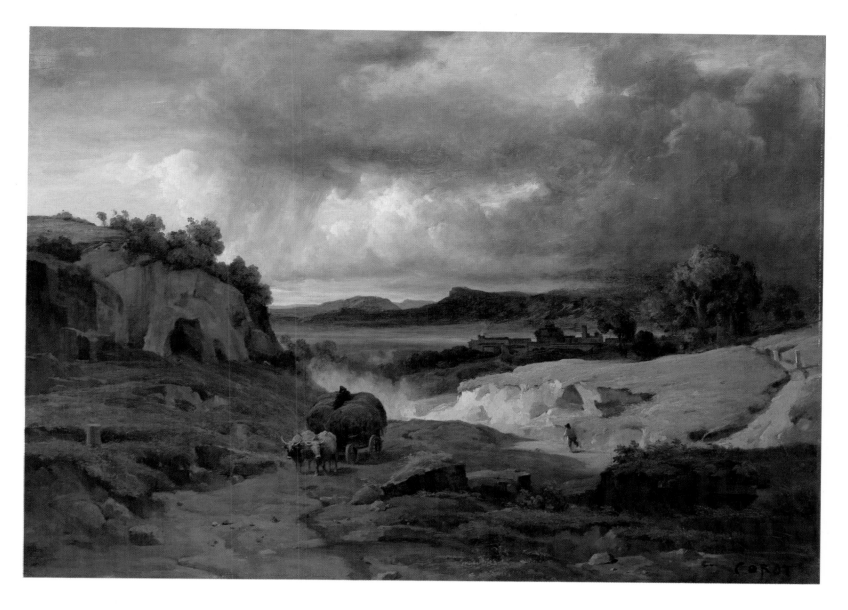

205. Corot. *The Roman Campagna*, 1826–27. Salon
of 1827. (R.200.) Oil on canvas, 68 × 95. Zurich,
Kunsthaus.

206. Corot. Preparatory sketch for *The Roman
Campagna*, 1827. (R.2459B.) Oil on canvas, 29.6 ×
43.5. Paris, Louvre.

apparently lacks an underlying drawing and thus also the compositional serenity
of Corot's mature style. Compared with the reserve of other studies, this one
is awkward. It is the awkwardness not of incompetence but of experiment and
discovery, and it is the source of the work's uncanny power.

Quite simply, Corot sought by main force to impose a full-blown classical
composition on the sprawling landscape, and the picture's discontinuities and
competing forms bear witness to his struggle. All the familiar elements of
Poussinesque composition are here: the alternating, receding masses, which
enter from either side of the frame; the foreground shadows and bright middle
distance; the central architectural motif and the vista of mountains, which act
as a visual goal. What is missing is the gentle transitions that insure the spatial
continuity of Poussin's pictures.

Striving to extract pictorial coherence from the broad view, Corot abandoned
the niceties of conventional description. He transformed a patch of green in the
middle distance into a band of bright, unbroken color. And he gave weight and
prominence to the cloud directly above the central tower, establishing a strong
symmetry with the aggressive shadow below. The hillock and bush on the right

171

207. Corot. *The Roman Campagna with the Claudian aqueduct*, 1826? (R.98 *bis.*) Oil on paper, mounted on canvas, 21.6 × 33. London, National Gallery.

have congealed into a dense mass, which stands up vertically to merge with the undulating line of the distant mountain range. Notice also the strange, bulbous shape of the shadow.

Corot's organizing impulse overpowered the scene. Instead of passively transcribing his view of the sunlit Campagna, he recreated the palpable forms of the landscape on the surface of his picture. The painting, with its abrupt transitions and wide range of saturated colors, its obstreperous contest of un-tamed forms, is opposed stylistically to the view of the Tiber Island (pl. 188), with its narrow tonal harmonies and settled composition. It is a primitive solution – all energy and no finesse – and possesses the visceral appeal of the early stages of many developments in art.

When Corot arrived in Italy, however, outdoor painting already was reaching a stage of maturity, and he rapidly absorbed the lessons of other artists. Joining the mainstream of a practised style, Corot soon moved beyond the struggle of the London picture toward more refined solutions. The process may be observed in detail in the work of Corot's first campaign at Civita Castellana in May and June 1826, his first excursion beyond the immediate outskirts of Rome. Before taking up that campaign, however, it will be useful to consider Corot's original approach to drawing.

THE ROLE OF DRAWING

Corot had accomplished very little in drawing before he arrived in Italy. Although he had copied drawings by Michallon, he had not yet learned to apply his master's lessons in the field. Most of the surviving drawings from Corot's student years are tiny sketchbook scribbles, and the few of any size are stiff and maladroit. The earliest Italian drawings, too, are rather timid.[63]

The prevailing style of landscape drawing in Italy was a linear Neoclassical manner. Ingres's Roman drawings offer the purest example of this international convention, but it appears also in many works by Corot's companions (e.g., pl. 208). The medium of monochrome washes, derived from Poussin and Claude and employed by David and Valenciennes, had all but disappeared. To indicate light and shadow the artists used areas of parallel hatching, which enrich but never compromise the linear austerity of the whole (pl. 209). After a few months in Rome Corot had achieved competence in this style (pl. 210).

It has been suggested that Corot learned the style from Aligny, although in

208. Jean-Charles-Joseph Rémond. *View from the Tarpian Rock, Rome*, 1822. Pencil on paper, 23.2 × 39.2. Paris, Ecole des Beaux-Arts.

209. Achille-Etna Michallon. *Near Marano, on the road to Subiaco*, July 1818. Pencil on paper, 28.1 × 43.1. Paris, Louvre.

210. Corot. *Group of young pines near the Ponte Molle*, 21 March 1826. Pencil on paper, 28.5 × 42.8. Bern, Kunstmuseum.

211. Corot. *Civita Castellana*, 1827. Pen and ink on blue paper, 20.4 × 27.8. Oxford, Ashmolean Museum.

212. Franz Horny. *Italian landscape*, 1816–24. Pen and ink on paper, 18.3 × 12.5 Hamburg, Kunsthalle.

the context of the rich artistic exhange at Rome it would seem pointless to isolate a single source.[64] It is possible, however, that Corot did learn from Aligny the technique of reworking the entire pencil drawing in pen and ink. Aligny in turn may have acquired the technique, rare among the French, from the Germans, who in some cases consciously modeled their drawings on the linear style practiced by Albrecht Dürer and other German artists in the first half of the sixteenth century.[65] In the extreme version of the style, represented in a drawing by Franz Horny (1798–1824) (pl. 212), the interval between the parallel strokes of hatching is wide, so that even as they indicate tone the strokes retain a purely linear character. This elegant abstraction appears in a number of Corot's mature Italian drawings (pl. 211).

Stylistically, Corot's drawings belong to a widely shared convention. In function, however, they are quite different from those of his peers. For most landscapists in Italy drawing and painting from nature were parallel but, for the most part, separate activities. For Corot they soon became part of a single, organic process. This active dialogue between drawing and painting, a key to Corot's achievement in Italy, began in and near Civita Castellana in May and June 1826. On this campaign Corot at first alternated unsystematically between the two media, but soon he discovered the value of making preliminary drawings for his oil studies.

Corot had experimented with the practice in Rome in the early months of 1826, but it was not until May and June that he adopted it as a regular procedure. One drawing from this episode (pl. 213), made in anticipation of an oil study (pl. 214), suggests that Corot was still rather timid as a draftsman. Not yet confident to handle a complex recession of space or the amorphous shapes of foliage, Corot limited himself to the intricate contour of the horizon, which he retraced several times. Sixteen months later, in October 1827, Corot drew the motif again (pl. 215). His earlier timidity and dependence on line are gone, replaced by a vigorous, almost sculptural style. The passages of rapid parallel

174

213. Corot. *Castel Sant'Elia*, June 1826. (R.2522.) Pencil on paper, 22.5 × 33. Paris, Louvre.

214. Corot. *Castel Sant'Elia*, 1826. (R.149.) Oil, 24 × 27. Unlocated.

hatching retain a linear identity, but the whole is conceived in terms of light and shadow. The difference between the two works cannot be explained by reference to the domain of drawing alone. The metamorphosis of the linear into the tonal vocabulary of drawing was a response to the medium of painting, which Corot had mastered first.

In a view of Mount Soracte, painted in May 1826, Corot advanced well beyond the style of the three Palatine studies of 1826, learning to suppress detail in favor of broad masses (pl. 230). Notice especially the somber middle band of deep green-brown, painted in a lively but uniform *frottis*, a technique that David often used for the backgrounds of his portraits and that has an unfinished quality. Yet there is nothing unfinished about Corot's study. The dark passage in the middle is free of detail but perfectly suggests the dense mass of foliage, animated by a flicker of bright light on the trees. This passage, moreover, is perfectly integrated into the whole, where, despite the absence of conventional signs of

215. Corot. *Castel Sant'Elia*, October 1827. (R.2581.) Pen and ink over pencil on paper, 27 × 41. Lyon, Musée des Beaux-Arts.

175

216. Corot. *Mount Soracte and Civita Castellana*, September 1827. Pen and ink over pencil on paper, 28 × 41.5. Cambridge, Mass., Fogg Art Museum. Bequest of Meta and Paul J. Sachs.

spatial recession, subtle shifts of color and brushwork give the impression of deep space.

This strategy of simplified description, so characteristic of Corot's best work, is still absent from a drawing he made a month after the oil study, in June 1826, looking across Civita Castellana toward the mountain (pl. 217). As yet he still had no idea how to draw the foliage and quickly abandoned the effort. Even the impressive form of the bridge is not impressive here; the drawing is crippled by a timid allegiance to tiny details. How different is another drawing of Soracte, from September 1827 (pl. 216), which shows how much Corot the draftsman had learned from Corot the painter.

The relationship between painting and drawing was a two-way street. On the one hand Corot's preparatory drawings were essential to the compositional rigor of his paintings; on the other the color harmonies and plastic brushwork of the oil studies led him to a more powerful and expressive style of drawing. Within the context of Corot's overall program the extremes of drawing – severe line and

217. Corot. *Civita Castellana*, June 1826. (R.2520.) Pencil on paper, 31 × 45. Paris, Louvre.

218. Corot. *Ronciglione*, June 1826. Pencil on paper, 22 × 35.7. Paris, Bibliothèque Nationale.

219. Corot. *Nepi*, June 1826. (R.2504.) Pencil on paper, 22.2 × 35.1. Chicago, Art Institute of Chicago.

220. Corot. *Civita Castellana*, 1826. (R.2492.) Pen and ink over pencil on paper, 27.5 × 45.4. Paris, Louvre.

rich tone – are more closely related than at first they might seem. Whether leading toward painting or emerging from it, each is conceived with reference to the ideal of the tangible, integrated surface of the oil study.

The transformation of the linear into the tonal method of drawing, mediated by painting, began in June 1826 and reached its apogee three or four months later near Papigno. The first hint of change may be observed in a drawing made at Ronciglione, west of Civita Castellana, in June 1826 (pl. 218). Here the linear contours have begun to swell into dark accents of a definite thickness and shape. These are the shadows which, scattered across the surface of the paper, give the impression of bright, direct sunlight. They are the harbingers of a new vocabulary of drawing that will describe transitions of tone instead of the contours of objects. In the fore- and middleground of another drawing, made the

same month at Nepi (pl. 219), Corot already began to think, somewhat tentatively, in terms of broad masses of light and dark. In yet another drawing of June 1826 (pl. 220), the tonal modeling has become richer and more confident, although the linear element still dominates. Here, indeed, the linear element has a quality of exaggeration. The pneumatic clouds and the incised contours of the rocks are symptoms of Corot's sometimes overpowering visual grasp of the world, which is evident also in other drawings.

The tonal vocabulary of drawing triumphed utterly, if only briefly, at the Cascade of Terni in August or September 1826. One remarkable drawing from this campaign shows a glimpse of the Cascade of Terni and below it a dense curtain of foliage, which Corot described in a highly original way (pl. 256). Not only has line almost completely disappeared in the pattern of light and dark, so also has Corot's earlier dependence on discrete forms. The more brightly lit foliage (especially in the foreground) is indicated only by the absence of tone. The positive forms created by Corot's pencil are not the trees but their shadows.

Corot's growth as a draftsman in the summer of 1826 is astonishing. Within a few months he had progressed from the timid linear style of May and June to the rich tonalism of August and September. This development was paralleled in the oil studies. By the fall of 1826, less than a year after arriving in Rome, Corot had mastered both drawing and painting from nature. After this plateau of first

221. Corot. *Casina di Raffaello, Rome*, 1826–28. (R.2551 verso.) Pencil on paper, 20.5 × 31. Paris, Louvre.

maturity, it is no longer possible to trace a progressive development of style. In drawing Corot had established a powerful repertory of style and technique, which he henceforth applied with great versatility. In some drawings the tonal element is dominant (pl. 221). Others are composed almost exclusively of line, now confidently and economically applied to foliage and buildings alike (pl. 222). In the latter drawing the sculptural contours, noticed earlier in plate 220, have become less insistent, more fully integrated into the overall planar scheme.

The range and versatility of Corot's drawings is a sign of their function. For Corot the drawing was never an end in itself; it was part of a continuous process of experiment and revision. This was true even when a series of drawings did not lead to the implied climax of an oil study. By conventional standards the vast majority of Corot's Italian drawings are unfinished. Even those drawings that seem complete in themselves are part of the open-ended process. Two drawings of precisely the same motif, made at Civita Castellana in October 1827 after nearly two years of work in Italy, reflect Corot's refusal to settle into a tried-and-tested manner; they show instead his ceaseless exploration of the descriptive functions of drawing (pls. 223, 224). It is this exploratory approach that lies behind the economy and mastery of Corot's best Italian drawings.

This aspect of Corot's procedure presents a marked contrast to the practice of his contemporaries. Among scores of Italian landscape drawings by Michallon

222. Corot. *Civita Castellana*, 1827. (R.2632.) Pen and ink over pencil on paper, 22 × 31. Paris, Louvre.

223. Corot. *Civita Castellana*, 1827. (R.2625.) Pencil on paper, 28.9 × 44.6. Paris, Louvre.

224. Corot. *Civita Castellana*, October 1827. Pen and ink over pencil on paper, 29 × 43. Oxford, Ashmolean Museum.

there are no more than a handful that are not fully realized from edge to edge of the sheet (pl. 225). Over a period of four years the competent style changes hardly at all. Michallon's is a crisp, picture-postcard vision; taken together his drawings constitute a detailed pictorial tour. They were conceived as reliable documents – a number were translated into topographical prints[66] – and a comprehensive record of each view was the first order of business.

The consistent, documentary standard of topographical reportage is exemplified in a view of Civita Castellana by Corot's friend Fries (pl. 226). For Fries, as for Michallon, the drawing was a definitive statement. Some of Corot's drawings

225. Achille-Etna Michallon. *View from the Palatine Hill, Rome*, 1917–21. Pencil on paper, 28.6 × 43. Paris, Louvre.

226. Ernst Fries. *Civita Castellana*, May 1826. Pencil and charcoal on paper, 35.5 × 47.6. Munich, Staatliche Graphische Sammlung.

227. Corot. *View of the Colosseum from the Farnese Gardens*, April 1827. (R.2484.) Pencil on paper, 28.7 × 44.5. Paris, Louvre.

also conform to this standard but, taken as a whole, his work displays a much wider range of function and style. Especially in and near Civita Castellana, Corot produced a great variety of drawings, from elaborately worked compositions to rapid, schematic sketches.

In keeping with the documentary conception of their studies (as it had been defined in academic theory), Corot's contemporaries generally drew or painted each view only once. The more views they were able to collect, the more useful these studies would be as material for studio composition, or for the trade in topographical prints. Corot, on the other hand, repeatedly searched the same sites, refining and adjusting a single pictorial idea, testing it against reality. He pursued this practice over the course of days, weeks, and even years. In March and April 1827, for example, thirteen months after he had painted the three Palatine studies, he repeated two of the views in drawings made from exactly the same vantage points (pl. 227; compare pl. 179).[67] It is as if he wanted to measure his improvement, or to see whether the earlier works matched his ever more demanding standard.

In one respect Corot's exploratory approach merely reflects the collective activity of landscape artists in Italy. Grouping and regrouping their ranks, they swarmed over increasingly familiar sites, competing with each other for supremacy in the act of planting the umbrella – choosing a viewpoint. Their activity was a massive communal appropriation of the landscape. By adopting this process as his own individual program, Corot opened a new door. He arrived intuitively at a modern conception of artistic process, in which the experimental is valued over the didactic, in which the provisional and contingent are more persuasive than the artificially resolved. Yet Corot developed this new method in the service of classical artistic ideals; it is another aspect of the fusion of opposites that gives Corot's art its special power.

In the Campagna view in London (pl. 207), probably painted in the early months of 1826, Corot had attempted to transform a particular patch of the landscape into a balanced classical design in a single powerful step. Later he transferred the exploratory struggle of the London picture to the domain of drawing. Considered without respect to the drawings, Corot's best oil studies might suggest a steady pattern of work, based on a proven stylistic formula. But the paintings are the fruit of a restless search that Corot carried out ceaselessly

in his drawings. In effect, Corot transposed the reconsiderations and subtle adjustments of studio work to the field. This process, a key to Corot's accomplishment in Italy, can be observed most fully in his work at Civita Castellana.

CIVITA CASTELLANA AND ENVIRONS

Civita Castellana, a medieval fortified town, lies north of Rome on the ancient via Flaminia. The town, and nearby Castel Sant'Elia and Nepi, which belong to the same geological formation, provided an ideal subject for Corot. Close by, to the southeast, is the unmistakable profile of Mount Soracte, a subject of poetry from Virgil to Byron. The town itself sits on a narrow plateau; from it, cliffs descend two hundred feet to quiet brooks, which nourish dense thickets of bushes and trees. From almost any point of view the rectilinear cliffs, decorated here and there with clumps of foliage, present majestic silhouettes.

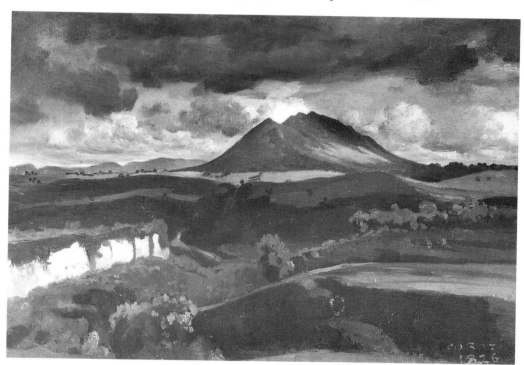

228. Corot. *Mount Soracte*, 1826. (R.169.) Oil on canvas, 30 × 43. England, private collection.

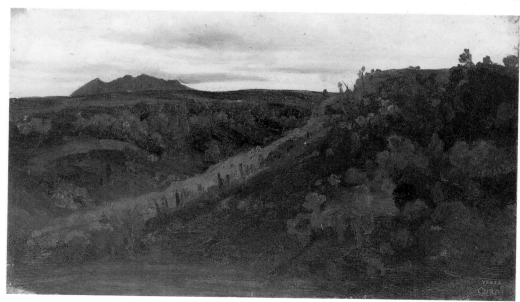

229. Corot. *Mount Soracte*. 1826–27. (R.171.) Oil on paper, 22.4 × 37.8. Munich, Bayerische Staatsgemäldesammlungen.

left Detail from pl. 230 (Corot).

Corot made two campaigns at Civita Castellana, the first in May and June 1826, when his mature style was just beginning to develop, the second in September and October 1827, when he was in full possession of his powers. Because it is not always possible to attribute a given study confidently to one campaign or the other, and because Corot's total production at Civita Castellana is especially revealing of his working method, I will consider the two campaigns together.

Arriving in mid-May 1826 for a stay of six or seven weeks, Corot did not immediately discover the artistic potential of the cliffs, which later would become his principal subject. He began by painting and drawing rather conventional topographical views, in conception not dissimilar to his Palatine studies of March.[68] As if to provide a topographical survey, he wandered from one end of the town to the other, recording general vistas and the major landmarks. He also painted a series of broad panoramas of the Sabine mountains to the east and southeast,[69] and several variants of Mount Soracte's serrated silhouette rising above the flat plain.

The views of Soracte, along with others painted in the fall of 1827, constitute

230. Corot. *Civita Castellana and Mount Soracte*, May 1826. (R.124.) Oil on paper, mounted on canvas, 27 × 36. Geneva, Musée des Beaux-Arts.

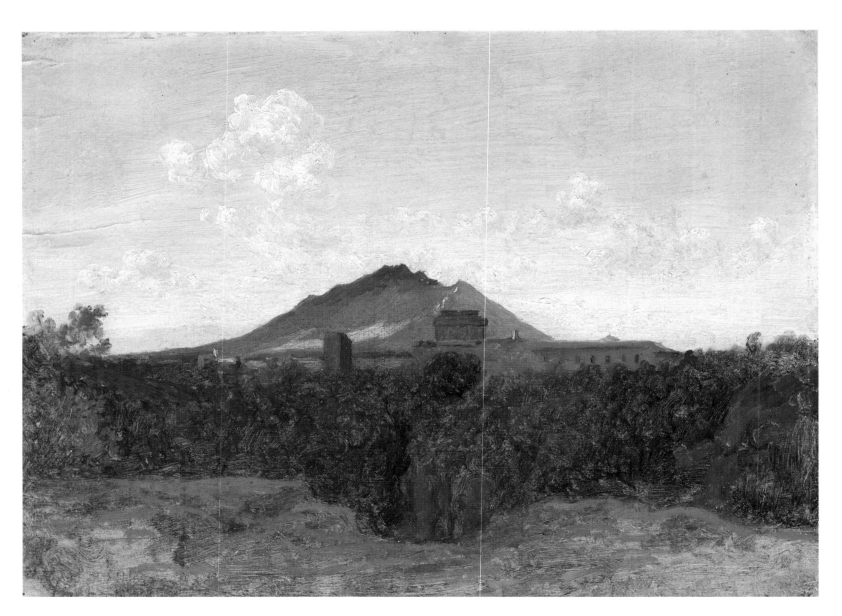

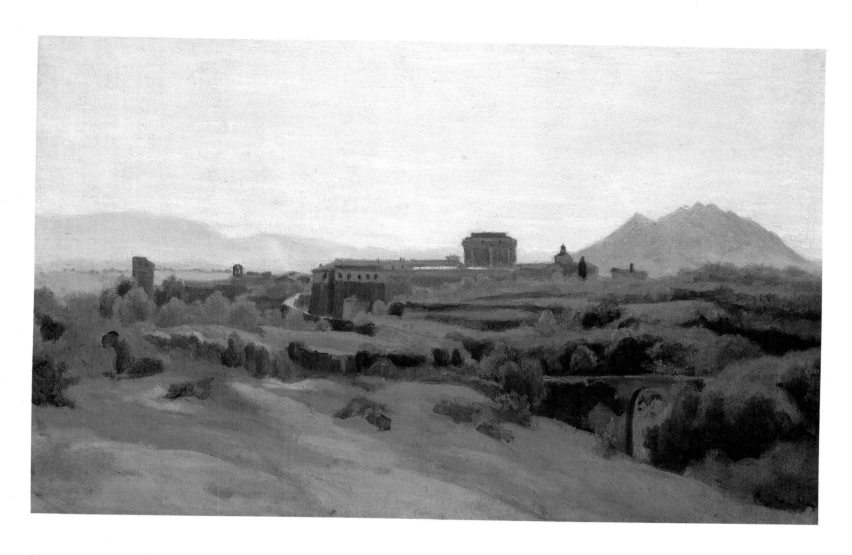

231. Corot. *Civita Castellana and Mount Soracte,* 1827. (R.170.) Oil on paper, mounted on canvas, 22.5 × 34.5. Copenhagen, Ny Carlsberg Glyptotek.

232. Corot. Copy from a landscape by Gaspard Dughet, 1822–25. (R.3121, f. 19 recto.) Pencil on paper, 10.5 × 14.3. Paris, Louvre.

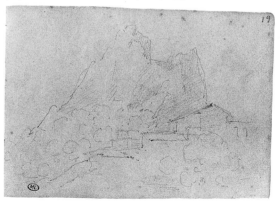

a magnificent series (pls. 228–31; a fifth study of Soracte, not illustrated here, is R.125). On the basis of two dated studies, it is reasonable to suggest dates for the others. In the paintings of May and June 1826 (pls. 228, 230) the palette is restricted to a few relatively sombre hues, and the brushwork is deliberate and muscular. By the fall of 1827, on the second campaign (pl. 231), Corot had considerably lightened his palette, introducing a much wider range of intermediate hues, and the brushwork had become more fluid and varied.

These distinctions of style, however, are irrelevant to the character of the series as a whole. As a student in Paris, Corot had copied a detail from an ideal landscape by Gaspard: a *fabrique d'Italie* built on the side of a mountain (pl. 232). The views of Soracte with the fortress of Civita Castellana repeat this image, invoking an analogy between the noble aspirations of Latin culture and the majesty of nature. In his series of variants on the theme Corot sought a perfect relationship between the fortress and the mountain. (In this respect plate 231, in which the turret of the fortress stands out against the sky, may be an improvement over plate 230, in which the shape of the fortress is entirely contained within the silhouette of the mountain.) These variations are like the subtle adjustments and pentimenti of studio work, but by studying a single motif from a variety of viewpoints, Corot has transposed the process of composition to the field. The most extensive application of this program took place among the cliffs of Civita Castellana and nearby Nepi and Castel Sant'Elia.

185

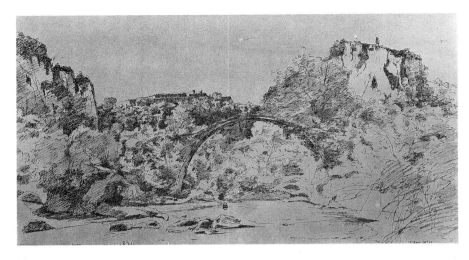

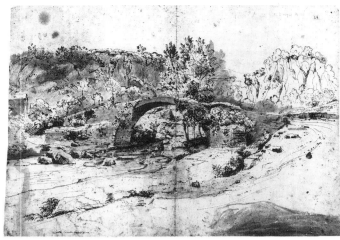

233. Charles Desavary after Corot. *Civita Castellana*, May 1826. (R.2507.) Paris, Louvre, Département des Peintures, Service d'Etude et de Documentation.

234. Vanvitelli. *Civita Castellana*, *c*.1700. Pen and ink and watercolor on paper, 39.7 × 54.7. Rome, Biblioteca Nazionale.

235. Corot. *Civita Castellana*, May 1826. Pen and ink over pencil on paper, 20.4 × 27.8. Oxford, Ashmolean Museum.

Among the drawings of Corot's first campaign are two that reflect the roots of his work in the conventions of picturesque view making. Both drawings, dated May 1826, were made from the floor of the valley, looking through it toward the convent of Santa Chiara in the distance, perched on the edge of the high plateau. In one drawing the foreground is occupied by a medieval bridge, a favorite subject of the *vedutisti* (pl. 233). Corot's view in fact repeats the composition of a drawing by Vanvitelli (pl. 234) and of the print copied by Turner from his guidebook (pl. 97). The other drawing by Corot is similarly conceived, with the foreground occupied by a rustic cottage (pl. 235). In both drawings the land-scape is pictured as a restful glen, in which the contours of the cliffs are softened by a lush blanket of foliage.

facing page Detail from pl. 245 (Corot).

236. Corot. *Civita Castellana*, September 1827. (R.2498.) Pen and ink over pencil on paper, 31 × 43. Paris, Louvre.

Corot soon abandoned this approach; by the middle of his first campaign in the summer of 1826, and throughout the second in the fall of 1827, he replaced the picturesque with the heroic. In a characteristic drawing of 1827 the rustic foreground has disappeared, the rugged cliffs have swelled into powerfully animated forms, and the style of drawing itself has become more spirited (pl. 236). Although the subject is the same as before (pl. 233), Corot has exchanged the picturesque material of nostalgic tourism for the power and dignity of nature.

In every respect the cliffs were a perfect subject for Corot. Formally, they provided ready-made classical compositions of alternating rectangular silhouettes. Metaphorically, the imposing pallisades evoked a noble and monumental ideal. Corot sometimes included glimpses of the town, but the human content of the buildings was already present in the cliffs themselves, which Corot savored as a triumph of natural architecture. The chiseled surfaces of rock were like the compact forms of Roman buildings, and Corot recorded them with the same angular bricks of color (pl. 245).

André and René Jullien have assiduously matched Corot's drawings and

237. Corot. *Civita Castellana*, 1826–27. (R.2564 verso.) Pencil on paper, 24 × 36. Paris, Louvre.

238. Corot. *Civita Castellana*, 1826–27. (R.2542 verso.) Pencil on paper, 22 × 33. Paris, Louvre.

paintings to particular sites in the general area of Civita Castellana.[70] Their research is especially useful since it shows that in a dozen or more separate spots, many pictured repeatedly, Corot sought out again and again an unvarying classical image. Consider, as an instance of this strategy, three drawings from the second campaign (pls. 236–38). In all three the composition is identical: the profile of one cliff, occupying nearly half the picture on the right, is answered by another on the left; the gap between them is closed by the face of a third, more distant cliff. It is a staple of classical landscape design – indeed the same one that Corot had already discovered at Castel Sant'Elia in June 1826 (pls. 213, 214). Nevertheless, it is fascinating to observe that each drawing represents a different view. Plates 236 and 237 were made from opposite directions on the same axis of sight, and plate 238 in a different (unidentified) spot. Plate 236 probably represents the same view that Valenciennes had drawn around 1780 (pl. 239); it is difficult to be certain, since Valenciennes often "adjusted" his subjects, as he put

239. Pierre-Henri de Valenciennes. *Civita Castellana*. 1777–84. Pen and ink on paper, 20.1 × 31.4. Paris, Louvre.

240. Corot. *Civita Castellana*, 1827. (R.2552.) Pen and ink over pencil on paper, 18.5 × 33. Paris, Louvre.

241. Corot. *Civita Castellana*, 1827. (R.2621.) Pen and ink over pencil on paper, 25 × 39. Paris, Louvre.

it, to suit his taste. Valenciennes's drawing is a reminder that Corot had not started from scratch, but it also shows how different Corot's procedure had become. In Valenciennes's tame, finished work, the muscular shoulders of the cliffs are all but lost in the artificial pattern of the foliage. By contrast, Corot's frankly provisional drawings are concerned above all with the powerful design created by the bold masses of rock.

If in these three drawings Corot was searching for the same image in different places, he also investigated the variety of pictorial possibilities offered by a single subject. Without a doubt his favorite was the prowlike protrusion called by the French "La Colonette," which he drew repeatedly from every conceivable angle, constantly testing different methods of drawing (pls. 211, 220, 236, 240, 241). Although experimental, this activity was not aimless. Here as always Corot's

190

search was governed by his classical intuition, which guided him through the chaos of unedited nature to a stable, organized image. Two painted studies of La Colonette from different angles illustrate this point (pls. 242, 243). Each work is a mirror image of the other – a simple structure that divides the picture into quadrants, filling three with a dense pattern of rock and foliage, leaving the fourth open to a vista and the sky. Other works at Civita Castellana present variants of this simple design (pls. 244, 245). Characteristically the oil studies are narrower in scope than the drawings; the paintings distill ideas of composition first explored in the drawings.

Many of Corot's best open-air paintings – plate 245 is a good example – possess a freshness and buoyancy that is closer to athletic grace than to intellectual deliberation. The study is a document of the liveliness – one is tempted to say, the abandon – of its own making. But like the athlete, Corot did not depend on natural talent alone. A deep effort of preparation and concentration lay behind his spirited performance.

Corot's accomplishment at Civita Castellana exemplifies both the process

242. Corot. *Civita Castellana*, 1826–27. (R.140.) Oil on paper, 36 × 50. Karlsruhe, Staatliche Kunsthalle.

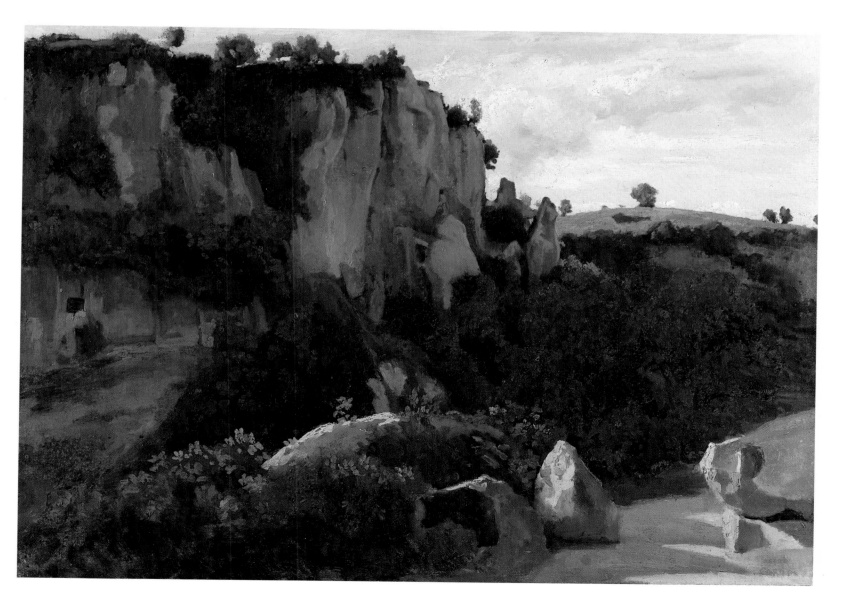

243. Corot. *Civita Castellana*, 1826–27. (R.138.) Oil on wood, 22 × 25. Paris, private collection.

244. Corot. *Civita Castellana*. 1826–27. (R.139.) Oil on canvas, 25 × 35. England, private collection.

and the meaning of his work in Italy. In Rome Corot relied on an established repertory of views, which had been refined by generation after generation of artists. In the countryside the repertory was weaker and more diffuse. There was a much wider gap between the heroic ideal of nature, expressed in the compositions of Poussin and Gaspard, and the outdoor painter's complex experience of the landscape itself. Corot sought to close this gap, incorporating into his own working method, especially in the exploratory drawings, the process of refinement that tradition had already provided in the city. The search first engaged in in the early *Roman Campagna* (pl. 207) matured at Civita Castellana. Corot's studies of the cliffs evoke the material presence of nature, but they also serve a noble ideal far removed from experience.

At Civita Castellana Corot's views of the cliffs and of the mountain are complemented by more modest studies made in the valleys (e.g., pl. 246). These works derive from the old tradition of studying rocks and trees and other details in isolation. But they are not mere fragments of nature; they are subtly developed little pictures, which look forward to Corot's own later *sous-bois* paintings and those of Courbet and Cézanne. As if in opposition to the detached

245. Corot. *Civita Castellana*, 1827? (R.137.) Oil, 36 × 51. Stockholm, Nationalmuseum.

246. Corot. *Rocks by a stream, Civita Castellana,* 1826–27. (R.176.) Oil on paper, mounted on canvas, 31 × 41.1. Chapel Hill, University of North Carolina, Ackland Art Museum. The William A. Whitaker Foundation Art Fund.

grandeur of Corot's landscapes and views, these studies possess a spirit of intimacy and quiet contemplation. An anticipation of Corot's later sylvan reveries is a work – perhaps a studio work – called by Robaut *The Fisher of crayfish* (pl. 247). The subject is borrowed from precedents such as Reinhart's print of 1790 (pl. 248). Corot has intensified the intimacy of the scene, reducing the figures to a single one and enveloping him in a luxury of cool foliage. A tiny glimpse of sunlit cliff at the top of the picture serves to emphasize the quality of retreat, of solitary communion with nature.

The drawings Corot made in the valleys at Civita Castellana are very different in mood. Here the linear style of drawing reaches a peak of obsessive inquiry; the restful intimacy of the oil studies is replaced by an almost hallucinatory intensity (pl. 249). Frequently Corot chose a motif of impossible intricacy and set out to master it with an extravagance of sharply incised detail. The interlace of arabesques that he discovered in the branches of the trees reflects his attachment to the tangibility of nature, as if he meant to transpose the wiry energy of the branches directly to the sheet.

The linear intricacy of plate 249 is foreign to the realm of painting, as is the vignette-like image, which floats in the middle of the sheet. Another drawing (pl. 250) fills the sheet; on the right, the frame cuts through the taut arc of a bent sapling. Here the pursuit of palpable nature is equally obsessive, but Corot has given as much weight to the spaces between the branches as to the branches themselves, creating an active field from edge to edge of the sheet. Here, as elsewhere, drawing emulates the condition of painting.

The wide range of Corot's work at Civita Castellana – the differences between the views and the *sous-bois* studies, between the paintings and the drawings – embodies the investigative spirit of his work throughout the first trip to Italy. His classical bent was strong, but he was unwilling to repeat a static classical prototype. He experimented ceaselessly. One of the most fruitful episodes of

247. Corot. *The Fisher of crayfish*, 1826–27. (R.165.) Oil on canvas, 43 × 41. Paris, private collection.

248. Johann Christian Reinhart. *At Civita Castellana*, 1793. Engraving, 38.2 × 28.3. Cologne, Wallraf-Richartz Museum.

his outdoor experiment took place in the environs of Terni, north of Civita Castellana, in the late summer and early fall of 1826.

Before considering this campaign, it will be useful briefly to recapitulate the chronology of Corot's first year in Italy. The first four months of work in Rome culminated in the three *études terminées* painted on the Palatine hill in March 1826. There are no dated works from April, when Corot was still in Rome. In mid-May he left for Civita Castellana, where he worked for about two months. On this campaign Corot first hit his stride. He abandoned the tidy brushwork of the Palatine views for a broader style of painting. He discovered that fidelity to visual experience did not depend on meticulous detail but on the cohesiveness of the image. Corot learned how to achieve that pictorial unity through a simple, powerful composition, an integrated fabric of brushwork, and a sensitive adherence to subtleties of light and color. On the first campaign at Civita Castellana Corot also began to mature as a draftsman, and he initiated an organic program of work, which included an active dialogue between drawing and painting. Corot's art continued to evolve in the environs of Terni in July, August, and September 1826. By the end of this campaign, less than a year after first arriving in Rome, Corot had reached full maturity as an outdoor painter.

195

249. Corot. *Study of trees, Civita Castellana*, 1827. Pen and ink over pencil on paper, 39.8 × 26.9. Paris, Louvre.

250. Corot. *Study of trees, Civita Castellana*, 1827? (R.2624.) Pen and ink over pencil on paper, 42 × 33. Paris, Louvre.

PAPIGNO, TERNI, NARNI

After visiting Rome briefly in late June 1826, Corot again traveled north on the via Flaminia, passing beyond Civita Castellana to the tiny village of Papigno, just beyond Terni. Papigno, which has hardly changed since the 1820s, is a cluster of houses perched on an outcrop of the steep incline that descends from the high plateau to the valley of the river Nera. From the village Corot could climb to the plateau to paint the Lake of Piediluco and the rushing stream of the Velino (pl. 118), which roars over the cliff in a magnificent cascade, called the Cascade of Terni. Or he could descend to the valley to paint the famous cascade from below. On the switchback road between the heights and the valley, Corot painted a series of mountain vistas to the east.[71] Sometime in September he retraced his steps some ten miles toward Rome and installed himself at Narni, which gives its name to the Augustan bridge that crosses the Nera in the valley below.

Between mid-July and mid-September Corot painted the town of Papigno itself three times, twice in profile, from the east (pl. 251) and the west (pl. 252), and once from a position to the south, on the incline overlooking the town (pl. 254). Plate 251 presents a design that Corot would later repeat many times, a closed composition in which a large foreground mass, secured in one lower

corner of the picture, is answered by another, smaller and more distant. Between the two is an avenue of vision which, as in many pictures by Claude, extends from darkness into light and reaches to the horizon. Plate 252, the second view, is asymmetrical in composition and more complex, but it, too, presents an opposition of near and far masses, between which the eye escapes into distance. The third view of Papigno represents a special variant of this design (pl. 254). The opposing wedges, now roughly balanced, have closed to form a dark "V" shape, which contains the central subject, brightly lit. A drawing of the same view by Michallon (pl. 253) illustrates Corot's reliance on established motifs – and his originality. Beside Corot's work, in which every component is integrated into the scheme of the whole, Michallon's drawing is casual and passive. From a position slightly to the right, Corot has presented a clearer view of the town, a series of subtly varied bright rectangles, descending in harmonic intervals from the small, brilliant attic at the top to the larger, darker building at the center. In the foreground he has adapted the uneven terrain and patches of foliage to a grid of interlocking diagonals and horizontals. Even the sapling at the upper left, which bends gracefully in Michallon's drawing, is a strict vertical accent in Corot's study.

251. Corot. *Papigno*, July–September 1826. (R.121.) Oil on canvas, 29 × 40. Private collection.

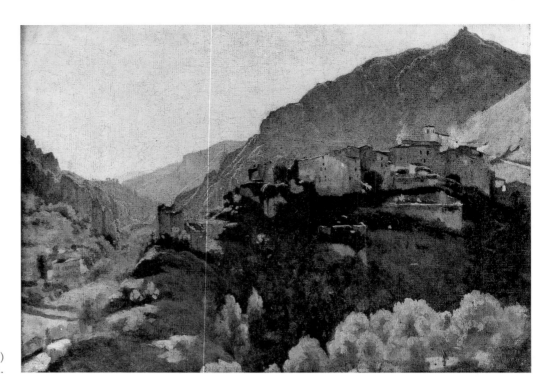

252. Corot. *Papigno*, July–September 1826. (R.115.) Oil on canvas, 33 × 46.5. France, private collection.

253. Achille-Etna Michallon. *Papigno*, June 1821. Pencil on paper, Paris, Louvre.

More remarkable than the design of the Papigno studies is their original and highly sophisticated painterly vocabulary. The view looking west (pl. 251), painted in the afternoon, is dominated by robust greens, which recall the saturated palette and firm brushwork of a view of Soracte, painted in May (pl. 228). Only in the distance does there appear the special quality of aerial perspective, indicated by pastel hues and slightly hazy contours. In the view looking east (pl. 252), painted in the *contre-jour* of early morning, this quality becomes the keynote. Confident that the picture's compact design would make itself felt, Corot concentrated on the unifying envelope of atmosphere, giving himself up to a luxury of delicate colors and blurred transitions of form. The buildings, unlike the discrete ocher and beige blocks of the Roman views, merge together in a band of subdued pink-orange. The foliage of the hillsides, which a few months earlier Corot had described with clearly articulated patches of saturated greens, is now rendered with gradual modulations of purple, lavender, turquoise, pale green, and blue. This atmospheric quality prevails also in the third Papigno view (pl. 254), where even the bright, sunstruck walls of the buildings take their proper place in a subtle progression of muted tones. The impression of raking light is conveyed through a unifying atmosphere, which hangs like a veil over the geometric design.

Already in October 1825, at Lausanne on his way to Rome, Corot had painted a view (pl. 157) that in its composition and gray tonal harmony anticipated the third Papigno study. It is a reminder that Corot's art did not follow a rigid sequence of progress. Nevertheless, the Papigno studies and others made on the same campaign represent a coherent episode, which may be described as an advance upon Corot's work at Civita Castellana a few months earlier. His grasp of composition became surer, yielding ever more powerful, fully resolved designs. And he achieved an increasingly subtle and comprehensive tonal harmony, which knits the picture together in a unifying atmosphere.

At Papigno Corot's choices of times of day and conditions of light in them-

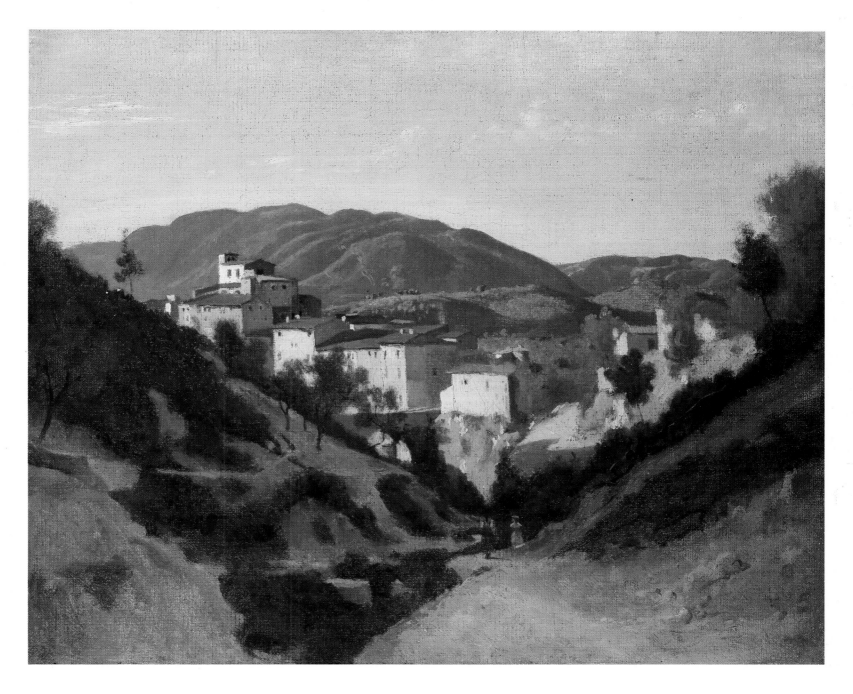

254. Corot. *Papigno*, July–September 1826. (R.114.)
Oil on canvas, 33 × 40. Private collection.

selves suggest a shift. At Civita Castellana, as often at Rome, Corot favored
the clarity and hard shadows of the midday sun. At Papigno he preferred the
raking light and subtle transitions of early morning or late afternoon; and instead
of working with the light behind him, he often painted facing into the light,
a choice that naturally emphasized the effects of aerial perspective. It is as if he
had transferred his allegiance from Poussin to Claude, exchanging the former's
airless geometries for the latter's atmospheric harmonies.

Corot's exploitation of the tonal harmonies of *contre-jour* light reached a peak
in his study of the Lake of Piediluco, on the plateau above Papigno (pl. 255).
The picture presents a composition simplified almost to the point of abstraction,
a planar geometric design, symmetrical across two axes. Linear perspective has
been expunged, so that spatial recession is suggested only by intervals of tone

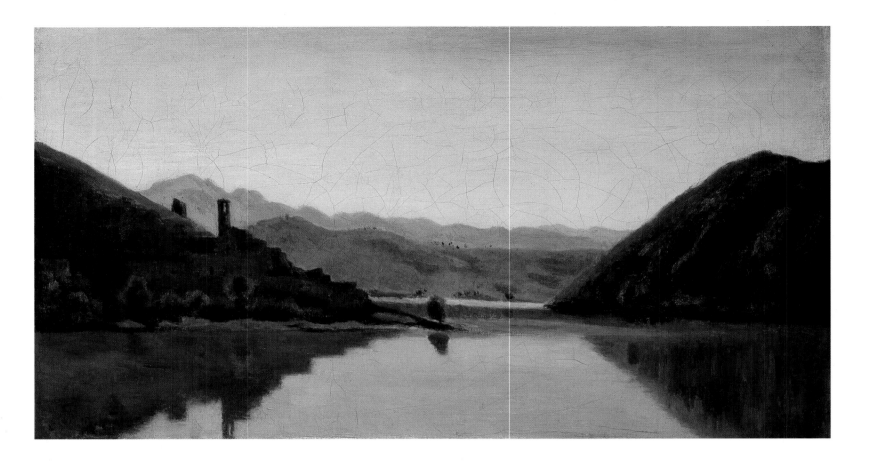

255. Corot. *Piediluco*, July–September 1826. (R.123.) Oil, 23 × 41. Oxford, Ashmolean Museum.

and by overlapping planes. In parallel with the austerity of the design, the color scheme also is severely restricted: trees, water, building, and sky all are indicated as variants of a single hue.

Corot studied the view closely, rendering its details with delicate distinctions of color and touch. Notice how subtle differences in stroke distinguish between the massive right bank and its glassy reflection and between this reflection and the reflection of the sky; or how the feathery contours and transitions give a vivid impression of atmosphere and light. Nevertheless, these qualities of naturalistic observation are narrowly confined by the austere formal conception of the whole. Corot has stifled the expectations of scenic topography with an enveloping mood of other-worldly stillness. The picture testifies to Corot's powerful aesthetic imagination, now fully developed and nearly overwhelming the descriptive function of the oil study.

Corot's stylistic advances during the Papigno campaign did not depend solely on the effects of *contre-jour* light, as can be seen by studying two works representing the Cascade of Terni, seen in strong direct light. One is the magnificent drawing discussed above (pl. 256), the extreme and the masterpiece of Corot's tonal manner of drawing, now precisely in step with painting. It is one of only a few drawings surviving from Corot's first Italian trip that were made on tinted paper. The blue paper, unsuited to the prevailing linear style, may have been given to Corot by Edouard Bertin, perhaps the only landscapist in Italy at the time who used the material regularly.[72] In any case, Corot's use of the paper suggests a conscious aesthetic choice, a deliberate pursuit of the potentials of tone as opposed to line.

An equally ambitious and somewhat larger drawing made earlier in the year by

256. Corot. *Cascade of Terni*. July–September 1826. (R.2559.) Pencil and white chalk on paper, 38 × 32.5. Paris, Louvre.

257. Ernst Fries. *Cascade of Terni*, 1826. Pen and ink and brown wash on paper, 55.2 × 42.6. Karlsruhe, Staatliche Kunsthalle.

258. Thomas Patch. *Cascade of Terni*, 1764. Oil on canvas, 120.3 × 87. Cardiff, National Museum of Wales.

259. Corot. *Cascade of Terni*, July–September 1826. (RS3.6.) Oil on canvas, 36 × 22. Rome, Banca Nazionale del Lavoro.

Ernst Fries (pl. 257) underscores the originality and sophistication of Corot's tonal style. Fries advanced well beyond the artificial drama and crisp detail of the topographical standard served earlier by Thomas Patch (pl. 258). Adding dark washes and bright highlights to forms first drawn in pencil, then in ink, Fries built up a rich chiaroscuro. Sensitive in observation, the drawing pursues the distinction between solid rock and the vaporous cascade. Corot instead chose a viewpoint from which rocks and water are hidden by trees, and he conceived his drawing as a curtain of flickering light and dark. Corot's attention to nature is no less keen, but he has abandoned Fries's attachment to the discrete identity of things.

For his painting of the cascade Corot adopted a viewpoint closer to the canonical position of Patch and Fries (pl. 259). As in many of Corot's studies a simple design – here a grand "Z" – organizes the composition. Observe how the sharp diagonal of the ridge is prolonged in the shadow below and to the left, or how this diagonal is paralleled by the descent of the bulbous shadows to the right. The geometric scaffold helps to enforce the planar integrity of the image, but it does not dominate. More prominent is the active interplay of irregular forms, which cohere in a thick tapestry of color.

The shadows, especially the large one on the right, recall the undulating black shape in the earlier *Roman Campagna* (pl. 207). These dense, almost aggressive,

202

260. Corot. *Cascade of Terni*, July–September 1826. (R.126.) Oil, 40 × 32. Unlocated.

forms threaten to detach themselves from the whole. Yet Corot had now learned to integrate the parts into a continuous pictorial fabric, without robbing them of their individuality and power. The achievement arose in part from Corot's organized program of work. By the fall of 1826, when he arrived at Papigno, he had established a productive dialogue between painting and drawing and had imposed upon the ostensible spontaneity of open-air work a logic of careful preparation. An unlocated oil study of the cascade is a document of his procedure. I have not seen the work, but an old photograph suggests that it is unfinished by Corot's standard (pl. 260). In effect, it is a study for Corot's study, an initial essay, closer in conception to the works of Patch and Fries. Such an approach allowed Corot at once to conduct his outdoor work with the deliberation of a studio painter and to discover in the process a solution so surprising that it revised the problem.

The *Cascade of Terni* is such a solution. It achieves the empirical aim of outdoor painting with stunning effectiveness. The juxtaposition of fresh color, at once robust and subtle, with the deep black of the shadows invokes the brilliant sunlight. Every detail of the picture conspires to impress upon the viewer the vividness of the scene. Yet the pictorial qualities of the work are not exhausted by description; they retain an exciting vigor of formal invention. It is as though the momentum of Corot's stylistic development had carried him beyond the descriptive function of the oil study toward a more formally rigorous and frankly expressive art. The parallel is not with the detached finesse of Impressionism but with the order and passion of post-Impressionist art.

The Papigno campaign is important because it reveals with unusual clarity the special character of all of Corot's work in Italy. He did not approach painting from nature passively; for him it was a process of concentrated attention and active invention. It is the rigorous formal perfection of Corot's Italian landscapes that makes them seem transparent, effortless, and true. It is their pictorial coherence – the flawless verve of the performance – that the viewer takes for the seamless immediacy of sight. The Papigno campaign is telling because the formal motive makes itself felt with unusual force, as a quality independent of the descriptive aspect of the work.

Throughout the first trip to Italy Corot's approach was more intuitive than systematic. It was not through a predetermined program but through a momentum of discovery, not from theory but from practice, that Corot arrived at the surprising *Cascade of Terni*. For the next two years he continued to work and to experiment, but his art did not evolve substantially. Corot's work in the five months from May to September 1826 is a remarkable episode. In this period he moved from competence to mastery and beyond it to works of astonishing originality and power, which could not be fully appreciated until much later, after their radical conception had become the norm.

NAPLES AND VENICE

This study has not been conceived as a comprehensive catalogue of Corot's Italian landscapes. The range and character of his achievement is best represented by his work in and near Rome, Civita Castellana, and Papigno. Focusing on these campaigns, I have been able to trace the development of Corot's style during the first nine or ten months of his stay in Italy and to analyze the best of his mature work. After September 1826 he varied but did not further develop his style. I have discussed some works from Corot's later campaigns to the Castelli

Romani and to Olevano and Subiaco, but I shall not treat these campaigns in depth.

Corot worked in the Castelli Romani in November 1826, immediately after his campaign in the environs of Papigno, and again, apparently intermittently, in May, June, and early July 1827. His work there is not only less extensive than his work in the north, but also less exploratory. This may be due in part to the prior fame of the Castelli Romani, which had given the towns a prominent place in the repertory of the *vedutisti*. Many of the studies Corot painted in the Castelli Romani, as in Rome, repeat motifs of the view painters (e.g., pl. 136 and R.159).

Corot's work at Olevano and nearby Subiaco, in April and the late summer of 1827, also is less extensive than in the north. Perhaps the rugged, in some places nearly barren, terrain appealed to him less than the landscape of Papigno or of Civita Castellana, where lush foliage always provided a complement to the bold

261. Corot. *Vesuvius*, February–March 1828. (R.186.) Oil, 24.2 × 41. Paris, Louvre.

262. Corot. *The Piazzetta, Venice*, 1828. (R.134.) Oil on paper, mounted on canvas, 20.5 × 34.5. Paris, Louvre.

205

263. Corot. *Civita Castellana*, 1827. (R.2537.) Pen and ink over pencil on paper, 26.5 × 45. Paris, Louvre.

rocks. Nevertheless, Corot painted some of his best landscapes and nature studies in the Serpentara, near Olevano (pls. 153, 168). These studies – and Corot's best work from the Castelli Romani – add to and enrich his work. But it is in Rome and in the country to the north that Corot most fully displayed his talent and resourcefulness.

There remains then Corot's work in 1828, for which there is very little documentary evidence. It is quite possible that some of the great Roman studies, all undated, were made that year. All that is known for certain about Corot's work in 1828 is that in February and March he made a trip of no more than seven weeks to Naples, and that later in the year, presumably in the early fall on his way back to Paris, he stopped at Venice.

Rome and the immediate surroundings had long dominated the visitor's map of Italy. From the mid-eighteenth century onwards and especially after 1820, as taste in art and architecture broadened, increasing attention was paid to other cities and locales. Corot's shorter but geographically more extensive journey of 1834 corresponds to this trend. His preoccupation with Rome and the surrounding country on his first trip had perhaps not then become old-fashioned, but it can be interpreted as an expression of his adherence to Neoclassical taste.

It is not only that Corot's response to Naples and Venice was cursory compared with his attachment to Rome; it is also that his work in the other cities came late in his three-year Italian sojourn, after the thrill of discovery had lost its intensity. A study of Vesuvius is a charming and characteristic simplification of a familiar view (pl. 261), but it lacks the vitality of the previous two years of work. The same may be said of Corot's view of the Piazzetta in Venice (pl. 262).

The drawings made in Naples display a new spirit of release, inspired by the confidence Corot had won in two years of deliberate study. Already at Civita Castellana in the fall of 1827 Corot had begun in certain drawings (pl. 263) to abandon the tonal style, returning to a method of pure linear contour. At Naples this process was complete. Unlike the laborious detailed outlines of the earliest Italian drawings, these late works are executed with great economy and verve. Some of the Neapolitan drawings give us a whole view in no more than two dozen rapid strokes of the pen, although here as always the pen follows an initial pencil sketch (pl. 264).

By late May 1828, in a drawing made at Rome only a few months after the Naples campaign, the confident fluidity of the Naples drawings had become impatience (pl. 265). As if anxious to be done with the job, Corot's hand passed in broad arcs over the sheet, making a pattern of flaccid, imprecise strokes. Even the description of the monuments, which are more carefully drawn than the terrain around them, is cursory and approximate in comparison with his drawings of the previous two years. Nevertheless, there is no reason to believe that this decline was general. Some of the surviving oil studies probably belong to the summer of 1828; and (again) it is possible that some of the great Roman views were painted then.

RETROSPECT

As a student Corot applied himself assiduously to the lessons of an exhausted tradition. French landscape painting in the decades before 1820 had realized with rare thoroughness the deadening potential of stylistic retrospection. Not only Valenciennes's Neoclassical school but the whole array of landscape painting had lowered a pall of inertia upon the horizon of artistic expectation. Yet it was precisely Corot's inculcated reverence for the classical past – for the lost grandeur of Poussin superimposed on the lost grandeur of Rome – that prepared him for the brilliance of his first trip to Italy.

The cohesiveness and security of the Neoclassical aesthetic had spawned a new opportunity for landscape painting. It took shape at Rome, where young disciples of Neoclassical doctrine assembled in great numbers. Collectively they embarked on an experiment of outdoor painting and elaborated it into a rich tradition. The practice had not been tested on any significant scale. Employing it, an international roster of painters created a highly original body of work, which shares many qualities with the new art of the nineteenth century. In effect they answered a call for change before it had been issued.

At the time no one remarked upon the novelty of this innovation; least of all did anyone attempt a new theory to explain it. The theory that did exist understood outdoor painting as a variety of preparation for studio work. Under this rubric studies after nature were mere raw material, a library of motifs and natural effect, a resource for composition. This hierarchy of practice had existed for a long time. By applying the complex and venerable medium of oil colors

264. Corot. *Capri*, 1828. (R.2633 verso). Pen and ink over pencil on paper. 21 × 31. Paris, Louvre.

265. Corot. *Panoramic view comprising the Arch of Constantine and the Colosseum*, May 1828. (R.2580.) Pencil on paper, 26.2 × 44.5. Paris, Louvre.

to the empirical function of the nature study, open-air painters in Italy overturned the old hierarchy. They progressively introduced into their outdoor work pictorial schemes and refinements derived from the classical landscape tradition. Guided by the cultural authority of Italy and by its rituals of tourism, they also absorbed the repertory of view making and its principle of collective repetition of selected motifs. Gradually and without fanfare, they reversed the terms of received theory, retaining its shell. The inherited art of the studio became a resource for outdoor work.

It would be misleading to describe this development as an innovation of practice for which a theory was articulated only much later. For the practical reversal of terms depended upon allegiance to the old theory, which provided those terms. The established theoretical distinction between private study and public composition provided an avenue of experiment insulated from the confining expectations of public art. The opportunity for innovation, in other words, was most available to adherents of the very theory that later would seem so repressive. This is why it is senseless to impose on Corot the role of radical or conservative. In Italy at least, it was the conservatism of his sensibility and training that fostered his originality.

By their very presence in Italy the outdoor painters expressed attachment to the legacy of classical culture. A long tradition had invested the physical qualities of the place with the ideals of heroism and of harmony between nature and man. This tradition provided an indispensable support for the outdoor painters, who approached their subject as a concrete expression of lofty concepts. Moreover, there existed a continuum between the most artificial conventions of art and the most concrete details of topography. This continuum lent fluidity to the parallel relationship between composition and study, thus facilitating an inversion of the traditional hierarchy between the two.

The great number of landscape painters who went to Italy and the collegial spirit and practical habits they created there also were important. The highly restricted itinerary and repertory of motifs, shared by the group, focused the talent of the individual on common problems. The mythology of open-air painting, that is, the mythology of Impressionism, stresses the independence of the painter from the repressive norms of the organized establishment. In the development of outdoor painting in Italy, the collective spirit of the milieu, its attachment to tradition, and the rather rigid conventions of the common style are essential elements in the imagination of the individual. Corot's innovations in Italy, the most impressive and original of the entire episode, arose from a commitment to tradition that otherwise would seem almost slavish.

Indeed, Corot's work embodies in heightened form the immediate tradition from which it derived. Arriving just as the tradition reached maturity, Corot benefited enormously from the experiments of his predecessors. He painted only sites and motifs that they had identified as fruitful, and he employed techniques whose stylistic range had been tested. The collective enterprise, a resource in both practical and aesthetic terms, was an essential factor in the speed with which Corot's own style matured and in the coherence of his overall program of work. The community lent Corot the momentum that soon enabled him to stand out from the group.

For Corot painting from nature was a matter not of passive transcription but of active formal invention. Thus his work displays an experimental quality and stylistic variety not present in the work of his companions. Corot did not interpret his unvarying classical ideal as a static prototype; his work is full of searching revisions. Unlike others, he often treated a single motif repeatedly,

transposing into the field the deliberations and subtle adjustments of studio work. This process of experiment is especially apparent in the drawings and in the ever-changing dialogue between drawing and painting. Often it seems as if Corot had abandoned the stable classical tradition for a profoundly modern conception of painting as a purely visual art and as an open process, constantly susceptible to reconsideration. Yet even Corot's most original experiments were deeply rooted in communal practice. In these opposing respects his work is representative of the entire episode of outdoor painting in Italy, which was both the last great expression of the classical landscape tradition and a new beginning.

Corot's work exhibits no conflict between his attachment to visual experience and his attachment to academic values. So fully had he incorporated the classical ideals of order and nobility that his pursuit of these abstract ideals was coextensive with his personal experience of the landscape. This identity – between the impersonal and the immediate, between the formal and the spontaneous, between the ideal and the real, between tradition and experience – is the heart of Corot's achievement in Italy.

EPILOGUE

WHEN COROT RETURNED TO FRANCE in 1828 he did not abandon outdoor painting. Frequent, extended sketching excursions remained a life-long habit. This was Corot's principal innovation in French landscape painting and the key influence of his first Italian sojourn on his later work. Throughout the 1830s and 1840s he submitted to the Salon works of high ambition, which conformed to the program set forth by the *Méridionaux* and the *Septentrionaux*. But unlike Valenciennes and his disciples, Corot did not continue to treat outdoor painting as a problem mainly for students working in Italy. He transformed it into a problem for mature painters working in France.

Corot's career is the only one that provides a bridge from the world of Valenciennes and Bidauld to the world of Pissarro and Monet. His friends and contemporaries in Italy – Aligny and Bertin, for example – remained mired in the received certainties of the Neoclassical era. Those who joined Corot in forging the modern landscape tradition in France – Rousseau and Daubigny, for example – were young enough to have escaped the mold of Valenciennes's school. Rousseau, born in 1812, studied briefly with Rémond, winner of the *prix de Rome* for *paysage historique* in 1821, but the experience was ephemeral. Daubigny, born in 1817, student of J.-V. Bertin, was the last French landscape painter of consequence to travel to Italy in his youth, in 1836. By then the new French tradition was underway, and the journey left no lasting mark on his work.

Corot's outdoor painting in France just after he returned from Italy is a rich and fascinating object of study. Its main import here is the contrast it provides with the work of his first trip to Italy. There Corot had followed a circumscribed itinerary and had focused on a narrow range of motifs, virtually all of which had been painted repeatedly by others. In just the first few years after his return to France, he traveled and painted much more widely, from Paris and the Ile-de-France to Normandy and the Channel coast, from the Forest of Fontainebleau and Ville-d'Avray to Burgundy, the Morvan, and the Auvergne. In some of these places an embryonic landscape tradition existed, in others it did not; in none was the tradition well established. Corot essayed an impressive diversity of motifs, from city and town views to seacoast and inland panoramas, from studies of rocks and trees to farmyard and harvest scenes, from views of country roads, or of medieval architecture and ruins, to studies of boats at mooring.[1]

In view of such a diversity of motif, it is not surprising that Corot's outdoor painting of the late 1820s and early 1830s also is diverse in style and quality. Some studies recall the simple, robust design of the Italian landscapes, most often when the subject invited it (e.g., pl. 266). Others return to the vocabulary of Dutch naturalism that Corot had essayed as a student (e.g., pl. 267). Together with this range of style, but not strictly parallel to it, is a troubling range of quality. Although some studies rival the masterful concision of the Italian work, others display an awkward, almost naïve composition and a sprawling accumulation of imperfectly realized details. The two works reproduced here may suggest the range of style and quality, but they are inadequate to represent the complexity of Corot's effort. More telling than one comparison or a few is the ceaseless vacillation from one subject, one stylistic problem, to another. The whole program of

left Detail from pl. 269 (Corot).

211

266. Corot. *Medieval ruins, France,* 1828–30. (R.212.) Oil on canvas, mounted on cardboard, 23 × 30. Los Angeles, The Armand Hammer Foundation.

267. Corot. *Farmyard near Fontainebleau,* 1828–30. (R.215.) Oil, 41 × 49. Unlocated.

work is marked by uncertainty and lack of coherence, especially when measured against the heady logic of progress of Corot's first years in Italy.

More decisively and more completely than Corot's student work before 1825, his work in France after 1828 reveals the disparity between the circumstance of outdoor painting in Italy and in France. In Italy Corot was the inheritor of a rich tradition and the beneficiary of an active contemporary school at the height of its maturity. His achievement of 1825–28 is one of the most consistent and concentrated episodes in the work of any nineteenth-century painter. In France Corot was a pioneer; lacking the guidance of tradition and the support of an established milieu, he took many false steps. That he did so may reflect Corot's own youth, but it also expresses the immaturity of the tradition that he, more than any other, was in the process of creating.

Such a conclusion is at odds with the ingrained modernist expectation that boldness of innovation and certainty of achievement go hand in hand. But the flaws and false steps of Corot's early outdoor work in France are integral to the originality of his project. His first trip to Italy expresses a seamless collaboration of personal talent and collective circumstance, of training and opportunity, of tradition and innovation. Had Corot died in 1829 he would be admired; but he deserves still deeper admiration for the courage with which he left the perfection of Italy behind. Without a new manifesto, without rejecting his education, Corot led the creation of a new artistic opportunity rich enough to sustain more than half a century of exploration by a roster of very talented painters. His Italian work is magnificent, but it marks the end of a tradition. His French work is imperfect, but it began a new one.

* * *

Corot returned to Italy twice, in 1834 and 1843. Both were six-month summer sketching trips, that is, very much shorter that the first, three-year journey. Neither remotely approaches the significance of the first trip, and neither redirected the course of Corot's work. That he undertook the trips at all is evidence of his abiding attachment to the ideals of his earliest artistic training, even as

212

268. Corot. *Genoa*, 1834. (R.301.) Oil on paper, mounted on canvas, 29.5 × 41.7. Chicago, The Art Institute of Chicago.

his ongoing work in France progressively revised those ideals. Stylistically and philosophically, perhaps also personally, Corot's second and third trips to Italy were echoes of the first.

Nevertheless, there were differences. In the 1820s Corot had spent the lion's share of his time in and near Rome. In 1834 he never ventured south of Florence.[2] Leaving Paris toward the end of May with the painter Jean-Charles-Denis Grandjean, he spent the first half of June at Genoa. He spent six weeks in Tuscany, visiting Volterra and Florence, then three weeks at Venice, and concluded the sojourn at Lakes Garda and Como. As subjects for painting most of these places were new to Corot, and the rather rapid pace of his tour discouraged exploration and reflection. His longest stop – a month at Volterra in June and July – hardly compares with the four months spent at Civita Castellana in 1826 and 1827.

Corot's itinerary corresponds to a general trend of the mid-nineteenth century, in which the lure of Rome weakened beside the attraction of other cities and locales. Turner and Ruskin made Venice their capital of Italy; the Brownings made Florence theirs. This broadening of the tourist's map arose in part from the erosion of Neoclassicism and a new appreciation for Italian architecture and

269. Corot. *Volterra, view toward the fortress.* 1834. (R.304.) Oil on canvas, 47 × 82. Paris, Louvre.

270. Camille Pissarro. *Jallais Hill, Pontoise*, 1867. Oil on canvas, 87 × 114.9. New York, The Metropolitan Museum of Art. Bequest of William Church Osborn, 1951.

painting before Raphael. Corot, whose work in France had begun to welcome the new taste for Gothic architecture, copied Giotto at Pisa and a thirteenth-century fresco in Santa Maria Novella in Florence (R.2661, R.2665).

At work in the major cities – Genoa, Florence, and Venice – Corot followed local conventions of picturesque topography. As at Naples and Venice in 1828, he was passing through as a tourist and his response to the anonymous, panoramic motifs often seems superficial, even dutiful. The exception is a splendid view of Genoa, compact in structure and rich in delicate observation (pl. 268).

Elsewhere, however, at the lakes and especially at Volterra, Corot encountered a landscape whose physiognomy he could easily adapt to the Italianate schemes he knew so well. At Volterra he painted two magnificent views, which in conception and execution constitute an unbroken extension of his work at Civita Castellana some seven or eight years earlier (e.g., pl. 269). What is new about these pictures is their size: the larger is nearly a meter wide.[3]

Corot's open-air style had relied – one might almost say, had depended – upon the modest size of the *étude d'après nature*. The role of each brushstroke in the cohesive fabric of the whole was managed with such confidence because the reach of scale from the former to the latter was not large. At Volterra Corot now tested his ability to deploy the style over a much broader field. In the larger view, perhaps, he overstepped his limits; the treatment of many details is uncertain. But the smaller view – itself quite large – is vigorous and confident throughout, a faultless performance. The artistic achievement is impressive, without reference to the novel practical difficulty of attempting such a large painting out of doors. Pissarro's grand view of Pontoise, painted more than three decades later, represents no substantial advance in outdoor painting (pl. 270).

214

Another fine work of Corot's second Italian journey is a view painted at Lake Como (pl. 271). Unlike the Volterra pictures, it is not a compact distillation of Poussinesque pictorial structure, but a full-blown classical composition, frankly imposed on the view. This in itself is not surprising. What is new here is the completeness with which Corot has taken the classical design for granted, concentrating on other qualities. In respect to the norm of Corot's earlier Italian work, the geometric scaffold is less secure and the drawing less precise, but the color scheme is correspondingly more fluid and subtle. In short, Corot neglected the rigid fundamentals of his Italian style to pursue – and achieve – a new limpid delicacy of color and light.

The views at Volterra and Como represent original and divergent elaborations of Corot's repertory of open-air style. Painted within a few months of each other, they suggest the unprogrammatic character of his work, his taste for experiment. Neither led directly to a new stylistic plateau but each left behind, for Corot and for others, a stunning document of an unexhausted opportunity for outdoor painting.

In 1843, after an interval of fifteen years, Corot at last returned to Rome. He spent most of his third and final trip to Italy in Rome and nearby – in the Castelli

271. Corot. *Lake Como*, 1834. (R.308.) Oil on canvas, 29 × 42. London, The Lefevre Gallery.

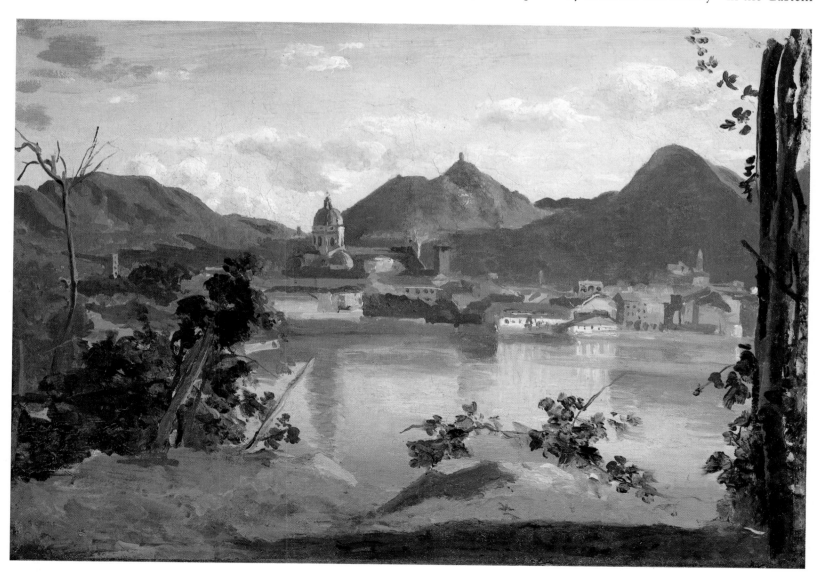

Romani, especially at Genzano and Nemi, and at Tivoli, where he had stopped only very briefly in the twenties. He did not return to his favorite sites at Civita Castellana or even at Rome, but the motifs he did paint were famous ones – the Lake of Nemi, the cascades at Tivoli, the Arch of Constantine at Rome.

By 1843 Corot was nearing the age of fifty. He had been painting outdoors regularly for more than twenty years. Most of his traveling and sketching had been done in France, and Rome no longer held for his work the special significance it had held in the 1820s. The subjects he chose in 1843 were no longer so much revered talismans of the classical past as they were attractive motifs along the route of an artist who had traveled a good deal and would travel a good deal more. While a study of the Arch of Constantine (pl. 272) honors Roman grandeur, Corot gave more attention to the Renaissance villas, which he had ignored before. Stylistically, his view of the Villa Doria Pamphili (pl. 273) recalls the clear structure and workmanlike brushwork of the first trip (and, in the pots and statues on the wall, returns to the old game of near-and-far), but the modern, wedding-cake luxury of the palace strikes a new note.

In other studies the style, too, is different. An example is the soft, pale gray-green-blue harmony of the *Cascades at Tivoli* (pl. 274). Here Corot envisioned an icon of the classical scene through the veil of the silvery atmosphere of the Ile-de-France. If Italy had provided the scene of Corot's early triumph, that triumph was now in the past; the essential nourishment for his new art now lay in the

272. Corot. *The Arch of Constantine and the Forum, Rome*, 1843. (R.445.) Oil on paper, mounted on canvas, 27 × 41.9. New York, collection of Mr. and Mrs. Eugene V. Thaw.

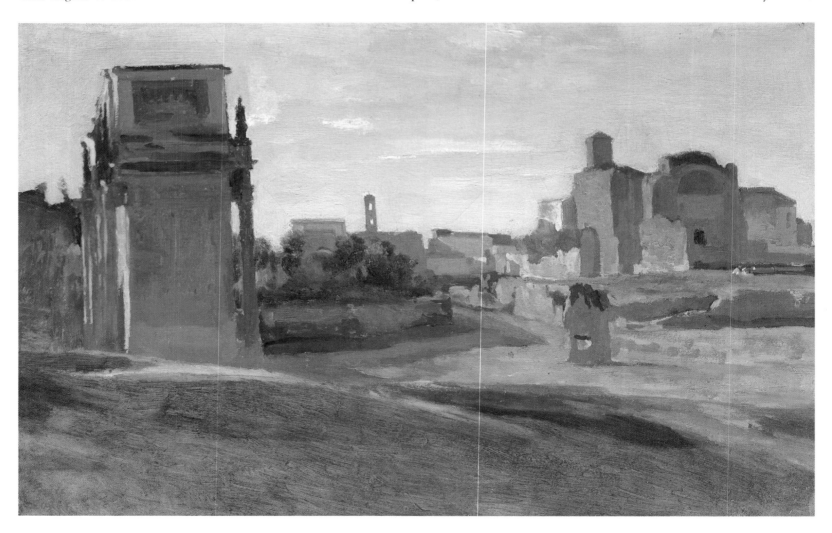

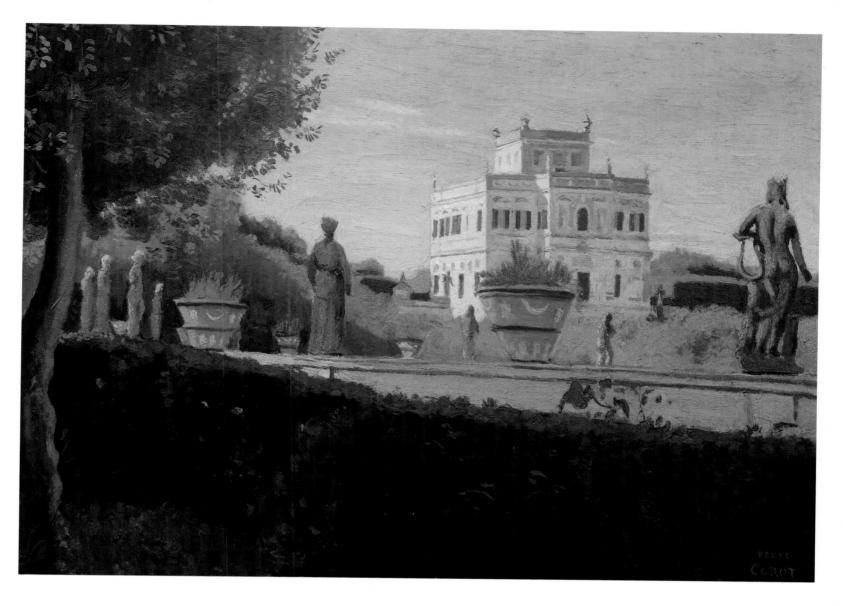

273. Corot. *Villa Doria Pamphili, Rome*, 1843. (R.448.) Oil on canvas, 26 × 36.2. New York, collection of Mrs. Beverly Sommer.

North. One study of 1843, painted on the shore of Lake Nemi, embodies that transformation (pl. 275). The stability and robustness of Corot's first Italian work have evaporated. The dark foreground frames a shimmering apparition. Architectonic rigor has given way to a delicate arabesque of trunks and branches, which answers the gentle undulation of the distant bank and its reflection. Precedents for the image exist in Léon Cogniet's study at Nemi (pl. 106) and in Corot's serene view of Lake Piediluco (pl. 255). But as Germain Bazin has observed, the *Lake Nemi* looks back much less than forward, toward the *Memory of Mortefontaine* (pl. 276).[4] That an Italian landscape painted in the open air could so anticipate Corot's most artificial Salon style suggests at once how much his art had evolved by 1843 and how complex was the exchange, throughout his career, between the empirical and the aesthetic.

* * *

It was not only for Corot that the lure of Rome had weakened. By 1840 throughout Northern Europe the whole constellation of values that had maintained

217

Rome's authority was under revision. What once had seemed universal and timeless increasingly came to seem parochial and atavistic. Outdoor painting in Italy atrophied with the Neoclassical aesthetic it had served, as the locus of the vital tradition shifted to the North.

It is also true that by 1840, after more than half a century of lively exploration, the Italian landscape study no longer presented a fresh opportunity. The communal routines and conventions that had provided such a rich resource for Corot in the 1820s became a burden for his successors. Studies of the 1840s by Ernest Hébert (1817–1908) and Corot's student Auguste Ravier (1814–1895) are symptomatic of the general decline, in which empirical clarity gave way to pastiche (pls. 277, 278). Hébert and Ravier were less talented than many of their contemporaries who stayed at home in France, but that is only part of the explanation. The closed world of landscape painting at Rome had settled into inertia, and the ritual repetition of favorite motifs drained outdoor painting of vitality.

After mid-century, Northern landscapists generally remained at home, leaving the weakened Italian tradition in the hands of figure painters who continued to uphold the classical tradition. For Girodet and Ingres the landscape study had been part of the history painter's initiation to Italy, and so it was in the early 1850s for Frederic Leighton (1830–1896)[5] and Adolphe William Bouguereau (1825–1905),[6] and, slightly later, for Edgar Degas (1834–1917). Degas's Italian landscapes, broad in effect and elegiac in tone, are not so much studies in observation as gestures of homage to the tradition that had come before (pl. 280).

Shortly after arriving at Rome in 1852, Leighton wrote home:

274. Corot. *Cascades at Tivoli*, 1843. (R.451.) Oil on canvas, 25.8 × 40.8. Paris, Louvre.

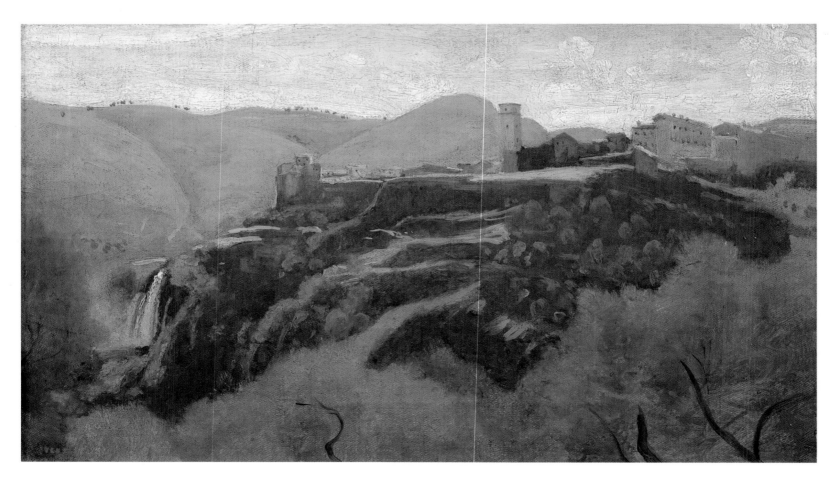

275. Corot. *Lake Nemi*, 1843. (R.455.) Oil on canvas, 23 × 29. Vienna, Oesterreichische Galerie.

I look forward, too, with the greatest delight to the studies that I shall make this summer in the exquisitely beautiful spots to which the artists always take refuge from the heat and malaria of Rome. I long to find myself again face to face with Nature, to follow it, to watch it, and to copy it, closely, faithfully, ingenuously – as Ruskin suggests, 'choosing nothing, and rejecting nothing.' I have come to the conviction that the best way for an historical painter to bring himself home to Nature, in his own branch of art, is strenuously to study *landscape*, in which he has not had the opportunity, as in his own walk, of being crammed with prejudices, conventional, flat – academical.[7]

276. Corot. *Memory of Mortefontaine*, Salon of 1864. (R.1625.) Oil on canvas, 65 × 89. Paris, Louvre.

The remark is rich in unintended irony. Fresh and eager as they are (pl. 279), Leighton's landscape studies follow what had become an academic pattern. They had little effect on his "conventional prejudices" and still less on the landscape tradition, which had left Italy behind. The same may be said generally of the Americans, who began to reach Italy in numbers in the 1840s, just as the North-Europeans decamped.[8]

With virtual unanimity Italian painters had abstained from the open-air tradition that had flourished on their soil. Only in the late 1820s did they begin to join it, and then only within the parochial Scuola di Posillipo, established at Naples by the Dutch landscapist Antonio Sminck van Pitloo (1790–1837).[9] Still more remote from the initial tradition was the school of the Macchiaioli, which emerged in Tuscany in the 1860s, and which owed more to recent French painting than to the international precedent in Italy.[10]

For German artists the tradition of Italianate landscape and of the youthful pilgrimage to Rome survived much longer than for the French and the British, and continued to evolve. The nostalgic, often melancholy aesthetic of the *Deutsche-*

277. Ernest Hébert. *S. Trinità dei Monti, Rome*, early 1840s. Oil on canvas, 25 × 45. Paris, Musée Hébert.

278. Auguste Ravier. *Garden of a Roman Villa*, *c*.1832. Oil on paper, mounted on cardboard, 25 × 27. Paris, Louvre.

279. Frederic Leighton. *Monte alla Croce*, 1850s. Oil on cardboard, 9.9 × 17.7. Oxford, Ashmolean Museum.

280. Edgar Degas. *View of Rome from the banks of the Tiber*, *c*.1857. Oil on paper, mounted on canvas, 18 × 26. Switzerland, private collection.

281. Max Klinger. *View of the Colosseum from the artist's studio*, 1888. Oil on canvas, 77 × 102. Dresden, Staatliche Kunstsammlungen.

Römer replaced the principled austerity of the Nazarenes; the *Villa by the sea*, painted in 1864 by Arnold Böcklin (1827–1901) is a long way from the *Heroic landscape* of 1805 by Josef Anton Koch.[11] Within the evolving tradition, the open-air study remained a staple of German art at Rome. As late as 1888 Max Klinger (1857–1920), like Corot and others before him, marked his arrival in the Eternal City by painting the view from his studio (pl. 281).

The depth and longevity of German *Sehnsucht nach Italien* thus maintained the identity of outdoor painting in Italy – and much of its spirit – well after its peak of maturity. Many Italian open-air landscapes painted by German artists in the 1840s carry the conviction of works made two decades earlier, in the heyday of the tradition (pl. 282). Even for the young Böcklin and his contemporary Anselm Feuerbach (1829–1880), when they arrived at Rome in the 1850s, the vitality of the landscape study was not yet exhausted. An abruptly framed cliffside study by Böcklin, horizonless, vivid in its pattern of light and shadow, is not a pastiche but a fresh discovery (pl. 283).

Overall, however, the survival was achieved at the expense of change. Between Reinhold and Blechen in the 1820s and Böcklin and Feuerbach in the 1850s, German painters in Italy brought little new to the open-air tradition. In this period the most original German painter of outdoor landscapes – Adolf Menzel (1815–1905) – never traveled to Italy. Those Northerners who did – Böcklin and Feuerbach, Leighton and Bouguereau and Degas – transformed the Italian landscape study from an opportunity to be explored into an hermetic ideal to be preserved.

* * *

Corot's brief, brilliant achievement in Italy stands apart from his long, complex, influential career in France. For the latter to flourish, it was essential that the

282. Johann Wilhelm Schirmer. *Cypresses*, 1840. Oil on canvas, 76 × 54. Dusseldorf, Kunstmuseum, extended loan from the Staatliche Kunstakademie, Dusseldorf.

former be left behind. The experience offers a paradigm for European landscape painting generally. Although outdoor painting first prospered in Italy, although the participants were international, the Italian episode was largely isolated from subsequent developments in the North.

The circumstances that fostered early outdoor painting in Italy also confined it. The first of these was the consensus created by Neoclassical values. That consensus assembled many painters in one spot, forming an active milieu; it

283. Arnold Böcklin. *Study in the Sabine mountains*,
1850–55. Oil on canvas, 20 × 23. Switzerland,
private collection.

focused their enthusiasm on a communal problem; it provided them with a
well-defined repertory of landscape motifs and a venerable pictorial vocabulary,
closely tied to those motifs. Most painters worked in Italy for only a short time,
then returned home. The coherence and continuity of the tradition did not
depend on the sustained leadership of a few outstanding artists but on the social
and artistic cohesiveness of the community. That very cohesiveness made the
Roman milieu a closed world, despite the internationality of its constituents.
Its habits and achievements were not easily transposed to other environments;
Corot's deep familiarity with the motifs of Civita Castellana was of little use
to him in the Ile-de-France.

The second limiting circumstance of early outdoor painting in Italy was its
dependence upon the framework of theory that had established the identity of
the study after nature. Isolated from the formalities and pretensions of public art,
outdoor painting flourished. But isolation was also a constraint. Corot went
further than any other painter in applying the lessons of the studio to his open-
air work. Further progress meant loosening and, ultimately, abandoning the
barrier between empirical study and synthetic composition. This is precisely
what happened later in France. The Italian study after nature, deeply rooted in
the old hierarchy, was cut off from that process.

The passage from early outdoor painting in Italy to the new traditions of the
North can be described as an unbroken continuity only in the case of Denmark.
When Eckersberg returned to Copenhagen in 1816, after three years at Rome,
he brought to Denmark the Italian style of bright, simply structured views of
modest scale. As a professor at the Copenhagen Academy from 1818 onward,

224

Eckersberg formed the sensibility of a younger generation of landscape painters. In the 1830s and 1840s his students – Christen Købke (1810–1848), Constantin Hansen (1804–1880), and others – extended their master's example into a national school.[12] Elsewhere in the North, especially in France, the development of modern landscape was nourished by a creative tension between the empiricism of the study after nature and the ambitions of the grand tradition. In Denmark this tension was resolved, without struggle, by omitting the latter term. In Købke's work there is an occasional oil study for a finished picture, but typically the latter is only a marginal elaboration of the former. The distinction of Danish landscape painting of the nineteenth century is its modesty.

Hansen and Købke both visited Italy, where they painted outdoor landscapes in the late 1830s and early 1840s. Thanks to Eckersberg these painters already had developed a native school of outdoor painting before they ever saw Italy. This prior experience diluted the impact of the declining Italian tradition, which hardly inflected their work. Their crisp, light-hearted landscapes are not so much contributions to the lingering international school in Italy as they are applications of the established Danish style to Italian motifs (e.g., pl. 284).

In Britain the far richer development of landscape painting owed far less to the Italian precedent. In the eighteenth century British artists, from Wilson to Cozens to Jones, had played a major role in the unfolding of landscape painting and sketching in Italy, and the work they did there profoundly influenced developments at home. But between 1793 and 1814 – precisely when outdoor painting in Italy was emerging as a tradition – political conditions excluded British painters from Italy. By the time Turner first traveled there in 1819, he was a fully mature artist who readily absorbed the Italian tradition of outdoor painting into his own wide-ranging program.

In the matter of open-air painting Britain's most original and accomplished artist was Constable, who never visited Italy. Like those who did, Constable studied Claude, but he owed nothing to the precedent of outdoor painting in Italy. Transposing Claude's Italianate schemes to the English scene, Constable

284. Constantin Hansen. *In the gardens of the Villa Albani, Rome*, 1841. Oil on canvas, 34 × 50. Copenhagen, Statens Museum for Kunst.

also transformed Claude's legacy far more deliberately and far more deeply than his contemporaries at work in Italy.

For Constable in the 1810s as for Corot in the 1820s the challenge of outdoor painting achieved a splendid but ephemeral autonomy. The two episodes are distinct one from the other and cannot be traced to a common source. This is all the more reason to take them together as expressions of a fundamental change in the European landscape tradition. It would be a mistake, however, to isolate the outdoor work of Constable and Corot as an avatar of modernity. Both artists regarded open-air painting as part of an organic program of work; neither rejected the studio for the field. Their essential achievement lies not in their outdoor work taken alone, but in the originality and resourcefulness with which they engaged a new dialogue between the studio and the field.

The same is true generally of modern landscape painting in France. By treating outdoor painting in isolation it is possible to construct a continuous tradition from Valenciennes to Cézanne. Such a continuity is implied when historians note, as they now often do, that Pissarro advised his son to consult Valenciennes's treatise. But the key to the French tradition is precisely that outdoor painting was not isolated from the grand ideals of the studio. Impressionism is inaccurately described as a triumph of outdoor painting over studio routine, of empiricism over stale convention. Rather the triumph consisted in investing the fresh opportunity of open-air work with the venerable ambitions of the studio.

Corot's chief contribution to that triumph was not the perfection of his achievement in Italy but his willingness to leave it behind – to outgrow the certainties of Neoclassicism and, especially, to engage the empirical challenge beyond the narrow autonomy of the Italian study after nature. This is the most important reason why it is wrong to regard Corot's Italian work as the harbinger of Impressionism and his Salon compositions as a regrettable capitulation to official taste.

* * *

The mythology of modernism celebrates the individual – one's independence, one's spontaneity, one's depth of feeling. The story of nineteenth-century landscape painting is an exemplar of that mythology, a story of progressive emancipation from the past and from the repressive authority of institutions. Open-air painting is still more exemplary. The act of quitting the studio embodies the spirit of rejecting the whole received burden of studio cuisine and academic philosophy. In the open air, art became a matter of private communion with nature, and the picture became an immediate trace of personal experience.

This way of telling the story once put great faith in the idea that such an immediate impression could be achieved without the interference of tradition, that it was possible to capture the candor of vision without recourse to the studied recipes of art. This myth of the innocent eye has now been laid to rest. All art is active invention – all art is artificial – and open-air painting is no exception.

There remains the need to account for the newness of outdoor painting. Since the Renaissance the empirical and synthetic motives of art had coexisted in fruitful collaboration. Outdoor painting gave an original and striking salience to the empirical motive, thus introducing a new expressive vocabulary. It is reasonable to describe this development as a rupture in the tradition, a new beginning. There follows the familiar paradigm of conflict – between new and old, individual and academy, radical and conservative.

Early outdoor painting in Italy does not fit that paradigm. It was not the

creation of a few advanced painters in opposition to entrenched authority but the collective achievement of a broad community, supported by the academy. It did not answer a radical manifesto but served established values. It did not gradually shed convention but began at an extreme of spontaneity and progressively absorbed the lessons of the past. Corot, its outstanding figure, arrived not at the beginning but at the end; the originality of his work arose not from impatience with tradition but from deep devotion to it. In Italy he was not the precursor of Impressionism but the vessel of Neoclassicism.

The principle of Neoclassicism distills the *raison d'être* of the academy: that the future of art can be anticipated and promoted as a systematic extension of past achievement. The principle applied not only to the practical problems of mastering a craft and a complex pictorial vocabulary. It was also a philosophical principle, which construed artistic evolution as a logical and controllable sequence, in which the past defined the expectation of the future.

The emergence and enrichment of outdoor painting in Italy confounded that expectation. Tradition indeed contained a fresh opportunity, which the open-air painters seized and exploited, but it was not one that theory had identified or encouraged. Outdoor painting was an unanticipated avenue of innovation, whose significance was recognized and applauded only after the fact. Theory – neither radical nor conservative – cannot claim it. It was an achievement of practice, an unbidden chance created and fulfilled by painters as they worked.

Modern culture might be defined by its active pursuit of such chances, its taste for opportunities left untouched by established theory. With such an outlook comes the open conflict of the individual with the keepers of tradition, the tendency of the latter to dismiss the inventions of the former, the isolation and alienation of the advanced few from the more slowly moving social environment, the prominence of manifestoes violently opposed to the status quo, the fevered search for the new and shocking. A sensibility schooled in such a pattern – our sensibility – is ill prepared to understand Corot's artistic world and especially Corot himself, even as it wishes to appropriate his achievement. It can only cast him as a radical or a conservative, when he was neither. His early work in Italy belongs to a moment, now obliterated, when the unfolding of tradition was no longer in the hands of the academy, but when commitment to tradition was not yet an obstacle to originality.

ABBREVIATIONS

Age of Revolution	*French Painting 1774–1830: The Age of Revolution*. Exh. cat. Detroit: Detroit Institute of Arts and New York: The Metropolitan Museum of Art, 1975.
Bazin, *Corot*	Germain Bazin. *Corot*. 3rd ed. Paris: Hachette, 1973.
BSHAF	*Bulletin de la Société de l'histoire de l'art français*
Elémens	Pierre Henri de Valenciennes. *Elémens de perspective pratique, à l'usage des artistes, suivis de réflexions et conseils à un élève sur la peinture et particulièrement sur le genre de paysage*. Paris: Desenne [1800].
French Landscape Sketches	*French Landscape Drawings and Sketches of the Eighteenth Century*. Exh. cat. London: British Museum, 1977.
GBA	*La Gazette des Beaux-Arts*. Unless otherwise noted, reference is made to the *sixième période*, which began in 1929.
McMordie, "Historical Landscape"	Colin P. McMordie. "The Tradition of Historical Landscape in French Art 1780–1830." B. Litt thesis, Oxford: University of Oxford, Oriel College, 1976.
Moreau-Nélaton, "Histoire de Corot"	Etienne Moreau-Nélaton. "Histoire de Corot et des ses oeuvres." In Robaut, *Corot*, vol. 1.
R	Designates catalogue number in Robaut, *Corot*.
Radisich 1977	Paula Rea Radisich. "Eighteenth Century Landscape Theory and the Work of Pierre Henri de Valenciennes." Dissertation, Los Angeles: University of California at Los Angeles, 1977.
Radisich 1982	Paula Rea Radisich. "Eighteenth Century *Plein-Air* Painting and the Sketches of Pierre Henri de Valenciennes," *Art Bulletin*, 64 (1982), 98–104.
Robaut, *Cartons*	Paris, Bibliothèque Nationale, Cabinet des Estampes. *Don Moreau-Nélaton. Collection Robaut. Notes, croquis, calques, photos, estampes*. 34 cartons. S.N.R. Format 4. See the Bibliography for further explanation.
Robaut, *Corot*	*L'Oeuvre de Corot par Alfred Robaut, catalogue raisonné et illustré, précédé de l'histoire de Corot et de ses oeuvres par Etienne Moreau-Nélaton*. 4 vols. Paris: H. Floury, 1905.
Robaut, *Documents sur Corot*	Paris, Bibliothèque Nationale, Cabinet des Estampes. *Don Moreau-Nélaton. Alfred Robaut. Documents sur Corot*. 3 vols. Yb.3.949/4to. See the Bibliography for further explanation.
RS	Designates catalogue number in one of the three supplements to Robaut, *Corot*; e.g., "RS2.5" means "Second supplement to Robaut, number five." The supplements are cited in n.1 to the Introduction.
Sterling and Adhémar	Charles Sterling and Hélène Adhémar. *Musée national du Louvre. Ecole française. XIXe siècle*. 4 vols. Paris: Editions des musées nationaux, 1958–61.

NOTES

INTRODUCTION

1. I refer here to works (not all of them presently located) that appear in *L'Oeuvre de Corot par Alfred Robaut, catalogue raisonné et illustré, précédé de l'histoire de Corot et de ses oeuvres par Etienne Moreau-Nélaton*, 4 vols. (Paris: H. Floury, 1905; hereafter cited as Robaut, *Corot*) and in three supplements to the catalogue: André Schoeller and Jean Dieterle, *Corot, premier supplément à L'Oeuvre de Corot par A. Robaut et E. Moreau-Nélaton* (Paris: Arts et Métiers Graphiques, 1948); André Schoeller and Jean Dieterle, *Corot, deuxième supplément...* (Paris: Arts et Métiers Graphiques, 1956); and Jean Dieterle, *Corot, troisième supplément...* (Paris; Quatre Chemins-Editart, 1974). Throughout this book (and in the captions to the illustrations) Corot's works are cited by Robaut number as follows: "R.5" means "Robaut number 5"; "RS2.5" means "Second supplement to Robaut, number five."
2. The colleague was Théodore Caruelle d'Aligny (1798–1871). The story was recorded for the first time by Théophile Silvestre in 1853. See Silvestre, "Corot" (1853), in *Les Artistes français: Etudes d'après nature* (Paris: G. Charpentier, 1878), pp. 261–76.
3. This remained a life-long habit. A number of Corot's own late figure studies, painted in his studio, show the Italian studies displayed on the wall; e.g., R.1558 (Washington, D.C.: National Gallery of Art) and R.1559 (Paris: Louvre), in both of which R.79 appears; also R.1561 (Lyons: Musée des Beaux-Arts) and R.1557 (Paris: Louvre). See also Robaut's drawings of Corot's studio, rpr. in Robaut, *Corot*, vol. 1, 316–17, 322.
4. For example, R.3053 (Paris: Louvre, Cabinet des Dessins, R.F.8708) and R.3103 (Paris: Louvre, Cabinet des Dessins, R.F.6742 *bis*). Corot himself apparently valued his early studies very highly. Robaut recorded an episode of the early 1870s in which Corot admonished a young painter for spending so much time copying Corot's latest studies, saying, "Because, in the end, one learns nothing from those, whereas with my old studies it's something else again." Robaut, *Documents sur Corot*, vol. 2, 85.
5. Silvestre, "Corot", p. 266. Corot's studies also are mentioned in Charles Asselineau, "Intérieurs d'atelier: C. Corot," *L'Artiste*, 5e série, 7 (15 Sept. 1851), 53–55.
6. Philippe Burty, "Camille Corot," in *Exposition de l'oeuvre de Corot* (exh. cat. Paris: Ecole nationale des Beaux-Arts, 1875), p. 7.
7. Jules Claretie, *Peintres et sculpteurs contemporains. Première série: Artistes décédés de 1870 à 1880* (Paris: Librairie des Bibliophiles, 1880), p. 115.
8. Paul Mantz, "Corot," *GBA*, 1e pér., 11 (1861), 419.
9. In the late nineteenth century, preference for Corot's Italian landscapes over his later works was confined to a few artists, such as Edgar Degas, and a few sophisticated collectors, such as Degas's friend Henri Rouart. See Theodore Reff, *Degas: The Artist's Mind* (New York: The Metropolitan Museum of Art, 1976), pp. 138 and 318, nn. 146, 147.
10. David Croal Thomson, *Corot* (London: Simpkin, Marshal, Hamilton, Kent & Co., 1892), p. 19.
11. Charles Blanc, "Achille Etna Michallon," in *Histoire des peintres de toutes les écoles. Ecole française*, vol. 3 (Paris, 1869), 5.
12. Silvestre, "Corot", p. 262.
13. Henri Focillon, *La Peinture au XIXe siècle: Le Retour à l'antique, le romantisme* (Paris; Renouard, 1927), p. 304.
14. The exception is the work of Paul Marmottan, who, alone in the late nineteenth century, tried to rescue the Neoclassical landscapists from the oblivion into which they were rapidly sinking. See especially his *L'Ecole française de peinture (1789–1830)* (Paris: Laurens, 1886).
15. See *Hommage à Corot* (exh. cat. Paris: Editions des musées nationaux, 1975), p. 22.
16. See n. 6 above.
17. See Robaut, *Corot*, vol. 4, 383–85, for a list of exhibitions between 1875 and 1905, and Germain Bazin, *Corot*, 3rd ed. (Paris: Hachette, 1973), pp. 304–6, for a list of subsequent exhibitions.
18. See n. 1 above.
19. Germain Bazin, *Corot* (Paris: Tisné, 1942); 2nd. rev. ed. (Paris: Tisné, 1951); 3rd. rev. ed. (Paris: Hachette, 1973).
20. Examples of this phenomenon – each titled *Corot* – are books by: Paul Cornu (Paris: Louis Michaud, 1911); Marc Lafargue (Paris: Rieder, 1925); Elie Faure (Paris: G. Crès, 1930); François Fosca (Paris: Floury, 1930); Camille Mauclair (Paris: Librairie Grund, 1930); and Paul Jamot (Paris: Plon, 1936).
21. Etienne Moreau-Nélaton, "Deux heures avec Degas," *L'Amour de l'art*, 12 (1931), 267. The *Monte Cavo* to which Degas referred is probably R.164 (Rheims: Musée des Beaux-Arts), sold in 1907 (the year of the interview with Moreau-Nélation) at the Robaut sale, no. 12.
22. Walter Sickert, "French Art of the Nineteenth Century – London," *Burlington Magazine*, 60 (1922), 260–71. Sickert referred to R.79.
23. Roger Fry, "Exhibition of French Landscapes in Paris. II – Claude & Poussin," *Burlington Magazine*, 67 (1925), 11.
24. Alfred H. Barr, Jr., *Corot, Daumier* (exh. cat. New York: The Museum of Modern Art, 1930), p. 13.
25. Lionello Venturi, *Les Peintres modernes* (1941), ch. 6, reprinted in translation in *Corot 1796–1875* (exh. cat. Philadelphia: Philadelphia Museum of Art, 1946), p. 14.
26. Clive Bell, *Landmarks in Nineteenth-Century Painting* (London: Chatto & Windus, 1927), p. 93.
27. André Michel, "L'Oeuvre de Corot et le paysage moderne," *Revue des Deux Mondes*, 4e pér., 133 (1896), 920.
28. Julius Meier-Graefe, *Corot* (Berlin: Bruno Cassirer und Klinkhardt & Biermann, 1930), p. 36.
29. Bazin, *Corot* (1942), p. 37.
30. Lawrence Gowing, "Confidence and Conscience in Two Centuries of Art," *Art News Annual*, no. 30 (1965), 118.
31. Barr, *Corot, Daumier*, p. 13.
32. Already before World War I Maurice Denis had painted a view of the fountain in front of the French Academy in Rome – a self-conscious reprise of Corot's study (R.79). See Marie-José Salmon, *Vasques de Rome, ombrages de Picardie: Hommage de l'Oise à Corot* (exh. cat. Beauvais; Musée Départemental de l'Oise, 1987), pp. 59–62.
33. Bissière, "Notes sur Corot," *L'Esprit nouveau*, no. 9 (c.1922), 1006–8. See also Carl Einstein, "Jean-Baptiste Corot (1796–1875): Compositions classiques," *Documents* (Paris), 1e année, no. 2 (May 1929), 84–92.
34. Focillon, *La Peinture au XIXe siècle*, p. 321. A similar formulation, equally nationalistic, is suggested in Georges Wildenstein, intro., *The Serene World of Corot* (exh. cat. New York: Wildenstein, 1942), p. 9.
35. Elie Faure, intro., *Exposition d'oeuvres de Camille J.-B. Corot (1796–1875): Figures et paysages d'Italie* (exh. cat. Paris: Paul Rosenberg, 1928), n.p.
36. Max Raphael, "Monographie eines Bildes: Corot 'Römische Landschaft'," in *Arbeiter, Kunst und Künstler: Beiträge zu einer marxistischen Kunstwissenschaft* (Frankfurt am Main: S. Fischer, 1975), pp. 51–78. The quoted sentence is from p. 56. I am grateful to Helmut Wohl for bringing the essay to my attention. The entire essay concerns a single painting in the Museum of Fine Arts, Boston, not by Corot but an anonymous copy of R.75.
37. See J. Guiffrey, *Catalogue de l'exposition des*

oeuvres provenant des donations faites par Madame la Princesse Louis de Croÿ et de Monsieur Louis Devilliez (exh. cat. Paris: Musée de l'Orangerie des Tuileries, 1930).

38. Prosper Dorbec, *L'Art du paysage en France: Essai sur son évolution de la fin du XVIIIe siècle à la fin du Second Empire* (Paris: Laurens, 1925), pp. 25–26.

39. René Huyghe, "Le Don de Mme. la Princesse de Croÿ," *Beaux-Arts*, 8e année, no. 10 (1930), 5.

40. See Lawrence Gowing, *The Originality of Thomas Jones* (London: Thames and Hudson, 1985).

41. *Thomas Jones (1742–1803)* (exh. cat. London: Greater London Council, 1970). See also the review of the exhibition by J. A. Gere, "Thomas Jones: An Eighteenth-Century Conundrum," *Apollo*, n.s., 91 (1970), 469–70.

I PAINTING FROM NATURE

1. See Rudolf Wittkower, intro., *Masters of the Loaded Brush: Oil Sketches from Rubens to Tiepolo* (exh. cat. New York; Columbia Univ., 1967), pp. xx–xxv; Charles de Tolnay, *History and Technique of Old Master Drawings* (New York: Bittner and Co., 1943), p. 16; Mark M. Johnson, *Idea to Image: Preparatory Studies from the Renaissance to Impressionism* (exh. cat. Cleveland: Cleveland Museum of Art, 1980); and Albert Boime, *The Academy and French Painting in the Nineteenth Century* (London: Phaidon, 1971).

2. E.H. Gombrich, *Art and Illusion: A Study in the Psychology of Pictorial Representation*, 2nd ed. (Princeton: Princeton Univ. Press, 1961), p. 173.

3. For brief definitions of these and related terms see Wittkower, *Loaded Brush*, pp. xx–xxii.

4. On the origin and development of this aesthetic see Julius S. Held, *The Oil Sketches of Peter Paul Rubens* (Princeton, N.J.: Princeton Univ. Press, 1980), vol. 1, 6–14; also idem., "The Early Appreciation of Drawings," *Acts of the 20th International Congress of the History of Art* (Princeton, 1963), vol. 3, 72–95; Paul Wescher, *La Prima Idea: die Entwicklung der Oelskizze von Tintoretto bis Picasso* (Munich, 1960); and Otto Bushart, "Bild, Vorbild, Nachbild in der Malerei des Barock," *Acts of the 21st Congress of the History of Art* (Berlin, 1967), vol. 3, 149–52.

5. Denis Diderot, *Salons*, ed. Jean Seznec and Jean Adhémar, vol. 2, *1765* (Oxford: Oxford Univ. Press, 1960), 134–35. Jonathan Richardson, in his *Essay on the Theory of Painting* (1715), stated his affection for the small sketch handled with "bold rough touches" (quoted by Wittkower, *Loaded Brush*, p. xxiv). For a comparable position, see "Discours du Comte de Caylus sur les dessins," *Revue universelle des arts* (1859), pp. 316–23. For P.-J. Mariette's preference for

Hubert Robert's sketches over his finished paintings see *Le Cabinet d'un grand amateur, P.-J. Mariette, 1694–1774* (exh. cat. Paris: Louvre,1967), p.158, no. 264. John Ruskin expressed the nineteenth-century version of this outlook in *Modern Painters*, 3rd ed. (New York, 1856), vol. 1, 11: "Three penstrokes of Raffaelle are a greater and a better picture than the most finished work that ever Carlo Dolci polished into inanity. A finished work of a great artist is only better than its sketch, if the sources of pleasure belonging to color and realisation – valuable in themselves – are so employed as to increase the impressiveness of the thought. But if one atom of thought has vanished, all colour, all finish, all execution, all ornament, are too dearly bought. Nothing but thought can pay for thought, and the instant that the increasing refinement or finish of the picture begins to be paid for by the loss of the faintest shadow of an idea, that instant all refinement or finish is an excrescence and a deformity." I am grateful to Marjorie Munsterberg for the reference.

6. The clarity of this distinction is somewhat blurred in the important book by Boime (see n. 1 above), which concerns "the aesthetics of the sketch" in both nature studies and compositional sketches. See also John Minor Wisdom, ed., *French Nineteenth Century Oil Sketches: David to Degas* (exh. cat. Chapel Hill, N.C.: Ackland Memorial Art Center, 1978).

7. Much of the available evidence for this period is presented in Philip Conisbee, "Pre-Romantic *Plein-air* Painting," *Art History*, 2 (1979), 413–28. Aspects of this paper were developed in collaboration with Lawrence Gowing, who presented some of the material in a lecture, "The Pre-history of Open-air Painting," which I heard at Columbia Univ., N.Y., on 6 Dec. 1978. Conisbee, Gowing, and J.A. Gere collaborated on the exhibition *Painting from Nature: The Tradition of Open-air Oil Sketching from the 17th to the 19th Centuries* (Cambridge: Fitzwilliam Museum, and London: Royal Academy of Arts, 1980–81). See the exh. cat. of the same title; intro. by Gowing; cat. by Conisbee (London: Arts Council of Great Britain, 1980). Gere in turn had inspired the exhibition *French Landscape Drawings and Sketches of the Eighteenth Century* (exh. cat. London: British Museum, 1977).

Another essential work on the landscape study in oil is John Gage, *A Decade of English Naturalism 1810–1820* (exh. cat. Norwich: Castle Museum, 1969), which despite its title considers Continental as well as English artists. This important critical work was the first to treat early open-air painting as a coherent international development.

Some of the material discussed here was first presented in my *Before Photography: Painting and the Invention of Photography* (exh. cat. New York: The Museum of Modern Art, 1981).

8. Just which of the relevant drawings are from

Poussin's hand is a matter of recurring dispute. See Konrad Oberhuber, *Poussin: The Early Years in Rome: The Origins of French Classicism* (exh. cat. Fort Worth: Kimbell Art Museum, in association with Hudson Hills Press, New York, 1988) and the many review articles the catalogue inspired.

9. See Michael Kitson, "The Relationship between Claude and Poussin in Landscape," *Zeitschrift für Kunstgeschichte*, 24 (1961), 142–62. Claude's sketching practice is recorded in Joachim von Sandrart, *Teutsche Academie* (Nuremberg, 1675), of which the section on Claude is translated in Marcel Roethlisberger, *Claude Lorrain: The Paintings* (New Haven: Yale Univ. Press, 1961), vol. 1, 47–50; and in F. Baldinucci, *Notizie de' professori del disegno* (Florence, 1728), p. 356. For discussions of these accounts and attempts to connect them with surviving works, see Marcel Roethlisberger, *Claude Lorrain: The Drawings*, (Berkeley and Los Angeles: Univ. of California Press, 1968), vol. 1, 35–44; Lawrence Gowing, "Nature and the Ideal in the Art of Claude," *The Art Quarterly*, 37, no. 1 (Spring 1974), 91–96; and Conisbee, "*Plein-air* Painting," pp. 415–19.

10. See Marcel Roethlisberger, *Bartholomäus Breenbergh: Handzeichnungen* (Berlin: Walter de Gruyter & Co., 1969).

11. The first account of Gaspard's sketching practice is in Baldinucci, *Notizie*, p. 473. See Conisbee, "*Plein-air* Painting," pp. 419–20; *Gaspard Dughet, called Gaspard Poussin (1615–1675)* (exh. cat. Kenwood: The Iveagh Bequest, 1980), pp. 47–48, nos. 30–31; and Marie-Nicole Boisclair, *Gaspard Dughet* (Paris: Arthena, 1986).

12. See *Painting from Nature* p. 15, no. 2. G.B. Passeri, in a biography written between 1673 and 1679, states that Salvator painted outdoors. See Passeri, *Vite de' pittori, scultori ed architetti che hanno lavorato in Roma . . .*, ed. J. Hess (Vienna, 1934), p. 386; and Michael Kitson, *Salvator Rosa* (exh. cat. London: Arts Council of Great Britain, 1973), p. 19, no. 3.

13. In 1649–50 Velázquez painted two oil studies in the garden of the Villa Medici: cat. nos. 46 and 47 in José López-Rey, *Velasquez* (Lausanne and Paris: Bibliothèque des Arts, 1979). See Enriqueta Harris, "Velasquez and the Villa Medici," *Burlington Magazine*, 123 (1981), 537–41, where the previously accepted date of 1630 is replaced by 1649–50; and Jonathan Brown, *Velázquez: Painter and Courtier* (New Haven and London: Yale Univ. Press, 1986), pp. 203–7.

14. On the basis of an old inscription, pl. 5 and a related work in the same collection were thought to be by Gaspard Dughet. However, dated renovations of S. Trinità dei Monti, which appears in pl. 5, prove that the study could not have been painted before 1677, after Gaspard's death. See *Painting from Nature*, p. 15, no. 3, where the study is ascribed to an anonymous Northern painter working in Rome, *c*.1700.

15. Ph. de Chennevières and A. de Montaiglon, eds., *Abécédario de P.-J. Mariette et autres notes inédites de cet amateur sur les arts et les artistes*, vol. 1 (Paris: J.-B. Dumoulin, 1851), 127.

16. J.B. Deperthes, *Histoire de l'art du paysage* (Paris: Lenormant, 1822), p. 100. To support his account Deperthes cited two *études* by Poussin in the Louvre: "one of a beautiful tree, and the other of a picturesque building situated in the environs of Rome" – both subjects that Valenciennes and his successors painted frequently. That these two works were surely not paintings but drawings hardly would have discouraged Corot and his fellows from the conviction that, painting from nature in the environs of Rome, they were following the example of the great master. Another symptom of this attitude is the following remark in reference to a picture exhibited at the Salon of 1801 by Jean-Victor Bertin, later Corot's teacher: "Citizen Bertin doubtless is not unaware that the most beautiful compositions by Poussin are views after nature, to which he rarely added." From T.C. Bruun Neergaard, *Sur la situation des beaux-arts en France, ou lettres d'un danois à son ami* (Paris: Dupont, 1801).

17. Roger de Piles, *Cours de peinture par principes* (Paris: Jules Estienne, 1708). The passage before the ellipsis occurs on p. 243, the passage after, on p. 247.

18. See *Paysages de François Desportes* (exh. cat. Compiègne: Musée national du château, 1961); *French Landscape Sketches*, pp. 22–24, nos. 6–17; and Lise Duclaux, *L'Atelier de Desportes: Dessins et esquisses conservés par la Manufacture nationale de Sèvres* (exh. cat. Paris: Louvre, 1982), esp. section 2, "Paysages, arbres, plantes et fleurs," pp. 58–87.

19. Cl.-F. Desportes, "La vie de M. Desportes écrite par son fils," in L. Dussieux et al., eds., *Mémoirs inédits sur la vie et les ouvrages des membres de l'Académie Royale de Peinture et de Sculpture* (Paris: J.-B. Dumoulin, 1854), vol. 2, 98–113.

20. Another instance of painting from nature in the early eighteenth century is the work of Michel-Ange Houasse (1680–1730), who worked for the court at Madrid. In addition to portraits and figure pieces, Houasse made several small landscapes that appear to have been painted out of doors. An example is a *View of Aranjuez* (Madrid: Royal Palace), rpr. in *L'Art européen à la cour d'Espagne au XVIIIe siècle* (exh. cat. Paris: Réunion des musées nationaux, 1979), p. 124, no. 63. See Jutta Held, "Michel-Ange Houasse in Spanien," *Münchner Jahrbuch*, 19 (1968), 185–206.

21. Although no oil studies by Oudry survive, it is reported that "He never went into the countryside without taking with him a little tent under which he drew and even painted landscapes." From Louis Gougenot, "Vie de M. Oudry," in Dussieux et al., *Mémoirs inédits*, vol. 2, 377. See also *J.B. Oudry* (exh. cat. Paris: Louvre, 1982).

22. See A.P. Oppé, ed., "Memoirs of Thomas Jones," *Walpole Society*, 32 (1946–48); J.A. Gere, "An Oilsketch by Thomas Jones," *British Museum Quarterly*, 21 (1957–59), 93–94; *Thomas Jones (1742–1803)* (exh. cat. London: Greater London Council, 1970), reviewed by J.A. Gere, *Apollo*, n.s., 91 (1970), 469–70; and Lawrence Gowing, *The Originality of Thomas Jones* (London: Thames and Hudson, 1985).

23. See David H. Solkin, *Richard Wilson: The Landscape of Reaction* (exh. cat. London: Tate Gallery, 1982), pp. 10 and 152–53.

24. Reynolds to Nicholas Pocock in *Letters of Sir Joshua Reynolds*, ed. Frederick Whiley Hilles (Cambridge: Cambridge Univ. Press, 1929), p. 173. See also Jonathan Skelton to William Herring, 20 July and 25 Sept. 1758, in "Letters of Jonathan Skelton," *Walpole Society*, 36 (1956–58), 51, 60.

25. M. C[ochin], *Lettres à un jeune artiste peintre, pensionnaire à l'Académie de France à Rome* (n. loc., n.d. [c.1774]; [Bibliothèque Nationale, Impr. V.24206]). On Cochin, who is an important figure here, see S. Rocheblave, *Charles-Nicolas Cochin, graveur et dessinateur (1715–1790)* (Paris and Brussels: G. Vanoest, 1927).

26. Quoted in Philip Conisbee, *Claude-Joseph Vernet 1714–1789* (exh. cat. Kenwood: The Iveagh Bequest, 1976), n.p. This is the best critical study of Vernet, and takes up the issue of his influence. See also Florence Ingersoll-Smouse, *Joseph Vernet: Peintre de marine* (Paris: Etienne Bignou, 1926).

27. Philip Conisbee, "Pierre-Henri de Valenciennes at the Louvre," *Burlington Magazine*, 118 (1976), 336.

28. Lebrun and Levasseur, *Notice des tableaux, dessins et estampes . . . après le décès de M. Vernet . . . 20–21 avril 1790* (Paris, 1790), lot 17.

29. See the entry on the *Ponte Rotto* in Conisbee, *Vernet*, n.p.

30. Hackert's outdoor work is discussed in Radisich 1977, pp. 305–9; Radisich 1982, p. 101; Jeanne Plekon, "Jakob Philipp Hackert" (unpublished research paper [1980?], on file in the Dept. of Art History and Archaeology, Columbia Univ., New York), esp. pp. 27–28 and 80–84; and Bruno Lhose, *Jakob Philipp Hackert: Leben und Anfänge seiner Kunst* (Inaugural-Dissertation, Frankfurt am Main: Wolfgang-Goethe-Universität, 1936), which, however, treats only the period up to 1772. The essential source for the study of Hackert is his autobiography, revised and published by Johann Wolfgang von Goethe as *Philipp Hackert. Biographische Skizze, meist nach dessen eigenen Aufsätzen entworfen* (Tübigen, 1811), which includes Hackert's own fragmentary remarks on landscape painting, written c.1800. The entirety is reprinted in Goethe, *Werke. Berliner Ausgabe* (Berlin, 1973), vol. 19, *Kunsttheoretische Schriften und Übersetzungen, I. Schriften zur bildenden Kunst.*

31. See Duncan Bull et al., *Classic Ground: British Artists and the Landscape of Italy, 1740–1830* (exh. cat. New Haven: Yale Center for British Art, 1981); Lindsay Stainton, *British Artists in Rome 1700–1800* (exh. cat. Kenwood: The Iveagh Bequest, 1974); E. Bauer, *Die Englische Aquarellmalerei der 'Grand Tour' im 18. Jahrhundert* (Dissertation, Munich: Ludwig-Maximilians-Universität, 1976); and Francis W. Hawcroft, *Travels in Italy 1776–1783: Based on the Memoirs of Thomas Jones* (exh. cat. Manchester: Whitworth Art Gallery, 1988).

32. The sketchbooks, now at the Whitworth Art Gallery, Manchester, are reproduced in their entirety in the *Catalogue of Seven Sketch-Books by John Robert Cozens* (sale cat. London: Sotheby & Co., 29 Nov. 1973). See also Charles F. Bell and Thomas Girtin, "The Drawings and Sketches of John Robert Cozens," *Walpole Society*, 23 (1934–35); A.P. Oppé, *Alexander and John Robert Cozens* (London, 1952); Francis W. Hawcroft, *Watercolours by John Robert Cozens* (exh. cat. Manchester; Whitworth Art Gallery, 1971); Andrew Wilton, *The Art of Alexander and John Robert Cozens* (New Haven: Yale Center for British Art, 1980), which reproduces and discusses a number of related drawings and sketches by Cozens's contemporaries; and Kim Sloan, *Alexander and John Robert Cozens: The Poetry of Landscape* (New Haven and London: Yale Univ. Press, in association with the Art Gallery of Ontario, 1986).

33. On Wilson's drawings see Solkin, *Wilson*, pp. 153–76; Brinsley Ford, *The Drawings of Richard Wilson* (London, 1951); David H. Solkin, "Some New Light on the Drawings of Richard Wilson," *Master Drawings*, 16 (1978), 404–14; and Denys Sutton and Ann Clements, *An Italian Sketchbook by Richard Wilson R.A.*, 2 vols. (London: The Paul Mellon Foundation for British Art, in association with Routledge and Kegan Paul, London, 1968).

34. For Claude's drawings see n. 9 above, and J.A. Gere, intro., *Claude Lorrain: Dessins du British Museum* (exh. cat. Paris: Louvre, 1978).

35. The fundamental study of Valenciennes is Robert Mesuret, *Pierre-Henri de Valenciennes* (exh. cat. Toulouse: Musée Paul-Dupuy, 1956). Other studies include Paula Rea Radisich, "Eighteenth-Century Landscape Theory and the Work of Pierre Henri de Valenciennes" (Ph.D. dissertation, Los Angeles: University of California at Los Angeles, 1977); Paula Rea Radisich, "Eighteenth-Century Plein-air Painting and the Sketches of Pierre Henri de Valenciennes," *Art Bulletin*, 64 (1982), 98–104; Wheelock Whitney III, "Pierre-Henri de Valenciennes (1750–1819)" (M.A. thesis, London: Courtauld Institute of Art, 1975); idem., "Pierre-Henri de Valenciennes: An Unpublished Document," *Burlington Magazine*, 118 (1976), 225–27; and Geneviève Lacambre, "Pierre-Henri de Valenciennes en Italie; un journal de voyage inédit," *BSHAF*, année 1978 (1980), 139–72.

The great majority of Valenciennes's surviving Italian oil studies – a group of more than one hundred – is in the Département des peintures, Musée du Louvre, Paris. Most of them are reproduced in Sterling and Adhémar, vol. 4 (1961), nos. 1821–1939. The works had been acquired at or soon after Valenciennes's posthumous sale in 1819 by the comte de l'Espine, Directeur de la Monnaie under the Restoration. His descendant, the princesse Louis de Croÿ, bequeathed them to the Louvre in 1930, whereupon they were seen publicly for the first time since 1819. See J. Guiffrey, *Catalogue de l'exposition des oeuvres provenant des donations faites par madame la Princesse Louis de Croÿ et de Monsieur Louis Devilliez* (exh. cat. Paris: Musée de l'Orangerie des Tuileries, 1930).

Critical works on Valenciennes's studies include Lionello Venturi, "Pierre-Henri de Valenciennes," *Art Quarterly*, 4 (1941), 89–109; and Germain Bazin, "Pierre-Henri de Valenciennes," *GBA*, 59 (1962), 353–62.

In 1976 Geneviève Lacambre, working with new evidence, recatalogued the Louvre Valenciennes holdings in *Les Paysages de Pierre-Henri de Valenciennes 1750–1819*, Dossier du département des peintures, no. 11 (exh. cat. Paris: Louvre, 1976). This scrupulous analysis is the basis for all further scholarship. In the present context, Lacambre's important conclusions are the following: for the most part Valenciennes's Italian oil studies were painted in 1782–84. Some of the replicas or copies also may have been made at this time, but most were made later, perhaps not until 1817, when they were organized as a group, probably as a teaching aid.

36. See Bernard Hercenberg, *Nicolas Vleughels, peintre et directeur de l'Académie de France à Rome 1668–1737* (Paris: Léonce Laget, 1975); and Pierre Rosenberg, "A propos de Nicolas Vleughels," *Pantheon*, 31 (1973), 143–52.

37. See Jean-François Méjanès, "L'Académie de France à Rome sous l'Ancien Régime. Inventaires des dessins des pensionnaires sous les directorats de N. Vleughels et J.F. Detroy (1725–1751) dans les collections publiques françaises" (typescript thesis, Paris: Ecole du Louvre, 1969).

38. See Conisbee, *Vernet*, n.p.

39. See Lise Duclaux, "Les Paysages romains et des environs de Rome," in *Charles-Joseph Natoire* (exh. cat. Troyes, Nîmes, Rome: Académie de France, 1977), pp. 102ff.; Emile Dacier, "Natoire paysagiste," *Archives de l'art français*, nouv. pér., 8 (1916), 230–42; Ferdinand Boyer, "Catalogue raisonné de l'oeuvre de Charles Natoire, peintre du Roy (1700–1777)," *Archives de l'art français*, nouv. pér., 21 (1949), 31–106, section 9, "Paysages de Rome et de ses environs," nos. 591–678; and Wolfgang Krönig, "Rom-Vedute mit Rom-Historie im Werk von Charles Natoire," in *Festschrift für Heinz Ladendorf*, ed. Peter Bloch and Gisela Zick (Cologne:

Bohlau Verlag, 1970), pp. 50–57.

Natoire's enthusiasm for the sketching excursions is recorded in a letter to J.G. Wille from Hackert, who had met Natoire upon Hackert's arrival in Rome in 1768. The letter, dated 7 January 1769, is quoted and interpreted in Lohse, *Hackert*, pp. 62–65. In the spring of 1769, in the company of Antoine-François Callet (1741–1823) and the sculptor Johann Tobias Sergel (1740–1814), Hackert made sketching excursions to the Castelli Romani and then later to Subiaco, Palestrina, and Tivoli. These excursions yielded drawings from nature, from which Hackert later worked up views in gouache and oil (see Lohse, p. 14). In 1777 Hackert accompanied Richard Payne Knight, Charles Gore, and possibly also J.R. Cozens on a sketching trip to Sicily (see Bell and Girtin, "Cozens"). Thus Hackert's activities in and of themselves suggest that in landscape sketching as in other branches of art in Italy, exchanges among artists of various nationalities were fluid and frequent.

40. Jules Guiffrey and Anatole de Montaiglon, eds., *Correspondance des directeurs de l'Académie de France à Rome avec les surintendants des bâtiments*, vol. 10 (Paris, 1900), 394.

41. See Jean-François Méjanès, "Le Voyage d'Italie," in *La Donation Suzanne et Henri Baderou au Musée de Rouen: Peintures et dessins de l'école française*, Etudes de la Revue du Louvre, no. 1 (Paris: Réunion des musées nationaux, 1980), pp. 81–88; François-Georges Pariset, "Dessins de voyages. Artistes français en Italie dans la seconde partie du XVIIIe siècle," *GBA*, 54 (1959), 117–28; *Monuments et sites d'Italie vus par les dessinateurs français de Callot à Degas* (exh. cat. Paris: Louvre, 1958); and Marco Chiarini, *Vedute Romane: Disegni dal XVI al XVIII secolo* (exh. cat. Rome: Gabinetto Nazionale delle Stampe, 1971).

42. See the entries by Pierre Rosenberg in *French Master Drawings from the Rouen Museum* (exh. cat. n. loc.: International Exhibitions Foundation, 1981–82), pp. 90–91; and Thomas W. Gaehtgens and Jacques Lugand, *Joseph-Marie Vien: Peintre du Roi (1716–1809)* (Paris: Arthena, 1988), p. 233, nos. 17a-I-LII. The drawings previously had been attributed to Charles-Louis Clérisseau.

43. On Vincent's drawings see Jean-Pierre Cuzin, "Vincent, de l'Académie de France à l'Institut de France," in *La Donation Baderou*, pp. 93–100.

44. See Gerhard Fremmel, ed., *Corpus der Goethezeichnungen* (Leipzig: E.A. Seemann), vol. 2 (1960) and vol. 3 (1965).

45. See Alexandre Ananoff, *L'Oeuvre dessiné de Jean-Honoré Fragonard* (Paris: De Nobelle, 1963); Eunice Williams, *Drawings of Fragonard in North American Collections* (exh. cat. Washington, D.C.: National Gallery of Art, 1978); Pierre Rosenberg, *Fragonard* (exh. cat. New York: The Metropolitan Museum of Art, 1988), esp. pp. 94–117; Jean-Pierre Cuzin, *Jean-Honoré Fragonard: Life and Work,*

trans. Anthony Zielonka and Kim-Mai Mooney (New York: Abrams, 1988), esp. pp. 56–64; Victor Carlson, *Hubert Robert: Drawings and Watercolors* (exh. cat. Washington, D.C.: National Gallery of Art, 1978); Pierre de Nolhac and G.K. Loukomski, *La Rome d'Hubert Robert* (Paris: Vincent et Fréal, 1930); Marianne Roland Michel, intro., *Rome 1760–1770: Fragonard, Hubert Robert et leurs amis* (exh. cat. Paris: Cailleux, 1983); and Jean de Cayeux in collaboration with Catherine Boulot, *Hubert Robert* (Paris: Fayard, 1989).

46. See Marie-Felicie Perez, "The Italian Views of Jean-Jacques de Boissieu," *Master Drawings*, 17 (1979), 34–43; and G. Bergstrasser, "Zeichnungen von J.J. de Boissieu im Hessischen Landesmuseum zu Darmstadt," *Kunst in Hessen und am Mittelrhein*, 10 (1970), 89–99.

47. Cochin, "Réflexions sur les tableaux de M. Robert" (1759), quoted in Georges Wildenstein, *Un peintre de paysage au XVIIIe siècle: Louis Moreau* (Paris: Les Beaux-Arts, 1923), p. 20.

48. On the related outdoor work of history painters see Marc Sandoz, "Some Roman Views of Gabriel-François Doyen," *Master Drawings*, 12 (1974), 279–82; Régis Michel, "A proposito dei disegni del primo soggiorno di David a Roma (1775–1780)," in *David e Roma* (exh. cat. Rome: Académie de France, 1981); Arlette Sérullaz, "Dessins de Jacques-Louis David," in *La Donation Baderou*, pp. 100–5; idem., "A propos d'un album de dessins de Jean-Germain Drouais au Musée de Rennes," *Revue du Louvre*, 26 (1976), 380–87; and *Jean-Germain Drouais, 1763–1788* (exh. cat. Rennes: Musée des Beaux-Arts, 1985). Outside Rome the Tiepolos contributed to the practice. See George Knox, *Un Quaderno di vedute di Giambattista e Domenico Tiepolo* (Milan: Electa, [1974?]).

49. *Elémens de perspective pratique à l'usage des artistes suivis de réflexions et conseils à un élève sur la peinture, et particulièrement sur le genre de paysage* (Paris: Desenne [1800]). The preface (n.p.) acknowledges the collaboration of the painter and writer Simon-Celestin Croze-Magnan (1750–1818), "My Student in Painting, who has traveled a great deal," and who must have written most of the more than one hundred pages (519ff.) describing appropriate sites for the landscape painter throughout the Mediterranean and France. A second, posthumous edition of the work appeared in Paris in 1820. References here are to the first edition. Both editions are really two virtually independent books, the *Elémens de perspective* (pp. 1–374) and the *Réflexions et conseils* (pp. 375ff.). The latter is the important treatise on landscape painting. To avoid confusion, however, I have followed the pervasive practice of referring to the entire volume as *Elémens*.

50. *Elémens*, p. 404.

51. In 1973 a previously unknown group of oil studies by Valenciennes appeared in the exhibition *P.H. de Valenciennes* at the Galerie

de Bayser, Paris. A number of these works represent French sites, mainly in Brittany (e.g., pl. 78 below). Geneviève Lacambre, in "Pierre-Henri de Valenciennes en Italie," pp. 141–43 and 171 n. 26, has proposed that Valenciennes painted these studies in 1785, shortly after his return to France from Italy. See also Denis Delouche, *Peintres de Bretagne: Découverte d'une province,* Publications de l'Université de Haute Bretagne, no. 7 (1977), pp. 10, 78, 340.

52. *Elémens,* pp. 404–7.

53. A single exception is the broadly painted *Ruins in a plain* (Paris: Louvre, R.F. 2898), Sterling and Adhémar, vol. 4, no. 1926, pl. 749.

54. *Elémens,* p. 409.

55. Ibid.

56. Quoted in Geneviève Lacambre, "Une lettre de Pierre Henri de Valenciennes à une jeune élève," *Archives de l'art français,* nouv. pér., 28 (1986), 160.

57. John Gage, *A Decade of English Naturalism 1810–1820* (exh. cat. Norwich: Norwich Castle Museum, 1969).

II COROT'S EDUCATION

1. Versions of this formulation appear in most early twentieth-century surveys of nineteenth-century French art. See Henri Focillon, *La Peinture au XIXe siècle: Le Retour à l'antique, le romantisme* (Paris: Renouard, 1927), pp. 301–5 and 323ff.; L. Dimier, *Histoire de la peinture française au XIXe siècle* (Paris: Laurens, 1929), pp. 104ff.; and Léon Rosenthal, *Du Romantisme au réalisme: Essai sur l'évolution de la peinture en France de 1830 à 1848* (Paris: Renouard, 1914), pp. 262–97. See also Georges Lanoe and Tristan Brice, *Histoire de l'école française de paysage* (Paris: A. Charles, 1901), pp. 71ff.; François Benoit et al., *Histoire du paysage en France* (Paris: Renouard, 1908), pp. 194–210 (chapter by Benoit on the Neoclassical period) and pp. 211–43 (chapter by L. Rosenthal on the Romantic period); Raymond Bouyer et al., *Le Paysage français de Poussin à Corot* (exh. cat. Paris: GBA, 1926), pp. 75–89; Jeanne Magnin, *Le Paysage français des enlumineurs à Corot* (Paris: Payot, 1928), pp. 181–215. The best study of French landscape painting just before and just after 1800 is Prosper Dorbec, *L'Art du paysage en France: Essai sur son évolution de la fin du XVIIIe siècle à la fin du Second Empire* (Paris: Laurens, 1925).

The identification of the new landscape painting with the spirit of Romantic innovation dates from about 1830. See, for example, Gustave Planche, *Salon de 1831* (Paris, 1831). Apart from the criticism of the period itself, the most virulent claims that the naturalism of 1830 was conceived in direct opposition to the preceding landscape school date from the second half of the nineteenth century. See above all Charles Blanc's *Histoire des peintres de toutes les écoles. Ecole française,* vol. 3 (Paris, 1869), passim, esp. the article on Achille-Etna Michallon; also Henri Delaborde, "Le Paysage historique – Valenciennes," in *Etudes sur les beaux-arts en France et en Italie* (Paris: Renouard, 1864), pp. 138–76.

The most persistent symptom of the view that the landscapists of 1830 broke utterly with their masters is the preoccupation with the presumed influence of English painters in the 1820s. It is present in all of the general works cited above. See also Prosper Dorbec, "Les Paysagistes anglais en France," *GBA,* 4e pér., 18 (1912), 257–81; A. Dubuisson, "Influence de Bonington et de l'école anglaise sur la peinture du paysage en France," *Walpole Society,* 2 (1912–13), 111–126; Michel Florisoone, "Constable and the 'Massacres de Scio'," *Journal of the Warburg and Courtauld Institutes,* 20 (1957), 180–85; and Marcia Pointon, *The Bonington Circle: English Watercolour and Anglo-French Landscape 1790–1855* (Brighton, England: The Hendon Press, 1985).

2. The revisionist position is represented most fully in two doctoral dissertations: Radisich 1977; and Carol Rose Wenzel, "The Transformation of French Landscape Painting from Valenciennes to Corot, 1787 to 1827" (Philadephia: Univ. of Pennsylvania, 1979). The origins of this trend in scholarship may be traced to the writings of Paul Marmottan. In a long series of articles on individual painters and in his book *L'Ecole française de peinture (1789–1830)* (Paris: Laurens, 1886), esp. pp. 33–50, Marmottan challenged the dominant position of Charles Blanc (see n. 1 above), claiming that modern French landscape was not an invention of the School of 1830, but of the previous generation. Marmottan's influence is evident in the scholarship of Marie-Madeleine Aubrun and Suzanne Gutwirth, whose studies of French landscape painting in this period are cited throughout this book and in the bibliography. See also Aubrun, "La Tradition du paysage historique et le paysage naturaliste dans la première motié du XIXe siècle français," *L'Information de l'histoire de l'art,* 13e année (1968), 63–72; William S. Talbot, "Some French Landscapes: 1779–1842," *Bulletin of the Cleveland Museum of Art,* 65 (1978), 75–91; the passages on landscape painting in *French Painting 1774–1830: The Age of Revolution* (exh. cat. Detroit: Detroit Institute of Arts and New York: Metropolitan Museum of Art, 1975); *William Turner und die Landschaft seiner Zeit* (exh. cat. Hamburg: Kunsthalle, 1976); *Zurück zur Natur: die Künstlerkolonie von Barbizon, ihre Vorgeschichte und ihre Auswirkung* (exh. cat. Bremen: Kunsthalle, 1978); and Lisa A. Simpson, *From Arcadia to Barbizon: A Journey in French Landscape Painting* (exh. cat. Memphis: The Dixon Gallery and Gardens, 1987). On Marmottan and his collection see Bruno Foucart, "The Taste for a Moderate Neo-classicism," *Apollo,* n.s., 103 (1976), 480–87; and P. Fleuriot de Langle, *Bibilothèque Marmottan: Guide analytique* (Boulogne-sur-Seine, 1938).

3. See ch. 1, n. 35.

4. See ch. 1, n. 49.

5. No. 171. *Cicero discovering the tomb of Archimedes at Syracuse* (Paris: Louvre); no. 172. *The Ancient city of Agrigentum* (Paris: Louvre); no. 173. *A Landscape of ancient Greece* (Detroit Institute of Arts); and no. 174. *Another landscape, in which one sees the entrance to an ancient city* (unlocated). On the Detroit picture see Dewey F. Mosby, "A Rediscovered Salon Painting by Pierre-Henri de Valenciennes: *Landscape of Ancient Greece,*" *Detroit Institute of Arts. Bulletin,* 55 (1977), 153–57.

6. *The Ancient city of Agrigentum* illustrates the hospitality of the inhabitants of Agrigentum, famous in antiquity. The picture shows in the foreground a slave of a prominent citizen inviting passing travelers to enjoy his master's generosity. *Cicero discovering the tomb of Archimedes at Syracuse* represents the climax of the following story. The great scientist Archimedes, killed in the sack of Syracuse in 212 bc after heroically defending his city against the Romans, was buried and forgotten. Some 137 years later Cicero, elected Questor in Sicily, sought out Archimedes' tomb, reminding the Syracusans of the heroism of their former fellow citizen. The latter painting was Valenciennes's reception piece at the Academy. Its subject had been prescribed by the Director, J.-M.-B. Pierre. See Anatole de Montaiglon, ed., *Procès-verbaux de l'Académie royale de peinture et de sculpture,* vol. 9 (Paris, 1892), 329.

7. For example, Anon., *Merlin au Salon de 1787* (Rome, 1787), p. 3: "Since our immortal Nicolas Poussin, no one seems to have responded to landscape as has M. de Valenciennes"; and Anon. [Comte Jean Potocki], *L'Amateur Polonais au Salon de 1787* (Paris, 1787), on Valenciennes's *Cicero:* "Here I recognized the beautiful designs of Gaspard Poussin, the richness of his compositions rendered in a manner so new that, even as he imitates, M. de Valenciennes has charted a new path."

8. Anon., *Lettres critiques et philosophiques sur le Salon de 1796,* quoted in Benoit et al., *Histoire du paysage en France,* p. 196. The anonymous critic may also have been the author of the *Lettres analytiques, critiques et philosophiques sur les tableaux du Salon* (1791), in which it is stated, "I will not mention landscape, since in my opinion it is a genre that ought to be avoided." Quoted in McMordie, "Historical Landscape," p. 47. For a thorough review of this motif of criticism and the relevant academic politics in the 1790s see Radisich 1977, pp. 220–40.

9. Quoted in François Benoit, *L'Art sous la*

Révolution et l'Empire (Paris, 1911), p. 45.

10. Roger de Piles, *Cours de peinture par principes* (Paris: Jules Estienne, 1708), pp. 201–2. The lasting influence of de Piles's book is suggested in C.H. Watelet and P. Levesque, *Encyclopédie méthodique: Beaux-Arts* (Paris, 1788–1805), in which a long segment of de Piles's text on landscape is repeated (vol. 1, pp. 619–29). On the development of landscape theory from de Piles to Valenciennes see Radisich 1977, pp. 9–176.

11. *Elémens*, pp. 376–84.

12. Anon., "Exposition du Salon au Musée," *Journal des Arts*, (1800); quoted in Radisich 1977, p. 208.

13. [Pierre-Jean-Baptiste Chaussard], *Le Pausanias français: Etat des arts du dessin en France, à l'ouverture du XIXe siècle. Salon de 1806* (Paris: F. Buisson, 1806), pp. 390–91. Valenciennes's reputation, as the new Poussin persisted throughout his career. See, for example, J.B. Deperthes, *Théorie du paysage* (Paris: Lenormant, 1818), p. 220, n. 1: "M. Valenciennes, who, tracing the same career as his famous predecessor [Poussin], and following closely in his footsteps, has reproduced his grand manner for our eyes, and has merited, by his success, to be cited, in the new school, as the restorer of a genre so noble and so long neglected."

14. C.P. Landon, *Annales du Musée et de l'école moderne des beaux-arts*, vol. 3 (Paris, 1808), 46.

15. See Suzanne Gutwirth, "Jean-Victor Bertin: Un Paysagiste néo-classique (1767–1842)," *GBA*, 83 (1974), 337–58, including a catalogue raisonné of the paintings; and the entry by Jacques Foucart in *Age of Revolution*, pp. 313–16. I am grateful to Colin McMordie for allowing me to read an unpublished article by the late Mme. Gutwirth, "L'Atelier Bertin et le renouveau du paysage au XIXe siècle."

16. See Suzanne Gutwirth, *Jean-Joseph-Xavier Bidauld (1758–1846): Peintures et dessins* (exh. cat. Carpentras: Musée Duplessis, 1978), reviewed by Philip Conisbee, *Burlington Magazine*, 120 (1978), 880; also Gutwirth, "*The Sabine Mountains*: an Early Italian Landscape by Jean-Joseph-Xavier Bidauld," *Detroit Institute of Arts. Bulletin*, 55 (1977), 147–52.

17. In doing so, Bertin and Bidauld earned reputations as reactionaries among progressive critics of the 1830s and 1840s. Gustave Planche blamed Bidauld for the rejection of two pictures by Théodore Rousseau from the Salon of 1836. Reviewing the Salon of 1840, Théophile Gautier wrote, "Rousseau has been refused . . . he is clearly one of our best landscapists; certainly one of the most audacious and most original. Are you then afraid, Messieurs Bidauld and Victor Bertin?" For both citations see Marie-Thérèse de Forges, *Théodore Rousseau 1812–1867* (exh. cat. Paris: Louvre, 1968), n.p.

18. A fourth figure of some importance is Louis-Etienne Watelet (1780–1866), a student of Valenciennes and one of the teachers of Corot's friend Caruelle d'Aligny. Beginning in 1800 Watelet exhibited regularly at the Salon and was known as a teacher of landscape painting. In addition to conventional *paysage historique* he pursued a vein of rustic imagery of streams and mills, roughly derived from Hobbema and Ruisdael, sometimes placed in an alpine setting. These "*paysages romantiques*," "*cascades*," and "*vues prises à . . .*" won Watelet a reputation as an independent spirit. But although he borrowed from both Southern and Northern models, there is no indication that he broke the mold of seventeenth-century conventions. Very few pictures survive and there has been no serious study of his work.

For an indication of Watelet's reputation see Anon., *Lettres à David par quelques élèves de son école* (Paris: Pillet Ainé, 1819), p. 222: "Wattelet [*sic*] and Bertin occupy, without dispute, the first place among the masters of landscape." See also Landon's *Salons* of the 1810s, which contain a number of line engravings after Watelet's works.

Another leading member of the Neoclassical school has been studied by Aubrun in "Pierre Athanase Chauvin (1774–1832)," *BSHAF*, année 1977 (1979), 192–216. See also the entry by Jacques Foucart in *Age of Revolution*, pp. 348–51.

19. See Alexandra R. Murphy, *Visions of Vesuvius* (exh. cat. Boston: Museum of Fine Arts, 1978), p. 6.

20. See Geneviève Lacambre, "L'*Eruption du Vesuve* par Pierre-Henri de Valenciennes," *Revue du Louvre*, 30 (1980), 312–14.

21. See Radisich 1977, pp. 260–67.

22. This formula is spelled out by Valenciennes in his recipe for making a "composition d'après Nature"; *Elémens*, pp. 420–22.

23. See Marie-Madeleine Aubrun, "Nicolas-Didier Boguet (1755–1839): 'un émule du Lorrain'," *GBA*, 83 (1974), 319–36, including a catalogue raisonné of the paintings; Lidia Bianchi, *Nicolas-Didier Boguet: Acquarellista*, extract from the commemorative volume "Te Roma sequor" (Rome: Associanzione di cultura romana "Te Roma sequor," 1956); and Giulia Fusconi, *I Paesaggi di Nicolas-Didier Boguet e i luoghi tibulliani* (Rome: De Luca, 1984).

24. The river god in the foreground, for example, is based on a Roman marble personification of the Tiber River, in the Louvre. See Francis Haskell and Nicholas Penny, *Taste and the Antique* (New Haven and London: Yale Univ. Press, 1981), p. 310.

25. C.-J.-F. Lecarpentier, *Essai sur le paysage dans lequel on traite des diverses méthodes pour se conduire dans l'étude du paysage, suivi de courtes notices sur les plus habiles peintres en ce genre* (Paris: Treuttel et Wurtz, 1817), p. 28.

26. For example, A.L. Millin, *Dictionnaire des Beaux-Arts* (Paris: Desray, 1806), vol. 3, 107, under the entry "Paysage": "Two different styles may be said to form the division of this genre: one is the heroic or ideal style; the other, the rustic or pastoral style."

27. Anon., "Exposition au Salon du Musée," *Journal des Arts* (1800); quoted in Radisich 1977, p. 274.

28. Original emphasis. A. Quatremère de Quincy, "Essai historique sur l'art du paysage à Rome," *Archives littéraires de l'Europe ou Mélanges de littérature et de philosophie par une société de gens de lettres*, 10 (1806), 384.

29. See Blanc, *Histoire des peintres Ecole française*, vol. 2, n.p.; Jacques Watelin, *Le Peintre J.-L. de Marne (1752–1829)* (Paris: Bibliothèque des Arts, 1962); and the entry by Jacques Foucart in *Age of Revolution*, pp. 392–96.

30. Quoted in Magnin, *Le Paysage français*, p. 184.

31. C.P. Landon, *Salon de 1812* (Paris, 1812), vol. 2, 106.

32. Serge Grandjean, *Inventaire après décès de l'Impératrice Joséphine à Malmaison* (Paris: Réunion des Musées Nationaux, 1964), p. 154, nos. 1094–97. For a partial list of other major collections containing works by Demarne see Watelin, *De Marne*, pp. 30–31.

33. See Raymond Bouyer, "Petits maîtres oubliés: Georges Michel," *GBA*, 3e pér., 18 (1897), 304–13; idem., "Georges Michel," *Revue de l'art ancien et moderne*, 51 (Jan.–May 1927), 237–48; Léo Larguier, *Georges Michel (1763–1843)* (Paris, 1927); Georg Pudelko, "Georges Michel," *GBA*, 17 (1937), 232–44; and *Age of Revolution*, pp. 550–51.

34. Théophile Thoré, "Histoire de Michel, peintre excentrique," *Constitutionnel*, feuilleton of 25 Nov. 1846; and Alfred Sensier, *Etude sur Georges Michel* (Paris: Alphonse Lemerre, 1873).

35. Sensier, *Michel*, p. 6.

36. See, beyond the works cited in n. 1 above, Jean Bouret, *L'Ecole de Barbizon et le paysage français au XIXe siècle* (Neuchâtel: Editions Ides et Calendes, 1972), pp. 25–31; and Robert Rosenblum and H.W. Janson *19th-Century Art* (New York: Abrams, 1984), p. 80.

37. Landon, *Salon de 1812*, vol. 2, 57–58.

38. See Wenzel, "The Transformation of French Landscape Painting from Valenciennes to Corot," esp. the statistical table on p. 370. Obviously the statistics were compiled on the basis of titles, not the actual works, and therefore contain a margin of error.

39. To my knowledge the statistic was first discussed in Benoit, "Le Paysage au temps de la Révolution et de l'Empire," in *Histoire du paysage en France* (1908), p. 203.

40. See Lorenz Eitner, "Two Rediscovered Landscapes by Géricault," *Art Bulletin*, 36 (1954), 131–42; *Age of Revolution*, pp. 448–49; and Lorenz Eitner, *Géricault: His Life and Work* (Ithaca, N.Y.: Cornell Univ. Press, 1983), pp. 142–45.

41. See *Age of Revolution*, pp. 626–27.

42. The monument of *troubadour* landscape was the ill-fated Galerie de Diane at Fontainebleau. See Marie-Claude Chaudonneret, *Fleury Richard et Pierre Révoil: La Peinture troubadour* (Paris: Arthena, 1980), pp. 39–41; and McMordie, "Historical Landscape," pp. 128–64.

43. Unless otherwise documented, the biographical facts presented here are drawn from Etienne Moreau-Nélaton, "Histoire de Corot et de ses oeuvres," in Robaut, *Corot*, vol. 1, and from the research of Hélène Toussaint, former curator in the Département des Peintures at the Louvre, who generously shared her notes with me. Moreau-Nélaton's biography of Corot was based principally on Robaut's reasearch. The latter's notes and archives on Corot survive and frequently provide greater detail than the published biography. In several cases I have relied upon this material, which is preserved in the Bibliothèque Nationale, Paris, under a variety of headings and call numbers, and in the Service d'Etude et de Documentation of the Département des Peintures at the Louvre. The classification and location of the material is explained in the Bibliography.

44. See *Album journal des modes et des théâtres*, 4 (1822).

45. Letter of 2 Dec. 1825 to Abel Osmond, quoted in Etienne Moreau-Nélaton, *Corot raconté par lui-même* (Paris: Laurens, 1924), vol. 2, 130. This two-volume publication reprinted Moreau-Nélaton's "Histoire de Corot et de ses oeuvres" and appended a new section titled "Le Roman de Corot." The latter published nine early letters by Corot (now in the Cabinet des Dessins, Musée du Louvre, Paris), with extensive commentary.

46. Moreau-Nélaton, *Corot raconté par lui-même*, vol. 2, 135; letter of May 1826 to Abel Osmond.

47. Robaut, *Documents sur Corot*, vol. 3, 59.

48. Moreau-Nélaton, *Corot raconté par lui-même*, vol. 2, 128.

49. Robaut, *Documents sur Corot*, vol. 3, 3.

50. What is known about the lithographs, including Robaut's documentation, is presented in Michel Melot, *Graphic Art of the Pre-Impressionists* (New York: Abrams, 1980), p. 260. Lithography was a recent invention; thus Corot was participating in a vogue. See Léon Lang, *Godefroy Engelmann, imprimeur lithographique: Les Incunables 1814–1817* (Colmar: Editions Alsatia, 1977) (Corot's stones were printed by Engelmann); and W. McAllister Johnson, *French Lithography: The Restoration Salons 1817–1824* (Kingston, Ontario: Agnes Etherington Art Centre, 1977).

51. The Barcelona plague was a popular subject for painting, in part because the French had rushed to the aid of the Spaniards. At the Salon of 1822, for example, Besselièvre exhibited *French Doctors at Barcelona* (no. 97).

52. Robaut, *Documents sur Corot*, vol. 3, 3, records Corot's recollection of his response to becoming an artist at last: "For several weeks I went about doing nothing, armed with my portfolio, promenading the quays, showing myself to all. Then I surprised myself by saying out loud, 'so now I am an artist,' and truly it seemed as if flames were coming from beneath my hat. Fortunately this silliness lasted only a month."

53. Robaut, *Documents sur Corot*, vol. 3, 3, 8.

54. Ibid., p. 4.

55. The pictures cited are R.362 (New York: Metropolitan Museum of Art), R.366 (Church of Ville d'Avray); R.376 (Nantes: Musée des Beaux-Arts), and R.1063 (Baltimore: Walters Art Gallery). See also Marie-Thérèse de Forges, "Nouvelles précisions sur une peinture de Corot," *Revue du Louvre*, 25 (1975), 169–72.

56. R.3063 (unlocated); quoted in Robaut, *Corot*, vol. 4, 91.

57. Moreau-Nélaton, *Corot raconté par lui-même*, vol. 2, 138–39, letter of 8 Aug. 1826 to Abel Osmond; and vol. 2, 144, letter of 23 Aug. 1827 to Osmond.

58. Moreau-Nélaton, "Histoire de Corot," p. 22. It is possible that the two had met in the fall of 1821, after Michallon returned from Italy, or even before the fall of 1817, when he had left France as the first winner of the *prix de Rome* for historical landscape.

59. The basic study of Michallon is by Pierre Lamicq, published as a chapter, "Achille-Etna Michallon," in Pierre Miquel, *Le Paysage français au XIXe siècle, 1824–1874: l'Ecole de la nature* (Maurs-la-Jolie: Editions de la Martinelle, 1975), vol. 2, 76–85. See also Dale G. Cleaver, "Michallon et la théorie du paysage," *Revue du Louvre*, 31 (1981), 359–65.

60. See Philippe Grunchec, *Le Grand Prix de peinture: Les Concours des Prix de Rome de 1797 à 1863* (Paris: Ecole nationale supérieure des Beaux-Arts, 1983), pp. 46–53, 98–100, 110, 165.

61. See Colin P. McMordie, "The Tradition of Historical Landscape in French Art 1780–1830" (B. Litt. thesis, Oxford: University of Oxford, Oriel College, 1976), pp. 179–202; and Lamicq, "Michallon," pp. 78–80. McMordie's analysis, on which I have depended here, is an important corrective to the suggestion, common in the current literature, that the new landscape prize represented a loosening of academic dogma and thus a step toward naturalism in landscape painting. See, for example, Albert Boime, *The Academy and French Painting in the Nineteenth Century* (London: Phaidon, 1971), pp. 133–47.

62. On Quatremère see René Schneider, *L'Esthétique classique chez Quatremère de Quincy (1802–1825)* (Paris: Hachette, 1910).

63. The proposal and supporting letter are quoted in full in Lamicq, "Michallon," pp. 78–79.

64. See McMordie, "Historical Landscape," pp. 180–82.

65. Ibid., p. 190, quoted from the *Règlements* of the *Concours définitif*.

66. E.F.A. Miel, *Essai sur le Salon de 1817, ou examen critique des principaux ouvrages dont l'exposition se compose . . .* (Paris: Didot le jeune, 1817), pp. 330–31. Valenciennes did not exhibit at the Salon of 1817.

67. Original emphasis. J.B. Deperthes, *Histoire de l'art du paysage depuis la Renaissance des beaux-arts jusqu'au dix-huitième siécle* (Paris: Le Normant, 1822).

68. J.B. Deperthes, *Théorie du paysage ou considérations sur les beautés de la nature que l'art peut imiter, et sur les moyens qu'il doit employer pour réussir dans catte imitation* (Paris: Lenormant, 1818).

69. See McMordie, "Historical Landscape," pp. 193–95.

70. Deperthes, *Théorie du paysage*, pp. 138–39.

71. See Grunchec, *Le Grand Prix de peinture*, pp. 165, 176, 187–89.

72. Examples of historical landscapes with classical subjects exhibited at the Salons by younger painters are: at the Salon of 1819: no. 114, *Death of Polydamas, athlete of Thessaly, historical landscape* by Antoine-Félix Boisselier (1790–1857); no. 941, *Historical landscape representing Oedipus*, and no. 942, *Historical landscape representing Philoctetes on the Isle of Lemnos*, both by Jean-Charles-Joseph Rémond (1795–1875); at the Salon of 1822: no. 762, *Marius at Minturnae*, by Symphorien Lajoye (1773–after 1848), and no. 1324, *The Rape of Proserpine*, by Louis-Jules-Frédéric Villeneuve (1796–1842); and at the Salon of 1824: no. 156, *Meleager and Atalanta*, by Henri-Pierre-Léon-Pharamond Blanchard (1805–1878); and no. 1219, *Oedipus and Antigone at the temple of the Eumenides*, by Michallon.

73. See *Age of Revolution*, pp. 549–50.

74. Quoted in Lamicq, "Michallon," p. 81.

75. Ibid., p. 82.

76. R.362 and R.460, both in the Metropolitan Museum of Art, New York. The former was exhibited at the Salon of 1835; the latter, rejected at the Salon of 1843, was cut down and reworked for the Salon of 1857.

77. In conversation with Robaut, 2 Jan. 1874; recorded in Robaut, *Documents sur Corot*, vol. 3, 18. Quoted in Pierre Courthion and Pierre Cailler, eds., *Corot raconté par lui-même et par ses amis* (Geneva: Cailler, 1946), vol. 1, 88. Corot's dismissal of his education had been less sweeping a few years earlier, in 1871: "I was in school in Rouen until I was eighteen. From there I spent eight years in commerce. No longer able to keep to that, I made myself a painter of landscapes; first as a student of Michallon. Having lost him, I entered the studio of Victor Bertin. After that I set out alone, upon nature, and there you have it." Quoted in Moreau-Nélaton, "Histoire de Corot," p. 17.

78. Silvestre, "Corot" (1853), in *Les Artistes français* (Paris: G. Charpentier, 1878), p. 262.

79. Corot himself suggested his lasting allegiance to the traditional system of artistic education when, as late as 1840, he advised the young landscape painter Auguste Ravier (1814–1895) to spend a year and a half in the studio of a history painter. See Paul Jamot, "Ravier en Italie; Ravier et Corot; Ravier et Carpeaux," *Revue de l'art*, 44, no. 2 (June–Dec. 1923), 325.

80. See Jeremy Strick, "Connaissance, classification et sympathie: Les Cours de paysage et la peinture de paysage au XIXe siècle," *Littérature*, no. 61 (Feb. 1986), 17–33.

81. The editor of one such album explained its function as follows: "The rigorous method that will be employed, the simplicity of the principles that are presented here, the analytical program that will be observed with utmost care, will, if studied with application, in the short span of six months, prepare the least intelligent student to draw from nature." From N.A. Michel Mandevaere, *Principes raisonnés du paysage à l'usage des écoles des Départements de l'Empire français, dessinés d'après nature* (Paris: Boudeville, 1804), n.p.

82. See below, n. 134.

83. Moreau-Nélaton, "Histoire de Corot," p. 26, n. 2.

84. The date of this program of self-instruction is uncertain. It is inscribed in what is apparently Corot's hand (f.1 recto) in a small sketchbook originally owned by Léon Fleury (1804–1858), then by Corot, and now in the Louvre (R.3103; Cabinet des Dessins, R.F. 6742 *bis*). Robaut, *Corot* (vol. 4, 96) records Corot's comment on the album, in 1872: "It is an old album that I had from Fleury, in which I went over quite a few pencil sketches as I discussed them with a young man, to show him where these drawings had gone wrong." Indeed the sketchbook consists mainly of timid pencil landscapes by Fleury, vigorously and liberally overdrawn in ink by Corot. The style of the ink drawings indicates a date after 1850, but Fleury's drawings are entirely consistent with a date in the early 1820s when, as a fellow student in the studio of J.V. Bertin, Fleury first met Corot. That Corot already possessed the album in the 1820s is indicated by a Corot pencil sketch (f.9 recto) of the head of a young girl, drawn over a faint landscape by Fleury and inscribed in Corot's hand "claire or blanche – at the age of eight." Although Corot's indecision at the identity of the girl indicates that this inscription was made much later, there is no question that he refers to two of his nieces, Louise Claire Sennegon, later Charmois (b. 1821; d. between 1851 and 1875), and Marie Denise Blanche Sennegon, later Lemaistre (b. *c.* 1816; d. 1846). Thus, if the drawing represents Claire, Corot had the album by 1829; if Blanche, by about 1824.

All of this of course proves nothing about the date of Corot's program of study. However, it is so clearly the list of a student that it is reasonable to suppose that, if indeed written by Corot, the list should be dated before 1825. If not Corot but Fleury wrote the list, it is still highly relevant here, since the two painters were students in Bertin's studio at the same time.

85. Several of the items require comment:

(1) *Dessiner tous les soirs*. Drawing in the evening, Corot would have been copying (most likely prints), not working from nature.

(4) *fabriques d'Italie*. This phrase refers to old Italian buildings such as appear in the backgrounds of landscapes by Poussin and Claude. Corot was reminding himself to copy prints of such subjects; indeed one such copy appears in sketchbook R.3121, f. 29, here pl. 232.

(5) *arbres de différentes sortes*. Again it is likely that Corot refers here not to real trees but to prints published as models for students, such as J.V. Bertin's *Receuil d'études d'arbres* (Paris: Engelmann, 1818–21; [Bibliothèque Nationale, Estampes, Dc. 68. Fol.]).

(6) *faire des calques dans les annales*. More copying (or tracing) of prints; Corot refers to C.P. Landon's *Annales du Musée et de l'école moderne des beaux-arts*, 16 vols. (Paris 1801–8), which contained engraved reproductions of older and modern paintings and sculpture.

(10) *Dessiner des chevaux & des chiens d'après Van der Meulen*. Corot refers to horses and dogs that appear in prints after battle paintings and scenes from the life of Louis XIV by Adam van der Meulen (1632–1690).

(12) *tâcher d'avoir à copier des figures de Le Prince*. Corot probably refers here not to the more famous Jean-Baptiste Le Prince (1734–1781) but to Xavier Le Prince (1799–1826), a popular young painter who occupied a position among the *Septentrionaux* similar to that occupied by Michallon among the *Méridionaux*. Le Prince often painted figures in landscapes by other painters. For example: landscapes by André Giroux (1801–1879) (no. 591) at the Salon of 1822, by Nicolas-Alexandre Barbier (1789–1864) (no. 54) and by Charles Caïus Renoux (1795–1846) (no. 1417) at the Salon of 1824, and by Alexandre-Hyacinthe Dunoüy, (1757–1841) n.d. (Cherbourg: Musée Thomas Henry, *Catalogue* [1870], no. 109).

86. For example, Paris: Louvre, Cabinet des Dessins, R.F. 13888; R.F. 13921; R.F. 13926–29 (after David's *Socrates*); R.F. 13946–49; R.F. 13938–39; R.F. 14243 (after Poussin's *Diogenes*).

87. Another conventional exercise of the Neoclassical studios was the male nude or *académie*. Corot painted at least one, which was withdrawn from the posthumous sale in 1875 but included in the catalogue, 2e partie,

no. 229 (Robaut, *Corot*, vol. 4, 221).

88. For example, Corot consulted James Thomson's *Seasons* (1730), which had been popular in France since it had been translated in 1759. In an early sketchbook (R.3066; with Galerie Schmit, Paris, 1980), Corot made several rapid sketches of the episode in Thomson's "Summer" in which Amelia is struck by lightning and her companion Celadon with grief. (In a pencil note next to one sketch Corot identified the subject as "Amelie & Celadon thomson l'été, p. 208.") Corot's interest in the theme may have derived from Michallon, who had treated a similar scene of death by lightning in *Woman struck by lightning* of 1817 (Paris: Louvre), which in turn recalls Poussin's *Landscape with a Storm*, which Michallon surely knew through prints. For Richard Wilson's *Celadon and Amelia* (also known in prints) see David H. Solkin, *Richard Wilson: The Landscape of Reaction* (exh. cat. London: The Tate Gallery, 1982), pp. 220–21.

89. Article in *Le Journal du département du Nord* (1817), quoted in Lamicq, "Michallon," p. 80.

90. R.3063 (unlocated); Robaut, *Corot*, vol. 4, 91.

91. Thus Bazin, *Corot*, p. 27, approvingly repeats Robaut's assertion that Corot rarely visited the Louvre: "feeling neither need nor much pleasure in visiting the galleries, he was happy above all in the countryside."

92. Robaut, *Documents sur Corot*, vol. 2, 18.

93. Moreau-Nélaton, "Histoire de Corot," p. 26: "Occasionally he crossed the bridge and entered the Museum. He took a sketchbook from his pocket; but it was not for copying the pictures of the masters. . . . Life alone attracted and seduced him. He turned his back on the masterpieces and drew the copyists at their easels, or better still the visitors and curiosity seekers." As if to prove the point Moreau-Nélaton reproduced (p. 25) one of Corot's drawings of a copyist, from the sketchbook under discussion here.

94. The sketchbook is R.3121 (Paris: Louvre, Cabinet des Dessins, R.F. 8735). The drawing of the copyist is f.16 recto. The exhibitions were *Corot* (Paris: Bibliothèque Nationale, 1931) and *Dessins de Corot (1796–1875)* (Paris: Louvre, 1962). My dissertation includes a page-by-page catalogue of the sketchbook, noting sources of the copies where I was able to identify them. See Galassi, "Corot in Italy 1825–1828" (1986), Appendix One, "A Student Notebook of Corot, 1822–1825," pp. 389–402.

95. R.3063 (unlocated); Robaut *Corot*, vol. 4, 91.

96. R.3121, f.13 verso.

97. The *Borghese Gladiator* appears in sketchbook R.3044 (Louvre, Cabinet des Dessins, R.F. 8705), f.3 verso. According to Robaut, Corot made other sketches of "statues after the antique" in sketchbook R.3063 (unlo-

cated); see Robaut, *Corot*, vol. 4, 91.

98. R.3121, f.30 verso, f.31 verso, f.32 recto and verso, and f.33 recto.

99. R.3121, f.9 recto, f.13 recto, f.18 recto. Examples of the kinds of albums Corot used are Jean-Victor Bertin, *Recueil d'études d'arbres* and *Receuil d'études de paysage. Plantes, rochers, troncs d'arbres, fabriques & c. Dessinés d'après nature et exécutés sur pierre par C. Bourgeois* (Paris: F. Delpech, [*c.* 1822]; [Bibliothèque Nationale, Estampes, Kc.98.Pet.fol.]).

100. R.3121, f.5 recto. Lethière's enormous picture was acquired by Louis XVIII in 1819 and is now in the Louvre. A line engraving after the work appeared in Landon's *Salon de 1812*, vol. 2, 6.

101. R.3121, f.19 recto. The landscape by Gaspard (Paris: Louvre, Inv. 270) had been engraved by Muller.

102. R.3121, f.2 verso and f.17 verso derive from one landscape by Orizzonte, f.3 recto and verso and f.4 recto and verso derive from the other. Both works by Orizzonte were reproduced in *Le Musée français, recueil complet des tableaux, statues, et bas-reliefs, qui composent la collection nationale; avec l'explication des sujets et des discours historiques . . . par S.C. Croze-Magnan* (Paris: Robillard-Peronville et Laurent, 1803–9), vol. 3, *Paysages, marines et vues*.

103. R.3121, f.39 verso. The landscape by Claude also was reproduced in Croze-Magnan, *Le Musée français*, vol. 3.

104. R.3121, f.29 recto and verso and f.30 recto. The latter two are copies after a view of Tivoli.

105. R.3121, f.26 verso is a copy of the figure of Psyche from *Psyche received in Olympia* by Polidoro da Caravaggio (*c.*1500–1543), in the Louvre.

106. R.3121, f.28 verso is a copy after *Caesar's money* by Valentin (1591–1632), in the Louvre.

107. E.g., R.3121, f.21 verso and f.27 recto.

108. R.3121, f.35 verso.

109. R.3121, f.37 recto.

110. R.3121, f.7 verso. Of the many analogues perhaps the closest is the *Death of Alcibiades* by Charles-Philippe de Larivière, which won the *prix de Rome* in 1824. See Grunchec, *Le Grand Prix de peinture*, p. 183.

111. R.3121, f.26 recto.

112. C.P. Landon, *Salon de 1822* (Paris, 1822), vol. 1, 18; the painting by Drolling is reproduced as pl. 8.

113. R.3121, f.36 recto. The source is a Neoclassical *académie* transformed into a subject picture by the addition of accessories. Prominent examples are David's *Hector* (1778) and François-Xavier Fabre's *Death of Abel* (*c.* 1790), both in the Musée Fabre, Montpellier.

114. R.3121, f.20 verso and f.38 verso.

115. The catalogue of Valenciennes's posthumous sale noted that his studies had served as "models for students of the late M. Valenciennes." See *Notice des tableaux, dessins, livres . . . composant le cabinet de feu M. P.H. Valenciennes . . . dont la vente aura lieu . . . le . . . 26 avril, 1819*, etc. (Paris, 1819), n.p.

116. For the catalogue of Vernet's posthumous sale see ch. 1, n. 28. For Michallon see M. Masson de Saint-Maurice, commissaire-priseur, *Catalogue des tableaux, études, peintures et dessins de feu Achille Etna Michallon, pensionnaire du Roi* (Paris, 26, 27, 28 Dec. 1822).

117. Baron François Gérard (1770–1837), for example, owned studies after nature by Dunouÿ and Bidauld. See *Catalogue de tableaux, dessins et esquisses de M. le Baron Gérard . . . par Charles-Paillet, commissaire-expert* (Paris, 1837), p. 17, lots 38 and 43.

118. Letter dated 4 March 1823, in Léon-G. Pélisser, ed., "Les Correspondants du peintre Fabre (1808–1834)," *Nouvelle revue rétrospective*, 4e semestre (Jan.–June, 1896), 22–23.

119. See Geneviève Lacambre, *Les Paysages de Pierre Henri de Valenciennes*, Dossier du Département des peintures, no. 11 (exh. cat. Paris: Louvre, 1976), n.p., commentary on "Série B."

120. Letter dated 30 April 1825, in Pélisser, ed., "Les Correspondants," pp. 45–46.

121. Institut de France. Académie Royale des Beaux-Arts. Extrait du procès-verbal de la séance de samedi 18 Oct 1823. Unpublished MS. in the library of the French Academy at Rome. Correspondance des Directeurs de l'Académie de France à Rome, carton 30 (Directorat de Guérin), n.p.

122. Valenciennes, *Elémens*, p. 404.

123. E. Robertson, ed., *Letters and Papers of Andrew Robertson, A.M.* (1895), p. 236; quoted in *Painting from Nature* (exh. cat. London: Arts Council of Great Britain, 1980), p. 28.

124. Edouard Joyant, ed., *Jules-Romain Joyant (1803–54): Lettres et tableaux d'Italie* (Paris: Laurens, 1936), p. 70.

125. Lecarpentier, *Essai sur le paysage* (1817), p. 33.

126. Sketchbook R.3103 (Paris: Louvre, Cabinet des Dessins, R.F. 6742 *bis*); quoted in Moreau-Nélaton, "Histoire de Corot," p. 49.

127. See, for example, T.C. Bruun Neergaard, *Sur la situation des beaux-arts en France* (1801), p. 56, on studies by Dunouÿ and by Jacques-André-Edouard at the Salon of 1800; Chaussard, *Le Pausanias français*, p. 448, on studies painted at Tivoli by Claude Thienon (1772–1846); and P.-A. V[ieillard], *Salon de 1824: Revue des ouvrages. Extrait du Journal des Maires* (Paris, 1825), p. 21, on studies painted in Italy and Provence by Antoine-Félix Boisselier (1790–1857). Only rarely did the studies elicit more than a passing reference.

128. For example, Auguste Jal, *L'Artiste et le philosophe, entretiens critiques sur le Salon de 1824* (Paris, 1824), passim.; Emeric David, "Exposition de 1824," *Revue européenne*, 1 (1824), 35–38; and A. Thiers, *Salon de 1824* (Paris, n.d. [1824–25]), pp. 1–5.

129. C.P. Landon, *Salon de 1819* (Paris, 1820), vol. 2, 82.

130. R.1–R.40 (landscapes) and R.55–R.56 (figure studies). The supplements to Robaut, *Corot* add a few more works, but certainly the list is still far from complete. The catalogue of the posthumous sale in 1875 included a number of studies absent from Robaut's catalogue. See Robaut, *Corot*, vol. 4, 221–24, nos, 224, 228, 237 *bis*, 240, 240 *bis*, 243, 248, 252, and 254.

131. The drawings are R.2461–R.2469 (all but the last in the Louvre, Cabinet des Dessins). The sketchbooks are R.3042 (Louvre, R.F. 8705), R.3063 (unlocated); R.3066 (with Galerie Schmit, Paris, 1980; subsequently dispersed); R.3072 (unlocated); R.3076 (Louvre, R.F. 8715); and R.3121 (Louvre, R.F. 8735). The sketchbooks contain relatively few complete landscapes. Most of the sketches are of separately observed details: cottages, mills, farmers and peasants, wagons, animals, trees, etc. There are few drawings of more than passing interest. Most notably, the active dialogue between painting and drawing that Corot conducted in Italy had not begun before 1825.

132. Silvestre, "Corot," p. 262.

133. A group of Corot's copies of Michallon's drawings ("studies of trees, plants and architecture [10 sheets]") was sold at the posthumous sale in 1875, 2e partie (suite), no. 505 (Robaut, *Corot*, vol. 4, 240).

134. RS2.1. The work was sold as no. 225 of the posthumous sale in 1875, where it was catalogued as "The Alps in Sunshine. Copy by Corot after Michallon" (Robaut, *Corot*, vol. 4, 221). In the supplement Schoeller and Dieterle, without explanation, suggested instead that the work is an original study by Corot, made on his passage through Switzerland in the fall of 1825. Stylistically, however, the work is very different from Corot's two known Swiss studies of October 1825 (R.42 and RS2.3). R.42, for example, is unified in color and brushstroke, while RS2.1 unsuccessfully combines the bright, detailed mountains with the darker, vaguely painted middleground. These qualities in themselves suggest that the work is a copy. A drawing by Michallon (Paris, Louvre, Cabinet des Dessins, R.F. 14079) confirms the original entry in the catalogue of Corot's posthumous sale. Michallon's drawing shows the same mountain range and lake from a slightly different point of view.

Corot owned another study by Michallon: *A Gorge and entrance to a grotto* (perhaps similar to Michallon's studies now in the Louvre, R.F. 2869 and R.F. 2892), no. 728 in Corot's posthumous sale in 1875 (Robaut, *Corot*, vol. 4, 260).

135. Quoted in Robaut, *Corot*, vol. 4, 91.

136. Bazin, *Corot* (1973), p. 29.

137. Lawrence Gowing, "Confidence and Conscience in Two Centuries of Art," *Art News Annual*, no. 30 (1965), 129.

138. See above, ch. 1, n. 51.

139. Deperthes, *Histoire du paysage*, p. 537.

140. Quatremère de Quincy, *Suite des Considérations sur les arts de dessin en France* (Paris, 1791), p. 45.

141. Un Amateur, *Observations sur le concours du Grand Prix de paysage historique, et sur le nécessité de donner une nouvelle direction aux études de ce genre* (Paris: Didot l'aîné, 1821).

142. E.J. Delécluze, article in the *Moniteur*, May 29, 1822, cited in Léon Rosenthal, *La Peinture romantique* (Paris, 1900), p. 92, n. 2.

143. On Huet see René-Paul Huet, *Paul Huet (1803–1869) d'après ses notes, sa correspondance, ses contemporains* (Paris: Renouard, 1911); Pierre Miquel, *Paul Huet, de l'aube romantique à l'aube impressionniste* (Sceaux: Editions de la Martinelle, 1962); and *Paintings by Paul Huet (1803–1869)* (exh. cat. London: Heim Gallery, 1969).

144. See Andrew Shirley, *Bonington* (London, 1940); *Romantic Art in Britain: Paintings and Drawings 1760–1860* (exh. cat. Detroit Institute of Arts, 1968), pp. 246–50; John Ingamells, *Richard Parkes Bonington*, Wallace Collection Monographs, 3 (London: The Wallace Collection, 1979); Carlos Peacock, *Richard Parkes Bonington* (New York: Taplinger, 1980); Pointon, *The Bonington Circle*; and Malcom Cormack, *Bonington* (Cambridge and New York: Cambridge Univ. Press, 1989).

145. See Jean Larat, *Les Artistes découvrent les provinces: l'Auvergne et le Velay* (Clermont-Ferrand, 1964); and Denise Delouche, *Peintres de la Bretagne, découverte d'une province*, Publications de l'Université de Haute Bretagne, 7 (Paris: Klincksieck, 1977).

146. See Georges Wildenstein, *Un Peintre de paysage au 18e siècle: Louis Moreau* (Paris: Les Beaux-Arts, 1923); and *Age of Revolution*, pp. 555–56.

147. On the forest see Emile Michel, *La Forêt de Fontainebleau dans la nature, dans l'histoire, dans la littérature et dans l'art* (Paris: Renouard, 1909); Jean Bouret, *L'Ecole de Barbizon et le paysage français au XIXe siècle* (Neuchâtel, 1972); and *Zurück zur Natur: die Künstlerkolonie von Barbizon. Ihre Vorgeschichte und ihre Auswirkung* (exh. cat. Bremen: Kunsthalle, 1977).

148. See M. Rieu-Edelmann, "La Forêt de Fontainebleau dans l'estampe et la photographie, d'après les collections topographiques du Cabinet des Estampes de la Bibliothèque Nationale, de 1780 à 1890" (typescript thesis, Ecole du Louvre, Paris, 1973).

149. Ibid.

150. See Dorbec, "Les Paysagistes anglais en France"; R.B. Beckett, "Constable and France," *Connoisseur*, 137 (Jan.–June 1956), 249–55; and Robert L. Herbert, *Barbizon Revisited* (New York: Clarke & Way, 1962), pp. 16–18.

151. The first picture by Corot in which the influence of Constable is clear is *Forest of Fontainebleau–The Ford*, exhibited at the Salon of 1833 (R.257; unlocated).

152. F. de Clarac, *Lettre sur le Salon de 1806* (Paris, 1806), p. 246.

III "MAGICK LAND"

1. *Walpole Society*, 32 (1946–48), 55.

2. Quoted in Richard Krautheimer, *Rome: Profile of a City, 312–1308* (Princeton: Princeton Univ. Press, 1980), p. 200.

3. Edward Gibbon, *Memoirs of my Life*, ed. Georges A. Bonnard (New York: Funk & Wagnalls, 1969), p. 134.

4. Joseph Addison, *Remarks on Several Parts of Italy, in the years 1701, 1702, 1703* (1705; 2nd. ed. London, 1718), preface, n.p.

5. Ibid. This and other comparable remarks are quoted and interpreted in Peter Nisbet, "'Poetick Fields': The Grand Tourists' View of Italy in the Eighteenth Century," in Duncan Bull et al., *Classic Ground: British Artists and the Landscape of Italy, 1740–1830* (exh. cat. New Haven: Yale Center for British Art, 1981), pp. 10–16.

6. Michallon's study of Lake Garda (unlocated) was listed as no. 19 in the catalogue of the posthumous sale of his studio (see ch. 2, n. 116). Corot's studies, painted in 1834, are R.319 (Stuttgart: Staatsgalerie) and R.358 (Saint-Gall: Kunstmuseum).

7. Johann Wolfgang von Goethe, *Italian Journey*, trans. W.H. Auden and Elizabeth Mayer (1962; rpt. San Francisco: North Point Press, 1982), p. 25. The line Goethe quoted is *Georgics*, ii.v.159–60. Nearly a century earlier Joseph Addison (*Remarks*) had recalled the same line as he observed a storm on Lake Garda.

8. Cecilia Powell, *Turner in the South: Rome, Naples, Florence* (New Haven and London: Yale Univ. Press, 1987), pp. 29–30.

9. Goethe's guidebook was J.J. Volkmann, *Historisch-kritische Nachrichten von Italien*, 3 vols. (Leipzig, 1770–71). This was an abbreviated translation of J.J. Lalande, *Voyage d'un françois en Italie, fait dans ces années 1765 et 1766*, 8 vols. (Paris and Venice, 1769). Valenciennes recommended the latter in *Elémens*, p. 594, n. 2.

10. The literature on this subject is enormous. I shall confine the citations to (1) extensive bibliographies, (2) major scholarly studies, and (3) several less ambitious but useful studies:

 (1) The bibliographies are Boucher de la Richardie, *Bibliothèque universelle des voyages*, 6 vols. (Paris, 1808); Joseph Blanc, *Bibliographie italico-française universelle, ou catalogue méthodique de tous les livres imprimés en langue française sur l'Italie . . . 1475–1885*, 2 vols. (Milan, 1886); the bibliography of Alessandro d'Ancona, *L'Italia alla fine del secolo XVI: Giornale de viaggio di Michele di Montaigne in Italia nel 1580 e 1581* (Città di Castello, 1895), pp. 565ff; Sergio Samek-Ludovici, "Bibliografia di viaggiatori stranieri in Italia nel secolo XIX," *Annales Institutorum Urbis Romae*, 7–10 (1934–38); Antonio Pescarzoli, *I Libri di viaggio e le guide della raccolta Luigi Fossati Bellani*, 3 vols. (Rome, 1957); and R.S. Pine-Coffin, *Bibliography of British and American Travel in Italy to 1860*, Biblioteca di Bibliografia Italiana, vol. 76 (Florence, 1974).

 (2) The most comprehensive and analytical of the general studies are those by Ludwig Schudt, *Le Guide di Roma: Materialen zu einer Geschichte der römische Topographie* (Vienna and Augsburg: Filser, 1930) and *Italienreisen im 17. und 18. Jahrhundert* (Vienna: Schroll, 1959). A summary of the latter is provided in a review by Hans Huth, *Art Bulletin*, 42 (1960), 162–64. Also useful is Camillo von Klenze, *The Interpretation of Italy During the Last Two Centuries*, The Decennial Publications, 2nd. ser., 17 (Chicago: Univ. of Chicago Press, 1907).

 (3) Other useful works include Gaspard Valette, *Reflets de Rome: Rome vue par les écrivains*, 3rd ed. (Paris: Plon-Nourrit, 1909); E. Rodonachi, *Les Voyageurs français à Rome de Montaigne à Stendhal* (Pavia, 1910); W. Waetzold, *Das klassische Land: Wandlungen der Italiensehnsucht* (Leipzig, 1927); Margaret R. Scherer, *Marvels of Ancient Rome* (New York: The Metropolitan Museum of Art, 1955); Carlo Bernari, Cesare de Seta, and Atanasio Mozzillo, *Grandi viaggiatori stranieri in Italia* (Rome, 1987); and Attilio Brilli, *Il Viaggio in Italia: Storia di una grande tradizione culturale dal XVI al XIX secolo* (Milan: Banca Popolare di Milano, 1987).

11. This development is a central theme of Klenze, *The Interpretation of Italy*. The best short summary is Schudt, *Le Guide*, pp. 168–80.

12. Charles de Brosses (1709–1777), *Lettres familières écrites d'Italie en 1739 et 1740*, published posthumously. See the edition by R. Colomb, *Le Président de Brosses en Italie*, 2 vols. (Paris, 1858). De Brosses's discursive style is a precedent for the developments of the late eighteenth and early nineteenth centuries. Stendhal called him "the Voltaire of travelers in Italy."

13. François-René de Chateaubriand (1768–1848) visited Italy in 1803 and again in 1828 and 1833. The first trip served as the basis for *Voyages en Amérique et en Italie*, first published in 1827. I have used the *Oeuvres complètes de Chateaubriand*, new ed. (Paris: Garnier, 1859), vol. 6, 267–322. The first trip also provided material for *Les Martyrs*; the later trips for *Mémoires d'outre-tombe*. On Chateaubriand's descriptions of Italy see Thomas Chapell Walker, *Chateaubriand's Natural Scenery: A Study of his Descriptive Art*, Johns Hopkins Studies in Romance Literature and

Languages, extra vol. 21 (Baltimore: Johns Hopkins, 1946), pp. 63ff.

On his first visit to Rome Chateaubriand was accompanied by Louis-François Bertin (1766–1841), founder of the *Journal des Débats* and father of François-Edouard Bertin (1797–1871), one of Corot's companions in Italy in the 1820s.

14. Marie Henri Beyle (1783–1842), called Stendhal, was often in Italy. The important work in this context is *Promenades dans Rome*, first published in 1829. I have used the *Oeuvres complètes*, ed. Georges Eudes (Paris: Pierre Larrive, 1953), vols. 5 and 6. On the circumstances of the publication of the *Promenades* see Charles Dédéyan, *L'Italie dans l'oeuvre romanesque de Stendhal* (Paris: Société d'édition d'enseignement supérieur, 1963), vol. 1, pp. 101–21. See also Pietro Paolo Trompeo, *Nell'Italia romantica sulle orme di Stendhal* (Rome: Casa Editrice Leonardo da Vinci, 1934), pp. 217–69.

15. The major figures are Chateaubriand, Stendhal, Mme. de Staël, Lamartine, Byron, and Shelley. See Klenze, *Interpretation of Italy*, pp. 86–110; and Urbain Menguin, *L'Italie des romantiques* (Paris: Plon-Nourrit, 1902). Both works provide extensive citations for each of these authors. On Lamartine see also Gemma Cenzatti, *Alfonso de Lamartine e l'Italia* (Leghorn, 1903).

16. Anne Louise Germaine Necker, baronne de Staël-Holstein (1766–1817). Her *Corinne, ou l'Italie* was first published in 1807. I have used the 8th ed. (Paris: H. Nicolle, 1818).

17. George Gordon, Lord Byron (1788–1824). The first two cantos of *Childe Harold* were published in 1812; the third and fourth, more important here, appeared in 1816 and 1818. I have used *The Works of Lord Byron*, Thomas Moore, ed. (Philadelpia: J.B. Lippincott, 1879), vol. 1, 1–195.

18. *Childe Harold*, canto iv, 74: "I've looked on Ida with a Trojan's eye;/ Athos, Olympus, Aetna, Atlas, made/ These hills seem things of lesser dignity,/All, save the lone Soracte's height, displayed/ Not *now* in snow, which asks the lyric Roman's aid/ For our remembrance, and from out the plain/ Heaves like a long-swept wave about to break,/ And on the curl hangs pausing." The phrase "not *now* in snow" refers to Horace's *Odes*, i, 9. The reference is noted in Agnes Mongan and Paul J. Sachs, *Drawings in the Fogg Museum of Art* (Cambridge, Mass.: Harvard Univ. Press, 1940), vol. 1, p. 349. Virgil also mentioned Soracte (*Aeneid*, xi, 785).

19. For his references to visual art, at least, Byron depended on the *Lettres sur l'Italie, en 1785* of Jean-Baptiste Dupaty. See Kölbing, "Byron und Dupatys 'Lettres sur l'Italie'," *Englische Studien*, 17 (1892), 448ff.; cited in Klenze, *The Interpretation of Italy*, p. 95.

20. See Giuliano Briganti, *Gaspar van Wittel e l'origine della veduta settecentesca* (Rome: Ugo Bozzi, 1966); idem., "Dessins de Vanvitelli," *L'Oeil*, no. 205 (1972), 12–17; and Walter Vitzthum, *Drawings by Gaspar van Wittel (1652/53–1736) from Neapolitan Collections* (exh. cat. Ottawa: National Gallery of Canada, 1977).

21. For the earliest views of Rome see Hermann Egger, Christian Hülsen, and Adolf Michaelis, *Codex Escurialensis: ein Skizzenbuch aus der Werkstatt Domenico Ghirlandaios*, Oesterreichisches Archaeologisches Institut, *Sonderschriften*, vol. 4 (2 vols., Vienna, 1905–6); Hermann Egger and Christian Hülsen, *Die Römischen Skizzenbücher von Marten van Heemskerck*, 2 vols. (Berlin, 1913–16); Hermann Egger, *Römische Veduten: Handzeichnungen aus dem XV. bis XVIII. Jahrhundert*, 2 vols. (Vienna and Leipzig: F. Wolfrum, 1911–16); and *Il Paesaggio nel disegno del cinquecento europeo* (exh. cat. Rome: Académie de France, 1972). See also *The Origins of the Italian Veduta* (exh. cat. Providence, Rhode Island: Brown Univ., 1978); Nolfo di Carpegna, *Paesisti e vedutisti a Roma nel '600 e nel '700* (exh. cat. Rome: Palazzo Barberini, 1956); Giuliano Briganti, *The View Painters of Europe* (London: Phaidon, 1970); and Raymond Keaveney, *Views of Rome from the Thomas Ashby Collection in the Vatican Library* (London: Scala Books in association with the Biblioteca Apostolica Vaticana and the Smithsonian Institution Traveling Exhibition Service, 1988).

22. The principle of a series of isolated views or motifs that were repeated again and again, and which could be combined without regard to chronology or historical importance of the subject, has been analyzed in the literature on Antonio Lafreri's sixteenth-century "Speculum Romanae Magnificentiae." Long thought to be a published book enlarged variously by supplements, the "Speculum" turned out to be a single title page covering idiosyncratic collections of prints selected from a large group created by many different engravers from the drawings of many different artists, representing works of art, architecture, and city views. Thus the "Speculum" represents in miniature the essential conventions of the entire *veduta* tradition. The crucial study is Bates Lowry, "Notes on the *Speculum Romanae Magnificentiae* and Related Publications," *Art Bulletin*, 34 (1952), 46–50. See also L.R. McGinniss, *Catalogue of the Earl of Crawford's "Speculum Romanae Magnificentiae," now in the Avery Architectural Library* (New York: Columbia Univ., 1976); and Richard Brilliant, review of McGinniss, *Journal of the Society of Architectural Historians*, 37 (1978), 318–19.

A later work similar to the "Speculum" but without its bibliographical complications is the *Griffonis* of the Abbé de Saint-Non, which began to appear in the 1760s. Because Fragonard, Hubert Robert and other landscape artists contributed to this collection of *Vues, paysages, fragments antiques et sujets historiques*, it provides a direct link between the old *veduta* tradition and the late eighteenth-century landscape sketches discussed here in ch. 1. See J. de Cayeux, "Introduction au catalogue critique des *Griffonis* de Saint-Non," *BSHAF*, année 1963 (1964), 297–372.

23. On Vasi see Alfredo Petrucci, *Le Magnificenze di Roma di Giuseppe Vasi* (Rome: Fratelli Palombi, 1946); and the annotated facsimile of a 1794 edition of his guidebook (published by his son Mariano), ed. Guglieimo Matthiae, *Roma del Settecento: Itinerario istruttivo di Roma di Mariano Vasi romano* (Rome: Golem, 1970).

24. In addition to the many French editions of Vasi, the guidebooks that Corot might have used include Auguste Creuzé de Lesser, *Voyage en Italie et en Sicile, fait en 1801 et 1802* (Paris: Didot, 1806); P. Petit-Radel, *Voyage historique, chorographique, et philosophique dans les principales villes de l'Italie, en 1811 et 1812*, 3 vols. (Paris: Chanson, 1815); and George Mallet, *Voyage en Italie dans l'année 1815* (Paris: J.J. Paschouel, 1817).

25. See Gerald Wilkinson, *Turner Sketches 1802–20* (New York: Watson-Guptill, 1974), p. 179; and Powell, *Turner in the South*, pp. 13–14. About the same time Turner received further preparation when, working from sketches by James Hakewill, he made drawings to be engraved as illustrations to Hakewill's *A Picturesque Tour of Italy from Drawings made in 1816–1817* (London: John Murray, 1820). For Turner's own later contribution to the *veduta*-guidebook tradition see Adele M. Holcomb, "A Neglected Phase of Turner's Art: His Vignettes to Rogers' 'Italy'," *Journal of the Warburg and Courtauld Institutes*, 32 (1969), 405–10; and Powell, "Turner's Vignettes and the Making of Rogers' *Italy*," *Turner Studies*, 3, no. 1 (Summer 1983), 2–13.

26. Corot's works are R.126 and R.130 (Cascade of Terni), R.123 (Lake of Piediluco), R.130 (the Augustan bridge at Narni), R.2507 (the medieval bridge at Civita Castellana), RS2.15 bis (St. Peter's from the north).

27. See An Zwollo, *Hollandse en Vlaamse Veduteschilders te Rome, 1675–1725* (Assen: van Gorcum, 1973), with English summary; reviewed by Marco Chiarini, *Master Drawings*, 16 (1978), 185–87.

28. Wolfgang Krönig, "Storia di una veduta di Roma," *Bollettino d'Arte*, serie 5, 57 (1972), 165–98.

29. From Ramsey's "Enquiry into the Situation and Circumstances of Horace's Sabine Villa" (1775–77); quoted in J. Holloway, "Two Projects to Illustrate Allan Ramsey's Treatise on Horace's Sabine Villa," *Master Drawings*, 14 (1976), 284. See also Wolfgang Krönig, *Phillip Hackert: "Zehn Aussichte von dem Landhause des Horaz"* in 1780 (exh. cat. Düsseldorf: Goethe-Museum, 1983).

30. Brinsley Ford, ed., "The letters of Jonathan Skelton written from Rome and Tivoli in 1758," *Walpole Society*, 36 (1960), 42–43.

31. Chateaubriand, *Voyage en Italie*, in *Oeuvres complètes*, vol. 7, 238–39.

32. For the literature on Wilson see ch. 1, nn. 23, 33. For the phenomenon in general see Elizabeth Manwaring, *Italian Landscape in Eighteenth Century England: A Study Chiefly of the Influence of Claude Lorrain and Salvator Rosa on English Taste, 1700–1800* (New York, 1925); and Andrea Busiri Vici, *Jan Franz van Bloemen "Orizzonte" e l'origine del paesaggio romano settecentesco* (Rome: Ugo Bozzi, 1973).

33. On Hackert see ch. 1, n. 30.

34. *Elémens*, p. 596.

35. Ibid.

36. *Oeuvres complètes*, vol. 5, 76.

37. The literature on foreign landscape painters in Rome in the eighteenth and nineteenth centuries is substantial. For some important works on English and French artists see ch. 1, nn. 31 and 41. Other useful literature not cited elsewhere includes: R. v. Lichtenberg and E. Jaffé, *Hundert Jahre deutsche-römische Landschaftsmalerei* (Berlin, 1907); Germain Bazin et al., *L'Italia vista dai pittori francesi del XVIII e XIX secolo* (exh. cat. Rome: Palazzo delle Esposizioni, 1961); *Danske kunstnere i Italien* (exh. cat. Copenhagen: Thorwaldsens Museum, 1968), with English trans.; *Møde med Italien: Hollandske, tyske, og skandinaviske tegninger 1770–1840* (exh. cat. Copenhagen: Thorvaldsens Museum, 1971); Max Hasse, *Deutsche Künstler zeichen in Italien, 1780–1860* (exh. cat. Lübeck: Museen für Kunst und Kulturgeschichte, [1972?]); Hella Robels, *Sehnsucht nach Italien: Bilder deutscher Romantiker* (Munich: Hirmer, 1974); Denis Coeckelberghs, *Les Peintres belges à Rome de 1700 à 1830*, Etudes d'histoire de l'art publiés par l'Institut Historique Belge de Rome, vol. 3 (Brussels and Rome, 1976), ch. 5, 299–357; Gerhard Bott, *"Es ist nur ein Rom in der Welt": Zeichnungen und Bildnisse deutscher Künstler in Rom um 1800* (exh. cat. Darmstadt: Hessisches Landesmuseum, 1977); *Danske malere i Rom i det 19. århundrede* (exh. cat. Copenhagen; Statens Museum for Kunst, 1977); *Deutsche Künstler um Ludwig I. in Rom* (exh. cat. Munich: Staatliche Graphische Sammlung, 1981); and Wheelock Whitney III, *The Lure of Rome: Some Northern Artists in Italy in the Nineteenth Century* (exh. cat. London: Hazlitt, Gooden & Fox, 1979). A wealth of relevant illustrations is found in Marianne Bernhard, ed., *Deutsche Romantik Handzeichnungen*, 2 vols. (Herrsching: Pawlak, [c. 1977]).

38. See Inge Feuchtmayr, *Johann Christian Reinhart 1761–1847: Monographie und Werkverzeichnis* (Munich: Prestel, 1975).

39. The custom of visiting Paris before Rome has been surveyed in Wolfgang Becker, *Paris und die deutsche Malerei 1750–1850* (Munich: Prestel, 1971).

40. There is no standard comprehensive work on the community of foreign artists in Rome in the late eighteenth and early nineteenth centuries. The most useful general works include: Friedrich Noack, *Deutsches Leben in Rom* (1907; rpt. Bern, 1971); Louis Hourticq

et al., *Les Artistes français en Italie de Poussin à Renoir* (exh. cat. Paris: Petit Palais, 1934); L. Swane, *Danske Malere i Rom*, Rom og Danmark, no. 1 (Copenhagen, 1935); *Il Settecento a Roma* (exh. cat. Rome: Museo di Roma, 1959); *Les Français à Rome: Résidents dans la ville éternelle de la Renaissance aux débuts du Romantisme* (exh. cat. Paris: Hotel de Rohan, 1961); Dorothea Kuhn, *Auch ich in Arcadien: Kunstreisen nach Italien 1600–1900* (exh. cat. Marbach am Neckar: Schiller-Nationalmuseum, 1966); *Oesterreichische Künstler und Rom vom Barock zur Secession* (exh. cat. Vienna: Akademie der bildenden Künste, 1972); Frederick Den Broeder, *The Academy of Europe: Rome in the 18th Century* (exh. cat. Storrs, Conn.: The William Benton Museum of Art, 1973). See also Anthony Clark, "State of Studies: Roman Eighteenth-Century Art," *Eighteenth-Century Studies*, 9 (1975), 102ff.

41. On Granet's Italian landscapes see Emile Ripert, *François-Marius Granet (1775–1849): Peintre d'Aix et d'Assise* (Paris: Plon, [1937]), pp. 169–72; *French Landscape Sketches*, pp. 110–11; and *Painting from Nature*, p. 30.

42. See Elisabeth Vidal-Naquet and Henry Wytenhove, *Jean-Antoine Constantin* (exh. cat. Marseilles: Musée des Beaux-Arts, 1985); and *French Landscape Sketches*, p. 107.

43. "Memoirs of the Painter Granet," trans. Joseph Focarino, in Edgar Munhall, *François-Marius Granet: Watercolors from the Musée Granet at Aix-en-Provence* (exh. cat. New York: The Frick Collection, 1988), p. 20.

44. Denis had arrived in Rome in 1786 and soon took up the outdoor sketching tradition. One sketching excursion to Tivoli, in the company of F.G. Ménageot and Elisabeth Vigée-Lebrun, is recorded in the *Souvenirs de Madame Vigée-Lebrun* (Paris, 1869), vol. 1, p. 179.

45. Granet, "Memoirs," p. 21.

46. Coeckelberghs, *Les Peintres belges à Rome*, p. 340.

47. See Laure Pellicer, "Le Peintre François-Xavier Fabre (1766–1837)," Thèse de doctorat d'Etat, Université de Paris IV, 1982, pp. 745ff.

48. See George Levitine, *Girodet-Trioson: An Iconographical Study*, Outstanding Dissertations in the Fine Arts (New York: Garland, 1978), ch. 6, "Landscape".

49. Letters to Dr. Trioson from Rome, 28 Sept. 1790, and 15 May 1791, in *Oeuvres posthumes*, ed. P.A. Coupin (Paris; Renouard, 1829), vol. 2, *Correspondance*, respectively 374 and 390.

50. Another Italian landscape by Girodet is reproduced in Georges Bernier, *Anne-Louis Girodet* (Paris and Brussels: Jacques Damase, 1975), p. 29.

51. See William S. Talbot, "Cogniet and Vernet at the Villa Medici," *Bulletin of the Cleveland Museum of Art*, 67, (1980), 135–49; and David Ojalvo et al., *Léon Cogniet 1794–1880* (exh. cat. Orléans: Musée des Beaux-Arts, 1990), pp. 158–66, nos. 128–33.

52. See Hans Naef, *Ingres in Rome* (exh. cat. n. loc.: International Exhibitions Foundation, 1971).

53. See Agnes Mongan, "Ingres et ses jeunes compatriotes à Rome 1806–20," in *Actes du Colloque International Ingres et son influence*, Bulletin spécial des Amis du Musée Ingres (Montauban, 1980), p. 9–15.

54. Naef, *Ingres in Rome*, p. 17, no. 21.

55. *Painting from Nature*, p. 9.

56. On Catel's portrait see *Nationalgalerie Berlin: Verzeichnis der Gemälde und Skulpturen des 19. Jahrhunderts* (Berlin, 1976), p. 80.

57. Unlocated; rpr. in *L'Italia vista dai pittori francese del XVIII e XIX secolo* (exh. cat. Rome: Palazzo delle Esposizioni, 1961), no. 29.

58. W. Lessing, "Ein bayerische Corot: Dillis' Blicke auf Rom," *Die Kunst und das schöne Heim* (Munich), 49, Heft 1 (1950), 1–3; and Eberhard Ruhmer et al., *München: Bayerische Staatsgemäldesammlungen. Schack-Galerie*, vol. 1 (Munich, 1969), 90–95.

59. A[ntoine]-L[aurent] Castellan, *Lettres sur l'Italie, faisant suite aux lettres sur la Morée, l'Hellespont et Constantinople*, vol. 2 (Paris: A. Nepveu, 1819), 48. On Castellan, a student of Valenciennes, see Anne Puech-Segaut, "Antoine-Laurent Castellan, 1772–1838," Mémoire de maîtrise, Montpellier: Université Paul Valery, 1981.

60. *Corinne*, vol. 1, 128.

61. *Oeuvres complètes*, vol. 6, 292.

62. *Elémens*, p. 409.

63. See Heinrich Schwarz, "Heinrich Reinhold in Italien," *Jahrbuch der Hamburger Kunsthalle*, 10 (1965), 71–96; and Gerhard Winkler et al., *Heinrich Reinhold (1788–1825): Italienische Landschaften* (exh. cat. Gera: Kunstgalerie, 1988).

64. "Extraits de notes de voyage de Prosper Barbot . . ." (unpublished MS., Paris, Bibliothèque Nationale, Cabinet des Estampes), p. 1. See ch. 4, n. 12 below for an explanation of this document.

65. Letter from Michallon to the family of Charles de l'Espine, written at Tivoli on 19 Sept. 1818. MS., Paris, Louvre, Cabinet des Dessins.

66. Further variants of the same motif are a watercolor, dated 1825, by Johann Heinrich Schilbach (1798–1851), in the Hessisches Landesmuseum, Darmstadt; rpr. in Hella Robels, *Sehnsucht nach Italien* (1974), pl. 78; and an oil study of 1816–27 by Johann Joachim Faber (1778–1846), rpr. in Eva Maria Krafft and Carl-Wolfgang Schümann, eds., *Katalog der Meister des 19. Jahrhunderts in der Hamburger Kunsthalle* (Hamburg, [1969]), p. 60, Inv. Nr. 1415.

67. Quoted in Robels, *Sehnsucht nach Italien*, p. 91.

68. Castellan, *Lettres sur l'Italie*, vol. 2, 55.

69. Rpr. respectively in Robels, *Sehnsucht nach Italien*, pl. 12, and *Møde med Italien*, cat. no. 113.

70. On Rémond see Suzanne Gutwirth, "Jean-

Charles-Joseph Rémond (1795–1875), Premier Grand Prix de Rome du Paysage historique," *BSHAF*, année 1981 (1983), 188–218.

71. See for example the engraving by Giovanni Battista Falda (1648–1678), rpr. in Isa Belli Barsali and Maria Grazia Branchetti, *Ville della Campagna Romana* (Milan: SISAR, 1975), p. 255.

72. Later known as an animal painter, Brascassat was at this time a landscapist. The runner-up in the competition for the *prix de Rome* for *paysage historique* in 1825, he petitioned for and obtained a pension at the French Academy in Rome. See Charles Marionneau, *Brascassat: Sa Vie et son oeuvre* (Paris: Renouard, 1872), pp. 56–118.

73. Plate 141 provides an example of this link. It is an *Italian Landscape* by Karel Dujardin, famous in the eighteenth and nineteenth centuries as *Le Diamant*. About 1820 Xavier Le Prince (1799–1826), Corot's contemporary and possibly his friend, copied the Dujardin. For the Dujardin, see *Landscapes from the Fitzwilliam* (exh. cat. London: Hazlitt, Gooden & Fox, 1974), p. 26, no. 21; fig. 9. For the Le Prince, see Sterling and Adhémar, vol. 3, no. 1175, pl. 431.

74. Stendhal, *Oeuvres complètes*, vol. 5, 16.

75. On Knip see E. Bergevelt, *J.A. Knip 1777–1847: De Brabatse Schilder van Landschappen en Dieren* (The Hague, 1977); and Fransje Kuvvenhoven, *De Familie Knip: drie generaties kunstenaars uit Noord-Brabant*, exh. cat. 's-Hertogenbosch: Noordbrabants Museum (Zwolle: Uitgeverij Waanders, 1988).

76. The extensive repertory of views in the environs of Rome is well represented in a five-volume work, which Corot might have known: Abbé Angelo Uggeri, *Journées pittoresques des édifices antiques dans les environs de Rome* (Rome, 1804–6). Of special interest are vol. 4 (Frascati) and vol. 5 (Albano and Castel Gandolfo).

77. See Coriolano Belloni, *I Pittori di Olevano* (Rome: Istituto di Studi Romani, 1970); and Domenico Riccardi, "I Pittori tedeschi di Olevano tra Romanticismo e Realismo nella primo metà del XIX secolo," in A. D'Alessandro, ed., *Artisti e scrittori europei a Roma e nel Lazio dal grand tour ai Romantici* (Rome, 1984), pp. 87–102.

78. Quoted in Ernst Jaffé, *Joseph Anton Koch: Sein Leben und sein Schaffen* (Innsbruck, 1905), p. 97. See Otto R. von Lutterotti, *Joseph Anton Koch 1768–1839: Leben und Werk* (Vienna and Munich: Herold, 1985); and Christian von Holst, *Joseph Anton Koch 1768–1839: Ansichten der Natur* (exh. cat. Stuttgart: Staatsgalerie, in association with Edition Cantz, Stuttgart, 1989).

79. Quoted in André and Renée Jullien, "Corot dans les Montagnes de la Sabine," *GBA*, 103 (1984), p. 182.

80. Richter, *Lebenserinnerungen eines deutschen Malers* (Leipzig, 1944), p. 193; quoted in Belloni, *I Pittori de Olevano*, p. 15.

81. Antoinette-Cécile-Hortense Haudebourt-Lescot (1784–1845). See *Age of Revolution*, pp. 486–87.

IV COROT IN ITALY

1. The basis for any study of Corot is Robaut, *Corot*. Three supplements to the catalogue are cited here in n. 1 to the Introduction. Also essential are Robaut's unpublished notes, archives, and *Documents sur Corot*, whose classification and location are explained in the Bibliography.

Inevitably Robaut made mistakes, but I have found the catalogue to be remarkably reliable. Consequently, and because Robaut's source often was Corot himself, it has been my principle to follow Robaut except where significant evidence contradicts him. Although the catalogue is illustrated liberally, the illustrations are poor, and, because it was published in 1905, it is not very useful as an index to the present location of Corot's works. In two appendices to my dissertation I listed current locations, where I knew them, and cited provenance, literature, and reproductions for R.1–R.200 (paintings, 1822–28) and R.2461–R.2634 (drawings, 1822–28) (Galassi, "Corot in Italy, 1825–1828" [1986], pp. 403–36; 437–52). These appendices simply organized material I had accumulated in the course of my work and were not intended as a new catalogue. They contain a number of errors and omissions. Far more useful are three detailed studies by André and Renée Jullien: "Les Campagnes de Corot au nord de Rome (1826–1827)," *GBA*, 99 (1982), 179–202; "Corot dans les montagnes de la Sabine," *GBA*, 103 (1984), 179–97; and "Corot dans les Castelli Romani," *GBA*, 110 (1987), 109–30.

2. Robaut, *Documents sur Corot*, vol. 2, 53.

3. Letter dated 2 Dec. 1825, from Corot to Abel Osmond; Etienne Moreau-Nélaton, *Corot raconté par lui-même* (Paris: Laurens, 1924), vol. 2, 129.

4. Letter dated May 1826, from Corot to Abel Osmond: "Here now more than six months have gone by, six months of absence. Let us keep up our correspondence as best we can and the five months to come soon will be behind us." Moreau-Nélaton, *Corot raconté par lui-même*, vol. 2, 136.

5. Letter dated 23 Aug. 1827, from Corot to Osmond: "I asked my parents for an extension, which I must say is entirely necessary. Beyond that, I will try to keep it as short as possible." Moreau-Nélaton, *Corot raconté par lui-même*, vol. 2, 145.

6. Letter dated 2 Feb. 1828, from Corot to Osmond: "[during the winter] I have sketched out two pictures [*tableaux*], which I will not execute until I return to Paris." Moreau-Nélaton, *Corot raconté par lui-même*, vol. 2, 148. It is possible that one of these pictures is a canvas now in Cleveland. See Ann Tzeutschler Lurie, "Corot: The Roman Campagna," *Bulletin of the Cleveland Museum of Art*, 53 (1966), 51–57. The picture is not, as Lurie proposes, one of the two exhibited at the Salon of 1827, but in conception and style it is closely related to these works and might well have been begun in Italy.

7. The chronological limits of the journey are established by two letters written by Corot at Rome, dated respectively 2 Feb. and 27 Mar. 1828. Moreau-Nélaton, *Corot raconté par lui-même*, vol. 2, 147; and Gustave Geffroy, *Corot* (Paris: Nilsson, 1924), p. 39. The latter letter, not to Abel Osmond but to Théodore Duverny, is the only one of Corot's surviving letters from Italy not published by Moreau-Nélaton.

8. Letter dated 14 Nov. 1827, from Corot to Osmond: ". . . I am making an effort to try to be able to return to France in the month of October 1828." Moreau-Nélaton, *Corot raconté par lui-même*, vol. 2, 147. See also the letter of 27 Mar. 1828 to Duverny, in which he states his intention to return in September 1828; quoted in Geffroy, *Corot*, p. 39.

9. The evidence for Corot's itinerary in Italy is presented in an appendix to my dissertation (Galassi, "Corot in Italy" [1986] pp. 453–61). See also the articles by André and Renée Jullien cited above, n. 1.

Although Corot's letters contain some important evidence, the essential basis for reconstructing his itinerary is provided by the (many) drawings and (few) paintings that are dated by month. Thus Corot's seven principal campaigns outside of Rome may be summarized as follows, by reference to works cited by Robaut number, without the "R." prefix:

CIVITA CASTELLANA AND ENVIRONS, *May–June 1826*. Civita Castellana: 124, 2506, 2507 (May); 2520 (June). Castel Sant'Elia: 2522 (June). Nepi: 2504 (June). Viterbo: 2516, 2517 (June).

PAPIGNO, TERNI, NARNI and ENVIRONS, *July–Sept. 1826*. Papigno: 2510, 2518 (July); 2493, 2497 verso (Aug.); 2489, 2490 (Sept.); Cascade of Terni: 2508 (Sept.); Narni: 2488, 2491 (Sept.).

CASTELLI ROMANI, *Nov. 1826*. Ariccia: 2531; Frascati: 2495; Nemi: 2519; Rocca di Papa: 2430.

OLEVANO AND ENVIRONS, *Apr. 1827*. Olevano: 2609; Civitella: 2619.

CASTELLI ROMANI. *Campaign interrupted by visits to Rome, Apr.–July 1827*: Genzano: 2550 (Apr.); Marino: 2549, 2502, 2569, 2570, 2571, 2582 (May); Lake Albano: 2608 (July); Ariccia: 2435 (July).

OLEVANO AND ENVIRONS, *July–Aug. 1827*. Civitella: 2620, 2545 (July); near Subiaco: 2615 (Aug.).

CIVITA CASTELLANA AND ENVIRONS, *Sept.–Oct. 1827*. Civita Castellana: 2527, 2498, 2539, 2540, 2623 (Sept.); 2513, 2536 (Oct.); Castel Sant'Elia: 2581, 2631 (Oct.).

10. Letter dated May 1826, from Corot to Osmond; Moreau-Nélaton, *Corot raconté par*

lui-même, vol. 2, 133.

11. Quoted in Paul Ortwin Rave, *Karl Blechen: Leben, Würdigungen, Werk* (Berlin: Deutscher Verein für Kunstwissenschaft, 1940), p. 13.

12. Barbot was in Italy from 1825 to 1828 and, like Corot, made his debut at the Salon of 1827, sending his pictures to Paris from Rome. While in Italy he kept a journal, which he edited some thirty years later, transposing the text into the past tense. Barbot's manuscript, now lost, has never been published. Although he left many works to the museum in his native Nantes, the manuscript cannot be found there. But a partial transcript, made by Alfred Robaut, survives among his papers conserved at the Bibliothèque Nationale, Paris (*Don Moreau-Nélaton. Corot. Peintre. Graveur. S.N.R. Boîte; boîte 4*). The document, in Robaut's hand, is titled, "Extraits de notes de voyage de Prosper Barbot artiste peintre redigés par lui en 1859. Excursions dans les environs de Rome et quelques provinces des états de l'église en 1827." A generous excerpt from the journal (or memoir) is presented as an appendix to my dissertation (Galassi, "Corot in Italy" [1986], pp. 462–70).

13. See R.2574 (Louvre, R.F. 9089; rpr. Robaut, *Corot*, vol. 1, 40), titled by Robaut, "Salvatore Mariotti and Filippo, slaves of [Léon] Fleury and Corot, at Ariccia."

14. Letter dated Mar. 1826, from Corot to Osmond; Moreau-Nélaton, *Corot raconté par lui-même*, vol. 2, 131.

15. Letter dated 2 Feb. 1828, from Corot to Osmond: "As for parties and society, I don't participate at all. . . . But Behr [*sic*] is not at all such a bear as I am; he goes everywhere; he shows up at the houses of all the ambassadors; he misses neither soirées nor balls." Moreau-Nélaton, *Corot raconté par lui-même*, vol. 2, 147.

16. At the museum in Naples, Corot made quick pencil copies of paintings by Titian and Giovanni Bellini, in the sketchbook R.3039 (Paris: Louvre, Cabinet des Dessins, R.F. 8702), f.32 recto and verso.

17. "Extraits de notes de voyage de Prosper Barbot" (as in n. 12). Among the painters mentioned by Barbot are Jacques-Raymond Brascassat (1804–1867), Jules-Louis-Philippe Coignet (1798–1860), André Giroux (1801–1879), and François Bouchot (1800–1842), winner of the *prix de Rome* for history painting in 1823.

18. See Kurt Erich Simon, "Julien Boilly: Camarade de Corot en Italie," *Revue de l'art ancien et moderne*, 67, no. 362 (May 1935), 225–28.

19. See Suzanne Gutwirth, "Léon-François-Antoine Fleury (1804–1858), peintre d'après nature," *BSHAF*, année 1979 (1981), 191–209, esp. nos. 1–11 of the catalogue, which are Italian oil studies exhibited at the Salon of 1831.

20. The great majority of Bodinier's surviving works, including several copies after Italian

landscapes by Corot, is in the Musée Turpin de Crissé, Angers.

21. See Henri Delaborde, *Mélanges sur l'art contemporain* (Paris: Renouard, 1866); Charles Clément, *Catalogue des tableaux et dessins de Edouard Bertin exposés à l'Ecole des Beaux-Arts* (Paris, 1872); Pierre Miquel, *Le Paysage français au XIXe siècle, 1824–1874* (Maurs-la-Jolie: Editions de la Martinelle, 1975), vol. 2, 86–103; and Philippe Grunchec, "Edouard Bertin (1797–1871): Sa Participation au Prix de Rome et ses dessins au musée de Chartres," *Revue du Louvre*, 30 (1980), 138–46.

22. See Marie-Madeleine Aubrun, *Théodore Caruelle d'Aligny et ses compagnons* (exh. cat. Orléans: Musée des Beaux-Arts, 1979); Patrick Ramade, "Théodore Caruelle d'Aligny: Dessins du premier séjour italien (1822–1827)," *Revue du Louvre*, 36 (1986), 121–30; and Aubrun, *Théodore Caruelle d'Aligny 1798–1871: Catalogue raisonné de l'oeuvre peint, dessiné, gravé* (Paris: [the author], [1989]).

23. E.g., E.J. Delécluze, *Journal des Débats*, 14 May 1831, quoted in Robaut, *Corot*, vol. 4, 351, and further quotations (p. 352) from the criticism of the Salon of 1833.

24. Edouard Bertin's father was the great journalist Louis-François Bertin (1766–1841), founding editor of the *Journal des Débats* and the subject of Ingres's famous portrait of 1832, now in the Louvre. Some writers on Corot have mistakenly identified Bertin the elder with Corot's teacher Jean-Victor Bertin. The two were not related.

25. Moreau-Nélaton, "Histoire de Corot," p. 34. The story of Aligny's recognition of Corot's talent, first recorded in 1853 by Théophile Silvestre, also was told to Robaut by the painter François-Louis Français (1814–1897), and is recorded in Robaut, *Documents sur Corot*, vol. 2, 84.

26. See Ingrid Wechssler, *Ernst Fries: Gemälde, Aquarelle und Zeichnungen im Besitz des Kurpfälzischen Museums Heidelberg* (Heidelberg, [1974]); and Gisela Scheffler and Barbara Hardtwig, *Von Dillis bis Piloty: Deutsche und österreichische Zeichnungen, Aquarelle, Ölskizzen 1790–1850 aus eigenem Besitz* (exh. cat. Munich: Staatliche Graphische Sammlung, 1979), pp. 32–33.

27. Edouard Joyant, ed., *Jules-Romain Joyant (1803–54): Lettres et tableaux d'Italie* (Paris: Laurens, 1936), p. 62.

28. A.L. Castellan, *Lettres sur l'Italie* (Paris: A. Nepveu, 1819), vol. 2, 49–50.

29. This is the vantage point also chosen by J.G. Dillis and J.C. Erhard for drawings reproduced in *Deutsche Künstler um Ludwig I. in Rom* (exh. cat. Munich: Staatliche Graphische Sammlung, 1981), pp. 124–25.

30. See *Danish Painting: The Golden Age* (exh. cat. London: The National Gallery, 1984), p. 100.

31. Robaut catalogued this study correctly as *The Roman Campagna* Feb. 1826 (R.97). He also catalogued it (or a copy) incorrectly, as *Naples and Vesuvius seen from Ischia*, 1828 (R.191). Earlier I mistakenly followed the

second entry. That the first is correct is demonstrated in André and Renée Jullien, "Corot dans les Castelli Romani," *GBA*, 110 (1987), p. 111.

32. R.57–R.64, R.89–R.94, R.104–R.113, and R.168. R.58, R.87, and R.112 are copies or revisions of other studies. In France before leaving for Italy Corot had painted two figure studies: R.55 and R.56. See *Figures de Corot* (exh. cat. Paris: Louvre, 1962); and Antje Zimmermann, *Studien zum Figurenbild bei Corot*, Inaugural-Dissertation, Universität zu Köln (Cologne, 1986).

33. See Hercenberg, *Vleughels*, pp. 103–4, cat. nos. 135–40.

34. Quoted in Lamicq, "Michallon," in Miquel, *Le Paysage français*, vol. 2, 82.

35. See Giuliano Briganti, Ludovica Trezzani, and Laura Laureati, *The Bamboccianti: The Painters of Every Day Life in Seventeenth Century Rome* (Rome: Ugo Bozzi, 1983).

36. On Robert see Pierre Gassier, *Léopold Robert et les peintres de l'Italie romantique* (exh. cat. Neuchâtel: Musée des Beaux-Arts, 1983). On Victor Orsel, another acquaintance of Corot in Italy, see Gilles Chomer, "Le Séjour en Italie (1822–1830) de Victor Orsel," in G. Chomer and Marie-Félice Perez, eds., *Lyon et l'Italie: six études d'histoire de l'art* (Paris: Editions du CNRS, 1984), pp. 181–211.

37. Quoted in *Age of Revolution*, p. 596.

38. See Félix-Sébastien Feuillet de Conches, *Léopold Robert, sa vie, ses oeuvres, sa correspondance* (Paris, 1848).

39. E.-J. Delécluze, *Carnet de route d'Italie (1823–24): Impressions romaines* (Paris: Bonvin, 1942), p. 177.

40. See Marcel Roethlisberger, "Aggiunte a Claude," *Paragone*, 20, no. 233 (1969), 54–58; and H. Diane Russell, *Claude Lorrain 1600–1682* (exh. cat. Washington, D.C.: National Gallery of Art, 1982), pp. 161–62, 455–56.

41. Thus it was called in the title of a lithograph after a drawing by Michallon (here pl. 177). The lithograph was published in the series *Choix de vues d'Italie dessinées d'après nature par d'habiles artistes* (Paris: Hilaire Sazerac, 1826).

42. Another view of La Crescenza, drawn in 1811 by Christian Xeller (1784–1872), is reproduced in Marianne Bernhard, ed., *Deutsche Romantik Handzeichnungen* (Herrsching: Pawlak, n.d. [c. 1977]), vol. 2, 1952. Constant Bourgeois (1767–1836) published two views of La Crescenza in a series of prints titled *Vues et fabriques d'Italie* (Paris, 1803).

43. On the issue of finish in outdoor studies, see above, ch. 2, pp. 66–67. The term *étude terminée* had been used, for example, in the catalogue of Michallon's posthumous sale, lots 42 and 57. The catalogue is cited above, ch. 2, n. 116.

44. Robaut, *Cartons*, vol. 1, 85, 87, in notes on R.65 and R.66, states that these works were part of a trio of studies executed in morning, midday, and afternoon sessions each day for seventeen days in March 1826.

45. See Marcel Roethlisberger, "Les Pendants dans l'oeuvre de Claude Lorrain," *GBA*, 51 (1958), 215–28.
46. Toussaint was the first to recognize the two works as pendants; see *Hommage à Corot* (exh. cat. Paris, 1975), p. 21.
47. The conception of the picture was based on a type favored by landscape painters in Italy. See, for example, Johann Christian Reinhart's *Landscape with approaching storm* (1803; Cassel: Staatliche Kunstsammlungen), rpr. in *La Peinture allemande à l'époque du Romantisme* (exh. cat. Paris: Louvre, 1976), p. 155, no. 180; and J.-C.-J. Rémond's *Tomb of Nero in the Roman Campagna* (*c.*1825), recorded in a lithograph by Delpech (Paris: Bibliothèque Nationale, Cabinet des Estampes).
48. Paris, Louvre, Inv. 270.
49. Sketchbook R.3103 (Paris: Louvre, Cabinet des Dessins, R.F. 6742 *bis*); quoted in Moreau-Nélaton, "Histoire de Corot," p. 49.
50. Valenciennes, *Elémens*, p. 404.
51. The oil study is R.46; rpr. in Bazin, *Corot* (1973), p. 128. The drawing is R.2600 verso (Paris: Louvre, Cabinet des Dessins, R.F. 8986 verso).
52. See *Hommage à Corot*, p. 22.
53. Ibid., p. 20.
54. The daguerreotype, made in 1842 by Joseph-Philibert Girault de Prangey, is reproduced in Helmut and Alison Gernsheim, *L.J.M. Daguerre (1787–1851)* (2nd. ed., New York: Dover, 1968), fig. 45. In the daguerreotype the view is laterally reversed.
55. In sketchbook R.3103 (Paris: Louvre, Cabinet des Dessins, R.F. 6742 *bis*); quoted in *Corot raconté par lui-même et par ses amis*: Pierre Courthion and Pierre Cailler, eds., *Pensées et écrits du peintre* (Geneva: Cailler, 1946), p. 87.
56. Ibid., p. 89.
57. Other precedents, including works by Valenciennes, Michallon, Chauvin, and Goethe, are reproduced in Marie-José Salmon, *Vasques de Rome, ombrages de Picardie: Hommage de l'Oise à Corot* (exh. cat. Beauvais: Musée Départemental de l'Oise, 1987).
58. Wolfgang Krönig, "Storia di una veduta di Roma," *Bolletino d'Arte*, serie 5, 57 (1972), 165–98.
59. Delécluze, *Carnet de route d'Italie*, pp. 98–99.
60. See Richard Verdi, "Poussin's Life in

Nineteenth-Century Pictures," *Burlington Magazine*, 111 (1969), 741–50.
61. R.2495 verso (Paris: Louvre, Cabinet des Dessins, R.F. 9031 verso). The drawing is a partial sketch of the lower left corner. It includes a peasant boy and sheep, and the left riverbank has become – as it is in the finished work – an abrupt cliff. Thus the drawing probably represents an interim stage between the general compositional drawing (here pl. 204) and the finished painting.
62. While in the finished picture the peasants tend a flock of sheep, in the compositional drawing it is a herd of cattle, as in Hackert's engraving of the bridge at Narni, published in 1779; rpr. in *Wallraf-Richartz-Jahrbuch*, 30 (1968), 260.
63. See for example a drawing of the Forum dated Feb. 1826, rpr. (fig. 1) in Jean Ehrmann, "Etudes de Corot sur le Forum," *Archives de l'art français*, nouv. pér., 25 (1978), 297–99.
64. Indeed, a review of the surviving works suggests that Aligny learned more from Corot than vice versa. See Patrick Ramade, "Théodore Caruelle d'Aligny: Dessins du premier séjour italien (1822–27)," *Revue du Louvre*, 36 (1986), 121–30.
65. One indication that Aligny may have been following the Germans consciously is his distinctive monogram, which evidently was modeled on Dürer's and appears in a number of his Italian drawings.
66. E.g., *Vues d'Italie et de Sicile, dessinées d'après nature par A.E. Michallon, ancien pensionnaire du Roi à l'Ecole de Rome et lithographiées par MM. Villeneuve, Deroi et Renoux* (Paris: Lami-Denozan, 1827).
67. The other drawing of Mar. 1827, not reproduced here, is R.2529, a reprise of R.67, the view over the Forum.
68. For example drawings R.2506 (dated May 1826) and R.2514 (undated but similar in conception and style) are panoramas taken from opposite sides of the town's northern end, and may have been conceived as a pair. Another early work of the first campaign at Civita Castellana is R.152.
69. R.142, R.143, R.145, and R.173.
70. André and Renée Jullien, "Les Campagnes de Corot au nord de Rome (1826–27)."
71. R.2489, R.2558 (drawings); R.116, R.117,

R.118, R.119, R.120, R.132 (paintings).
72. See the article on Bertin's drawings by Philippe Grunchec, cited above, n. 21.

EPILOGUE

1. The reference is to the outdoor work contained in the sequence R.200–R.300.
2. See Laura Gabellieri Campani, "Viaggio di Corot in Toscana," *Rassegna Volterrana*, anni 42–53 (1977), 5–29.
3. R.303; Paris: Louvre, R.F. 1618; 70.5 × 94 cm.
4. Bazin, *Corot* (1973), p. 49.
5. See Leonée and Richard Ormond, *Lord Leighton* (New Haven and London: Yale Univ. Press, 1975); and *Painting from Nature*, p. 48.
6. See *William Bouguereau 1825–1905* (exh. cat. Montreal: The Montreal Museum of Fine Arts, 1984), p. 149, no. 13.
7. In Mrs. Russell Barrington, *The Life, Letters and Work of Frederic Leighton* (New York: Macmillan, 1906; rpt. New York: AMS Press, 1973), vol. 1, 109–110.
8. See *The Arcadian Landscape: Nineteenth-Century American Painters in Italy* (exh. cat. Lawrence: Univ. of Kansas Museum of Art, 1972); John W. Coffey, *Twilight of Arcadia: American Landscape Painters in Rome, 1830–1880* (Brunswick, Maine: Bowdoin College Museum of Art, 1987); and William L. Vance, *America's Rome*, vol. 1, *Classical Rome* (New Haven and London: Yale Univ. Press, 1989).
9. See Raffaelo Causa, *Il Paesaggio napoletano nella pittura straniera* (exh. cat. Naples, 1962); and idem., *La Scuola di Posillipo* (Milan: Fratelli Fabbri Editori, 1967).
10. See Norma Broude, *The Macchiaioli: Italian Painters of the Nineteenth Century* (New Haven and London: Yale Univ. Press, 1987).
11. See Christoph Heilmann, ed., *"In uns selbst liegt Italien": Die Kunst der Deutsche-Römer* (exh. cat. Munich; Haus der Kunst, in association with Hirmer Verlag, Munich, 1987).
12. On Eckersberg and his school see Torsten Gunnarsson, *Friluftsmåleri före Friluftsmåleriet: Oljestudier i nordiskt landskapsmåleri 1800–1850*, Acta Universitatis Upsaliensis, *Ars Suetica*, 12 (Uppsala, 1989), with English summary.

BIBLIOGRAPHY

I ARCHIVES

MALIBU, CALIFORNIA: THE J. PAUL GETTY MUSEUM

Notes on the provenance and location of paintings by Corot, assembled by Julius H. Weitzner.

PARIS: BIBLIOTHÈQUE NATIONALE, CABINET DES ESTAMPES

Don Moreau-Nélaton.

In 1927, Etienne Moreau-Nélaton bequeathed to the State the notes and materials he and, before him, Alfred Robaut had assembled in preparing their catalogue of Corot's work. These materials entered the Collections of the Bibliothèque Nationale and are listed here according to the B.N. classification system, with occasional explanatory notes.

S.N.R. Format 4

Collection Robaut. Notes, croquis, calques, photos, estampes. 34 cartons.

1–14.	Paysages 1822–1875.
15–27.	Compositions divers 1822–1870.
28.	Dessins divers.
29.	Charles Desavary. *Album de Fac-simile d'après les dessins de C. Corot.* Arras, 1873. 1ère série.
30.	Desavary. *Fac-simile.* 2e et 3e séries.
31.	Desavary. *Fac-simile.* 4e et 5e séries.
32.	Portraits peints par Corot.
33.	Portraits de Corot.
34.	Photographies Braun d'après l'oeuvre de Corot exposé à l'Ecole des Beaux-Arts [1875].

[These are the *Cartons* to which Hélène Toussaint refers in *Hommage à Corot* (exh. cat. Paris, 1975). In effect they contain Robaut's manuscript for the catalogue, as well as the photographs and other visual documents from which the illustrations in the printed catalogue are derived. However, Moreau-Nélaton did not print Robaut's entries verbatim. Nor would Robaut have wanted him to do so, for they sometimes contain remarks meant only for himself and his collaborator. These notes (and in the case of unlocated works, the photographs) are very useful. Since 1983, all thirty-four *cartons* have been housed at the Service d'Etude et de Documentation, Département des Peintures, Musée du Louvre, Paris. They remain, however, part of the B.N. Collections and are so listed here.

Some of the photographic portraits of Corot, themselves works of art, have been removed from the *cartons* and integrated into the portrait holdings of the B.N. or the photography collection of the Musée d'Orsay, Paris.]

S.N.R. Boîte

Corot. Peintre. Graveur. 6 boîtes.

[Miscellaneous documents collected by Robaut and Moreau-Nélaton.]

1.	Photographies d'après les oeuvres. Paysages.
2.	Photographies d'après les oeuvres. Paysages.
3.	Photographies d'après les oeuvres. Figures. Portraits. Compositions.
4.	Correspondance. Notes et manuscrites.
5.	Brochures. Articles de revues. Catalogues. Coupures journaux.
6.	Supplément d'après les oeuvres. Paysages.

S.N.R. Format 3

Corot. Peintre. Graveur. XIXe siècle. 2 portfolios.

[Portfolio 1: Tearsheets from major sale catalogues, *c.*1900; original *clichés-verre* by Corot. Portfolio 2: Photographs of miscellaneous works by Corot, with notes by Robaut.]

S.N.R. Format 5 (Grand S.N.R.)

Corot. Peintre. Graveur. XIXe siècle. 1 portfolio.

[Prints by other artists after Corot's works.]

Yb.3.949 4to

Alfred Robaut. Documents sur Corot. 3 vols.

[An extensive and disorganized collection of Robaut's original notes on Corot's life and work. Some of the notes are records of conversations held with Corot in the years 1872–75. Moreau-Nélaton used much of this material for his biography of Corot. It is indispensable, not only as the source of Moreau-Nélaton's information, but also for many facts and comments that he did not use.]

Dc.282.p 4to

Corot. Croquis par Prévost. Avec notes manuscrites [by Robaut].

[Robaut's drawings after 79 copies made by Prévost after works by Corot. For an explanation of this material see Bazin, *Corot*, p. 81.]

Dc.282.1 4to

Calques d'après les dessins de Corot par Alfred Robaut. 2 vols.

1.	Paysages.
2.	Compositions. Figures.

Dc.282.0 4to

Oeuvres de Corot. Photographies Desavary.

Dc.282.t 4to

Oeuvres de Corot. Photographies Desavary.

Dc.282.n pet. fol.

Croquis, calques, notes, photographies, coupures de journaux se rapportant aux oeuvres fausses ou douteuses de Corot. 1 vol.

Dc.282.r pet. fol.

Croquis divers. Photographies d'après Corot. 1 vol.

[Primarily proof sheets for the printing of the catalogue.]

Dc.282.m 4to

Photographies d'après les oeuvres de Corot. (Illustrations pour l'histoire de Corot d'Etienne Moreau-Nélaton). 1 vol.

PARIS: MUSÉE DU LOUVRE, CABINET DES DESSINS

Corot, Jean-Baptiste-Camille. Autographes.
Michallon, Achille-Etna. Autographes.

PARIS: MUSÉE DU LOUVRE, DÉPARTEMENT DES PEINTURES, SERVICE D'ETUDE ET DE DOCUMENTATION

Collection Suzanne Gutwirth.

Suzanne Gutwirth (d. 1983) was an assiduous researcher in the field of French Neoclassical landscape painting. Upon her death, her widower donated to the Louvre her many notes, fine-art photographs, and other research materials. These have been divided and classified among the dossiers on individual artists.

Although Mme. Gutwirth's work touched on virtually all painters in the field she studied, her research is particularly valuable for the following: Jean-Victor Bertin, Jean-Joseph-Xavier-Bidauld, Léon Fleury, Jean-Charles-Joseph Rémond, and Nicolas-Antoine Taunay.

II CATALOGUES OF EXHIBITIONS DEVOTED TO COROT

For the period up to the date of publication, Robaut, *Corot*, vol. 4, 383–85; Bazin, *Corot*, pp. 304–5; and *Hommage à Corot* (exh. cat. Paris, 1975), pp. 185–89, each provide virtually exhaustive citations of exhibitions and exhibition catalogues devoted to Corot's work.

1875. Paris. Ecole Nationale des Beaux-Arts. *Exposition de l'oeuvre de Corot*. Text by Philippe Burty.
1928. Paris. Galerie Paul Rosenberg. *Exposition d'oeuvres de Camille J.-B. Corot: Figures et paysages d'Italie*. Text by Elie Faure.
1930. New York. The Museum of Modern Art. *Corot, Daumier*. Text by Alfred H. Barr, Jr.
1930. Paris. Galerie Paul Rosenberg. *Exposition d'oeuvres de Camille J.-B. Corot: Paysages de France*. Text by Elie Faure.
1934. Zurich. Kunsthaus. *Corot*.
1936. Paris. Musée de l'Orangerie. *Corot*. Text by Paul Jamot.
1938. Paris. Galerie Maurice Gobin. *Exposition de dessins et de quelques peintures par C. Corot*. Text by M[aurice] G[obin].

1942. New York. Wildenstein. *The Serene World of Corot*. Text by G[eorges] W[ildenstein].
1946. Philadelphia. Philadelphia Museum of Art. *Corot: 1796–1875*. Text by Lionello Venturi.
1951. Paris. Galerie Daber. *Le Divin Corot*. Text by Alfred Daber.
1956. New York, Gallery Paul Rosenberg. *Corot*. Text by Elie Faure.
1957. Paris. Galerie Brame. *Corot*.
1958. Dieppe. Musée des Beaux-Arts. *Corot*.
1960. Bern. Kunstmuseum. *Corot*.
1960. Chicago. The Art Institute of Chicago. *Corot: 1796–1875*. Texts by S. Lane Faison, Jr., and James Merrill.
1962. Paris. Louvre. *Figures de Corot*. Text by Germain Bazin.
1962. Paris. Louvre, Cabinet des Dessins. *Dessins de Corot (1796–1875)*. Text by J. Bouchot-Saupique.
1963. London. Marlborough Fine Art Ltd. *Corot*. Text by Denys Sutton.
1965. London. Arts Council of Great Britain. *Corot*. Text by Cecil Gould.
1969. New York. Wildenstein. *Corot*. Text by

Jean Dieterle.
1975. Paris. Orangerie des Tuileries. *Hommage à Corot: Peintures et dessins des collections françaises*. Texts by Hélène Toussaint, Geneviève Monnier, and Martine Servot.
1975. Rome. Académie de France à Rome, Villa Medicis. *Corot 1796–1875: Dipinti e disegni di collezioni francesi*. Rome: De Luca, 1975. Texts by Hélène Toussaint, Geneviève Monnier, and Martine Servot.
1979. London. David Carritt Ltd. *Corot and Courbet*. Text by John Richardson.
1986. New York. Salander-O'Reilly Galleries. *Corot-Delacroix: An Exhibition of Paintings, Drawings, Watercolors*. Texts by S. Lane Faison, Jr., and Julius Meier-Graefe.
1987. Beauvais. Musée Départemental de l'Oise. *Vasques de Rome, Ombrages de Picardie: Hommage de l'Oise à Corot*. Texts by Jacques Foucart and Marie-José Salmon.
1988. San Diego. Timken Art Gallery. *J.-B.-C. Corot: View at Volterra*. Text by Fronia E. Wissman.
1989. London. The Lefevre Gallery. *Corot*.

III WORKS ON COROT

For the period up to the date of publication, Robaut, *Corot*, vol. 4, 351–80 and 387–92; and Bazin, *Corot*, pp. 299–310, each provide extensive bibliographies of works on Corot.

Asselineau, Charles. "Intérieurs d'atelier: C. Corot," *L'Artiste*, 5e série, 7 (15, Sept. 1851), 53–55.
Bazin. Germain. *Corot*. Paris: Tisné, 1942.
———. *Corot*. 2nd ed. Paris: Tisné, 1951.
———. *Corot*. 3rd ed. Paris: Hachette, 1973.
Bissière, [Roger]. "Notes sur Corot," *L'Esprit nouveau*, no. 9 (c.1922; rpt. New York: Da Capo, 1968), 1006–8.
Brookner, Anita. "The Eye of Innocence." Review of Leymarie, *Corot* (1979), *Times Literary Supplement* (21 March 1980), 317–18.
Courthion, Pierre and Pierre Cailler, eds. *Corot raconté par lui-même et par ses amis*. 2 vols. Geneva: Cailler, 1946.
Dieterle, Jean. *Corot, troisième supplément à l'Oeuvre de Corot par Alfred Robaut et Etienne Moreau-Nélaton*. Paris: Quatre Chemins-Editart, 1974.
Dumesnil, Henri. *Corot: Souvenirs intimes*. Paris: Rapilly, 1875.
Ehrmann, Jean. "Etudes de J.B.C. Corot sur le Forum," *Archives de l'art français*, nouv. pér., 25 (1978), 297–99.
Einstein, Carl. "Jean-Baptiste Corot (1796–1875): Compositions classiques," *Documents* (Paris), 1e année, no. 2 (May 1929), 84–92.
Forges, Marie-Thérèse de. "Nouvelles précisions sur une peinture de Corot," *Revue du Louvre*, 25 (1975), 169–72.

Gabellieri Campani, Laura. "Viaggio di Corot in Toscana," *Rassegna Volterrana*, anni 42–53 (1977), 5–29.
Galassi, Peter. "Corot in Italy, 1825–1828." Dissertation, New York: Columbia Univ., 1986.
Geiger, M. "Corot et la Bourgogne," *Mémoires de l'Académie des Sciences, Arts et Lettres de Dijon*, 122 (1973–75), 329–37.
Geffroy, Gustave. *Corot*. Paris: Nilsson, 1924.
Gowing, Lawrence. "Confidence and Conscience in Two Centuries of Art," *Art News Annual*, no. 30 (1965), 117–39, 172–75.
Gualazzi, E. "Le Due facce di Corot a Villa Medici," *Arti*, 25 (1975), 3–10.
Held, Julius S. "Corot in Castel Sant'Elia," *GBA* 23 (1943), 183–86.
Hill, Ian Barras. "Jean-Baptiste-Camille Corot: A Centenary Appraisal," *Connoisseur*, 189, (1975), 100–9.
Huntley, G. Haydn. "Complexity and Corot," *Art News*, 59, no. 6 (Oct. 1960), 33–5, 53.
Jullien, André and Renée. "Les Campagnes de Corot au nord de Rome (1826–27)," *GBA*, 99 (1982), 179–202.
———. "Corot dans les montagnes de la Sabine," *GBA*, 103 (1984), 179–97.
———. "Corot dans les Castelli Romani," *GBA*, 110 (1987), 109–30.
Leymarie, Jean. *Corot*. Geneva: Skira, 1966.
———. *Corot*. Rev. ed., trans. Stuart Gilbert. New York: Rizzoli, 1979.
Lhote, André. *Corot*. Paris: Delamain, Boutelleau et Cie., 1923.

Lurie, Ann Tzeutschler. "Corot: *The Roman Campagna*," *Bulletin of the Cleveland Museum of Art*, 53 (1966), 51–57.
Mantz, Paul. "Corot," *GBA*, 1e pér., 11 (1861), 416–32.
Meier-Graefe, Julius. *Corot*. Berlin: Bruno Cassirer und Klinkhardt & Biermann, 1930.
Meynell, Everard. *Corot and his Friends*. London: Methuen & Co., 1980.
Michel, André. "L'Oeuvre de Corot et le paysage moderne," *Revue des Deux Mondes*, 66e année, 4e pér., 133 (1896), 913–30.
Morant, Henry de. "Deux Corot inconnus au Musée d'Angers," *Les Cahiers de Pincé et des Musées de la ville d'Angers*, année 1950 (1951), 1–10.
Raphael, Max. "Monographie eines Bildes: Corot 'Römische Landschaft'," in *Arbeiter, Kunst und Künstler: Beitrage zu einer marxistischen Kunstwissenschaft*. Frankfurt am Main: S. Fischer, 1975.
Robaut, Alfred and Etienne Moreau-Nélaton. *L'Oeuvre de Corot*. 4 vols. Paris: H. Floury, 1905. For the supplements see Schoeller, André and Jean Dieterle; and Dieterle, Jean.
Schoeller, André and Jean Dieterle. *Corot, premier supplément à l'Oeuvre de Corot par Alfred Robaut et Etienne Moreau-Nélaton*. Paris: Arts et Métiers Graphiques, 1948.
———. *Corot, deuxième supplément à l'Oeuvre de Corot par Alfred Robaut et Etienne Moreau-Nélaton*. Paris: Arts et Métiers Graphiques, 1956.
Sells, C. "Corot exhibition at the Orangerie,"

Burlington Magazine, 117 (1975), 689–90.

Selz, Jean. *La Vie et l'oeuvre de Camille Corot* Courbevoie (Paris): ARC Edition, 1988.

Silvestre, Théophile. "Corot" (1853), in *Les Artistes français: Etudes d'après nature.* Paris: G. Charpentier, 1878, pp. 261–76.

Thomson, David Croal. *Corot.* London: Simpkin, Marshal, Hamilton, Kent & Co., 1892.

Wagner, Hugo. "Bermerkungen zum Frühwerk von Camille Corot," *Mitteilungen des Berner Kunstmuseums*, 37 (1960), 1–4.

Willoch, S. "Totegniger av Camille Corot i

Nasjonalgalleriet," *Kunst og Kultur*, 59, no. 3 (Nov. 1976), 146–54.

Zimmermann, Antje. *Studien zum Figurenbild bei Corot.* Inaugural-Dissertation, Cologne: Universität zu Köln, 1986.

IV OTHER WORKS

Addison, Joseph. *Remarks on Several Parts of Italy, in the years 1701, 1702, 1703.* 1705. 2nd ed. London, 1718.

Adhémar, Jean. "L'Enseignement académique en 1820: Girodet et son atelier," *BSHAF*, année 1933 (1934), 270–83.

———. *Les Lithographies de paysage en France à l'époque romantique.* Paris: Armand Colin, 1937.

Un Amateur. *Observations sur le concours du Grand Prix du paysage historique, et sur le nécessité de donner une nouvelle direction aux études de ce genre.* Paris: Didot l'ainé 1821.

Ananoff, Alexandre. *L'Oeuvre dessiné de Jean-Honoré Fragonard.* Paris: De Nobelle, 1963.

Andrews, Keith. *The Nazarenes: A Brotherhood of German Painters in Rome.* Oxford: Oxford Univ. Press, 1964.

Angeli, Diego. *Le Cronache del "Caffè Greco".* Milan: Fratelli Treves, 1930.

Anon. *Lettres à David par quelques élèves de son école.* Paris: Pillet Ainé, 1819.

Anon. *Lettres analytiques, critiques et philosophiques sur les tableaux du Salon.* Paris, 1791.

Anon. *Merlin au Salon de 1787.* Rome, 1787.

The Arcadian Landscape: Nineteenth-Century American Painters in Italy. Exh. cat. Lawrence: Univ. of Kansas Museum of Art, 1972.

The Art of the Landscape: Classical, Neo-classical and en plein-air, 1650–1900. Exh. cat. London: Crawley & Asquith Ltd., with John Lishawa, 1988.

Ashby, Thomas. *Forty Drawings of Roma: Scenes by British Artists (1715–1850) from Originals in the British Museum.* London: British Museum, 1911.

Aspects du paysage néo-classique en France de 1790 à 1855. Exh. cat. Paris: Galerie du Fleuve, 1974.

Assunto, Rosario. *Specchio vivente del mondo: Artisti stranieri in Roma, 1600–1800.* Rome: De Luca, 1978.

Aubrun, Marie Madeleine. "La Tradition du paysage historique et le paysage naturaliste dans la première moitié du XIXe siècle français," *L'Information de l'histoire de l'art*, 13e année (1968), 63–72.

———. "Nicolas-Didier Boguet (1755–1839): 'un émule du Lorrain'," *GBA*, 83 (1974), 319–36.

———. "Pierre-Athanase Chauvin (1774–1832)," *BSHAF*, année 1977 (1979), 192–216.

———. *Théodore Caruelle d'Aligny (1798–1871) et ses compagnons.* Exh. cat. Orléans. Musée des Beaux-Arts, 1979.

———. *Théodore Caruelle d'Aligny 1798–1871:*

Catalogue raisonné de l'oeuvre peint, dessiné, gravé. Paris: [the author], 1989.

Ausstellung deutsche Romantiker in Italien. Exh. cat. Munich: Städtische Galerie, 1950.

Bailey, C. "The English Poussin: An Introduction to the Life and Work of George Augustus Wallis," *Walker Art Gallery at Liverpool. Annual Report*, 6 (1975–76), 34–54.

Balslev Jørgensen, Lisbet. "P.H. Valenciennes' Elémens og det heroiske landskab i Thorvaldsens malerisamling," *Meddelelser fra Thorvaldsens Museum* (1970), 88–114.

Barcham, William. Review of Briganti, *Gaspard Van Wittel, Art Bulletin*, 51 (1969), 189–93.

Barthélemy, Abbé Jean-Jacques. *Voyage en Italie.* Paris: F. Buisson, 1802.

Bauer, E. *Die Englische Aquarellmalerei der 'Grand Tour' im 18. Jahrhundert.* Dissertation, Munich: Ludwig-Maximilians-Universität, 1976.

Bazin, Germain. "Pierre-Henri de Valenciennes," *GBA*, 59 (1962), 353–62.

———, et al. *L'Italia vista dai pittori francesi del XVIII e XIX secolo.* Exh. cat. Rome: Palazzo delle Esposizioni, 1961.

Beckett, R.B. "Constable and France," *Connoisseur*, 137 (Jan.–June 1956), 249–55.

Bell, Charles F. and Thomas Girtin. "The Drawings of John Robert Cozens," *Walpole Society*, 23 (1934–35).

Belloni, Coriolano. *I Pittori di Olevano.* Rome: Istituto di Studi Romani, 1970.

Benoit, François et al. *Histoire du paysage en France.* Paris: Renouard, 1908.

Bergeret de Grancourt, P.-J.-O. *Voyage d'Italie, 1773–1774.* J. Wilhelm, ed. and introd. Paris, 1948.

Bergevelt, E. *J.A. Knip 1777–1847: De Brabatse Schilder van Landschappen en Dieren.* The Hague, 1977.

Bergsträsser, G. "Zeichnungen von J.J. de Boissieu im Hessischen Landesmuseum zu Darmstadt," *Kunst in Hessen und am Mittelrhein*, 10 (1970), 89–99.

Bernari, Carlo, Cesare de Seta, and Atanasio Mozzillo. *Grandi viaggiatori stranieri in Italia.* Rome, 1987.

Bernhard, Marianne. *Deutsche Romantik Handzeichnungen.* 2 vols. Herrsching: Pawlak, [c.1977].

Berthoud, Dorette. "Autour de l'Académie de France à Rome: Léopold Robert et Edouard Odier," *GBA*, 155 (1948), 365–72.

Bertin, Jean-Victor. *Receuil d'études d'arbres.* Paris: Engelmann, 1818–21.

Bianchi, Lidia. *Nicolas-Didier Boguet: Acquellerista.* Extract from the commemorative volume "Te Roma sequor." Rome: Associazione di cultura romana "Te Roma sequor," 1956.

Birkedal Hartmann, J. "Zu Thorvaldsens Rezeption der nordischen Kunst in Rom um 1770–1800," *Kölner Berichte zur Kunstgeschichte*, 2 (1977), 129–71.

Blanc, Charles. *Histoire des peintres de toutes les écoles. Ecole française.* 3 vols. Paris: Renouard, 1865–69.

Blanc, Joseph. *Bibliographie italico-française universelle, ou catalogue méthodique de tous les livres imprimés en langue française sur l'Italie . . . 1485–1885.* 2 vols. Milan, 1886.

Boime, Albert. *The Academy and French Painting in the Nineteenth Century.* London: Phaidon, 1971.

Boisclair, Marie-Nicole. *Gaspard Dughet.* Paris: Arthena, 1986.

Bordes, Philippe. "Louis Gauffier and Thomas Penrose in Florence," *Minneapolis Institute of Arts. Bulletin*, 13 (1974), 72–75.

Bott, Gerhard. *"Es ist nur ein Rom in der Welt": Zeichnungen und Bildnisse deutscher Künstler in Rom um 1800.* Exh. cat. Darmstadt: Hessisches Landesmuseum, 1977.

Bouret, Jean. *L'Ecole de Barbizon et le paysage français au XIXe siècle.* Neuchâtel: Editions Ides et Calendes, 1972.

Bourgeois, Constant. *Receuil d'études de paysage.* Paris: F. Delpech, [c.1822].

Bouyer, Raymond. "Petits maîtres oubliés: Georges Michel," *GBA*, 3e pér., 18 (1897), 304–13.

———, et al., *Le Paysage français de Poussin à Corot.* Paris: *GBA*, 1926.

———. "Georges Michel," *Revue de l'art ancien et moderne*, 51 (1927), 237–48.

Briganti, Giuliano. *Gaspar van Wittel e l'origine della veduta settecentesca.* Rome: Ugo Bozzi, 1966.

———. *The View Painters of Europe.* London: Phaidon, 1970.

Brilli, Attilio. *Il Viaggio in Italia: Storia di una grande tradizione culturale dal XVI al XIX secolo.* Milan: Banca Popolare di Milano, 1989.

Brosses, Charles de. *Le Président de Brosses en Italie.* R. Colomb, ed. 2 vols. Paris, 1858.

Bruun Neergaard, T.C. *Sur la situation des beaux-arts en France, ou lettres d'un danois à son ami.* Paris: Dupont [1801].

Bruyn Kops, C.J. de. "Hendrik Voogd, Nederlandse Landschapschilder te Rome (1768–

1839)," *Nederlands Kunsthistorisch Jaarboek*, 21 (1970), 319–69.

Bull, Duncan et al. *Classic Ground: British Artists and the Landscape of Italy, 1740–1830.* Exh. cat. New Haven: Yale Center for British Art, 1981.

Busiri Vici, Andrea. *Jan Franz von Bloemen "Orizzonte" e l'origine del paesaggio romano settecentesco.* Rome: Ugo Bozzi, 1973.

Carlson, Victor. *Hubert Robert: Drawings and Watercolors.* Exh. cat. Washington, D.C.: National Gallery of Art, 1978.

Castellan, A[ntoine]-L[aurent]. *Lettres sur l'Italie, faisant suite aux lettres sur la Morée, l'Hellespont et Constantinople.* 3 vols. Paris: A. Nepveu, 1819.

Catalogue of Seven Sketch-Books by John Robert Cozens. Anthony Blunt, introd. Sale cat. London: Sotheby & Co., 29 Nov. 1973.

Causa, Raffaello. *Il Paesaggio napoletano nella pittura straniera.* Exh. cat. Naples: L'Arte Tipographica, 1962.

———. *La Scuola di Posillipo.* Milan: Fratelli Fabbri Editori, 1967.

Cayeux, Jean de, in collaboration with Catherine Boulot. *Hubert Robert.* Paris: Fayard, 1989.

Chateaubriand, François-René de. *Oeuvres complètes de Chateaubriand.* New ed., vol. 6. Paris: Garnier, 1859.

Chaudonneret, Marie-Claude. *Fleury Richard et Pierre Révoil: La Peinture troubadour.* Paris: Arthena, 1980.

[Chaussard, Pierre-Jean-Baptiste]. *Le Pausanias français: Etat des arts du dessin en France à l'ouverture du XIXe siècle. Salon de 1806.* Paris: F. Buisson, 1806.

Chessex, Pierre. *Ducros 1748–1810: Paesaggi d'Italia all'epoca di Goethe.* Exh. cat. (Rome, Palazzo Braschi). De Luca, 1987.

Chiarini, Marco. *Vedute romane: Disegni dal XVI al XVIII secolo.* Rome: De Luca, 1971.

———. *I Disegni italiani di paesaggio dal 1600 al 1750.* Rome: Libreria Editrice Canova, 1972.

———. Review of An Zwollo, *Hollandse en Vlaamse Veduteschilders te Rome, Master Drawings,* 16 (1978), 185–87.

Clarac, F. de. *Lettre sur le Salon de 1806.* Paris, 1806.

Claretie, Jules. *Peintres et sculpteurs contemporains. Première série: Artistes décédés de 1870 à 1880.* Paris: Librairie des Bibliophiles, 1880.

Cleaver, Dale G. "Michallon et la théorie du paysage," *Revue du Louvre,* 30 (1981), 359–65.

C[ochin, Charles-Nicolas]. *Lettres à un jeune artiste peintre, pensionnaire à l'Académie de France à Rome.* N.loc., n.d. [c.1774]. (Bibliothèque Nationale, Impr. V.24206).

Coekelberghs, Denis. "Martin Verstappen, paysagiste flamand à Rome au XIXe siècle," *Bulletin de l'Institut belge de Rome,* fasc. 37 (1967), 743 ff.

———. *Les Peintres belges à Rome de 1700 à 1830.* Etudes d'histoire de l'art publiés par l'Institut Historique Belge de Rome, no. 3 (Brussels and Rome, 1976).

Coffey, John W. *Twilight of Arcadia: American Landscape Painters in Rome, 1830–1880.* Brunswick, Maine: Bowdoin College Museum of Art, 1987.

Cohn, Marjorie B. "Le Métier des paysages dessinés d'Ingres," *Bulletin du Musée Ingres,* no. 30 (Dec. 1971), 9–12.

Conisbee, Philip. *Claude-Joseph Vernet 1714–1789.* Exh. cat. Kenwood: The Iveagh Bequest, 1976.

———. "Pierre-Henri de Valenciennes at the Louvre," *Burlington Magazine* 118 (1976), 336.

———. Review of Gutwirth, *Bidauld, Burlington Magazine,* 120 (1978), 880.

———. "Pre-Romantic *Plein-Air* Painting," *Art History,* 2 (1979), 413–28.

———. *Painting in Eighteenth-Century France.* Ithaca, N.Y.: Cornell Univ. Press, 1981.

Consulat-Empire-Restauration: Art in Early XIX Century France. Exh. cat. New York: Wildenstein, 1982.

Cormack, Malcolm. *Bonington.* Cambridge and New York: Cambridge Univ. Press, 1989.

Creuzé de Lesser, Auguste. *Voyage en Italie et en Sicile, fait en 1801 et 1802.* Paris: Didot, 1806.

Cuzin, Jean-Pierre. "Vincent, de l'Académie de France à l'Institut de France," *La Donation Suzanne et Henri Baderou au Musée de Rouen; Peintures et dessins de l'école française.* Etudes de la revue du Louvre, no. 1. Paris: Réunion des Musées Nationaux, 1980, pp. 93–100.

Danish Painting: The Golden Age. Exh. cat. London: The National Gallery, 1984.

Darmstadt in der Zeit des Klassizismus und der Romantik. Exh. cat. Darmstadt, 1979.

Dédéyan, Charles. *L'Italie dans l'oeuvre romanesque de Stendhal.* 2 vols. Paris: Société d'édition d'enseignement supérieur, 1963.

Delaborde, Henri. "Le Paysage historique: Valenciennes," *Etudes sur les beaux-arts en France et en Italie,* vol. 2. Paris: Renouard, 1864, 138–76.

Delécluze, E.–J. *Carnet de route d'Italie (1823–24): Impressions romaines.* Paris: Bonvin, 1942.

Delouche, Denis. *Peintres de Bretagne: Découverte d'une province.* Publications de l'Université de Haute Bretagne, no. 7. Paris: Klincksieck, 1977.

Den Broeder, Frederick. *The Academy of Europe: Rome in the 18th Century.* Exh. cat. Storrs, Conn.: The William Benton Museum of Art, 1973.

Deperthes, J.B. *Théorie du paysage, ou considérations sur les beautés de la nature que l'art peut imiter, et sur les moyens qu'il doit employer pour réussir dans cette imitation.* Paris: Lenormant, 1818.

———. *Histoire de l'art du paysage depuis la renaissance des beaux-arts jusqu'au dix-huitième siècle.* Paris: Lenormant, 1822.

Deutsche Künstler um Ludwig I. in Rom. Exh. cat. Munich: Staatliche Graphische Sammlung, 1981.

Dimier, L. *Histoire de la peinture française au XIXe siècle.* Paris: Laurens, 1929.

Dorbec, Prosper. "Les Paysagistes anglais en France," *GBA,* 4e pér., 18 (1912), 257–81.

———. *L'Art du paysage en France: Essai sur son évolution de la fin du XVIIIe siècle à la fin du Second Empire.* Paris: Laurens, 1925.

Duclaux, Lise. *L'Atelier de Desportes: Dessins et esquisses consevés par la Manufacture nationale de Sèvres.* Exh. cat. Paris: Louvre, 1982.

———. "Les Paysages romains et des environs

de Rome," *Charles-Joseph Natoire.* Exh. cat. Troyes, Nîmes, Rome: Académie de France, 1977, pp. 102ff.

Dubuisson, A. "Influence de Bonington et de l'école anglaise sur la peinture du paysage en France," *Walpole Society,* 2 (1912–13), 111–26.

Dumesnil, J. *Voyageurs français en Italie depuis le XVIe siècle jusqu'à nos jours.* Paris, 1865.

D[upuis], A[ntoine]. *Réflexions sur les paysages exposés au Salon de 1817.* Paris, 1817.

Dussieux, L., et al., eds. *Mémoires inédits sur la vie et les ouvrages des membres de l'Académie Royale de Peinture et de Sculpture.* 2 vols. Paris: J.–B. Dumoulin, 1854.

Egger, H. *Römische Veduten: Handzeichnungen aus dem XV. bis XVIII. Jahrhundert.* 2 vols. Vienna and Leipzig: E. Wolfrum, 1911–16.

Eitner, Lorenz. "Two Rediscovered Landscapes by Géricault and the Chronology of his Early Work," *Art Bulletin,* 36 (1954), 131–42.

Eleuteri, Egidio M. *La Campagna romana tra ottocento e novecento.* Exh. cat. Rome, 1980.

Enfantin, A. *Croquis progressifs de paysage d'après nature.* Paris: Gihaut frères, 1824.

Feuchtmayr, Inge. *Johann Christian Reinhart 1761–1847: Monographie und Werkverzeichnis.* Munich: Prestel, 1975.

Fleuriot de Langle, P. *Bibliothèque Marmottan: Guide analytique.* Boulogne-sur-Seine, 1938.

Flocon, F. and M. Aycard. *Salon de 1824.* Paris: A. Leroux.

Focillon, Henri. *La Peinture au XIXe siècle: Le Retour à l'antique, le romantisme.* Paris: Renouard, 1927.

Ford, Brinsley. *The Drawings of Richard Wilson.* London: Faber and Faber, 1951.

The Forest of Fontainebleau, Refuge of Reality: French Landscape 1800 to 1870. Exh. cat. New York: Shepherd Galeries, 1970.

Forges, Marie-Thérèse. de. *Théodore Rousseau 1812–1867.* Exh. cat. Paris: Louvre, 1968.

Foucart, Bruno. "The Taste for a Moderate Neoclassicism," *Apollo,* n.s., 103 (1976), 480–87.

Foucart, Jacques and Jean Lacambre. "Musée de Saint-Lô: Paysages du XIXe siècle," *Revue du Louvre,* 22 (1972), 485–90.

Les Français à Rome: Résidents dans la ville éternelle de la Renaissance au début du Romantisme. Exh. cat. Paris: Hôtel de Rohan, 1961.

Fremmel, Gerhard, ed. *Corpus der Goethezeichnungen.* Vols. 2 and 3. Leipzig: E.A. Seemann, 1960, 1965.

French Artists in Italy, 1600–1900. Exh. cat. Dayton, Ohio: Dayton Art Institute, [1971?].

French Landscape Drawings and Sketches of the Eighteenth Century. Exh. cat. London: British Museum, 1977.

French Painting 1774–1830: The Age of Revolution. Exh. cat. Detroit: Detroit Institute of Arts and New York: The Metropolitan Museum of Art, 1975.

Fusconi, Giulia. *I Paesaggi di Nicolas-Didier Boguet e i luoghi tibulliani.* Rome: De Luca, 1984.

Gaehtgens, Thomas W. and Jacques Lugand. *Joseph-Marie Vien: Peintre du Roi (1716–1809).* Paris: Arthena, 1988.

Gage, John. *A Decade of English Naturalism 1810–*

1820. Exh. cat. Norwich: Norwich Castle Museum, 1969.

Galassi, Peter. *Before Photography: Painting and the Invention of Photography*. Exh. cat. New York: The Museum of Modern Art, 1981.

Gaspard Dughet, called Gaspard Poussin (1615–1675). Exh. cat. Kenwood: The Iveagh Bequest, 1980.

Gassier, Pierre. *Léopold Robert et les peintres de l'Italie romantique*. Exh. cat. Neuchâtel: Musée des Beaux-Arts, 1983.

Gere, J.A. "An Oilsketch by Thomas Jones," *British Museum Quarterly*, 21 (1957–59), 93–94.

————., introd. *Claude Lorrain: Dessins du British Museum*. Exh. cat. Paris: Louvre, 1978.

————. "Thomas Jones: An Eighteenth-Century Conundrum," *Apollo*, n.s., 91 (1970), 469–70.

Goethe, Johann Wolfgang von. *Italian Journey*. Trans. W.H. Auden and Elizabeth Mayer. 1962; rpt. San Francisco: North Point Press, 1982.

Gowing, Lawrence. "Nature and the Ideal in the Art of Claude," *Art Quarterly*, 37 (1974), 91–96.

————. *The Originality of Thomas Jones*. London: Thames and Hudson, 1985.

Granet, François-Marius. "Memoirs of the Painter Granet." trans. Joseph Focarino. In Edgar Munhall, *François-Marius Granet: Watercolors from the Musée Granet at Aix-en-Provence*. Exh. cat. New York: The Frick Collection, 1988, pp. 3–60.

Gravenkamp, Curt. "Ernst Fries, 1801–1833: Sein Leben und sein Kunst." Dissertation, Frankfurt am Main, 1921.

Grunchec, Philippe. "Edouard Bertin (1797–1871): Sa Participation au Prix de Rome et ses dessins au musée de Chartres," *Revue du Louvre*, 30 (1980), 138–46.

————. *Le Grand Prix de peinture: Les Concours des Prix de Rome de 1797 à 1863*. Paris: Ecole nationale supérieure des Beaux-Arts, 1983.

Guiffrey, J. *Catalogue de l'exposition des oeuvres provenant des donations faites par Madame la Princesse de Croÿ et de Monsieur Louis Devilliez*. Exh. cat. Paris: Musée de L'Orangerie des Tuileries, 1930.

Gunnarsson, Torsten. *Friluftsmåleri före friluftsmåleriet: Oljestudien i nordiskt landskapsmåleri 1800–1850*. Acta Universitatis Upsaliensis, *Ars Suetica*, 12. Uppsala, 1989, with English summary.

Gutwirth, Suzanne. "Jean-Victor Bertin: Un Paysagiste néo-classique (1767–1842)," *GBA*, 83 (1974), 337–58.

————. "*The Sabine Mountains*: An Early Italian Landscape by Jean-Joseph-Xavier Bidauld," *Detroit Institute of Arts. Bulletin*, 55 (1977), 147–52.

————. *Jean-Joseph-Xavier Bidauld (1758–1846): Peintures et dessins*. Exh. cat. Carpentras: Musée Duplessis, 1978.

————. "Léon-François-Antoine Fleury (1804–1858), peintre d'après nature," *BSHAF*, année 1979 (1981), 191–209.

————. "A Pre-Romantic Painting by Nicolas-Antoine Taunay," *Los Angeles County Museum of Art. Bulletin*, 25 (1979), 32–37.

————. "Jean-Charles-Joseph Rémond (1795–1875), Premier Grand Prix de Rome du Paysage historique," *BSHAF*, année 1981 (1983), 188–218.

Hakewill, James. *A Picturesque Tour of Italy from Drawings Made in 1816–1817*. London: John Murray, 1820.

Harambourg, Lydia. *Dictionnaire des peintres paysagistes français au XIXe siècle*. Neuchâtel, 1985.

Harris, Enriqueta. "Velasquez and the Villa Medici," *Burlington Magazine*, 123 (1981), 537–41.

Haskell, Francis. "The Not-So-Innocent Eye." Review of Miquel, *L'Ecole de la nature, New York Review of Books* (9 Dec. 1976), 53–57.

Hasse, Max. *Deutsche Künstler zeichen in Italien, 1780–1860*. Exh. cat. Lübeck: Museen für Kunst und Kulturgeschichte, [1972?].

Hawcroft, Francis. *Watercolours by John Robert Cozens*. Exh. cat. Manchester: Whitworth Art Gallery, 1971.

————. *Travels in Italy 1776–1783: Based on the Memoirs of Thomas Jones*. Exh. cat. Manchester: Whitworth Art Gallery, 1988.

Heilmann, Christoph, ed. *"In uns selbst liegt Italien": Die Kunst der Deutsch-Römer*. Exh. cat. Munich: Haus der Kunst, in association with Hirmer Verlag, Munich, 1987.

Held, Julius S. *The Oil Sketches of Peter Paul Rubens*. 2 vols. Princeton: Princeton Univ. Press, 1980.

Herbert, Robert L. *Barbizon Revisited*. Exh. cat. Boston: Museum of Fine Arts, 1962.

Herbet, Félix. *Dictionnaire historique et artistique de la forêt de Fontainebleau*. Fontainebleau: Maurice Bourges, 1903.

Hercenberg, Bernard. *Nicolas Vleughels, peintre et directeur de l'Académie de France à Rome 1668–1737*. Paris: Léonce Laget, 1975.

Holcomb, Adele M. "A Neglected Phase of Turner's Art: His Vignettes to Rogers' 'Italy'," *Journal of the Warburg and Courtauld Institutes*, 32 (1969), 405–10.

Holloway, James. "Two Projects to Illustrate Allan Ramsey's Treatise on Horace's Sabine Villa," *Master Drawings*, 14 (1976), 280–86.

Holst, Christian von. *Joseph Anton Koch 1768–1839: Ansichten der Natur*. Exh. cat. Stuttgart: Staatsgalerie, in association with Edition Cantz, Stuttgart, 1989.

Hourticq, Louis et al. *Les Artistes français en Italie de Poussin à Renoir*. Exh. cat. Paris: Petit Palais, 1934.

Huet, René-Paul. *Paul Huet (1803–1869) d'après ses notes, sa correspondance, ses contemporains*. Paris: Renouard, 1911.

Huth, Hans. Review of L. Schudt, *Italienreisen, Art Bulletin*, 42 (1960), 162–64.

Huyghe, René. "Le Don de Mme. la Princesse de Croÿ," *Beaux-Arts*, 8e année, no. 10 (1930), 4–6.

Images of the Grand Tour: Louis Ducros, 1748–1810. Manchester: Whitworth Art Gallery, 1985.

Ivanoff, N. "Venise dans la peinture française." In *A Travers l'art français: Du Moyen age au 20e siècle: Hommage à R. Jullian*. Paris: F. de Nobele, 1978, pp. 189–99.

Jal, Auguste. *L'Artiste et le philosophe, entretiens critiques sur le Salon de 1824*. Paris: Ponthieu, 1824.

————. *Salon de 1827: Esquisses, croquis, pochades ou tout ce qu'on voudra*. Paris: Ambroise Dupont et Cie., 1828.

Jamot, Paul. "Ravier en Italie; Ravier et Corot; Ravier et Carpeaux," *Revue de l'art*, 44, no. 2 (June–Dec. 1923), 321–32.

Jean-Germain Drouais, 1763–1788. Exh. cat. Rennes: Musée des Beaux-Arts, 1985.

Johann Jakob Frey (1813–1865): A Swiss Painter in Italy. Exh. cat. New York: Wheelock Whitney & Co., 1985.

Johnson, Mark M. *Idea to Image: Preparatory Studies from the Renaissance to Impressionism*. Exh. cat. Cleveland: Cleveland Museum of Art, 1980.

Johnson, W. McAllister. *French Lithography: The Restoration Salons 1817–1824*. Kingston, Ontario: Agnes Etherington Art Centre, 1977.

Jones, Thomas. "Memoirs of Thomas Jones." A.P. Oppé, ed. *Walpole Society*, 32 (1946–48).

Jørnaes, Bjarne et al., *Johan Christian Dahl i Italien*. Exh. cat. Copenhagen: Thorvaldsens Museum, 1987.

Joyant, Jules-Romain. *Jules-Romain Joyant (1803–54): Lettres et tableaux d'Italie*. Edouard Joyant, ed. Paris: Laurens, 1936.

Keaveney, Raymond. *Views of Rome from the Thomas Ashby Collection in the Vatican Library*. London: Scala Books, in association with the Biblioteca Apostolica Vaticana and the Smithsonian Institution Traveling Exhibition Service, 1988.

Kérartry, Auguste Hilarion de. *Annuaire de l'école française de peinture, ou lettres sur le Salon de 1819*. Paris: Maradan, 1820.

Klenze, Camillo von. *The Interpretation of Italy During the Last Two Centuries*. The Decennial Publications, 2nd ser., vol. 17. Chicago: Univ. of Chicago Press, 1907.

Knox, George. *Un Quaderno di vedute di Giambattista e Domenico Tiepolo*. Milan: Electa, [1974?].

Krautheimer, Richard. *Rome: Profile of a City, 312–1308*. Princeton: Princeton Univ. Press, 1980.

Krönig, Wolfgang. "Rom-Vedute mit Rom-Historie im Werk von Charles Natoire." In *Festschrift für Heinz Ladendorf*. Peter Bloch and Gisela Zick, eds. Cologne: Bohlau Verlag, 1970, pp. 50–57.

————. "Storia di una veduta di Roma," *Bolletino d'arte*, serie 5, 57 (1972), 165–98.

————. *Philipp Hackert: "Zehn Aussichte von dem Landhause des Horaz"* in *1780*. Exh. cat. Dusseldorf: Goethe-Museum, 1983.

Kuhn, Dorothea. *Auch ich in Arcadien: Kunstreisen nach Italien 1600–1900*. Exh. cat. Marbach am Neckar: Schiller-Nationalmuseum, 1966.

Kuvvenhoven, Fransje. *De Familie Knip: drie generaties kunstenaars uit Noord-Brabant*. Exh. cat. ('s-Hertogenbosch, Noordbrabants Museum). Zwolle: Uitgeverij Waanders, 1988.

L., L. "Atelier de M. Richard, peintre de paysage," *Revue du Midi*, 1 (Jan.–March 1833),

246–49.

Lacambre, Geneviève. *Les Paysages de Pierre-Henri de Valenciennes, 1750–1819*. Dossier du département des peintures, no. 11, Exh. cat. Paris: Louvre, 1976.

———. "Pierre-Henri de Valenciennes en Italie: Un Journal de voyage inédit," *BSHAF*, année 1978 (1980), 139–72.

———. "*L'Eruption de Vésuve* par Pierre-Henri de Valenciennes," *Revue du Louvre*, 30 (1980), 312–14.

———. "Une Lettre de Pierre Henri de Valenciennes à une jeune élève," *Archives de l'art français*, nouv. pér., 28 (1986), 159–60.

Lalande, J.J. *Voyage en Italie, fait dans ces années 1765 et 1766*. 8 vols. Paris and Venice, 1769.

Lamicq, Pierre. "Achille-Etna Michallon." In Pierre Miquel, *Le Paysage français au XIXe siècle, 1824–1874* (Maurs-la-Jolie: Editions de la Martinelle, 1975), vol. 2, 76–85.

Landon, C[harles] P[aul]. *Annales du Musée et de l'école moderne des beaux-arts.* . . . 17 vols. Paris: Landon, 1801–9.

———. *Salon de 1808* [*1810, 1812*, etc.]. 12 vols. Paris: Landon, 1808–24.

Lanoe, Georges and Tristan Brice. *Histoire de l'école française de paysage*. Paris: A. Charles, 1901.

Larat, Jean. *Les Artistes découvrent les provinces: l'Auverge et le Velay*. Clermont-Ferrand, 1964.

Lebrun. N.-G.-H. *Essai sur le paysage ou du pouvoir des sites sur l'imagination*. Paris: Didot, 1822.

Lecarpentier, C.-J.-F. *Essai sur le paysage dans lequel on traite des diverses méthodes pour se conduire dans l'étude du paysage, suivi de courtes notices sur les plus habiles peintres en ce genre*. Paris: Treuttel et Wurtz, 1817.

Lenormant, Charles. *Les Artistes contemporains*. 2 vols. Paris: A. Mesnier, 1833.

Lessing, W. "Ein bayerische Corot: Dillis' Blicke auf Rom," *Die Kunst und das schöne Heim* (Munich), 49, Heft 1 (1950), 1–3.

Levitine, George. *Girodet-Trioson: An Iconographical Study*. Outstanding Dissertations in the Fine Arts. New York: Garland, 1978, ch. 6, "Landscape."

Lhose, Bruno. *Jakob Philipp Hackert: Leben und Anfänge seiner Kunst*. Inaugural Dissertation, Frankfurt am Main: Wolfgang-Goethe-Universität, 1936.

Lichtenberg, R. and E. Jaffé von. *Hundert Jahre deutsche-römische Landschaftsmalerei*. Berlin, 1907.

Lowry, Bates. "Notes on the 'Speculum Romanae Magnificentiae' and Related Publications," *Art Bulletin*, 34 (1952), 46–50.

Lutterotti, Otto R. von. *Joseph Anton Koch 1768–1839: Leben und Werk*. Vienna and Munich: Herold, 1985.

Magnin, Jeanne. *Le Paysage français des enlumineurs à Corot*. Paris: Payot, 1928.

Mallet, George. *Voyage en Italie dans l'année 1815*. Paris: J.J. Paschouel, 1817.

Mandevaere, N.A. Michel. *Principes raisonnés du paysage à l'usage des écoles des Départements de l'Empire français, dessinés d'après nature*. Paris: Boudeville, 1804.

Manwaring, Elizabeth. *Italian Landscape in Eighteenth-Century England: A Study Chiefly of the Influence of Claude Lorrain and Salvator Rosa on English Taste, 1700–1800*. New York: Oxford Univ. Press, 1925.

Marchand, J. *Cours de paysages ou choix des plus belles fabriques et vues d'Italie*. Paris, 1809.

Marionneau, Charles. *Brascassat: Sa Vie et son oeuvre*. Paris: Renouard, 1872.

Marmottan, Paul. *L'Ecole française de peinture (1789–1830)*. Paris: Laurens, 1886.

———. "Le Peintre Louis Gauffier," *GBA*, 5e pér., 13 (1926), 281–300.

Masson de Saint-Maurice, M., commissaire-priseur. *Catalogue des tableaux, études, peintures et dessins de feu Achille Etna Michallon, pensionnaire du Roi*. Paris, 1822.

McMordie, Colin P. "Louis-François Cassas: The Formation of a Neo-classical Landscapist," *Apollo*, n.s., 103 (1976), 228–30.

———. "The Tradition of Historical Landscape in French Art 1780–1830." B. Litt thesis, Oxford: University of Oxford, Oriel College, 1976.

Méjanès, Jean-François. "L'Académie de France à Rome sous l'Ancien Régime. Inventaires des dessins des pensionnaires sous les directorats de N. Vleughels et J.F. Detroy (1725–1751) dans les collections publiques françaises." Typescript thesis, Paris: Ecole du Louvre, 1969.

———. "Le Voyage d'Italie." In *La Donation Suzanne et Henri Baderou au Musée de Rouen: Peintures et dessins de l'école française*. Etudes de la revue de Louvre, no. 1. Paris: Réunion des Musées Nationaux, 1980, pp. 81–88.

Melot, Michel. *Graphic Art of the Pre-Impressionists*. Trans. Robert Erich Wolf. New York: Abrams, 1980.

Menguin, Urbain. *L'Italie des romantiques*. Paris: Plon-Nourrit, 1902.

Mesuret, Robert. *Pierre-Henri de Valenciennes*. Exh. cat. Toulouse: Musée Paul-Dupuy, 1956.

Michallon, Achille-Etna. *Vues d'Italie et de Sicile par A.E. Michallon . . . lithographiée par MM. Villeneuve, Deroi et Renoux*. Paris, 1826.

Michel, Emile. *La Forêt de Fontainebleau dans la nature, dans la littérature et dans l'art*. Paris: Renouard, 1909.

Michel, Marianne Roland, introd. *Rome 1760–1770: Fragonard, Hubert Robert et leurs amis*. Exh. cat. Paris: Cailleux, 1983.

Michel, Régis. "A Proposito dei disegni del primo soggiorno di David a Roma (1775–1780)." In *David e Roma*. Exh. cat. Rome: Académie de France, 1981.

Miel, E.F.A. *Essai sur le Salon de 1817, ou examen critique des principaux ouvrages dont l'exposition se compose*. Paris: Didot le jeune, 1817.

Miquel, Pierre. *Paul Huet, de l'aube romantique à l'aube impressionniste*. Sceaux: Editions de la Martinelle, 1962.

———. *Le Paysage français au XIXe siècle, 1824–1874: l'Ecole de la nature*. 3 vols. Maurs-la-Jolie: Editions de la Martinelle, 1975.

Møde med Italien: Hollandske, tyske, og skandinaviske tegninger 1770–1840. Exh. cat. Copenhagen: Thorvaldsens Museum, 1971.

Mongan, Agnes. "Ingres et ses jeunes compatriotes à Rome 1806–20," *Actes du colloque international Ingres et son influence*. Bulletin spécial des Amis du Musée Ingres. Montauban, 1980, pp. 9–15.

Monuments et sites d'Italie vus par les dessinateurs français de Callot à Degas. Exh. cat. Paris: Louvre, 1958.

Naef, Hans. *Ingres in Rome*. Exh. cat. N. loc.: International Exhibitions Foundation, 1971.

Nathan, Peter. *Friedrich Wasmann, sein Leben und seine Werke: Ein Beitrag zur Geschichte der Malerei des neunzehnten Jahrhunderts*. Munich: Bruckmann, 1954.

Die Nazarener. Exh. cat. Frankfurt am Main: Städelsche Kunstinstitut, 1977.

Noack, Friedrich. *Deutsches Leben in Rom, 1700 bis 1900*. 1907; rpt. Bern: Lang, 1971.

Nolhac, Pierre de and G.K. Loukomski. *La Rome d'Hubert Robert*. Paris: Vincent et Fréal, 1930.

Notice des tableaux, dessins, livres . . . composant le cabinet de feu M. P.H. Valenciennes, etc. Paris, 1819.

Oberhuber, Konrad. *Poussin: The Early Years in Rome: The Origins of French Classicism*. Exh. cat. Fort Worth: Kimbell Art Museum, in association with Hudson Hills Press, New York, 1988.

Oesterreichische Künstler und Rom vom Barock zur Secession. Exh. cat. Vienna: Akademie der bildenden Künste, 1972.

Ojalvo, David et al., *Léon Cogniet 1794–1880*. Exh. cat. Orléans: Musée des Beaux-Arts, 1990.

The Origins of the Italian Veduta. Exh. cat. Providence, Rhode Island: Brown Univ., 1978.

Il Paesaggio nel disegno del cinquecento europeo. Exh. cat. Rome: Académie de France, 1972.

Paesisti e vedutisti a Roma nel '600 e nel '700. Exh. cat. Rome: Palazzo Barberini, 1956.

Painting from Nature: The Tradition of Open-Air Oil Sketching from the 17th to the 19th Centuries. Exh. cat. London: Arts Council of Great Britain, 1980.

Paintings by Paul Huet (1803–1869). Exh. cat. London: Heim Gallery, 1969.

Pariset, François-Georges. "Dessins de voyages: Artistes français en Italie dans la seconde partie du XVIIIe siècle," *GBA*, 54 (1959), 117–28.

La Peinture allemande à l'époque du Romantisme. Exh. cat. Paris: Louvre, 1976.

Pellicer, Laure. "Le Peintre François-Xavier Fabre (1766–1837)." Thèse de doctorat d'Etat, Paris: Université de Paris IV, 1982.

Perez, Marie-Felicie. "The Italian Views of Jean-Jacques de Boisieu," *Master Drawings*, 17 (1979), 34–43.

Périn, Alphonse, ed. *Oeuvres diverses de Victor Orsel*. 2 vols. Paris, 1850–78.

Pescarzoli, Antonio. *I Libri di viaggio e le guide della raccolta Luigi Fossati Bellani*. 3 vols. Rome, 1957.

Petit-Radel, P. *Voyage historique, chorographique, et philosophique dans les principales villes de l'Italie en 1811 et 1812*. 3 vols. Paris: Chanson 1815.

Pictures from the Grand Tour. Exh. cat. London: Colnaghi, 1978.

Piles, Roger de. *Cours de peinture par principes.* Paris: Jules Estienne, 1708.

P[illet], N.-B.-Fabien. *Une matinée au Salon, ou les peintres de l'école passés en revue; critique des tableaux de l'exposition de 1824.* Paris: Delaunay, 1824.

Pine-Coffin, R.S. *Bibliography of British and American Travel in Italy to 1860.* Biblioteca di Bibliografia Italiana, vol. 76. Florence, 1974.

Pinnau, Ruth Irmgard. *Johann Martin von Rohden, 1778–1868: Leben und Werk.* Bielfeld, 1965.

Plekon, Jeanne. "Jakob Philipp Hackert." Unpublished research paper (1980?), on file in the Dept. of Art History and Archaeology, Columbia Univ., New York.

Pointon, Marcia. "The Italian Tour of William Hilton, R.A. in 1825," *Journal of the Warburg and Courtauld Institutes,* 35 (1972), 339–58.

———. *The Bonington Circle: English Watercolour and Anglo-French Landscape 1790–1855.* Brighton, England: The Hendon Press, 1985.

[Potocki, Comte Jean]. *L'Amateur polonais au Salon de 1787.* Paris, 1787.

Powell, Cecilia. *Turner in the South: Rome, Naples, Florence.* New Haven and London: Yale Univ. Press, 1987.

———. "Turner's Vignettes and the Making of Rogers' Italy," *Turner Studies,* 3, no. 1 (1983), 2–13.

Quatremère de Quincy, A. "Essai historique sur l'art du paysage à Rome," *Archives littéraires de l'Europe ou Mélanges de littérature et de philosophie par une société de gens de lettres,* 10 (1806), 193–208, 376–91.

Radisich, Paula Rea. "Eighteenth Century Landscape Theory and the Work of Pierre Henri de Valenciennes." Dissertation, Los Angeles: University of California at Los Angeles, 1977.

———. "Eighteenth-Century *Plein-Air* Painting and the Sketches of Pierre Henri de Valenciennes," *Art Bulletin,* 64 (1982), 98–104.

Ramade, Patrick. "Théodore Caruelle d'Aligny: Dessins du premier séjour italien (1822–1827)," *Revue du Louvre,* 36 (1986), 121–30.

Ramisch, Hans K. "Johann Georg von Dillis, viaggi in Italia," *Antichità viva,* 3, no. 3 (1964), 31–40.

Rave, Paul Ortwin. *Karl Blechen: Leben, Würdigungen, Werk.* Berlin: Deutscher Verein für Kunstwissenschaft, 1940.

———. "Blechens italienisce Skizzenbücher." In *Deutschland-italien . . . Festschrift für W. Waetzold.* Berlin: Grote, 1941, pp. 315–26.

Reizen naar Rome: Italië als leerschool voor nederlandse kunstenaars omstreeks 1800. Exh. cat. Haarlem: Teylers Museum, 1984, with text in Italian.

Riccardi, Domenico. "I pittori tedeschi di Olevano tra Romanticismo e Realismo nella prima metà del XIX secolo." In A. D'Alessandro, ed. *Artisti e scrittori europei a Roma e nel Lazio dal grand tour ai Romantici.* Rome, 1984, pp. 87–102.

Rieu-Edelmann, M. "La Forêt de Fontainebleau dans l'estampe et la photographie, d'après les collections topographiques du Cabinet des Estampes de la Bibliothèque Nationale, de 1780

à 1890." Typescript thesis. Paris: Ecole du Louvre, 1973.

Ripert, Emile. *François-Marius Granet (1755–1849): Peintre d'Aix et d'Assise.* Paris: Plon, [1937].

Rodonachi, E. *Les Voyageurs français à Rome de Montaigne à Stendhal.* Pavia, 1910.

Roebels, Hella. *Sehnsucht nach Italien: Bilder deutscher Romantiker.* Munich: Hirmer, 1974.

Roethlisberger, Marcel. *Claude Lorrain: The Paintings.* New Haven: Yale University Press, 1961.

———. *Claude Lorrain: The Drawings.* 2 vols. Berkeley and Los Angeles: Univ. of California Press, 1968.

——— et al. *Im Licht von Claude Lorrain: Landschaftsmalerei aus drei Jahrhunderten.* Exh. cat. (Munich: Haus der Kunst). Munich: Hirmer, 1983.

Rosenblum, Robert. *Transformations in Late Eighteenth-Century Art.* Princeton: Princeton Univ. Press, 1967.

——— and H.W. Janson. *Nineteenth-Century Art.* New York: Abrams, 1984.

Rosenthal, Gisela. "Bürgerliches Naturgefühl und offizielle Landschaftsmalerei in Frankreich 1753–1824." Dissertation, Heidelberg: Rupert-Karl-Universität, 1974.

Rosenthal, Léon. *Du Romantisme au réalisme: Essai sur l'évolution de la peinture en France de 1830 à 1848.* Paris: Renouard, 1914.

Rudloff, M. "Rumohr und die Folgen: Zu den Bremer Oelskizzen Friedrich Nerlys," *Niederdeutsche Beiträge zur Kunstgeschichte,* 16 (1977), 93–106.

Russell, H. Diane. *Claude Lorrain 1600–1682.* Exh. cat. Washington, D.C.: National Gallery of Art, 1982.

Scherer, Margaret R. *Marvels of Ancient Rome.* New York: The Metropolitan Museum of Art, 1955.

Schneider, René. *Quatremère de Quincy et son intervention dans les arts (1788–1830).* Paris: Hachette, 1910.

Schnorr von Carolsfeld, Julius. *Briefe aus Italien, geschrieben in den Jahren 1817 bis 1827.* Gotha: Friedrich Andreas Berthes, 1886.

Schudt, Ludwig. *Le Guide di Roma: Materialen zu einer Geschichte der römische Topographie.* Vienna and Augsburg: Filser, 1930.

———. *Italienreisen im 17. und 18. Jahrhundert.* Vienna: Schroll, 1959.

Schwarz, Heinrich. "Heinrich Reinhold in Italien," *Jahrbuch der Hamburger Kunstsammlungen,* 10 (1965), 71–96.

Segal, Georges Berthold. "Der Maler Louis Léopold Robert 1794–1835: Ein Beitrag zur Geschichte der romantischen Malerei in der Schweiz." Dissertation, Basel, 1973.

Sensier, Alfred. *Etude sur Georges Michel.* Paris: Lemerre, 1873.

Sérullaz, Arlette. "A Propos d'un album de dessins de Jean-Germain Drouais au Musée de Rennes," *Revue du Louvre,* 26 (1976), 380–87.

Shirley, A. "Paintings by John Constable in Paris, 1824–1826," *GBA,* 23 (1943), 173–80.

Simon, Kurt Erich. "Julien Boilly: Camarade de Corot en Italie," *Revue de l'art ancien et moderne,*

67 (1935), 225–28.

Simpson, Lisa A. *From Arcadia to Barbizon: A Journey in French Landscape Painting.* Exh. cat. Memphis: The Dixon Gallery and Gardens, 1987.

Skelton, Jonathan. "Letters of Jonathan Skelton written from Rome and Tivoli in 1758." Brinsley Ford, ed. *Walpole Society,* 36 (1960), 23–82.

Sloan, Kim. *Alexander and John Robert Cozens: The Poetry of Landscape.* New Haven and London: Yale Univ. Press, in association with the Art Gallery of Ontario, 1986.

Solkin David H. "Some New Light on the Drawings of Richard Wilson," *Master Drawings,* 16 (1978), 404–14.

———. *Richard Wilson: The Landscape of Reaction.* Exh. cat. London: The Tate Gallery, 1982.

Staël, Mme. de. *Corinne, ou l'Italie.* 1807; 8th ed. Paris: H. Nicolle, 1818.

Stainton, Lindsay. *British Artists in Rome 1700–1800.* Exh. cat. Kenwood: The Iveagh Bequest, 1974.

Stendhal [Marie Henri Beyle]. *Oeuvres complètes.* Georges Eudes, ed. vols. 5 and 6. Paris: Pierre Larrive, 1953.

Sterling, Charles and Hélène Adhémar. *Musée national du Louvre. Peintures. Ecole française. XIXe siècle.* 4 vols. Paris: Editions des Musées Nationaux, 1958–61.

Strick, Jeremy. "Connaissance, classification et sympathie: Les Cours de paysage et la peinture de paysage au XIXe siècle," *Littérature,* no. 61 (Feb. 1986), 17–33.

Strieder, Barbara, et al. *Carl Rottmann 1797–1850: Kartons, Aquarelle, Zeichnungen.* Exh. cat. Darmstadt: Hessisches Landesmuseum, 1989.

Sutton, Denys and Ann Clements. *An Italian Sketchbook by Richard Wilson, R.A.* 2 vols. London: The Paul Mellon Foundation for British Art, in association with Routledge and Kegan Paul, London, 1968.

Swane, L. *Danske Malere i Rom.* Rom og Danmark, no. 1. Copenhagen, 1935.

Talbot, William S. "Some French Landscapes: 1779–1842," *Bulletin of the Cleveland Museum of Art,* 65 (1978), 75–91.

———. "Cogniet and Vernet at the Villa Medici," *Bulletin of the Cleveland Museum of Art,* 67 (1980), 135–49.

Thénot, Jean-Pierre. "Esquisse historique du paysage," *Journal des artistes,* 30 May and 12 June 1841.

Thiers, A. *Salon de 1822, ou collection des articles insérés au Constitutionel, sur l'exposition de cette année.* Paris: Maradan, 1822.

———. *Salon de 1824.* Paris, 1824.

Thomas Jones (1742–1803). Exh cat. London: Greater London Cuncil, 1970.

Trait d'union: Pittori italiani e francesi a Villa Medici. Exh. cat. Rome: Académie de France, 1988.

Uggeri, Abbé Angelo. *Journées pittoresques des édifices antiques dans les environs de Rome.* 5 vols. Rome 1804–6.

Valenciennes, Pierre-Henri de. *Elémens de perspective pratique, à l'usage des artistes, suivis de réflexions et conseils à un élève sur la peinture, et*

particulièrement sur le genre de paysage. Paris: Desenne [1800].

Valette, Gaspard. *Reflets de Rome: Rome vue par les écrivans.* 3rd ed. Paris: Plon-Nourrit, 1909.

Vance, William L. *America's Rome.* Vol. 1, *Classical Rome.* New Haven and London: Yale Univ. Press, 1989.

Vanier, V.A. *Oraison de feu Achille-Etna Michallon.* Paris: A. Boucher, 1822.

Vatout, J. *Notices historiques sur les tableaux de la galerie de S.A.R. Mgr. le duc d'Orléans.* 4 vols. Paris, 1825–26.

Venturi, Lionello. "Pierre-Henri de Valenciennes," *Art Quarterly,* 4 (1941), 89–109.

Verdi, Richard. "Poussin's Life in Nineteenth-Century Pictures," *Burlington Magazine* 111 (1969), 741–50.

Vidal-Naquet, Elisabeth, and Henry Wytenhove. *Jean-Antoine Constantin.* Exh. cat. Marseille: Musée des Beaux-Arts, 1985.

V[ieillard], P.-A. *Salon de 1824: Revue des ouvrages. Extrait du Journal des Maires.* Paris, 1825.

Vitzthum, Walter. *Drawings by Gaspar van Wittel (1652/53–1736) from Neapolitan Collections.* Exh. cat. Ottawa: National Gallery of Canada, 1977.

Von Dillis bis Piloty: Deutsche und österreichische Zeichnungen, Aquarelle, Oelskizzen, 1790–1850, aus eigenem Besitz. Exh. cat. Munich: Staatliche Graphische Sammlung, 1980.

Waetzold, Wilhelm. *Das klassische Land: Wandlungen der Italiensehnsucht.* Leipzig E.A. Seemann, 1927.

Walker, Thomas Chapell. *Chateaubriand's Natural Scenery: A Study of his Descriptive Art.* Johns Hopkins Studies in Romance Literature and Languages. Extra vol. 21. Baltimore: Johns Hopkins, 1946.

Watelin, Jacques. *Le Peintre J.-L. de Marne (1752–1829).* Paris: Bibliothèque des Arts, 1962.

Wechsler, S. *Ernst Fries: Gemälde, Aquarelle und Zeichnungen im Besitz des Kurpfälzischen Museums Heidelberg.* Heidelberg, 1974.

Wenzel, Carol Rose. "The Transformation of French Landscape Painting from Valenciennes to Corot, 1787 to 1827." Dissertation, Philadelphia: Univ. of Pennsylvania, 1979.

Whitfield, Clovis. "Nicolas Poussin's 'Orage' and 'Temps Calme'," *Burlington Magazine,* 119 (1977), 4–12.

Whitney, Wheelock III. "Pierre-Henri de Valenciennes (1750–1819)." M.A. thesis, London: Courtauld Institute of Art, 1975.

———. "Pierre-Henri de Valenciennes: An Unpublished Document," *Burlington Magazine,* 118 (1976), 225–27.

———. *The Lure of Rome: Some Northern Artists in Italy in the Nineteenth Century.* Exh. cat. London: Hazlitt, Gooden & Fox, 1979.

Wildenstein, Georges. *Un Peintre de paysage au 18e siècle: Louis Moreau.* Paris, 1923.

Wilkinson, Gerald. *Turner Sketches 1802–20.* New York: Watson-Guptill, 1974.

William Turner und die Landschaft seiner Zeit. Exh. cat. Hamburg: Kunsthalle, 1976.

Williams, E. *Drawings of Fragonard in North-American Collections.* Exh. cat. Washington, D.C.: National Gallery of Art, 1978.

Wilton, Andrew. *The Art of Alexander and John Robert Cozens.* New Haven: Yale Center for British Art, 1980.

Winkler, Gerhard, et al. *Heinrich Rienhold (1788–1825): Italienische Landschaften.* Exh. cat. Gera: Kunstgalerie, 1988.

Wisdom, John Minor. *French Nineteenth-Century Oil Sketches: David to Degas.* Chapel Hill, N.C.: Ackland Memorial Art Center, 1978.

Wittkower, Rudolf, introd. *Masters of the Loaded Brush: Oil Sketches from Rubens to Tiepolo.* Exh. cat. New York: Columbia Univ., 1967.

Zeri, Federico. *Le Mythe visuel de l'Italie.* Trans. Christina Paolini. Paris: Rivages, 1986.

Zurück zur Natur: die Künstlerkolonie von Barbizon, ihre Vorgeschichte und ihre Auswirkung. Exh. cat. Bremen: Kunsthalle, 1978.

Zwollo, An. *Hollandse en Vlaasme Veduteschilders te Rome, 1675–1725.* Assen: van Gorcum, 1973.

INDEX